MARICOPA COUNTY
CHANDLER

LEARNING
2626 EAST PECOS ROAD
CHANDLER, AZ 85225

DISCARD

F 731 .E47 2004

Elofson, W. M.

Frontier cattle ranching in
the land and times of

Donated

by

Peter Iverson

FRONTIER CATTLE RANCHING IN THE LAND
AND TIMES OF CHARLIE RUSSELL

Frontier Cattle Ranching in the Land and Times of Charlie Russell

WARREN M. ELOFSON

McGill-Queen's University Press
Montreal & Kingston · London · Ithaca
University of Washington Press
Seattle

© McGill-Queen's University Press 2004
ISBN 0-7735-2703-6
Legal deposit second quarter 2004
Bibliothèque nationale du Québec

Published simultaneously in the United States by University of Washington Press, PO Box 50096, Seattle, WA 98145-5096
www.washington.edu/uwpress

This book has been published with the help of a grant from the Canadian Federation for the Humanities and Social Sciences, through the Aid to Scholarly Publications Programme, using funds provided by the Social Sciences and Humanities Research Council of Canada.

McGill-Queen's University Press acknowledges the support of the Canada Council for the Arts for our publishing program. We also acknowledge the financial support of the Government of Canada through the Book Publishing Industry Development Program (BPIDP) for our publishing activities.

National Library of Canada Cataloguing in Publication Data

Elofson, W.M.
　Frontier cattle ranching in the land and times of Charlie Russell / Warren M. Elofson.
　Includes bibliographical references and index.
　ISBN 0-7735-2703-6
　1. Ranching – Prairie Provinces – History. 2. Frontier and pioneer life – Prairie Provinces. 3. Ranching – Montana – History. 4. Frontier and pioneer life – Montana. 5. Russell, Charles M. (Charles Marion), 1864–1926. I. Title.
　FC3218.9.R35E463 2004　　　971.2'02　　　C2003-905949-9

Library of Congress Cataloging in Publication Data

Elofson, W.M.
　Frontier cattle ranching in the land and times of Charlie Russell / Warren M. Elofson.
　p. cm.
　ISBN 0-295-98424-4 (hardback : alk. paper)
　1. Ranch life – Montana – History – 19th century. 2. Ranch life – Prairie Provinces – History – 19th century. 3. Frontier and pioneer life – Montana. 4. Frontier and pioneer life – Prairie Provinces. 5. Montana – Social life and customs – 19th century. 6. Prairie Provinces – Social life and customs – 19th century. 7. Russell, Charles M. (Charles Marion), 1864–1926. 8. Cowboys – Montana – Biography. 9. Cowboys – Prairie Provinces – Biography. 10. Artists – United States – Biography. I. Title.
　F731.E47 2004　　　978.6'01–DC22　　　2004005181

Typeset in Sabon 10/12
by Caractéra inc., Quebec City

Printed in Canada on acid-free paper that is 100% ancient forest free (100% post-consumer recycled), processed chlorine free.

For Betty Lou, Shane, Brett, and Wade.

Contents

Illustrations	ix
Preface	xiii
Map	xv
Introduction	3
1 The First Eastern and European Migration	7
2 The Pattern of Agricultural Development	15
3 "Go West, Young Man."	25
4 The Old World in the New	42
5 Unruly Young Men	63
6 Rustling	81
7 Rangeland Entertainment	96
8 "Nice" Ladies and "Sporting" Girls	119
9 Where Have All the Range Cattle Gone?	132
10 The Triumph of Ranch Farming	158
11 Conclusion	175
Notes	193
Index	241

Illustrations

PAINTINGS AND SKETCHES
BY CHARLES MARION RUSSELL

All paintings and sketches are from the Mackay Collection at the Montana Historical Society Galleries in Helena and are published with permission. *Waiting for a Chinook* is used also with permission from the Montana Stockgrowers Association.

The Mountains and Plains Seemed to Stimulate a Man's Imagination, pen and ink, 1920 41
The Herd Quitter, oil on canvas, 1897 51
The Roundup, oil on canvas, 1913 99
Like a Flash They Turned, pen and ink, 1925 103
Laugh Kills Lonesome, oil on canvas, 1925 109
Bronc to Breakfast, watercolour, 1908, 110
Rawhide Rawlins, pen and ink, 1925 113
Lady Buckeroo, pen and ink with watercolour, n.d. 130
Waiting for a Chinook, watercolour, 1886 137

PHOTOGRAPHS

All photographs are from the Glenbow Archives and are reproduced with permission.

Bow River Ranch house, Bow River, Alberta (NA-1940-9) 4
W.R. Newbolt (NA-1046-5) 11
Round-up crew in Montana at lunch (NA-207-72) 13
Cowboy on Circle Ranch of Conrad brothers (NA-740-14) 16
A roped steer, Montana round-up, c. 1890s (NA-707-84) 17

x Illustrations

Cowboys on round-up of Spencer brothers (NA-2927-1) 18
Walrond Ranch round-up near Pincher Creek, Alberta
 (NA-1010-27) 19
Cowboy from Maple Creek, Assiniboia (NA-774-9) 20
A poster of Buffalo Bill Cody riding buffalo (NA-2573-1) 29
Bar U Ranch cowboys, Pekisko, Alberta (NA-285-4) 31
Montana cowboy (NA-207-114) 32
Everett Cyrill Johnson (NA-2924-12) 33
Polo team, Fort Macleod, Alberta (NA-967-26) 43
Hunters and dogs at Rawlinson brothers' ranch house,
 Calgary area, Alberta (NA-1122-5) 46
Cowboy in Cypress Hills area (NA-862-6) 49
F.C. Inderwick, Pincher Creek area, Alberta (NA-1365-1) 50
Cox cattle ranch, Hanging Woman Creek near Powder River,
 Montana (NA-207-86) 55
A social night at John Beam's ranch near Cochrane, Alberta
 (NA-1130-9) 56
Konrad, thoroughbred Kentucky stallion (NA-2084-14) 57
Lady Adele Cochrane, Tom Cochrane, Lord Norbury,
 Algernon St Maur of Seymour, fifteenth Duke of Somerset,
 and Susan St Maur, Duchess of Somerset, on hunting
 expedition, British American Ranch, Cochrane, Alberta
 (NA-239-4) 58
Bow Gun cowboys on round-up, Montana (NA-207-92) 60
Cowboys on round-up, Cypress Hills area (NA-862-9) 61
Cowboys drinking and entertaining, Cochrane, Alberta
 (NA-1130-15) 70
Bow Gun Ranch cowboys, Montana (NA-207-112) 73
Canadian cowboy (NA-540-1) 75
G.E. Goddard, Bow River Horse Ranch, Cochrane area, Alberta
 (NA-2084-20) 76
Montana Peigans dancing (NA-1463-11) 89
Montana night-herder catching some sleep (NA-207-113) 101
"The Cowboy Race" (NA-3813-1) 116
Rancher's wife bringing elegance to the family washing
 (NA-2607-2) 120
Métis ranchers, Maple Creek, Assiniboia (NA-1368-6) 126
Ranching family, Pincher Creek, Alberta (NA-1602-7) 127
Cowgirl from the Strathmore, Alberta, area (NA-4054-1) 129
Lucille Mulhall, champion bucking horse rider at the Calgary
 Stampede (NA-3985-6) 131
Dead cattle, Shaddock Boys Ranch, Langdon, Alberta
 (NA-1636-1) 136

Dipping tank, Russell Ranch, Drumheller, Alberta (NA-2612-7) 147
Montana cattle (NA-207-78) 148
Alberta cattle (NA-3914-5) 149
Branding chute and squeeze (NC-43-22) 161
Haying (NC-43-45) 166
Calgary Stampede (NA-564-5) 177
Sheep beside Powder River, Montana (NA-207-119) 179

Preface

This study was made necessary by the publication of my first ranching book entitled *Cowboys, Gentlemen, and Cattle Thieves*. In that work I posited two major arguments that needed further illustration. First, I suggested that the ranching frontier in western Canada followed a very similar historical path to the opening up of the northwestern United States. Second, I insisted that the impact of the frontier environment was nearly as important in moulding communities on the north side of the forty-ninth parallel as it was on the south. The obvious way to enforce these claims was to undertake a new in-depth comparison of the early ranching societies in southern Alberta and Assiniboia with those in a state directly to the south. I chose Montana because it shares with the Canadian regions a longer portion of the international border than any other state and because I knew that many of the ranchers and cowboys traded livestock, ideas about the cattle business, and cultural attributes across that same border. In proceeding with the research for this volume, I was pleased to discover that my earlier assertions were largely sustainable but I was also humbled by the realization that they required a great deal of refinement.

In the process of assembling the information base and preparing the groundwork for this monograph I incurred many debts of gratitude. I should like to thank the staffs of the Glenbow Alberta Archives in Calgary, the Provincial Archives of Alberta in Edmonton, the Provincial Archives of Saskatchewan in Regina and Saskatoon, the Montana Historical Society in Helena, the Archives at the University of Montana in Missoula and Montana State University in Bozeman, the Huntington Library in San Marino, the Idaho State Archives in Boise, the National Library of Scotland in Edinburgh, and the British Library in London. I should also like to acknowledge the vital financial assistance provided by the Social Sciences and Humanities Research Council of Canada.

Finally it is impossible to give appropriate recognition to my wife, Betty Lou, who gave unstintingly of her time and energy to read and criticize early drafts. Her input has been crucial.

The Northern Great Plains

FRONTIER CATTLE RANCHING IN THE LAND
AND TIMES OF CHARLIE RUSSELL

Introduction

This study is only incidentally about the celebrated western artist Charles Marion Russell. It is primarily about adjacent cattle-ranching frontiers that mushroomed into existence on the northern Great Plains of North America in the late nineteenth century. One was in the United States territory and then state of Montana and the other in the western Canadian territories of Alberta and Assiniboia.[1] Russell's name appears in the title for a number or reasons, however. Not only was he a cowboy and rancher who lived his adult years in the time and general geographic area of concern, but his renowned art, his short stories, and a large manuscript collection about him in the Montana Historical Society Archives at Helena[2] offer invaluable insights into the period. Russell also represents both political entities examined here. While he spent most of his adult life in Montana, he ventured north into Alberta and Assiniboia on numerous occasions and he, more than anyone else, was able to raise public awareness of ranching culture in the entire region. Thus, in the words of an acclaimed modern writer, he can justly be considered "Canada's cowboy artist too."[3] Finally, his works contribute to, and will be used to underscore, the main theme of this study – that these two frontiers shared a common history.

Many chroniclers of Western history would not be entirely comfortable with this thesis. The following statement written by a North West Mounted Police officer stationed at Fort Macleod Alberta in 1894, sums up the prevailing opinion, both current and contemporary, about the difference between the early western ranching societies that bordered the forty-ninth parallel.

The prospect for settlers in the North-west Territories of Canada would, without the protection of the mounted police, be far from pleasant.

Bow River Ranch house, Bow River, Alberta: a structure typical of first housing on Canadian and American frontiers

In the American press we constantly read of "railway trains being stopped and robbed," "stage coaches being held up," etc. Take for instance the depredations committed by the "Cook gang," and compare that with the total absence of such crime in Canada. Yet there are persons who go so far as to advocate that the entire force be disbanded.

With the North-west Mounted Police in the country a settler may go away from home on a trip of fifty or sixty miles and leave his wife and family in perfect safety and security, but one can imagine what his anguish of mind would be if he was obliged to leave home, knowing that his wife would have to depend upon her own efforts alone to protect herself from Indians, tramps or outlaws who might feel disposed to raid the ranche ...

The policy of establishing the means of obtaining law and order, before settlement, has been most beneficial to the country at large, and makes "vigilant[e] committees," "white caps" and "lynching gangs," impossible. By such committees gross injustices have, and always will be perpetrated, and many innocent persons shot and hanged.[4]

The argument, in a few words, is that strict enforcement of eastern legal standards by the Mounties ensured that the more northerly frontier was orderly and safe, while lack of enforcement below the border allowed a wild and uncontrolled culture to develop. This line of reasoning has recently been extended well beyond the realm of law and order to make the two frontiers appear almost antithetical to each other. The Canadians, we have decided, having imported their culture in general from Great Britain and Ontario, were basically Old World,

while the Americans, we say, were truly a frontier society hewn out of the social fabric and natural environment of the Great Plains.[5] A detailed comparison of ranching life in Montana and in Alberta and Assiniboia between 1878 and the killing winter of 1906–07 suggests that this characterization is far too simplistic. Old World mores and values were prominent on both sides of the border and they were almost equally shaped by their subjection to the frontier setting.

To say as much is not to imply that the two societies were identical; one of the objectives here will be to ferret out and define what made each culture in any significant sense unique. However, this study does contend that we have been inclined to overstate their differences. The truth is that the first cattlemen in Montana, and Alberta and Assiniboia shared a common history. Similarly affected by Old and New World pressures, they moved west around the same time, enticed by similar sorts of individuals for more or less the same reasons, and they had to confront a host of nearly identical problems. Moreover, the cattle industry on both sides of the border was initially conducted in much the same way and underwent a similar transformation as it responded to climatic, geographic, cultural, and market stimuli. While Montana's path diverged at certain points from that of the territories to the north, differences between them were no greater than differences between Montana and states such as Wyoming or Colorado to the south. The political boundary known as the forty-ninth parallel was far more a psychological demarcation than a border that substantively distinguished between disparate peoples.

One reason that differences between societies are often exaggerated is that historians understandably tend to study political entities separately. Scholars of western Canada, such as David Breen,[6] Lewis Thomas,[7] or Hugh Dempsey,[8] have focused on Alberta and/or Assiniboia because they are experts in that field and wish to address their own national audiences. The same can be said of Montana writers such as Robert H. Fletcher,[9] Merrill Burlingame,[10] or J.M. Hamilton.[11] Their works are interesting and most useful to anyone trying to piece together what happened and why. However, in this study I wish to follow more in the steps of writers who have looked beyond local political boundaries. Terry Jordan, for example, in his seminal work *North American Cattle-Ranching Frontiers*, has illustrated the geographic and climatic forces that fostered developments in the ranching industry as it moved north from southern Texas and California, east from Oregon, and west from Iowa and Missouri.[12] Jordan shows how natural environment and customs interacted to form and alter agricultural practices, and situates local developments within the context of much larger trends. Richard W. Slatta, in his *Comparing Cowboys and*

Frontiers, illuminates as no one has previously the life and ways of the stock hand over a massive area.[13] Through his writing we see how cowboys of Canada and the United States, *vaqueros* of Mexico, *llaneros* of Colombia and Venezuela, and *gauchos* of Argentina each in their own way embraced and moulded the range man's culture. Finally, a recent cross-border study by Beth LaDow examines life from the 1870s to 1920 in a small area encompassing Maple Creek and the Cypress Hills on the Canadian side, and the town of Chinook and the Bear Paw and Little Rocky mountains in northern Montana.[14]

The present inquiry aspires to something between these approaches. It will focus more heavily on one geographic region than either Jordan or Slatta have done. However, it will also go beyond the political boundaries to which most previous historians of the Canadian prairie West or Montana have restrained themselves, and it will view a considerably larger territory than LaDow's work. Moreover, while it will be a study of society and agriculture, it will attempt to delineate the most important national and international pressures that drew men and women to the Great Plains and helped to guide and shape their behaviour there. This direction leads to an investigation of a multitude of political, legal, social, and economic forces extending all the way to Texas, Oregon, New York, Montreal, and London.

I

The First Eastern and European Migration

The geographic area that forms the backdrop for this study is the northern extremity of the western Great Plains. It encompasses virtually the entire present-day state of Montana and a slightly smaller region running some two hundred miles north of that state into what is now southern Alberta and southern Saskatchewan. Early ranchers soon learned that for grazing livestock this area suffered from some major environmental disadvantages, among which the most obvious were severe cold spells and a tendency toward aridity and drought. Before time and weather tempered their enthusiasm, however, they were much more likely to dwell on its physical attributes.

Running along the entire western side of the region, the Rocky Mountains slope into foothills terrain generously endowed with natural grasses and forests of pine, fur, spruce, and poplar. Numerous streams and major rivers, including the Bow, Highwood, Old Man, South Saskatchewan, Milk, Missouri, and Yellowstone, gather run-off from melting snow and rains for herds to drink from. Deep valleys separating hills and mountains collect moisture, conserve it for pastures when rains fail, and, along with the trees, offer shelter from cold northwest winds in the fall, winter, and spring. East of the foothills the land levels out, the forests become sparse or non-existent, and, because of thinner soils and lower annual precipitation, the grass is less plentiful. However, along the rivers and their tributaries, valleys continue to provide natural shelter, and sponge-like floodplains hold the moisture that does fall to produce relatively good pasture lands. Here and there the flatness of the plains is broken by clusters of hills and small mountain groups.

Moving from west to east on the Canadian side we find the Milk River Ridge, the Cypress Hills, and then the Wood Mountain and Moose Mountain regions. In Montana, some of the best known are the Sweet Grass Hills and the Crazy, Moccasin, Snowy, Judith, and

Highwood ranges. These rough clusters become less plentiful as one moves further and further east from the Rockies. However, between the Yellowstone and the Missouri, and for miles flowing from north to south across the international border on both sides of the Big Muddy River, rolling benchland is cut up with badlands, coulees, buttes, and, in the summertime, dry creek beds. Early frontier ranchers grazed their herds year round on the indigenous grasses. In the summer they allowed them to wander out onto the prairies to pick away at the relatively short stands, and then pushed them back to winter in the protection of the high country or the river valleys, where the animals had access to taller, thicker growth that was not so easily hidden by snow.

The cattle business first gained a foothold on the northern Great Plains during the 1860s to meet the demand for food from miners searching for gold and silver in the foothills and mountains around the fledging urban centres of Bannack, Virginia City, and Helena in the western part of Montana.[1] The earliest herds were made up mostly of exhausted and lame cattle abandoned or sold to traders by settlers making their way further west through Utah.[2] Later, larger numbers of so-called Westerns were trailed back along the Oregon Trail from grazing lands nearer the Pacific seaboard.[3] Most of the men who took up cattle raising in the sixties did so on a small scale. Some of them came as miners and then found they could make a more secure living by grazing a few cattle and marketing meat products in the new communities. Within a short time many had diversified their agricultural pursuits and moved into a full spectrum of mixed farming activities, including dairying, poultry, sheep, and hogs. Some also fenced in their herds, put up crops of hay, and cultivated feed grains such as oats and barley in order to sustain their livestock through the cold winter months.[4]

As this form of agricultural production was being developed and refined, a much more extensive approach based on cattle grazing alone also began. In 1862 a butcher named Conrad Kohrs took over the Highland City Meat Market in Helena City and started buying local cattle to slaughter for retail. Within a few years he became a cattleman himself and began grazing animals on the vast open ranges to the east of Helena.[5] After the opening of the Union and Pacific and the Northern Pacific railway services in the early eighties he was able to transport live cattle regularly to distant markets in Chicago and London. His business helped spawn other ranching ventures. In 1865, for instance, primarily to supply Kohrs, Tom Poindexter and Bill Orr began operations in the Siskiyou area with Oregon animals.

Missouri cattle were brought in by Dan Floweree in 1865, and shortly thereafter Texans were introduced. Before the American Civil War, Jesse Chisholm opened his famous trail from southern Texas across the Indian Territory to Abilene. In the years that followed, Charlie Goodnight and Oliver Loving opened a new trail bordering the Rockies, which extended all the way to Denver and Cheyenne and then to Montana.[6] The two routes provided for a relatively steady influx of Longhorn-influenced animals. In 1866 Nelson Story trailed in the first large herd, though he and his men had to use their guns to protect the animals on the open range from the Sioux and Cheyenne Nations. Robert S. (Bob) Ford went to Texas for 300 head in 1868 and, in 1870 and 1873 respectively, herds of 1,500 were brought to the ranges in Lewis and Clark, Teton, and Cascade counties. The Texas cattle interbred with the Westerns that continued to arrive principally from Oregon and with the Hereford, Shorthorn, and Angus cattle that came in from the East.

The early seventies marked the end of the "first cattle boom" in Montana.[7] During the 1871 grazing season, cattle were overcrowded on small ranges in the western foothills under drought conditions and as a result were in less than ideal shape in the fall. As luck would have it, that winter was one of the most ferocious ever recorded, and the roaming cattle were killed off in droves. To make matters worse, the market price of beef fell dramatically in the next few years. Although the industry did not die, its recovery had to wait until prices began to improve toward the end of the decade. By then grazers had spread out across the plains and Miles City, at the end of the trail from Texas, started to gain its reputation as one of the important cattle towns of the West.

Because Alberta and Assiniboia lacked a local market equivalent to the market surrounding mining towns in western Montana, it was not until the seventies that any cattle industry took a firm hold there. The missionary brothers John and David McDougall maintained a small dairy herd near Morley in 1870, which they augmented with beef steers the next year as a source of fresh meat for themselves and the Stoney population among whom they were living.[8] The North West Mounted Police were sent west in 1874 to establish a workable relationship with the Native bands in western Canada and to prepare the prairies for settlement. Shortly later, cattle were driven in to supply the force and for the Blood, Peigan, Sarcee, Siksika, and Stoney Tribes, which desperately needed red meat to supplement the rapidly diminishing supply of buffalo. The first substantial herd – about 400 – was trailed in from British Columbia in 1875 by John Shaw.[9] H.A. Kanouse, John Miller,

Tom Lynch, George Emerson, and a man named Olsen then imported relatively small herds mostly from Montana, and a number of Mounties, including the well-known Edward Maunsell, gave up their careers in law enforcement to become cattlemen.[10] By 1880 some two hundred small herds were grazing on the free grass north of the line.[11]

On the Great Plains generally, the thirty years following 1878 in Montana and 1881 further north represent what might be called an eastern and European invasion. This phrase refers in part to human migration. Scores of young men were beginning to abandon older civilizations to seek better lives on agricultural hinterlands in the West. Most of the men who headed to Montana or Alberta and Assiniboia had ambitions either to become cowhands on one of a growing number of new ranches or to start small spreads of their own.[12] Among them were some celebrated individuals. Charles Russell left his economically and socially advantaged family in St Louis to work with a number of Montana outfits and then spent a good proportion of his time illustrating cowboy adventures on both sides of the line.[13] Edward C. (Teddy Blue) Abbott, who was born in England in 1860, came to the United States at eleven years of age, went West with his father, and quickly learned the trade of the cowboy well enough to become expert at conducting long cattle drives. In the eighties he gained employment on several spreads in Montana before settling down on his own operation.[14]

Some of these easterners looked out of place on the frontier because of their dress or mannerisms, and had to prove to their peers that they were up to the rugged life. Bob Newbolt, for instance, who worked for the Military Colonization Ranch east of Calgary, Alberta, first appeared on the range in a bowler hat and three-piece suit. The cowboys treated him as a joke until they found out what a superb horseman he was. He mastered the cowpuncher's trade and eventually became a successful farmer. A man named Biggs worked on one of the big Montana spreads in 1883. "On account of his titled connections and so on," one of the regular cowboys was assigned the task of watching out for him. However, "he never needed no looking after." He wore "one of these eyeglasses with no string, and he could ride a bucking horse and never lose it."[15]

Lots of the young men from the East learned the trade of the cowboy relatively quickly. They followed the example of cowboys born or raised on an earlier American frontier who stayed to help run the ranches after arriving with incoming herds. These young men soon became adept at all the skills of the rancher's trade.[16] On the other hand, there were always a number who were neither physically nor mentally suited to the role. Speaking of the ranch hands on the

W.R. Newbolt, a young easterner who learned the ranchman's trade with success

Walrond operation near Pincher Creek Alberta in 1888, for example, William Bell commented, "they are getting a good deal more [in wages] than they earn. I must say they are a pretty poor lot. They cannot ride and they have no idea of herding or driving stock."[17] At the end of the spring round-up at least three of them left the country "a homesick lot of boys."[18] Harry Northrop, according to an acquaintance, arrived in Calgary from England thinking he would just "walk over to a blooming ranche and commence chasing cows." The acquaintance added: "He's too delicate to work hard, and too green to know how anyway."[19] Many of the English lads were known derisively as "remittance men." They were thought to be ne'er-do-wells who had been sent to the frontier with financial backing from their wealthy families in hopes that the rugged life would finally make men of them. One observer, astonished by the numbers of such men at Calgary, poked fun at these misfits:

Thither go the young gentlemen from England who cannot, or do not, pass their examinations; or cannot, or will not, sit on a stool in father's office or who have neither the capacity nor the will to make for themselves acceptable

careers in the Old Country. They go to Calgary, usually with some capital, to "raunch." When they have lost their money, as they sometimes do, they still "raunch" – as "cowpunchers," for somebody else, at from twenty dollars to forty dollars a month, according to their skill as stockmen. If they have not the grit to do this, and keep at it, they write home for money. Many of them have regular allowances. The remittance men form a notable element of Albertan society and Calgary is their headquarters. They abound in the lounges and bars of the hotels, clad in breeches and Norfolk jackets, and wearing round, soft felt hats, with enormous brims.[20]

Such lads often impressed local society more with "their ability to knock back one whiskey after another" than anything else.[21]

In Montana misplaced remittance men consorted with other Old World types. "Rich men's sons from the East were nothing new as far as I was concerned," a rancher recalled. "The range in the eighties was as full of them as a dog's hairs of fleas."[22] A fellow the cowboys nicknamed "Marmaduke" was the "most helpless man" some of them had ever seen. He had "no manners at all around camp, he was just a damn nuisance from start to finish."[23] One time he and Teddy Blue Abbott got lost in a storm. In an effort to contact another rider Abbott "fired off three shots" with his six-shooter. Marmaduke, who "was the kind that was always asking questions because he didn't know how to use his eyes and ears and he didn't have any brains ... piped up: 'What are you firing at?'" Sarcastically, Abbott told him he was just "taking a couple shots at God Almighty." Horrified, Marmaduke pleaded, "Oh please don't do that, I'd rather you'd shoot me than hear you blaspheme."

Not all of the individuals in the stream of easterners were English. Abe Gill, "a gentleman by breeding and nature" who began grazing cattle in the Little Rockies area of Montana in the winter of 1895–96, was one of many from the eastern seaboard of North America who fit the stereotype of the "dude traveling west to become a cowboy and rancher." He was born in Brooklyn, New York, and educated at the Brooklyn Polytechnic Institute. On the frontier he "wore clothes straight out of a Frederic Remington painting: a wide brimmed hat turned up in front and creased in the middle, and spurs with rowels that dragged on the floor." His life "in the wild country" was apparently about as natural as "a banana tree in the Arctic zone."[24]

The East provided its share of disreputable individuals, too. Indeed, some were outright bad. Harvey Logan, alias Kid Curry, made his way to Montana from Kentucky in 1884 and spent his days stealing cattle and horses, robbing banks and stagecoaches, and inflicting violence on his contemporaries across the entire plains from the Canadian border

Round-up crew in Montana at lunch

to southwest Texas.[25] Charley "Red" Nelson from Nova Scotia,[26] Frank Carlyle originally from Toronto,[27] and an Englishman known as Kid Trailer, were all part of the Dutch Henry–Nelson-Jones connection that terrorized and pillaged livestock producers in Assiniboia and northern Montana from the mid-nineties to near the end of the first decade of the twentieth century.[28]

While the phrase "eastern and European invasion" denotes the migration of a great array of individuals, it also refers to the influx of an enormous amount of money. To quote one authority, it was a time when "as many capitalists as cowboys" turned their attention to the West.[29] In Boston, New York, Montreal, Edinburgh, and London new corporations were hastily thrown together to invest huge pools of surplus capital in the frontier cattle industry. As a result, 879 joint stock companies, with a total capital of over $280 million, were incorporated, most of them by 1886, in Montana, Wyoming, Colorado, and New Mexico.[30] In the Canadian North-West Territories, 111 new companies took possession of several million acres between the international border and the Bow River between 1881 and 1888.[31] The new investment brought vastly more livestock to the northern Great Plains. In the summer of 1883, as Teddy Blue Abbott was driving cattle in from Texas, he was "hardly ever out of sight of [another] herd." One day he looked over the plains from a small hilltop in the

relatively flat country near the Platte River. "I could see seven herds behind us," he remembered. "I knew there were eight herds ahead of us, and I could see the dust from thirteen more of them on the other side of the river." By the end of 1880 there were already 555,000 cattle in Montana and at the turn of the century there were just over 900,000.[32] The numbers on the grazing lands to the north, rose from a modest 9,000 to around 100,000 in the early years of the eighties, and then proceeded on upwards to over 500,000 by 1901.[33]

In exclaiming that "all the cattle in the world" seemed to be "coming up from Texas,"[34] Abbott was perhaps allowing his imagination a little more license than necessary in order to make the point. However his words did not exaggerate the dynamism of the changes that were suddenly underway in the West. At the northern end of that region his home territory and Alberta and Assiniboia were all experiencing profound social as well as economic change. Montana rancher Granville Stuart succinctly articulated one of the more obvious signs of what was happening. As this period was starting, he said, "no one had heard tell of a cowboy" on the northern Great Plains. By 1883 young men "with leather chaps, wide hats, gay handkerchiefs, clanking silver spurs, and skin fitting high healed boots ... had become an institution."[35]

2

The Pattern of Agricultural Development

Generally speaking, between 1878 and 1910 agriculture developed in the same way on the Canadian and American sides of the northern Great Plains. At first these regions were both taken over by enormous outfits that used the most extensive form of production known. By the end of the period, however, they were predominantly in the hands of much smaller, more refined and diversified operations. This pattern was governed by the interplay of natural phenomena and man-made pressures.

Most of the first ranchers on both sides of the border seem to have recognized that the best land for their purposes was in the foothills where precipitation tends to be a little more dependable, and trees and uneven terrain offer the best relief from cold weather.[1] Many therefore wanted to locate along the edge of the Rockies. In Montana, however, the areas where the smaller operators had staked their claims during the early mining days were largely occupied, and most ranchers were forced to move into the hills around the smaller ranges scattered eastward into the central parts of the state or along one of the major river systems.[2] Several British companies appeared in Montana in these years: the Matador, whose head offices were in Dundee and which eventually controlled some six million acres in regions as far-flung as Texas and southern Assiniboia;[3] the Fergus Livestock and Land Company in the basin of the Judith Mountains, after whose Scottish immigrant founder Fergus County was named;[4] the Cross S Ranch at Mizpah Creek near Miles City;[5] the McDonald,[6] Neimmela,[7] Eureka,[8] and YT[9] ranches; and the massive Powder River Ranch, which flowed into southeastern Montana from Wyoming between the Powder and Tongue rivers. This spread was directed by truly blue English and Scottish aristocratic blood, including that of William Droga Montagu, seventh Duke of Manchester, the Earl of Manchester, Viscount Mandeville, and Baron Montagu of Kimbolton.[10]

Cowboy on Circle Ranch of Conrad brothers, who operated on both sides of the border

A number of individuals and companies also arrived from the eastern states in these years to start up large ranches. One or both of the very wealthy Conrad brothers from Virginia were major shareholders in the Benton and St Louis Cattle Company and the Circle Cattle Company, both of which also operated in southern Alberta.[11] J. Walter Scott, who was born in Ohio to English parents, made his way to Montana in 1883 to ranch in the region north of Red Rock in Beaverhead County.[12] T.J. Bryan came out to Miles City from Illinois in 1881, went into the lumber business, and then took to grazing cattle in eastern Montana.[13] R.C. Walker of Indianapolis travelled to Montana via Texas and Minnesota in 1880, to become the superintendent of the Montana Cattle Company at the mouth of the Sun River.[14] Joshua Spencer Day of New York located at Redwater along the Missouri River in Dawson County,[15] and S.S. Hobson of Iowa controlled some 5,000 acres in the basin of the Judith Mountains.[16] Unquestionably the most renowned easterner to sink money into large-scale Western grazing was the future president of the United States Theodore Roosevelt. He came out from New York in 1883 and invested just enough capital in Dakota and eastern Montana to enable him to play the role of the cowboy and become a voice in the stock associations.[17] He did not stay very long, however. Most of his cattle died in the disastrous winter of 1886–87, and he promptly hung up his spurs.[18]

A roped steer, Montana round-up

Only months after leaving the West, he recorded many of his experiences in a book entitled *Ranch Life and the Hunting Trail*.[19]

Considerable numbers of not-so-distant easterners from the Montana side of the Mississippi River ("mid-westerners") also established cattle-grazing operations at this time. Foremost among them was the Home Land and Cattle Company, or N bar N Ranch, owned by the Neidringhaus brothers from Missouri. Its main operation was in the northeastern part of Montana, although it ran some cattle in Assiniboia as well.[20] John T. Murphy, also from Missouri, came to Virginia City with a wagon train of merchandise in 1865 and proceeded to make a fortune as a retailer. He formed the Montana Cattle Company on the east side of the Crazy Mountains.[21] Thomas C. Power of Iowa operated steamers on the Missouri River in the sixties and in short order became a merchant, industrialist, and banker. He and his brother John began ranching in the Judith Mountains, ostensibly in the early eighties.[22]

Not surprisingly, there were also a number of ranchers from eastern Canada in Montana. Two of them are quite well known. Robert Coburn, born to Irish parents in Smith Falls, Ontario, started mining in the state in 1866 and twenty years later bought a ranch in the Little Rockies which he named the Circle C.[23] Samuel Spencer of Middlesex County, Ontario, came West in 1881 and along with his brother John built up a big ranch on the Marias River in Montana. In later years the brothers also took out a strategically located lease on the Milk River in Southern Alberta.[24]

18 Frontier Cattle Ranching

Cowboys on round-up of Spencer brothers, who operated in Montana and Alberta

If the filling of the West in Canada was accomplished less quickly, it was also undertaken in a somewhat more controlled fashion. American ranchers operated for the most part on free land to which they had no other claim than possession; they simply mapped out the area they wanted for their headquarters and for their livestock to graze on, built line cabins around the periphery for cowpunchers to watch the herds from and to mark their territory, and commenced operations.[25] Since the land was free, many of them were able to take control of huge tracts. The Canadians, on the other hand, got a law passed by the dominion government in Ottawa giving them the right to lease land in specified localities. The land was not free but, at one to two cents an acre per year, it was considered a good bargain. Moreover, the lease system did not prevent the Canadians from getting their hands on plenty of ground. The allowed maximum was 100,000 acres but, by using different companies and names, a number of Canadian ranchers were able to double and triple that.

The four so-called patriarchs of the Canadian ranching industry were the Cochrane Ranch, controlled by Senator Matthew Cochrane from the Eastern Townships in Quebec; the Walrond, financed by a well-known English Conservative, Sir John Walrond; the Oxley, formed by, among others, the English aristocrat Lord Lathom and a staunch member of the British prime minister's Conservative caucus, Sir Alexander Staveley Hill; and the Bar U, whose principal stockholders were the Montreal family of steamship and railway magnate Sir Hugh Allen.[26]

Walrond Ranch round-up near Pincher Creek, Alberta

The majority of the Canadian ranches also located in high country to take advantage of greater moisture levels and natural shelter. The largest block of them ran in a north-south direction along the still-unoccupied foothills of the Rockies from the international border to west of Calgary. It was in that area that the Cochrane, Bar U, and Walrond were established, as well as the Glengarry (or 44) Ranch, the Alberta Ranch, the Circle Ranch, and the Quorn. A smaller block that included the Spencer brothers ran east-west along the Milk River Ridge north of Coutts and southwest of Medicine Hat. A third block, which included the Stair Ranch, was situated in the Cypress Hills country around Maple Creek in Asssiniboia. In 1884 two-thirds of all the stocked land in southwestern Alberta was in the hands of ten companies, and almost 50 per cent of that was controlled by the biggest four. Of the 111 ranches that were leasing land in 1888, some thirty held between 1,280 and 10,000 acres, with the rest holding between 11,000 and more than 200,000 acres.[27] Today a ranch of 10,000 acres is thought to be big indeed. By modern standards, therefore, the wide majority of the leased operations were, like their American counterparts, somewhere between big and absolutely enormous.

A high proportion of the ranches on both frontiers were owned by men from the east and overseas. However, there were also a number of owners who, like many of the cattle, came up from southerly regions of the United States. Most of these southerners arrived in the Canadian prairie West in the nineties or later to take advantage of still-unsettled grasslands near the border. Along the Milk River on the western side were the McIntyres from Utah; around Lethbridge and Maple Creek were the Conrad Brothers and further east in Assiniboia were the Day and Cresswell (or Turkey Track) and Bloom (or Circle Diamond)

Cowboy from Maple Creek, Assiniboia

outfits, both of which were headquartered in Texas and had established operations in Montana before moving further north.[28] The majority of southern Americans in Montana were from Texas. Besides the Circle Diamond and Turkey Track ranches, there were the Long S or Slaughter Ranch, the Long X, located in the Larb Hills and the badlands north of the Missouri River, the enormous XIT in the Fallon and Custer counties on the Yellowstone River, and the 777 outfit on the Little Missouri.[29]

In keeping with their size, the great majority of these ranches were grazers pure and simple.[30] This was the most extensive form of agricultural production known, in that it involved proportionately the smallest investment in labour and the least refinement of method. Cattlemen simply allowed their herds to roam the open range summer and winter and, apart from rounding them up now and then to brand and castrate newborn calves and market the fat steers, they did little more than watch them from horseback and try to keep them as close as they could to their home ranges. For most of the time this required a work force of only one man per thousand head of cattle.

What is remarkable, however, is how rapidly this system began to break down. Again it was Montana that set the pace. By the late eighties, open range ranching in the western and central parts of the state had already pretty well run its course. As will be seen, a variety of factors contributed to this process but the tragic winter of 1886–87 was the culmination of them all. Before that winter, much of the

range had become overstocked and the overcrowding combined with a summer drought to leave the cattle too under-nourished to struggle through the long cold spells. When the vicious weather struck, many of them froze or starved to death.[31] After that winter, most of the western and central cattlemen got out of the business altogether, and those who did not quit moved into a more intensive form of production. In most cases they acquired as much deeded land as they could and cut down substantially on the size of their operations. They also started putting up roughage to feed to their cattle in the winter, and fenced in their winter pastures in order to keep their stock close to feed and shelter when the weather misbehaved.[32] The open-range approach did not die out altogether in these parts, but it was limited to the warmer months. Extensive dependence on year-round grazing then became the accepted practice only in remote areas north of the Missouri River and east and south of the Yellowstone where overstocking was still not a problem. Some ranchers who stubbornly clung to the system in the latter regions, including the Pioneer, Bloom, Turkey Track, and Matador, also took leases from the Canadian government and pushed on up into the least-settled ranges in Assiniboia.[33]

From the late 1880s on, Montana ranchers also found it necessary to make way for a massive influx of homesteaders. In this period the ranges were besieged by settlers who staked their claims to 160-acre parcels based on *Homestead* and *Preemption* acts, and by the turn of the century the population of the state had risen to nearly a quarter million. A good number of the settlers took possession of land on the flat dry plains where they soon turned to farming wheat and other grains.[34] However, many pushed into the former free ranges of the high country and the river valleys, which were more suitable to livestock. There they not only operated on a much smaller scale than the surviving range men but also intensified their modes of production further than just building fences and putting up hay. In doing so they became more akin to intensive mixed-farmers than ranchers. Teddy Blue Abbott was typical. He got married in 1889 and settled on land in the Maginnis district. In 1892, he tells us, "fences and sheep and settlers were coming in, and the old time big outfits was going out, and nothing was like it used to be anymore." By then he was fencing in his pastures, sowing and harvesting oats, and planting a huge garden and marketing vegetables. He did not go into sheep but took to milking a dozen or so cows and selling the milk and butter.[35] He also pastured cattle but he forked hay to them in the winter time and bucket-fed heavy grain rations to his older steers rather than simply attempting to grass-fatten them as the ranchers had done for the slaughter market. He eventually got to the point where he was selling a carload (18 to

20 head) of steers yearly. Abbott was reasonably successful and he managed by the turn of the century to increase his holdings to over 2,000 acres. By the standards of that day this was considered a relatively big operation.

In the Canadian West the great ranches did not undergo the same level of destruction in the eighties largely because those outfits had not yet overgrazed their ranges or suffered to the same extent from the deficiencies of the open range system. There is no doubt, however, that they too experienced enormous problems in this period and were badly wounded in the 1886–87 winter. To survive on into the next century most took the route of southern neighbours and intensified their approach at least to the point of putting up roughage feed for their livestock, building fences on the open range, acquiring deeded land, and cutting down on the size of their operations. For reasons that will be discussed below, they could not go far enough, however, and eventually they too were forced to quit. The turning point for the big Canadian ranches was the awful winter of 1906–07.[36] After it had wreaked its havoc nearly all the big operations that had not already given up did so in short order. The Cochrane beat the rush by closing out in 1905 but the Walrond, Stair, Spencer, Bloom, Cresswell or Turkey Track, and most others soon followed suit. Around the same time most of the cattlemen who had maintained the year-round grazing approach to any considerable extent in the northern and eastern regions of Montana gave up as well.[37]

In Canada the "great" ranches were also gradually replaced by homesteaders, many of whom took up mixed or ranch/farming on former grazing lands. The first wave of settlers was part of the group that had begun to stream into Montana in the eighties. However, their communities took a lot longer to develop. The difference may have reflected transportation facilities to the respective frontiers. By the time the Canadian Pacific Railway brought the first, and only, transcontinental service through to southern Alberta in 1883, Montanans had already been using the Union Pacific and the Northern Pacific and were only four years away from acquiring a third major line.[38] As a result, although southern Alberta and Assiniboia combined covered an area just a little smaller than Montana, they had only about 100,000 people by 1900, while the state had 243,000.[39] Still, this population represented a significant increase in the Canadian ranching areas, too, and it profoundly altered prairie demographics. Many of the first settlers took out small leases along with 160-acre homesteads and they grazed or ranched those holdings while instituting farming practices on their deeded land. Within a few years the size of the average lease declined from over 30,000 to just under 1,100 acres.[40] From time to time the

North West Mounted Police gave overall accounts of ranches and cattle numbers in specific districts. By 1892 in the Calgary area, where settlement proceeded the most quickly, there were only three ranches with thousands of animals. The Quorn had 7,800, the Northwest Cattle Company or Bar U eight thousand, and the Samson Ranch three thousand. At the same time there were over 130 outfits with between a handful and one or two thousand head.[41] The Macleod district lagged well behind Calgary in the contraction of ranch sizes, and yet by 1893 there were twenty-two outfits that were running two thousand head or less while only one – the Montana-based Circle Ranch with 11,500 animals – could still be classified as "great."[42] In these two districts, then, there were already between twenty-two and forty-five times as many small to medium ranches as large.

The process of contraction continued as a second and ultimately much bigger wave of homesteaders began to arrive early in the new century to take up land based on the 160-acre grant, normally without lease. In 1901 rancher Walter Skrine was already feeling threatened by in-migration. He told A.E. Cross: "[The] prospect of too much settlement makes me think of [salvaging] what I have got & pulling out ... I have no intention of sacrificing any thing ... but this may be the best time to sell."[43] The country was still sparsely settled in comparison to what would soon be the case (or in comparison to the state of Montana). The census reports indicate that the number of small outfits would continue to increase steadily for two or three years into the new century and then spiral upward at a much faster pace. In 1901, for example, there were 1,091 rural dwellers surrounding Maple Creek; by 1906 their number had almost tripled to 2,801, and by 1911 it had risen to 18,098. The Macleod area had 6,446 residents in 1901, 13,885 in 1906, and 18,312 in 1911. The numbers for the two Calgary rural districts rose from 3,854 to 15,139 in the same period.[44]

Ultimately, environmental factors, including severe winter weather, drought, predators, and disease, combined with in-migration to produce units of intensive agricultural production to replace the great ranches in Alberta and Assiniboia as well. These new units were very similar to those in Montana both in size and in livestock numbers. A considerable portion of the homesteaders on both sides of the border acquired a second 160-acre parcel of land as soon as they could, and by 1914 the average farmer or ranch/farmer owned just over 300 acres, which were divided into pasture, hay, and crop lands.[45] Having started out with as few as a dozen or as many as several hundred cattle, settlers too adjusted to what their land would support as they became familiar with their environment. Within a few years the average outfit seems

to have been keeping around forty or fifty head of cattle[46] as well as sheep, hogs, and fowl.

By the the end of the first decade of the twentieth century scores of the small units that took over from the open range system were run by families. As with most North American frontiers, young single males initially arrived in much greater numbers than married men or women.[47] The proportion of men to women gradually – and then dramatically – improved as these men married and started families. However, gender balance was never achieved in this period.[48] Despite often expressed fears of agro-businesses, the family has proved the most enduring and widespread unit of agricultural production on the northern Great Plains right through to the present. Illustrating in detail why this is so will be one of the purposes of the rest of this study.

3
"Go West, Young Man."

What were the forces that enticed both investors and ranch hands to these western frontiers and encouraged them in a naïve belief that extensive agriculture would succeed there? This story testifies to the immense impact that idyllic imagery of the Great Plains had on human imagination at the turn of the last century. But it is a story with no "happy ever after." As idealized pictures of a pristine new land were conjured up in the minds of a wide assortment of people, many were lured into northern regions to take up a life style and a promising form of agricultural production. But the way of life they aspired to was too fragile to survive the transplanting process.[1]

Many of the men who invested in ranching were shrewd businessmen from the East who were ostensibly accustomed to making decisions based on carefully considered and realistic economic principles. Senator Matthew H. Cochrane, for instance, had made his fortune in leather. He had a factory in Montreal that employed some 300 people and grossed more than $500,000 a year. Lord Lathom of the Oxley Ranch farmed some 11,000 acres of land in England and was an avid cattle breeder.[2] The brothers W.G. and Charles E. Conrad owned one of the biggest freighting and mercantile corporations in the North-West, as well as the Conrad Banking Company.[3] Sir John Pretender, a major backer of the Neimmela outfit, was an English financier.[4] Speculation was a strong drawing card for these investors. One reason for a sense of urgency about getting into the cattle business was the speculation that new and efficient transportation facilities would lead to a rapid growth in demand for western beef. In the early eighties the Union Pacific and Northern Pacific railways connected Montana to Chicago and the Canadian Pacific Railway linked Alberta and Assiniboia with Toronto. Moreover, refrigerated railway cars and ocean steamers made it possible to transport slaughtered as well as live cattle

from these and other cities to metropolitan centres such as Boston, New York, Liverpool, and London.[5] However, the dazzling market potential seems to have been about the only thing these businessmen were interested in hearing about the cattle business. Their decisions to go into ranching appear to have been unrealistically swayed by the general euphoria about the Great Plains that was stimulated through an enormous media campaign, most of which played to the imagination and the heart, rather than to sound business acumen.

This mythologizing of the West took a number of unrelated and seemingly innocuous forms, some of which, had little directly to do with the cattle industry. Its most prominent example was the amount of wilderness literature that circulated in eastern North America and Great Britain, relating the experiences of adventurers who had journeyed through the plains in the days before settlement. All such literature painted the region in superlative language, praising its unspoiled condition, its massiveness, and most of all its natural resources. "Ever since the days of my childhood I ... longed to see the great plains," wrote one author. "My highest ambition, my fondest dream [was] to hunt the buffalo on his native prairies, to see the antelope, the Rocky mountain sheep, the elk, the black-tail deer and the coyote roam at will in their favorite ranges."[6] Much of this adventure literature focused on the northwestern states, which still remained more sparsely populated than most other regions. In those territories "one may wander 500 miles in a direct line without seeing a human being, or an animal larger than a wolf," another writer recounted. "Vastness of plain, and magnitude of lake, mountain and river," are what mark the entire area as "great."[7] Although the Canadian West was indirectly implicated in these writings because of its proximity to the states, it also received its share of direct attention. Sir George Simpson, for example, who had spent many of his adult years as the principal administrator for the Hudson's Bay Company, in retirement regaled his readers with tales of his adventures on a canoe trip in 1828 through three hundred million acres literally teeming with flora and fauna.[8] In later years the Earl of Southesk's *Saskatchewan and the Rocky Mountains* (1875) and Edward Clive Oldnall Long Phillipps-Wolley's *A Sportsman's Eden* (1888) continued to introduce eastern audiences to the exploits of hunters and travellers in the wilds of the West's most northern territories.[9] Some of these writings predicted future agricultural abundance. George M. Grant's *Ocean to Ocean* (1877), for instance, opined that "thousands of cattle or sheep ought to be grazing" on the rich grasses in the "great valleys and enormous 'punch bowls,'" of the Red Deer River and its tributaries.[10] In *The North-West Passage by Land* (1865), which was a bestseller in England, Viscount Milton and Walter Butler Cheadle described the area west of Fort Pitt on the Saskatchewan River as a

"most glorious country ... rich and beautiful, a country of rolling hills and fertile valleys, of lakes and streams, groves of birch and aspen, and miniature prairies; a land of kindly soil, and full of promise to the settler to come in future years, when enlightened policy shall open out the wealth now uncared-for or unknown."[11]

The impact of the exploration and hunting books was reinforced by articles in periodicals such as *The Field* and *Badminton Library*, and was augmented by the visual media. The Irish-born Upper-Canadian painter, Paul Kane,[12] the Scottish artist William Keith, Americans George Catlin and Alfred J. Miller, and photographers Timothy O'Sullivan, Andrew J. Russell, Eadweard Maybridge, and William Henry Jackson kept a steady flow of idealized pictures of the Western mountains, plains, rivers and Native peoples into Old World markets.[13] Both the print and visual media struck a sympathetic chord with generations who wished to escape the soot and grime of densely populated cities. This was an era that had a special appreciation for the pastoral poetry of romantics like Keats, Byron, Shelley, and Wordsworth as well as the foreboding urban industrial paintings of Turner.[14]

Under the spell of such artistic representations of the wilderness, hunting parties ventured out onto the northern plains from both eastern North America and Great Britain in the late nineteenth century.[15] Some of the men who took part in these excursions were so charmed by what they discovered that they eventually became ranchers themselves. A.C. Huidekoper of Pennsylvania first came to the Little Missouri River in 1881 to hunt buffalo with Howard and Alden Eaton. He returned two years later to become their partner in the Custer Trail Ranch. Theodore Roosevelt's first encounter with western Dakota, and presumably eastern Montana, was on a buffalo hunting trip in the fall of 1883.[16]

While enchanting images of the Western environment were brought home to audiences in the East, fictional writings eulogized individuals who were products of the frontier or had the energy and verve to leave their quiet homes and immerse themselves in the experience it offered. These appeared in frenetic fashion with the advent of the "dime novel," introduced by Erastus Beadle of New York in 1860.[17] Beadle assembled teams of writers who turned out thousands of titles, written to formulae, in some thirty different series over the course of three decades. From 1869 on, the stories were all set in the far West and they recounted the audacious and daring exploits of a whole string of heroes such as "Waltermeyer," "Deadwood Dick," and "Duke Darrell." These men all cut striking figures in their distinctive outfits and were particularly adept at the art of self-defense, which they used primarily to rid the world of evil robbers and Natives. The cover of one of the novels, *The Fighting Trapper or Kit Carson to the Rescue*, shows a man dressed in buckskins and leggings stabbing two Indians at the same time. Inside

there is an explanation: "Kit Carson, the small, gentlemanly agent at Santa Fe, performed ... incredible wonders ...! There was not the wild impetuosity in his movements that characterized" others of his ilk. "But there was an inconceivable celerity and quickness" in his movements.

He fought with a knife in either hand, leaping in every direction with an agility that was astonishing, and unequalled ..."

There is a feat that is sometimes performed ... upon horseback, yet few indeed are those who ever acquire the necessary dexterity to accomplish it. The trapper, in making his charge, takes a knife in each hand, and, lowering his head, urges his horse directly between two savages, and in the passage slays them both! Very few indeed can do this, and yet Kit Carson did it on foot? At two separate times he slew two of his enemies at the same instant."[18]

In the late seventies stories began to portray a blend of the hunter and "Indian fighter" with the cowboy or plainsman. Their protagonists were heroes like Stampede Steve, Buck Taylor, and Buffalo Bill. Among them Buffalo Bill unquestionably made the greatest impression. He was evoked as a character who loved the solitude of the wild countryside, with its rolling plains and unspoiled mountain scenery, and disdained the turmoil and hectic pace of industrial cities. It may have helped the public imagination that he was an actual real-life figure. Bill Cody earned his sobriquet hunting buffalo to feed the workers building the Kansas Pacific Railway between 1867 and 1868. He was also a scout for the U.S. 5th Cavalry and took part in sixteen Indian battles. He first appeared in a dime novel in 1869 and from then until past the turn of the century he was the leading figure in over 1,700 of the Beadle stories, mostly written by Prentiss Ingraham. In 1883 Cody organized the first of his famous Wild West shows – an outdoor exhibition that dramatized the contemporary Western scene. This show went on the road in various forms and in 1887 did a special Jubilee performance in London for Queen Victoria.[19] Cody and his writers promoted Buffalo Bill as someone who "stood as a barrier between civilization and savagery, risking his own life to save the lives of others."[20]

In virtually every one of the Beadle stories the writers indulged in the intricate details of the central figure's appearance even more than his deeds. Stampede Steve, for instance, was "a young man of perhaps twenty years of age" and the type who "would command attention and admiration in any assemblage, even of distinguished men."

[He was] above the medium height, his form a type of perfect manhood, his face handsome and his eyes clear and hazel; while the eager glance, and the

"Go West, Young Man." 29

A poster of Buffalo Bill Cody riding buffalo

instantaneous clutch and coil of lasso ... as well as his costume and arms, indicated that he was one who was accustomed to the free life on the plains.

His symmetrical form hinted at unusual strength, and his movements were grace itself.

Long dark-brown hair hung, in wavy masses, low over his well-rounded shoulders, while a goatee and mustache, silky in fineness and gloss, added to the manly beauty of his face, which was tanned by sun and wind.

Buckskin breeches, fringed, and ornamented with silver buttons down the outer seams, were sustained about his waist by both belt and silken red sash. The breeches were thrust into the tops of high-legged boots of calfskin, upon the heels of which were buckled a pair of silver spurs, with but medium-sized rowels.

A blue woolen shirt, with wide collar loosely confined at the neck by a black kerchief, and a black wide-brimmed sombrero, made up his semi-Mexican costume.

A brace of revolvers, Colt's army size, and a huge Bowie, were in scabbards at his belt, while a Sharp's carbine hung at his saddle horn.[21]

The dime novels were aimed at a mass audience. They were cheap and short – no more than thirty thousand words – couched in the simplest terms, and their plots were very basic and easy to follow. They particularly appealed to adolescent boys and were probably instrumental in attracting many of them to the frontier as they matured.

Romantic novels, which grew in popularity in the final decades of the century, catered to the better-educated reader. Though longer, more complex, and more refined in style than dime novels, they carried a similar message: in the demanding and challenging setting of the West certain individuals would achieve greatness.[22] From the eighties most such works found their subject matter in the ranching industry. Some were clearly directed at British audiences.[23] In *Sky Pilot* (1899), originally published in London,[24] the acclaimed Canadian author Ralph Connor describes the "Noble Seven," a group of Britons and certain "approved colonials" who had made their way to the foothills of Alberta where, "freed from the restraints of custom and surrounding," they "soon shed all that was superficial in their make-up ... stood forth in the naked simplicity of their manhood," and adopted the ways and culture of the frontier.

> The Noble Company, with the cowboys that helped on the range and two or three farmers that lived nearer the Fort, composed the settlers of the Swan Creek country. A strange medley of people of all ranks and nations, but while among them there were the evil-hearted and evil-living, still, for the Noble Company I will say that never have I fallen in with men braver, truer or of warmer heart. Vices they had, all too apparent and deadly, but they were due rather to the circumstances of their lives than to the native tendencies of their hearts. Throughout that summer and the winter following I lived among them, camping on the range with them and sleeping in their shacks, bunching cattle in summer and hunting wolves in winter, nor did I, for I was no wiser than they, refuse my part on [drinking] nights; but through all not a man of them ever failed to be true to his standard of honor in the duties of comradeship and brotherhood.[25]

Another novel, *Sunset Ranch* (1902) by an author named St Rathborne,[26] represents the type that heaped praise on American ranchers and cowboys. A young man from the East enters the frontier and is soon attacked by wolves, but because he is from an urban, industrial background and has not developed his senses the way folks out West have, he can't perceive that help is close at hand. "Had he been prairie born with keen ears, able to detect and define every sound that the night wind carried he might have discovered reason for encouragement." But "with death staring him in the face the dull thud of horse's hoofs ... was quite unnoticed."[27]

Bar U Ranch cowboys, Pekisko, Alberta

The young man is rescued by a gallant, unassuming individual whose attributes are a direct contrast to his own. He hears "a shout not unlike the wild war-whoop of a Sioux brave plunging into the thick of battle, a rush of horse's hoofs and the sharp ringing salute of a heavy six-shooter ... Expecting to discover a brawny teamster, or at least a veteran cow puncher grizzled and bronzed and muscular," he is amazed to find that the figure on the yellow bronco is that of a rancher's boy "younger even than himself, and smaller of build." The lad is "garbed after the manner of a cowboy" and sits in his saddle with the look of one who considers it "no difficult task to 'bust broncos' and wear out the most vicious of prairie horses without 'pulling leather' or taking his hands from the bridle." The rancher is "brown as an Indian" and "keen of eye," and has "an air of determination about him" that foretells "future manhood." He instantly gains the respect of "the tenderfoot"[28] and the two boys form a close and lasting friendship. From this initial meeting the story follows the transformation of the boy from the East as he slowly learns "to mount the dizzy heights" his counterpart from the West has attained "with such apparent ease."[29]

The transformation of the newcomer was a common theme in many of the stories. In *The Boys of the Rincon Ranch* (1902) two young city boys leave New York to seek their manhood along the Rio Grande in

Montana cowboy

Texas. They meet their cousin of the same age and again the contrast between them is emphasized. The cousin is taller than them and "much heavier." His shoulders are "square, his arms long, his chest deep and arched – evidently a powerful boy for his age." He also has an obvious depth to him that is illustrated in various ways by physical characteristics – perhaps "the eyes," or maybe the "resolute chin." His hair too is "black, and curled massing over his brow," his face is "burnt to a neat brown, and through the darkened skin the clear flush of health" is unmistakable. There is "an air of independence ... self-reliance" and "positiveness" about him.[30] Even his smile is perfect – "inexpressibly debonair and engaging" and "intelligent and mature" beyond his years. The lad of course cuts a dashing figure, clad in typical cowboy style, with "a gray flannel shirt, and brown trousers stuffed into riding boots" and spurred heels; "on his head, tilted back [is] a wide dark hat of felt – a sombrero – and about his waist a broad leather belt with hoops upon it made for the holding of rifle and pistol cartridges."[31]

Predictably, one of the eastern boys, Ralph, stays the summer with this youngster and under his tutelage acquires the quintessential cowboy characteristics. Each day is "marked by some new experience, some new thing learned, some step forward towards manliness and self-reliance and self-control, frankness and truth." He learns "not only to stick in the saddle as if born there, to hurl the lariat with some

Everett Cyrill Johnson, Alberta rancher upon whom *The Virginian* is thought to have been based.

sureness of ensnaring his target, to ride all day without appreciable fatigue at night," but also "to estimate the profits to be expected from horse, cattle, sheep and goats," and "to know that a quick hand and ready brain and fearlessness are things of steady value, and to have driven into him, so deeply" that they will never be "uprooted." By the end he has incorporated the ancient "lessons that success comes only through repeated failure, and that he is thrice brave and thrice a conqueror who conquers self." Ralph has "good stuff in him," and the "semi-rough life" of the West brings it out.[32]

Variations of this theme were repeated in countless works. Foremost amongst them was *The Virginian* by Owen Wister, which appeared just after the turn of the century.[33] Earlier examples are *Son of Rosario Ranch*,[34] *The Giant Cowboys*,[35] *Ranch Verses*,[36] and *The Chief of the Cowboys*.[37] All, in one way or another, professed a deep admiration for men – and in some cases women – who were either born in the West or dared to go there, and who acquired character traits and skills that placed them beyond the spectrum of ordinary human beings back home.

In conjunction with the art, photography, and accounts of wilderness explorations, such novels helped create a fascination with the West. Men from the eastern seaboard of North America became convinced of the "superior calling" of the cowboy and were anxious to emulate it "in a hundred tricks of dress and attitude and even speech."[38] English youths grew "chock full of ideas" about saddles, ropes, guns, bandanas, big hats, and "red Indians."[39] Enhancing the effect was a great stream of non-fictional, testimonial literature depicting the supposed true life experiences of some of the earliest cattlemen themselves. It painted Western ranchers as incredibly rich and successful – the epitome of everything good in North American life. One of the principal and most influential authors was Theodore Roosevelt. In *Ranch Life and the Hunting Trail*, which was widely read on both sides of the Atlantic, he insisted that wealthy cattlemen were the salt of the earth. They "always spend their money freely," he said, "and accordingly towns like Denver, Cheyenne, and Helena ... are pleasanter places ... than cities of five times their population in the ... agricultural States to the eastward." There are "very few businesses so absolutely legitimate as stock-raising and so beneficial to the nation at large." The rancher must not only be "shrewd, thrifty, pliant, and enterprising but he must also possess qualities of personal bravery, hardihood, and self-reliance to a degree not demanded in the least by any mercantile occupation in a community long settled." These men "are in the West the pioneers of civilization, and their drive and adventurousness make the after settlement of the region possible."[40]

If Roosevelt clearly admired the ranch owners he met during his short stay in Dakota and Montana, he was even more in awe of the cowboys whose job it was to work the herds. He did, however, acknowledge a certain intemperance in their behaviour. "Years of long toil broken by weeks of brutal dissipation draw haggard lines across their eager faces," he told his readers, "but never dim their reckless eyes nor break their bearing of defiant self-confidence. They do not walk well, partly because they so rarely do any work out of the saddle, partly because their chaperajos or leather overalls hamper them when on the ground." However, they are "as hard and self-reliant as any men who ever breathed," and they cut a colourful figure with their "jingling spurs, their revolvers stuck in their belts, and bright silk handkerchiefs knotted loosely round their necks." He admitted that they tended to drink too much but claimed that when sober they were "quiet rather self-contained men, perfectly frank and simple, [who] ... on their own ground treat a stranger with the most whole-souled hospitality, doing all in their power for him" and inevitably refusing "any reward in return." They are "much better fellows and pleasanter

company than small farmers or agricultural laborers," he wrote. The "mechanics and workmen" of the cities should not even "be mentioned in the same breath."[41]

Roosevelt was of the opinion that the most successful cattlemen were south-westerners who had grown up in the business. However, perhaps alluding to his own example, he left the door open to the possibility that "many Eastern men, indeed, not a few college graduates" could also enter the profession and do "excellently by devoting their whole time and energy to their work." This statement was no doubt persuasive to other men of his ilk that they or their offspring could achieve the heroic stature he described, whether as ranch owners or as cow-punchers.

Ranch Life was only one of many rosy eyewitness reports that carried such ideals to industrialized societies. Others were *Ranch Notes*,[42] *Texan Ranch Live*,[43] *Ten Years a Cowboy*,[44] and *The Story of the Cowboy*.[45] Similar testimonials appeared as reports in eastern journals or newspapers. In 1896 the *Montreal Witness* published an article based on an interview with Fred Stimson, manager of the Bar U Ranch at High River, Alberta. It started with a description of the superb effects of frontier life on Stimson's physical stature, noting that when he first went West, he had been "a thin, delicate young man who feared consumption." Now, after over a decade on the Bar U, he was "colossal, hearty, and humorous." He had learned not only to "disdain ... the 'biled shirt' of civilization" but to enjoy sleeping "on the bare ground." The article also recorded Stimson's faith in the efficiency of the year-round grazing approach: "It costs nothing to fatten our cattle," he apparently claimed, "because they fatten themselves."[46]

The impact of all the print and visual imagery about the West that circulated in Old World societies can be measured by the reaction in London to Buffalo Bill's Wild West performances. The park in which the show was presented held some forty thousand people and demand was so strong that two presentations were given each day. The show included "Red Indians" and herds of buffalo and Texas Longhorn cattle, but the cowboys from Wyoming and Montana attracted "more attention than any other feature." They were "subjects of such interest" that they were "granted the freedom of the City of London" and "allowed to go through the streets wearing their shaps [sic], high-heeled boots, big hats and revolvers." They were followed by large crowds and showered with "immense numbers of valuable presents from all classes of people."[47]

While regular folks in eastern urban centres were obviously highly susceptible to artistic depictions of the West and its people, promotional appeals made in more technical terms also were influential. The obvious purpose of these appeals was to foster awareness of the

potential of the new frontier specifically for livestock grazing. They were aimed at the business-minded and laid out some basic economic theories. However, the theories were so superficial that it seems unlikely that they would have gone unchallenged by the experienced entrepreneur had he not been predisposed by all the other portrayals. In recent years, American scholars have called the authors of these works "boosters" because at least some of them were anxious, for personal financial reasons, to entice investment to the frontier.[48] Four individuals were particularly important: a general in the United States army, James S. Brisbin;[49] a German aristocrat who speculated in land, Walter, Baron von Richthofen;[50] a surgeon for the Union Pacific Railway, Dr. Hiram Latham;[51] and Joseph McCoy, a town site promoter.[52]

In a book entitled *Trans-Missouri Stock Raising*, Latham led the way in 1871 by appealing to his readers on a scientific level. There was also a touch of American patriotism in his pitch. To maintain a large population of labourers whose products could be sold in the competitive markets of the world, he announced, the country had to develop an inexpensive and inexhaustible supply of food and clothing. The cheaper the food and clothing, the cheaper and more competitive industrial production would be and thus, by implication, the wealthier and more successful the entire nation. Food must include meat for a well-balanced diet. Therefore it was necessary to use cattle and sheep to convert feed into beef and mutton. The best way to do this was to develop the agricultural potential of the Western plains where there was a never-ending amount of virgin grazing land. On the plains, a minimal investment was needed. As the land itself was free, or nearly so, and grazing did not require tilling the soil, the purchase and operation of expensive implements was unnecessary. Moreover, as the animals could largely fend for themselves, few hands were needed to watch over them. In the case of cattle, the ratio of one man for every 1,000 head or so would be sufficient.

The other promoters embraced this line of reasoning entirely and they all in one way or another propagated the belief that the secrets to certain success on the plains, apart from low land and labour costs, were the nutritious quality of the natural grasses and the fact that year-round grazing could be undertaken with impunity. Brisbin, in his book of 1881 tellingly entitled *The Beef Bonanza, or, How to Get Rich on the Plains,* quoted the glowing appraisals of ranchers who had grazed cattle themselves in Montana. He summed up their views as follows:

The air is so fine [on the plains] that the grasses cure on the ground without losing any of their nutriment, and ... the climate is so mild and genial that stock can range and feed all the winter, and keep in excellent condition without

artificial shelter or fodder. The fact of grasses curing on the ground is a well-known peculiarity of all the high country on the east slope of the mountains, and in this is found the great value of this immense range for grazing purposes ... I believe that all the flocks and herds in the world could find ample pasturage on these unoccupied plains and the mountain slopes beyond, and the time is not far distant when the largest flocks and herds will be found right here, where the grass grows and ripens untouched from one year's end to the other. I believe there is no place in this section of the country, from latitude 47 degrees down, where cattle and sheep will not winter safely with no feed but what they will pick up.[53]

On paper, ranching was a marvellous process. The boosters produced tables and other estimates of investment and yield that showed very low death rates amongst the cattle and sheep and very efficient records of reproduction. Profits of 100 to 200 per cent on original investment in a few years were to be the norm.[54] The animals would harvest the prairie grasses while their owners did little more than watch and rake in the money.

Canadian historians have recently underscored the importance of boosters in the settlement of Western Canada at the turn of the twentieth century.[55] However, they have been most interested in the farming frontier. Historians of ranching have almost totally ignored promotional literature, focusing instead on crucial government legislation. The Conservative administration under Sir John A. Macdonald, we have said, understood in 1881 that to begin the process of building a viable cattle industry in the West it made eminent good sense to provide a stimulus to investment. Consequently it sponsored a new law that allowed certain preferred and well-heeled individuals to lease up to 100,000 acres of land on the plains at the bargain price of a cent an acre per year. At that point the opening of the prairie West was pretty much secured. The managers of the great companies shrewdly seized this opportunity. They quickly chose their leases, set up headquarters, bought up enormous herds of cattle from Montana and other states, and hired the teams of cowhands they needed to trail them north.[56]

Closer examination, however, illustrates that there was more to the process than that. In bringing about the lease legislation, the Macdonald ministry was merely responding to pressure from men like Senator Matthew Cochrane, Captain William Winder, and others who may well have been influenced by all the media representations, including the promotional literature. The enthusiasm of the media for the plains-grazing industry was certainly reflected in eastern centres by considerable optimism about American agriculture as a supplier of

food for the urban industrial masses.[57] Further afield, the *Bristol Evening News* was by the summer of 1877 forecasting "much bigger importations of [live] cattle" from the other side of the Atlantic and arguing the incredible fallacy that animals could make the long trip across land and sea "looking none the worse for wear."[58] Three years later the *Daily Courier* in Liverpool claimed that the live cattle trade between Britain and America was so valuable that "anything calculated to curtail its limits could not be regarded as other than a national calamity."[59] The Scottish agricultural writer James Macdonald, who was sent to the United States by the *Scotsman* in 1877, told his readers at home to expect profits in the Trans-Mississippi West to run around 25 per cent annually.[60]

It is significant that in all the promotional literature differences between the northern and southern Great Plains were almost completely obscured. In 1879 Robert E. Strahorn employed the sort of reasoning used earlier by Brisbin to publicize the grasslands of Montana in a pamphlet entitled "The Resources of Montana Territory and Attractions of Yellowstone Park." A year later, a Royal Commission laid a report before the British Parliament on the condition of both American and Canadian agriculture. Unlike many other reports, it made an attempt to sound realistic by speaking of some of the major flaws of farming in America. Severe winters, dangerous droughts, harmful insects, and an inadequate supply of good drinking water for livestock can and do cause problems, it said. However, in assessing the potential of the plains for ranching, it simply repeated the supposed wisdom of earlier writers. "These vast plains appear to the stranger in the autumn fearfully scorched and sterile ... the short stunted herbage is quite brown, and looks burnt to a cinder." However, "this apparently worthless grass is in reality *self-made hay*. It grows rapidly in the spring, and is *cured* by the sun before it ripens."[61] The report also parroted the theories of the promoters about year-round grazing. "Lovely open weather may prevail until Christmas," it stated. "Great falls of snow are rare. When they happen cattle suffer severely, but more generally the snow quickly drifts into the hollows and the stock can get at the grass without much trouble."

The economic reasoning of the promoters was also echoed in the report almost verbatim. The land, it noted, is still free and labour costs are minimal, since the cattle fend for themselves "without even a single herdsman" from "November to April." With "no expense save that of herding his cattle during eight months of the year, and paying a trifle towards the local taxation ... there is no wonder that [the rancher] makes an enormous return upon the capital he invests." The average profit for years, the authors asserted with no detectable reservations, has been "fully 33 per cent."[62]

The reporters also estimated that there was no danger of the range being used up in the foreseeable future. "There is plenty of room," they announced, "not only for all the cattle and sheep that have now a free range over these plains, but also for any number of new settlers who like to stock them." The commissioners' views appeared in a number of British newspapers[63] and no doubt helped entice investors such as Alexander Staveley Hill, Lord Lathom, and Sir John Walrond, who were members of the political elite. Indeed, the report may even have influenced Cochrane, who spent a good portion of his life in England. It clearly made a significant impact on Sussex-born Moreton Frewen, who quoted directly from and embellished the Royal Commission's conclusions to interest his blue-blooded board of directors in the Powder River Ranch.[64]

Several years later the results of a United States government analysis specifically of the Western ranching frontier were published in a circular that was released on both sides of the Atlantic.[65] The circular was every bit as positive. A "vast area ... of no account a few years ago has come to have a high commercial value," it proclaimed.[66] "Cattle are not only well fed the year round" but "the winter's snow as a rule [is] too light to cover up the grasses" and anyway the animals are able to "bear without shelter" the most severe cold when it does come along.[67] Ironically the report appeared in print only months before the dreadful winter of 1886–87 that killed between 30 and 60 per cent of the range cattle on the northern plains.

In case anyone missed the point that year-round grazing meant very low production costs, the circular also noted that ranchers needed to do no preparation of ground surfaces or give their livestock any other care than "general supervision to prevent them from wandering off their ranges and ... branding of the calves."[68] It asserted that 50 to 60 per cent of the calves that "landed on the ground" in the spring would survive and eventually be delivered to the consumer market. The ranchers on the northern plains were soon to realize, however, that this estimate did not take into account that under rangeland conditions a large percentage of the cows would either fail to give birth or land their calves on the ground in the midst of winter when survival rates were much lower.[69]

The report was also indebted to earlier literature in its assertion of the potential "great benefit" of Western ranching "in reducing or preventing the rise of the price of meats" for the "people."[70] It warned that ranching was efficient enough to eventually threaten the entire British livestock industry to the core. "The introduction of 'Range' cattle into England is to that country ... more than a commercial question. It is a social and political as well as an economic one. English cattle raised on lands possessing a high value, or subject to high rents,

are hereafter to be subject to the competition of cattle from lands subject to no rental or burden whatever."[71] One of the major problems with range cattle, when shipped to consumer markets in the East, was the poor quality of the meat and low dressed weight in comparison to those of properly finished grain-fed animals.[72] The report blatantly denied this. After arguing that range cattle had been greatly improved through interbreeding, it insisted that the grasses of the plains were so nutritious that they "put the cattle in high flesh in the fall of the year, and often fully prepare them for Eastern or foreign markets."[73]

This kind of reasoning, which became endemic, treated the entire plains as if they were one environmental region. In 1890, even after ranchers had seen their cattle reduced year after year in the north by winter blizzards and a host of other natural calamities, a pamphleteer applied all the earlier assumptions about the virtues of the West directly to the Canadian West. "Those who doubted and those who wished the public to disbelieve the reports concerning the fertility" of this marvellous new hinterland, he said, "have ceased to be heard; the first have been converted into warm advocates of the country's merits, the others are silent for very shame sake and because no one will now believe them."[74]

Today Southern Alberta stands unequaled among the cattle countries of the world; and the unknown land of a few years ago is now looked to as one of the greatest future supply depots of the British markets. Great herds of range cattle roam at will over these seemingly boundless pastures. With proper management the profits to stockmen are large, as can be readily imagined when it is shown that $42.00 per head was paid for steers on the ranges this year, animals that cost their owners only the interest on the original investment incurred in stocking the ranch, and their share in the cost of the annual round-ups. Yearlings are now being sent into this country all the way from Ontario to fatten on the nutritious grasses of these western plains and it is reckoned that after paying the cost of calf and freight for 2,000 miles, the profit will be greater than if these cattle had been fattened by stall-feeding in Ontario. There [are] now on the ranges of Alberta hundreds of herds of fat cattle which at any season are neither fed nor sheltered; cattle too, which in point of breeding, size and general condition, are equal if not superior to any range cattle in the world. Shorthorns, Herefords and Angus bulls have been imported at great expense ... and the young cattle of Alberta ranges would compare favourably with the barnyard cattle of Great Britain.[75]

This pipe dream had no basis in fact. Among other things, the thought of breeding high quality herds on the open ranges, where all manner of cattle, including scrub bulls and low-grade cows from improperly culled herds, constantly interbred, was totally unrealistic.[76]

The Mountains and Plains Seemed to Stimulate a Man's Imagination

The fact that virtually overnight hundreds of capitalists invested immense amounts of money in Western ranching illustrates that they must have been persuaded by the economic arguments, however flawed. As recent historians have demonstrated, when man contemplates new frontiers he is inclined to dream; undeveloped territories offer all kinds of opportunities to start over again or begin new ventures.[77] Since limitations are unknown, the line between the possible and impossible or the real and imagined is easily blurred. In the case of ranching, the illusion may also have been caused by the apparent endlessness of the land resources on the Great Plains, which in a symbolic way allowed people to give free rein to their fantasies. "The mountains and plains seemed to stimulate man's imagination," Charlie Russell observed. "When he comes west he soon takes lessons from the prairies, where ranges a hundred miles away seem within touchin' distance, streams run uphill and Nature appears to lie some herself."[78] Whatever the reason, the tendency to wishful thinking coloured all the various media representations of the Great Plains and influenced people to take them at face value. From youth, easterners learned to view wilderness scenes with great relish, to delight in sparsely populated regions untouched by industrial pollution, and to worship heroes like Stampede Steve, Kit Carson, and a host of unnamed ranchers and cowboys. This mystique of the West in turn encouraged them almost instinctively to put their trust in a type of agricultural production that had never been tested over time.

4
The Old World in the New

The people who followed the call of the media and started new lives on the northern Great Plains in the late nineteenth and early twentieth centuries have been described in considerable detail by historians. It is, however, necessary to adjust those descriptions in order to present a more balanced picture than we have for the most part portrayed in the past. On close examination it becomes evident that the Canadian West was not nearly as "Old World" in outlook and flavour as we have proposed in the past; and Montana was far from completely a frontier or "New World" culture. Countless examples illustrate that eastern and western ways met and intermingled in both societies. The resulting complex cultural blend, like roaming livestock, flowed back and forth across the forty-ninth parallel.

Canadians have tended for years to stress the British and eastern influence on their western frontier in part, one assumes, to illustrate that they were not merely a second American society. They have looked primarily to cultural values and social mores to make the point. Over and over again our historians have demonstrated that ranchers and their families were governed by Victorian tastes and regularly participated in functions and entertainments that were firmly rooted in British traditions.[1] This depiction is not without merit. Old world norms were, to be sure, important ingredients in the composition of Western Canadian society at the turn of the twentieth century. They came first to the frontier with the elite ranchers and in a second wave with the host of settlers from eastern Canada and Great Britain.[2]

People from the East tended to revert to their original customs in almost any frontier locality. Their first homes were usually makeshift log structures furnished with packing crates for washstands and tables, and homemade cupboards and chairs. In due course, however, more stately houses were erected on the wealthier operations, usually in a

Polo team, Fort Macleod, Alberta

two-storey Victorian style with balconies and sometimes even stained glass. Builders at first used the wood that flourished naturally in nearby forests rather than brick and mortar as would have been the case in Europe. Eventually, however, bricks were imported for the chimneys, and many interiors were adorned with Chippendale furniture, fine linen draped over the tables and around the windows, and an array of ornaments and figurines.[3]

Social interaction was also frequently organized in traditional ways. The famous Mounted Police officer Sam Steele recorded that on the Glengarry ranch near Macleod, "the managing director, Mr Allen Bean Macdonald, and his charming wife and family did their utmost to make our visits agreeable by taking us for jaunts over the hills to the best fishing pools of the numerous pretty trout streams which meander through that favoured region." In the evening "the men of the ranch, several of whom could speak Gaelic and English, or, as they laughingly said, 'the two talks,' came to the house and, to Mrs Macdonald's inspiring music, danced Scotch Reels [and] the Highland Fling."[4] On a more formal level, friends and neighbours at Millarville, High River, and Calgary held grand European-style balls,[5] and in several towns, easterners instituted typical turf associations and upheld the convention that the annual races were "the social event of the year."[6] Cricket became very popular across southern Alberta, and teams from Calgary, Lethbridge, and Macleod regularly competed. Soccer, lacrosse, curling, and polo also had their "enthusiasts"[7] and gymkhana, a nineteenth-century British and East-Indian creation featuring athletic competitions and pattern racing on horseback, were held across Western Canada.[8]

It is important to note as well that British political culture was instrumental in founding and then fostering the Western cattle industry. Some of the wealthiest investors from the East had, or were able to cultivate, considerable clout with government officials in Ottawa. The owners and directors of the original great ranches were for the most part staunch members of the Conservative party either in Canada or in Great Britain. The fact that they were steeped in British institutions and accustomed to hobnobbing with important figures gave them the ability to access and develop routes to power. The original lease legislation providing for large-scale ranching on the prairies came into existence, for example, because Senator Matthew Cochrane had a good friend in the Conservative Minister of Agriculture, John Pope.[9] Cochrane was so influential with the Macdonald cabinet members that he persuaded them on short notice to change important regulations for him. When he decided he wanted to move his cattle operation south to the Waterton region in 1883 and to produce wool and mutton on his first lease west of Calgary, he was able to arrange an amendment to the recent law against grazing sheep in southern Alberta.[10] Duncan McEachran, the leading power behind the Walrond Ranch came West as Chief Inspector of Stock of the Dominion Department of Agriculture and then, along with Cochrane, Sir John Lister Kaye, Fred Stimson, Alexander Staveley Hill, and other elite owners and directors, proceeded to pressure the dominion government to support them on diverse matters such as the overstocking of the ranges, the problem of American cattle wandering onto Canadian grasslands, the preservation of stock watering reserves, hay rights on public land, and the issue of squatters.[11]

These politically active men normally got their way on such matters, although in the end their stewardship to some extent failed them. To protect their grazing lands they lobbied repeatedly against dense settlement on the prairies, claiming that the southern plains were unsuited to intensive agriculture.[12] Government policy would eventually shift away from supporting the few toward meeting the demands of the many. Thus, through the late eighties and the nineties, settlement was facilitated and the leases were increasingly restricted and then cancelled. However, the ranchers did not lose out altogether. They won the right to purchase large tracts of land at reasonable prices and to preserve access to the watering places that were so crucial to their roaming herds.[13] Many of them seized these opportunities and under freehold tenure became more secure in their holdings than they had ever been before.[14]

The same ranchers were among the most active in the livestock associations. Formed from the earliest days to take the initiative in organizing the round-ups, registering brands, providing bounties for

the killing of wolves, and hiring stock detectives to help the Mounties control rustling,[15] these associations acted as watchdogs for the cattle industry. Men like Billie Cochrane, A.E. Cross, H.M. Hatfield, Edward Maunsell, Fred Stimson, and Duncan McEachran consistently sat on executives and committees within the associations.[16] In 1886 the North-West Territories Stock Growers sent a request to the Montana Stock Growers Association asking it to demand that the Montana legislative assembly pass a law to deal as severely with rustlers "seeking refuge in Montana, as the present Canadian law deals with the stock thief from Montana seeking refuge in the Canadian Northwest."[17] To reinforce the request McEachran sent a personal letter to the secretary of the Montana organization pointing out the benefits its members had "received ... from the Mounted Police" in apprehending thieves who crossed into Canada, and returning stolen cattle and horses to them.[18] This type of action could not be directly reciprocated, however, because Montanans did not have an institution similar to the Mounties. The United States army was stationed at forts in Montana and elsewhere but it was a military, rather than a police, force and did little to impose laws relative to rustling.[19] However, there was considerable sympathy among Montana ranchers for the Canadians, and the lynching of rustlers caught with their livestock in later years suggests a genuine attempt to respond to their requests.[20]

The other area where men from the East and overseas played a leadership role was in modifying ranching practices. This was particularly the case on larger operations that had the capital to import Old World expertise and infrastructure. Their inclination to do this sometimes produced interesting results. For example, many ranches brought packs of hounds and Thoroughbred horses to the frontier so that they could institute the hunt as a means of controlling wild animals that preyed on newborn calves and colts. The following report describes a hunt that took place in 1898 near the town of Grenfell in Assiniboia.[21] Were it not for the mention of barbed wire and the fact that the prey was a wolf instead of a fox, it would be impossible to tell that this event did not occur in the English countryside.

[The Wolf] got a good start, but scent was good and improved as we went on. Starting off at a tremendous pace, we went towards Aston's for a bit, and then swinging around to the Pipestone [River] we went for miles along the north bank, up and down the steep ravines which run into the Pipestone every few hundred yards. Passing Lamb's and Widdow's without any signs of a check, we re-crossed the Pipestone again below John Taylor's and up the hill on the south side. By this time many of the horses were run to a standstill, and others bogged in the Pipestone, or shut off by the many barbed wire fences

Hunters and dogs at Rawlinson brothers' ranch house, Calgary area, Alberta

which we managed to go through or over. There were only about a dozen with the hounds when they crossed the Pipestone the last time ... On reaching the top of the hill, hounds turned due west for a couple of miles, and then south. Then we had the misfortune to come across a solid high barbed wire fence, and as we could not find a rail to place on the wire, it was two or three minutes before we managed to get on the far side of it. When we did get there hounds had raced clean out of sight and hearing, and we couldn't find them. Up to this point we had gone for an hour and fifteen minutes as hard as we could go without a check of any kind and hounds were still going. A bit later two of the tail hounds came up from behind on the line, and after following them slowly for about three miles, the huntsman found the pack with their wolf stiff and cold in the open. The hounds must have run every bit of 22 miles at a tremendous pace, and he was a grand wolf to live in front of them as long as he did.[22]

Some ranchers also imported technicians from home for certain specialized aspects of the cattle business. For instance, when they

eventually decided to move away from grazing alone and take up grain finishing, they hired qualified Britons to supervise their new, more complex feeding programs.[23] Many also took advantage of British breed selection to improve the quality of their herds. They had been forced to obtain most of their original cattle from the nearby American frontier where the needed quantities could be found and driven in relatively easily. The main problem with the American cattle, however, was the prevalence of Texas Longhorn characteristics. Many of these cattle were tall and thin, did not fatten well, and, because of their light hide, were unsuited to the colder northern climate. Breed selection in the American West had been virtually impossible to control because, on the open range, all sorts of bulls had access to all manner of females. As a result, Longhorn qualities had adversely affected most cattle, including even those whose lineage stretched back to the heavier-set European types.[24] The prominent Canadian ranchers understood this, and many worked methodically to upgrade their herds by importing stock.[25] The Cochrane Ranch purchased purebred Angus, Hereford, and Shorthorn bulls in Britain.[26] The Walrond brought out purebred Hereford and polled Angus cattle from Montreal.[27] The Half Circle V ranch on Nose Creek imported the Sussex breed in its search for a hardy type suited to the harsh northwestern environment.[28] The Bar U brought out shipments of Angus bulls from Chicago as well as from Scotland.[29] The Stewart Ranch near Pincher Creek, Alberta, imported directly from Scotland. A.E. Cross spent a fortune acquiring the best British bloodlines for his cattle ranch near Nanton, Alberta,[30] and F.W. Godsol began upgrading his herd in the 1880s with pedigreed Shorthorn bulls from Ontario.[31]

A number of ranchers bred horses for export too. That business never approached the cattle trade in volume or value, and it does not appear to have paid very well for any significant period of time.[32] However, some of the ranchers who got into it do seem to have produced some fairly well bred animals for the eastern upper classes. During the short periods when breeders were optimistic about the trade, some of them brought over specialists to train the horses to the standard desired "at home." One of the first and best examples of this group was the Bow River Ranching Company. In 1888 the *Calgary Herald* announced: "This year [the ranch] will export from thirty to forty head of horses to England. This will be the first shipment of the kind from the Northwest. The company employs Englishmen to break horses for use in Great Britain, thereby adding not a little to their value in the old country markets."[33] Another such ranch was the Quorn, ostensibly named after the Leicestershire village known for a famous hunt.[34] In 1888 the Quorn bred English Thoroughbreds with Irish Hunters in hopes of

attracting demand from the imperial army.[35] Obviously, as well, anyone from the East and overseas who had an agricultural background applied it where he deemed appropriate to the new setting. Much of this knowledge needed to be dramatically adopted to suit the conditions of the frontier, but it at least gave him a familiarity with basic breeds, their mating habits, their feed requirements, and so on.

Unquestionably, then, eastern forces exerted a strong influence from a number of directions on Western Canada's ranching frontier. Something that must be kept in mind, however, is that from the 1880s American influences also made a powerful impact as companies and individuals from the south pushed across the forty-ninth parallel looking for new sources of land or work.[36] After 1886 a relative "invasion" of Americans began, as new leaseholders such as the Powder River Ranch,[37] the Pioneer Cattle Company,[38] the Circle Ranch and Cattle Company,[39] and a dozen or so others took up or expanded their holdings mostly to the east and south of the original great ranches. They situated primarily in the valleys of the Bow and Old Man rivers; along the Milk River Ridge and to the east of Fort Macleod; in the Wood Mountain and Cypress Hills regions respectively near Maple Creek and Medicine Hat; and further east still in the Big Muddy district south of Regina.[40]

Of course many of these ranches had owners and directors from the East. However, they all brought cattle hands with them – like the famous black cowboy John Ware; the eventual owner of the Bar U ranch, George Lane; and the celebrated bronco buster Frank Ricks – who had been born or raised in the American West.[41] In 1886 a reporter observed that although "the management" of the Western Canadian ranches was "generally in the hands of Englishmen and Scotchmen with Ontario men," "the foremen, herders and cowboys [were] mostly from the States."

In fact, this district, its towns, and manners and methods is very American, so that it seems much like a section of the western American frontier ... The lasso and lariat, the broad-rimmed cowboy hat, the leather breeches, and imposing cartridge belts one meets at the frontier towns on the Union and Pacific railways are reproduced in this district in the same reckless and extravagant fashion. The cowboy dialect rules supreme in the talk of the people, while the American national game of "draw poker" ... flourishes exuberantly at Fort Macleod and elsewhere ... The cowboy who can ride the fastest and "round-up" the largest herd is the popular hero in this part of Alberta.[42]

Another factor was that many of the young men who came to the Great Plains directly from places like Montreal, New York, or London

Cowboy in Cypress Hills area

had grown up under the influence of the romanticization of the wilderness, the rancher, and the cowboy himself. When they reached Calgary, Medicine Hat, and Maple Creek they were determined to embrace Western ways as quickly and firmly as they could. They put many of their Old World customs aside after their arrival, reverting to them only now and again when occasion demanded. Recently a scholar of British migration to the Canadian prairies has aptly described this process.

Before even securing a job ... the young men had usually added a cowboy costume to the repertoire of outfits, such as formal dinner wear, polo uniforms, and croquet party wear, that they kept stowed in their steamer trunks. This new outfit was assembled after consulting in the hotels with cowboys who had come in from the range for a night on the town. The first and most serious acquisition was a cow pony, although these small, rangy horses were a bit of a disappointment to men used to thoroughbreds, or the even larger hunting and polo horses of Britain. Even if the young man had brought with him a saddle, its lack of a horn would make roping cattle and horses difficult, so

F.C. Inderwick, Pincher Creek area, Alberta

there was a need to purchase a highly ornamented western-style saddle and equally fine bridle. Having attended sensibly to the needs of his horse, it was now time to put together a suitable cowboy kit for himself. This, based on the advice again of working cowboys, consisted of boots with a good high heel, woolly chaps, spurs at least two inches in diameter, a woolen shirt worn well open at the neck so that a brilliant pink or violet silk handkerchief could be knotted at the throat, and a wide-brimmed Stetson with a fancy braided leather band around the crown.[43]

Admittedly, many of the wealthiest owners of the biggest ranches were largely impervious to cultural transformation because they tended only to visit their operations for short periods and then return to their homelands. On the other hand, the above photograph of F.C. Inderwick, a principal shareholder in the North Fork Ranch, suggests that even

The Herd Quitter

the highbrow set were far from immune to cowboy culture. In the Glenbow Archives in Calgary there is also a picture of Sir John Lister Kaye, owner of the immense Stair or 76 outfit, sitting Western-style on a horse, with a six-shooter in his belt, rifle in hand, and full cartridge belts across his chest.[44]

From the evidence, it seems unlikely that once a young man was established in the West his desire to embrace frontier customs ever waned very much. He soon found that the stature of the cowboy was every bit as high as he had expected, since they alone had the riding, roping, and branding skills required for the operation of the open range cattle business.[45] Young easterners soon caught on that they had to follow their example in more than style. Fred Ings tells us: "Most of our best riders came from the States and they taught us all we knew of cattle lore. Over there cattle and roundups were an old story; to us they were a new game."[46] Bob Newbolt, who came West in 1884, later remembered that after he spent a number of years working on the Military Colonization Ranch near Calgary, he learned "to ride and rope with any of them," and to "hold [his] own in a poker game." He also "acquired a liking" for the "good whiskey" that cowboys were known to be so fond of.[47] Billie Hopkins, who with his wife Monica started up a spread in the foothills near Millarville, soon showed signs of almost complete assimilation. Much to his wife's chagrin, when he attended dances and other functions he insisted on wearing a Stetson hat, a "large silk coloured bandanna," and a "buckskin coat that he got from a Stoney Indian." The formal suit, collar,

and dress shirt that he had brought from England almost never saw the light of day.[48]

If one feels obliged to stress the Western flavour on the Canadian side because it has been underplayed in the past, the opposite is true in Montana for the same reason. In describing the ranching life of that state, one is now inclined to emphasize the importance of British and eastern culture because to this point few historians have done it justice. No one would argue that the cowboy did not become as much an icon south as north of the border. In and around towns like Helena, Great Falls, and Miles City – as in Laramie, Denver, and Dallas – it was the image of the devil-may-care, fast-living, hard-riding but honourable men who roamed the unbounded plains, scoffed at their dangers, and escaped the limitations and drudgery of urban life that caught hold in the popular imagination. Early media representations had doubtless worked their magic as well. "His personal appearance as portrayed in print, is true to life," the *Rocky Mountain Husbandman* proclaimed in 1884, sounding as if the writer had just put down Teddy Roosevelt or a dime novel:

He wears spurs, chapps and a broad-brimmed hat, and not unfrequently has a flashy bandana tied about his neck and revolver swung to his belt. He is a reckless rider, has little mercy on horse flesh, and is not afraid to mount the wildest bronco that ever "wore hair" ... He is a good citizen and has long been the only sure safeguard to our frontier homes. Our stockmen have pioneered every valley, and to the presence of the cow boys, rather than the military, which has always been inadequate and insufficient, is due the security Montana has enjoyed for her homes and property ... [Cowboys] have moved on and on, stretching out their strong arm of protection around a defenseless people and making them comparatively secure. And to-day we find them as ready-handed and efficient in protecting the country from horse thieves and highwaymen as they were in earlier days in holding at bay and driving before them a wily Indian ... Now, as then, their tribunals are severe. Judgment is passed in the chase and they take no prisoners, and the name, "cow boy," has as much terror in it to the horse thief as it has to the society belle down east among the "genial influences" where only half the story is told.[49]

Of course, the widespread acceptance of the artistry of Russell and his fellow painter, Frederic Remington,[50] is also testimony to the stature of the cowboy on the American frontier, as are accounts left by numerous cattlemen of life on the open range and in the myriad saloons and other recreational establishments that operated in every little town.[51]

On close examination, however, it appears undeniable that eastern culture and values also made a noteworthy impression in Montana.

The census figures indicate that proportionately Montana also had a large Old World contingent throughout the frontier period. In 1880 there were just over 35,000 white people living in Montana, of which over 7,000 or 20 per cent were from England, Scotland, Wales, Ireland, or English-speaking regions of Canada.[52] By 1890 the white population had increased to 127,271, of whom 55.7 percent (73,661) were of foreign parentage.[53] Approximately half of those people (31,665) had at least one parent from the British Isles, and another 6,875 had at least one from English-speaking regions of eastern Canada.[54] In 1900 there were 243,329 people in Montana; 57.3 per cent (139,392) were of foreign parentage, including 8,039 who were English, 10,707 Irish, 3,107 Scottish, and 849 Welsh. Another 7,000 were German and just over 8,000 Canadian. Many others, of course, were Americans from east of the Mississippi River.[55] Thus, around two-thirds of the population could easily have been eastern rather than western or in any sense frontier in origin.[56]

In an influential essay written nearly half a century ago Earl Pomeroy stated that as the American West was being settled there were soon "enough gentlemen ranchers and miners, rich men with weak lungs, officeholders, and lawyers to add substantial cultural leavening" in a society "that was quick to demand schools, colleges, and grand opera."[57] He could have said this about Montana alone. Indeed, in one respect that state clearly outdid southern Alberta and Assiniboia in sustaining an eastern way of life. Because of its faster population growth, it experienced significant urban development at an earlier period. By the turn of the century, for example, Butte had 30,470 people, Great Falls had 14,930, Helena 10,770, and Deer Lodge 9,453. Miles City, Billings, Bozeman, and Missoula all had between 1,900 and 4,500 people. At the same time the Western Canadian centres of Maple Creek, Fort Macleod, and Medicine Hat all had under 2,000 people, Lethbridge had just over that number, and even Calgary was only just rising above 4,000.[58]

As the Montana towns grew, they developed significant echelons of people in professions such as banking, retail, the law, and teaching, which were not directly related to agriculture. A large percentage of these people seem to have maintained a rather "un-Western" culture. When they could afford it they built Victorian homes out of brick and tried to carry on life as if they were still in Boston, New York, or London. And they coveted all the accoutrements of high culture that they had left at home. There are far more advertisements in the Montana newspapers for apparel such as Dunlap Bowler Hats, formal two- and three-piece suits made of "Scotch-wool," "silk Cass and Cheviot dress shirts,"[59] and ladies' "fine High-cut French kid" and "custom-made Oil-

Pebble shoes"[60] than one finds in the Canadian newspapers. And gala balls, the opera, and the theatre appear to have been even more abundant throughout Montana than they were north of the forty-ninth parallel.[61] Headlines even in the seventies and eighties frequently announced such events as "A Season of English Opera," "Mother Hubbard Masquerade," and "Grand Ball at Forsyth." When Great Falls residents set about the task of financing and building an opera house in 1890, John Maguire, the "veteran theatrical manager," argued that it would put the city "on the threshold as it were of the best towns in the Montana circuit." Maguire also stated his intention to see that Great Falls was part of an operatic tour that included Winnipeg, Manitoba, as well as St Paul, Minneapolis, and Grand Forks.[62]

In most towns in the territory and then state of Montana, there were times when Old World customs seemed to be transplanted to the frontier wholly intact. In the town of Granite there were so many Scots and "Scotch Canadians" in the early nineties that one of them exclaimed that there was as much Gaelic spoken as in Bonar Bridge back home.[63] Deer Lodge held an annual Caledonian picnic; Bag pipes were played, traditional Scottish reels were danced, and young men competed in a series of Scottish games.[64] The Irish element was also heard from on various occasions. In 1885 a Miles City man named John Carter opened a new public house where he offered Bass Ale and Dublin Stout "from the wood." This, the *Yellowstone Journal* acknowledged, was "a rare thing even in large cities."[65] A number of towns also celebrated St Patrick's Day.[66] The *Great Falls Gazette*, announced in the nineties that "Company A, under the efficient command of Captain Jensen" would be providing as "much merriment and fun as any warm-hearted Celt could desire ... The park hotel ballroom will resound with music, and dancing will be continued until a late hour." The paper went on to quote from a speech made in Butte by John Hoyle O'Reilly advocating the cause of Irish home rule.

It would be misleading to suggest that the Montana towns at all lacked a frontier flavour. During the day cattlemen in their Western gear walked the streets doing business in general stores that were selling everything from barbed wire to saddles and hay seed, and at night cowboys frequented the saloons and whorehouses. Miles City at the end of the trail from Texas was described in the late seventies as "a rough and wild cowboy town" with "a solid block of saloons, brothels and gambling dens."[67] Commenting on the situation in Lewistown some twenty years later, James Fergus said that there were "ten fine whiskey Shops and not quite a 1,000 inhabitants." People understood the kind of clientele the town served much of the time too. Apparently there

Cox cattle ranch, Hanging Woman Creek near Powder River, Montana

were also three ministers but only one – a "Presbyterian Scotchman" – was prepared to speak out "against the whiskey shops [and] brothels."[68]

In all the bigger towns, however, ethnic groups from Europe made their presence felt and social elites attempted with some determination to replicate the styles and culture of their homeland. The retention of eastern and European cultural mores was arguably somewhat less pronounced in the countryside. Because the era of big ranching was so short in much of Montana, few of the wealthier owners ever got to the stage of replacing their first homes with Victorian elegance. Even surrounded by log living quarters, barns, and corrals, however, many made steadfast attempts to carry on a social existence that varied as little as possible from what they had experienced before heading West. There was, for instance, the example of Lady Kathleen Lindsay, who arrived from England in 1897 to dwell on the Cross S horse ranch in which her husband's family held shares.[69] The main stockholder was Major Pennell Elmhurst, a hunting correspondent to the newspaper of the English country gentry, *The Field, The Farm, The Garden*. Lady Kathleen and her husband spent their social hours hobnobbing with a host of other British people, including Sydney Paget, uncle of the famous racehorse owner Miss Dorothy Paget; Oliver Wallop, later to become Lord Portsmouth; Nellie Moncrieffe and her husband Malcolm, who was the son of a Scottish baronet and brother of Georgina, Lady Dudley; J.H. Price, who had once been an Oxford don; Maitland Kirwan, who had been sent to the country with supposedly hopeless tuberculosis; and the Ferdons, a couple who were very well off, had their own maid,

A social night at John Beam's ranch near Cochrane, Alberta

"an English girl," and a "first rate colored cook called Pete." None of these ex-pats were insulated from the effects of the frontier even in their private lives. The living room of the Ferdons' huge home was described as "very high with rough walls" and it was decorated with the "heads and skins" of various animals. However, in the early eighties the couple maintained many elements of their traditional culture. They commonly held dinner parties that required full formal dress and entertained themselves and their neighbours with card games such as whist. Under their patronage, steeple-chasing and a "three Day Fair, which corresponded to an Agricultural and Industrial Show in a country town in England," became annual events in Miles City.[70]

From Great Falls a young woman wrote home in 1904 of her enchantment with a play based on Dickens's *Pickwick Papers*[71] and with a presentation by a well-known vocalist. "Her singing was superb," she said; "her paper on Mendelosson [sic] and his orations 'St. Paul' and 'Elijah' just splendid." Many in the audience "were affected to tears by her rendering of one of the lullabies."[72] The same woman lavishly praised her wealthy ranching friends, who nurtured a magnificent English garden with vegetables, flowers, and fruit, and kept "servants including a Chinaman and a still more wonderful [man] called Sing," who had been "their cook for sixteen years."[73] Generally speaking, eastern ranchers were known to ride with "pancake saddles," and play polo on their

Konrad, thoroughbred Kentucky stallion

meadows. In a number of localities they also built race tracks that sported clubhouse, grandstand, stables, and betting facilities.[74] "Montana's wealth in fine race horses is beginning to be realized," the *Yellowstone Journal* reported on 11 April 1885, "and it is safe to predict that this territory will soon rank high in the turf books." Animals with good bloodlines were already being imported by breeders with some expertise. "The principal attraction" at W.H. Raymond's Belmont Park Horse Ranch, the *Journal* announced, was "the parent animal," Commodore Belmont, "a magnificent bay stallion foaled in 1872, and bred by Benjamin Gratz, Spring Station, Kentucky." He was sired by breeder R.A. Alexander's "Belmont," after whom the park is named. The stallion's offspring had apparently started in six races the previous season and won four.[75]

Old country sports were also frequently recreated in Montana. While baseball was popular as on the Canadian side of the border, so were quoits, rowing competitions like those staged annually between Oxford and Cambridge or Harvard and Yale, and English football (soccer).[76] Moreover, the Montana papers too carried countless reports of baying hounds and thoroughbred horses chasing wolves and coyotes across the prairie landscape.[77] Easterners also indulged in the kind of safari hunting expeditions that had been undertaken by wealthy Britons for centuries in the far corners of the empire.[78] These expeditions were so popular that local sportsmen were able to make their living as guides. Joe Bradshaw, the *Yellowstone Journal* announced on 4 October 1887, "an old time hunter and scout ... who has been for several weeks with the Wallop hunting party in charge

Lady Adele Cochrane, Tom Cochrane, Lord Norbury, Algernon St Maur of Seymour, fifteenth Duke of Somerset, and Susan St Maur, Duchess of Somerset, on hunting expedition, British American Ranch, Cochrane, Alberta

of pack animals, etc. has returned. He says the party have had good luck in the Blackfoot country [and] many bear, elk, deer and smaller game" have been bagged.[79]

Some of these trips were miserable failures, perhaps because the participants lacked experience in the wilderness – and perhaps because they were more concerned with having a jolly good time than with actually searching for game. "A couple of Englishmen went over to Libby Creek to look for Rocky Mountain goats about the first of October," the *Missoulian* reported in 1887. Morris Farrell "was with the party as packer and they had a hunter from Miles City who was paid $100 per month." The party had a total of "eighteen horses and several gallons of whisky." Though out about a month, their entire take was "two goat heads and three pelts," which Farrell estimated "cost the young gentlemen $2,000." The horses died up in the mountains, "there being no feed for sixty miles," and at the end the hunters had a "six days go-as-you-please walk into Thompson Falls," leaving "canned goods, pack saddles and the like" strewn along the wayside.[80]

Old World influences also affected the operation of ranches in Montana just as in the Canadian territories. Outfits like the Cross S,[81] the Eureka Horse Ranch,[82] and the Green Mountain Land and Cattle

Company[83] used their connections with the East to find purebred Thoroughbred, Morgan, and Cleveland Bay horses for their ranges. Captain E. Pennell Elmhurst[84] and O.H. Wallop[85] brought numerous Shire and Thoroughbred horses to Montana, and Alex Metzel of York Ranch was importing purebred bulls, heifers, and work horses as early as 1871.[86] Such men also imposed eastern ways on day-to-day agricultural practices. The Eureka Horse Ranch[87] and the Fergus Land and Livestock Company, for instance, did much to speed the way to diversification by implementing traditional mixed farming methods such as soil cultivation, crop husbandry, and livestock feeding and breeding.[88] The Hesper (Western) operation of I.D. O'Donnell some ten miles west of Billings had adopted irrigation on a broad scale by the mid-nineties and fed 1,000 head of calves and yearlings. It put up 2,000 tons of blue joint, timothy, and alfalfa hay and raised sheep, swine, draft horses, trotters, and "fine running stock." It also harvested 5,000 bushels of wheat, barley, and oats that were milled on site and fed to the stock.[89] As in the case north of the border,[90] not all of the men who embraced farming practices were either rich or involved in corporations. David B. Christie, whose parents immigrated to Wisconsin from Scotland in 1847, arrived in Montana in 1885. He staked a small land claim near Bridger Canyon, built a log house, and began to graze cattle on the open range like most other ranchers. After he got settled, however, he broke up the prairie soil, fenced his land, planted wheat and other crops, and kept chickens, milk cows, and pigs.[91]

It would be misleading to suggest that it was only newcomers from the East and overseas who guided agricultural production to a more diversified and developed stage. On the other hand, it is clear that many of the ranchers who were born or had cut their teeth on one or other of the Western ranching frontiers resisted change. Their resistance was in part due to their self-concept. They saw themselves as ranchers in societies where the cowboy had become an icon and they disliked anything that made them feel or act like dirt farmers. They could often be heard protesting against activities that required them to get down from the saddle for any extended periods of the working day. The cowpunchers "all say they have not time," a police officer observed in 1888; they "will not work on foot," and they have not as yet shown a willingness to "cut hay [or to] garden and attend domestic animals."[92] Such men also cursed the barbed wire fence because it facilitated and symbolized the end of the open range approach and seemed to guarantee that the "cow-boy's days were numbered."[93]

People in Montana were mindful of the fact that Old World attributes sometimes diluted their Western image. One contemporary later remembered that in the Judith Basin area, which, in his words,

Bow Gun cowboys on round-up, Montana

had been "dominated by eastern cattlemen," the persona of the round-up was severely affected. Although Charlie Brewster, "one of the finest broncho riders the west has ever seen," participated in the event, most of the men were referred to derisively as "a bunch of 'pumkin rollers,' or 'corn huskers,' or 'straight legs.'" Moreover, the round-up in this area was tagged a "feather bed" affair because some of the gentlemen insisted that "cots and mattresses" be hauled along the trail for their sleeping comfort.[94] Some observers were less critical. A career cowboy remembered that by far the best food to be had was on the eastern-owned operations. "In Texas," he said, "all they'd ever give [us] was cornbread and sowbelly and beans, except when they killed a beef." That was why, after driving cattle herds into Montana, "so many of the Southern cowpunchers stayed in the North ... It was on account of the grub being so much better." He believed "the English outfits were the first ones responsible for that, and the rich Easterners. They had plenty of money and they wanted to be comfortable, and as they had to eat the same grub the men did, they'd have white flour and canned fruits, and all such luxuries." They brought other amenities as well. The same operations "began using tents ... on the roundups, and some even had stoves in them."[95]

The big eastern owners in Montana also provided considerable political leadership for their industry. In a country with a much larger population and a lot more political complexity than Canada, they did not as individuals have the pull to directly affect government policy in Washington. However, they were not intimidated by political power

Cowboys on round-up, Cypress Hills area

and therefore worked within the system in their own territory and state as much as they could. James Fergus sat for one term as commissioner of Madison County and two as commissioner of Lewis and Clark County, which he also represented in the territorial legislature.[96] R.M. Holt was elected to the legislative assembly for two terms.[97] W.G. Conrad served as a county commissioner at a very young age and then represented north and east Montana as a member of the upper house in the territorial legislature in 1879 and 1880. He was also the first mayor of Fort Benton.[98] S.S. Hobson was a delegate to the constitutional convention in 1889 and helped frame the constitution for the state of Montana. The same year he was elected to the senate.[99]

When such men attained positions of power, they looked out for the interests of their industry. Among other things they were able to get a memorial sent from the legislative assembly to the House of Representatives on the problem of Native rustling and they sponsored the formation of the tax-supported Board of Stock Commissioners, which had the authority to fight rustling with hired cattle inspectors and detectives.[100] They also backed bills for the appointment of a Territorial Veterinarian Surgeon, to prohibit the branding of cattle on the public ranges during the month of August and from mid-November to mid-May, and to provide for and control the legal seizure of livestock.[101] They were also instrumental in forming the Eastern Montana Stock Growers Association in 1883 and the Montana Stock Growers Association in 1884 as well as amalgamating the two under the latter name in 1885.[102] Of course many of them were also active within those organizations; among them Alex Metzel, Joshua Day, T.J. Bryan, R.P. Walker, S.S. Hobson, R.M. Holt, and R.B. Harrison were the most energetic.[103]

Overall, the societies on the ranching frontiers of Montana and of Alberta and Assiniboia mirrored each other a lot. Both had a wealthy and influential eastern elite and a substantial Old World component in their customs and agricultural practices. However, the popular culture, at least during the period when ranching predominated, was that of the Western frontiersman or cowboy. The reasons that so many in both societies were eager to embrace that image were essentially the same, as well – an almost irresistible fusion of Old and New World forces or pressures.

Cowboys were popular for two main reasons: they were admired for their skills and gear, which were perfectly adapted to the environment; and they were loved for the universal praise heaped on them via the print-media, mostly from the east and overseas, both before and after large-scale ranching took hold on the northern Great Plains. Given the cowboys' popularity and the fact that their labours were so vital to the open range grazing approach, it would seem appropriate now to examine their lifestyle in both frontier cultures in some detail.

5
Unruly Young Men

One of the most distinct characteristics of popular culture in the West was a tendency towards licentious behaviour and lawlessness – and it was strong on both sides of the forty-ninth parallel. Much current historical analysis has depicted these two societies as more or less the antithesis of each other, but the contention here is that they were more similar than previously thought. American frontiersmen were indeed violent and unruly,[1] historians have informed us, whereas Canadians were essentially orderly, law-abiding – and even "tame."[2] In developing this argument scholars normally focus on the institutions the two societies relied upon for keeping the peace. Montana, like all Western states, turned to the extremely limited resources of the county sheriff and his deputies, whereas the North-West Territories, it is said, were blessed with the highly efficient, centralized, and dedicated work of the Mounted Police. The major problem with that approach, however, is that it fails to recognize the immense importance of the social and physical environments on the frontier. These dictated not only that American and Canadian legal authorities had to confront an array of the same obstacles but also that they should have very similar difficulties in trying to deal with them.

There were some basic environmental conditions that worked against the establishment of order on the northwestern ranges. One was simply the immensity of the task. When populations were sparse and tax bases meagre, American and Canadian governments attempted to control their frontiers with only the most fundamental administrations. A mere handful of lawmen had to exercise effective control over tracts of land that ran into the thousands of square miles, while at the same time fulfilling numerous other functions besides keeping the peace. Lawkeepers on the Canadian side of the border were less disadvantaged in this respect than their counterparts to their south,

and yet they aptly illustrate the point. In 1873 only three hundred North West Mounted Policemen were sent west to establish authority over the three new territories of Alberta, Saskatchewan, and Assiniboia – some 500,000 square miles. In 1885 police numbers were boosted to 1,000 because of the Riel Métis Rebellion, but from that point on the numbers declined. In 1895 there were 750 men, and six years later only 450.[3] On the ranching lands of southern Alberta and Assiniboia this was equivalent at the turn of the century to about one officer for every 500 square miles and for every 350 people.[4] The frontier police have been lauded by modern historians for frequently patrolling the ranching districts.[5] Contemporaries, on the other hand, sometimes expressed their doubts about how effective this coverage could be in such a huge expanse of territory. "The N.W.M.P. patrol under Inspector Jarvis, which went north from Edmonton in January, returned to Fort Saskatchewan last week having completed the longest patrol ever made by a police detachment," the *Regina Leader* reported in 1897. However, the writer added his reason for noting this: "It is frustrating! Did they not see anything?" He then went on to question the efficacy of the police in the face of widespread rustling.[6]

One needs to keep in mind as well that the frontier by definition had very limited facilities for serving the basic needs of the population. Consequently the Mounties had to shoulder an inordinately heavy load not only to ensure their own and their mounts' survival but also to provide for the well-being of the civilian population. The force was required to settle the Natives on the reserves, protect the civilian population from "natural disaster and human disruption," and provide state services normally offered by specialized agencies in more mature societies.[7] Construction, laying in their own food supply, cutting and hauling firewood, feeding and caring for the horses, providing medical services to the men and the community, and carrying out governmental duties such as collecting weather data and conveying mail occupied an enormous amount of their time. They also had to deal with emergencies such as prairie fires and floods or blizzards, and they had to protect Canadian ranges from inundation by hungry American cattle herds that were constantly pushing their way across the border in search of greener pastures.[8]

In comparison to their modern counterparts the frontier police worked under a formidable disadvantage; not only were they understaffed but for most of their time they were precluded from even turning their attention to crime prevention. As urban and agricultural communities developed, this situation no doubt changed somewhat. Grocery stores in burgeoning towns became available to the police as well as to the general public, and ranchers who streamed in offered

ready supplies of hay and other livestock feed.⁹ Moreover, medical and postal services were soon established, and some of the major urban centres eventually started their own police forces. However, in the nineties and the early years of the twentieth century, settlement significantly increased the number of people the Mounties were required to serve, just when their own resources were dwindling. "The rapid increase of population has caused an expansion of our duties which, with our fixed strength, we have great difficulty in meeting," the commissioner himself complained in 1902.¹⁰

On the frontier to the south law enforcers faced even greater odds. In Montana, as in most Western states and territories, the bulk of the responsibility for maintaining law and order tended to fall on the shoulders of the elected county sheriff – often because the other agents involved were not up to the task. Officially, above all of them was a state or territorial marshal appointed by the federal government.¹¹ In theory his job was to keep the peace while defending federal institutions and property from criminal activity. The marshal was typically a politician appointed for his allegiance to the government and he seldom had any experience in the law or its workings. He usually delegated the actual duties of his office to one or two deputies who lived or were stationed in the state. These deputies had to oversee thousands of square miles as well as carrying out routine functions relating to civil or criminal court activities, such as serving subpoenas, gathering jurymen, conducting property sales, locating witnesses, and issuing writs and warrants. Much more directly involved in regular prevention and control of crime were the marshals or constables appointed in larger urban centres such as Helena, Great Falls, and Miles City; however, their duty was to protect and serve their local community and they normally ventured beyond it only when performing that function.¹²

This shortage of personnel meant that the sheriff, working with a deputy or perhaps two, was required to serve the extensive countryside in his county as well as the small towns and villages that could not afford their own officers.¹³ One should remember, too, that these officials had to deal with a much bigger population throughout most of the frontier period than did the Canadian Mounties.¹⁴ The situation in Valley County, which was created in 1893 out of the northeastern corner of the state, illustrates how difficult law enforcement was. From its inception, Valley County literally teamed with outlaw bands and individual rustlers, many of whom had moved north from Wyoming in order to escape the vigilante groups and hired guns of the "cattle barons."¹⁵ In its first two decades the county had a string of elected sheriffs of varying degrees of skill and dedication. Even for the best of

them, however, the challenge was enormous. The county covered an area of approximately 22,000 square miles. The sheriff normally had at least two deputies, but, even so, the man to area ratio that he operated under was obviously many times worse than that of the Canadian Mounties. The sheriffs and their men were also required to fulfill a number of clerical and administrative duties, though not to the same extent as their northern equivalents.[16] They had other preoccupations too. As supposedly upstanding citizens of the community, most of them had professions other than that of the lawman to concern themselves about. Walter "Leather" Griffith, who was sheriff in 1900, for example, had interests in a ranch and a livestock business outside the town of Glasgow; within the town he operated saloons and the Glasgow Meat Market; and he also owned real estate.[17] These businesses must have severely limited his ability to fight crime. He was nicknamed "Leather" because he was so often found sitting in the leather chair in his office. Perhaps he had so much on his plate that at times he just didn't know where to turn next.

The situation of the preoccupied sheriff was anything but rare throughout the Western states and the same can be said about the deputies. Theodore Roosevelt's home place was across the Montana Territorial line in what today would be part of North Dakota. His county had a sheriff with two deputies – one for the northern region and one for the south. Roosevelt himself was the northern deputy for some time during his short ranching career. He clearly did not consider that his duties required his full attention. While he held the position he helped manage his ranch, regularly attended meetings in two Montana livestock associations, and made a number of extended trips to visit his family back home in New York.[18] The sheriff himself, one Bill Jones, also could not have given his all to fighting crime since he worked as a hired hand for Roosevelt while in office.

Under normal circumstances the American lawmen were thus in an even weaker position than the Mounties. There were, however, two well-known forces they could call on to bolster their strength in emergencies. First, they could appoint posses of special deputies from the local citizenry. This convention was sometimes used by the Mounties as well, but much less frequently.[19] In Montana posses seem to have been relied upon primarily when regular officers needed help to hunt down criminals.[20] However posse efficiency was often limited by the fact that the only labour pool the sheriff could draw on was made up of cowboys and drifters hanging around the local saloon. Extra-legal citizen action committees were much more effective. As Montana Territory was being settled, vigilantism was already an established

tradition in more southern frontiers, and when lawlessness seemed to get out of control people were inclined to resort to it.

Probably the most disorderly period in Montana's history was the early mining stage of the sixties when desperados hungry for gold and silver filed into the camps around Virginia City faster than any kind of legal forces could keep up with. Miners were robbed and in some cases murdered for the wealth they were carrying with them. After some particularly brutal incidents in 1863, citizens got together to hunt criminals down and either execute them or banish them from the area. Some twenty-three men were put to death, most by lynching, through 1863 and 1864, and others were chased away under the threat of a similar fate.[21] In a number of cases the men who were lynched were left hanging for some time as a public warning. Nearby on a bridge, a large rock, or some other highly visible object, the numbers 3-7-77 were painted in large characters. This informed anyone considering a life of crime that he too could end up in a grave 3 feet wide by 7 feet long by 77 inches deep.[22] There was substantial public support for this kind of action.[23] "Lawless men are bound to be present in the West as it grows," one journalist asserted in 1869. However, "it is not long tolerated, and the ... means taken to hasten its departure – the vigilance committees and summary execution – which are greeted elsewhere as evidence of western barbarism, are really demonstrations of a capacity of self-government." The same journalist could see that the need for such action was a frontier condition. "Where law and its officers do not exist, or are powerless," he continued, "the people are not only justified in taking the administration of justice into their own hands but it is the expected first step towards the establishment of law and order."[24]

Vigilante action tended to get results. However, it was only an intermittent device called upon in desperate times. In addition to a dearth of human resources, another basic condition that ordinarily made enforcement challenging on both sides of the Canadian/American border was gender imbalance. Single young men tended to set out to all the new areas of settlement in North America in far greater numbers than women. Census reports indicate that Alberta/Assiniboia and Montana were typical. In 1901 the rural district of Fort Macleod, Alberta, had 296 men, of whom 207 were unmarried, and single males outnumbered single females by nearly two to one. A few miles further west around the small town of Pincher Creek, 168 of 235 men were unmarried, and there were only 83 single women. Near Millarville 209 of 311 men were single compared to 139 of 233 women.[25] In Montana this situation was also more or less universal. As a whole, 65.2 percent of the population was male in 1890[26] and ten years later 61.6 percent

was male.[27] A very large number of the men there too were obviously unmarried. Gender balance began slowly to improve in both cases shortly after the turn of the century, but it was never achieved before World War I.[28]

This preponderance of males unquestionably led to a lower respect for the law in a general way. Men who live outside families behave in a much less "civilized" manner than those who are married. When part of a family, they are likely to be concerned with establishing a culture based on home, church, school, and domestic values. Far from taking up lives of crime, they are inclined to work towards a social setting in which wives, sons, and daughters can be securely insulated from the baser aspects of the world around them. Single men, on the other hand, are inclined to establish a culture devoted to the satisfaction of basic animal urges. They compete with each other on the most fundamental levels (often simply by making bizarre bets) and seek sexual satisfaction and unconstrained entertainment in various forms of nightlife. Many show little reluctance to break the law.[29] This point is amplified by taking a look at the behaviour of a group of predominantly single young men who were entrusted to enforce legal standards. The diary of Mounted Policeman Sergeant S.J. Clarke, who was stationed at posts in Macleod and Calgary between 1876 and 1886, illustrates beyond doubt that illegal whiskey, gambling, and prostitution were regularly enjoyed by the men of the force. One night in 1880 police misbehaviour nearly caused a major catastrophe. "All the stables" at one of the barracks, along with the "shoe shop" and "saddle shop," burned to the ground by a fire that had "commenced at four oclock" in the morning when "some of the boys were drunk." A Corporal Paterson and "a bad squaw" had got drunk in the "shoe shop" and in their passion had apparently "[k]nocked pipes of[f] the stove" so that the fire "caught on the wall and roared out the stables."[30] In 1883 the *Regina Leader* reported that "the red-coat of the Mounted Policeman is seen flashing in and out from [the house of ill-repute] at all hours. As no arrests have been made, the character of these visits may be easily surmised." In Calgary in 1891–92 five policemen were stripped of their ranks for being intimately involved with Lottie Carkeek, alias Dutch Lottie, a.k.a. Lottie Diamond.[31]

With respect to early ranching, the tendency of single young males to become involved in criminal activity was even greater than it might otherwise have been because their work was generally seasonal. Cowpunching required a full labour force for only two periods of the year: from about mid-May to late June during the spring round-up branding and castrating new calves; and from late August to October when the

fall round-up gathered animals to be shipped to market. Between the two general round-ups and in the wintertime most of the ranches laid off a high percentage of their men,[32] leaving them with time on their hands and the temptation to get into all sorts of trouble.

Trouble would often begin immediately after the end of a round-up or a cattle drive, when the unemployed cowboys, their pockets jingling with the wages from their recent gigs, headed off to the nearest bars and brothels. As Lady Kathleen Lindsay put it: "When paid their habit was to immediately ride off to Miles City and spend all they had on drinking and gambling and having ... a right good time. They returned after every dollar had been squandered and started piling up for the next orgy."[33] It was their letting off steam that gave the cattle towns their raucous atmosphere. The cowpunchers stabled their horses and immediately got ready for a night on the town. First they checked into a hotel. Sometimes they got separate rooms but, ostensibly because they expected to spend as little time as possible in their quarters, they more often reserved a place in an attic-level "dormitory" with a long row of single beds and a number of washstands, pitchers, and wash bowls. Once the men were checked in, they went through an extensive process of self-grooming. They would first go to a store and purchase new underwear. Then they would proceed to the bath house out back of the hotel, where they would fill one of the tin tubs with fresh water and use a bar of soap to scrub away weeks of dirt, sweat, and grit. When they were finally shaved and combed, they disposed of their old underwear and got into a complete set of clean clothes.[34] At that point they were ready for action.

And it didn't take them long to find action in one of the multitude of local saloons and whorehouses. As late as 1904 the red light and saloon district in Butte included "both sides of Galeno Street from Main to Wyoming, both sides of Main from Main to Wyoming, and Paradise Alley from Wyoming west." In that large area the backs and upper floors of the buildings were apparently "nearly all one string" of small apartments containing "two or three rooms" for the purposes of prostitution.[35] Helena was similarly designed. Many years after the fact Fred Edmunds, a cowpuncher who had known Charlie Russell in the early days, described a night on the town with him. Early one evening, he said, "I ran into him" and he suggested we "go down to the 'theatre.' The 'theatre' was down a side street. A balcony ran all around it inside." The whole place was "full of 'actresses,' rustling drinks among the boys. Once in a while, one of them would go on the stage to gargle, in a husky voice, or a couple would come out to make a few wise-cracks." Russell evidently spent a considerable amount of

Cowboys drinking and entertaining, Cochrane, Alberta

his time in the place; after the two of them arrived there he "pointed to the wings and curtains and said, 'there's some of my work.'"[36] That was the first time Edmunds had heard of his artistic talents.[37]

Despite the Canadian reputation for orderly standards, the early towns on the northern Great Plains were not much different. In the first place, even in the prohibition days prior to 1892, liquor was usually plentiful primarily because of the smuggling trade. Those who understood the demands of a society composed of more than its share of thirsty young men hauled it in from places as close as Fort Benton and as far away as Ontario. Some also made it at home in illegal stills. Fred Ings tells the story of the time when a whole keg of home brew was left by the cook tent during a round-up. "That was a wild and hilarious branding, and calves that year wore their brands at all angles."[38] The police were powerless to stop the liquor trade and, as single young men themselves, their hearts do not seem to have been in it. Sam Steele went through the motions of enforcing the law while he was the commanding officer at Calgary. "The officers and men hated this detestable duty," he said, because it "gave them much trouble and gleams of unpopularity."

We soon learned that compulsion will not make people sober ... The prohibitory law made more drunkards than if there had been an open bar and free

drinks at every street corner. Liquor was brought into the territories by every conceivable trick. Egg shells were emptied of their contents and alcohol substituted; tin imitations of the Holy Bible were filled with intoxicants and sold on the trains; metal kegs filled with alcohol came concealed in the centre of barrels of kerosene, and mince-meat soaked in brandy and peaches prepared in the same manner were common.[39]

Liquor contributed to a booming illegal saloon business in every urban centre from Maple Creek to Fort Macleod and Calgary.[40] Along with it went a burgeoning prostitution industry that was prosecuted only spasmodically by police forces that seem to have understood the need for it in a predominantly male society and turned a blind eye. In the Calgary area in 1891, "keepers of disorderly houses, inmates and frequenters" were indicted forty-one times, by far the highest number for any crime except liquor offences during that year.[41] In the same city four years later, indictments for the crime were just over half that number.[42] Then for some time little action was taken. From 1905 to 1909, when Calgary's population grew from a few thousand to well over 20,000,[43] the police "arrested on the average three keepers, 20 inmates and ten frequenters of houses of ill-fame each year; only one prostitute ... and two procurers were arrested in the entire five-year period ... for the entire 'E' division, which extended from Red Deer south to Cayley and east to Tilley."[44] When irate citizens demanded in 1906 that Police Chief Thomas English shut down the brothels, he told them "there is less gambling and less prostitution in Calgary, than in any other city of its size in the U.S. or Canada. There may be houses of prostitution in Calgary, but I don't know of them."[45] Two days later, the *Morning Albertan* observed that there were at least nine such establishments within the city whose locations were known to everyone "except the chief of police'" and that "new houses were opening weekly across the river."[46]

Drinking young men needed something to do when they couldn't find women or when their sexual urges had been satisfied. On those occasions they did their best to blow their money on gambling. This could take almost any form. In Calgary, for instance, a group of cowboys would "get onto their cow ponies outside the Queen's Hotel and race up Stephen Ave to the Royal, the last man in paying for drinks."[47] They also played more formal and widely recognized games. Charlie Russell remembered that the typical Montana cowpuncher put in his time at "the stage [or shipping] station playing monty or stud poker ... On the range he played on a blanket; in town he could generally hold his own on a round table agin tin horns."[48] Though illegal, casinos operated in the larger Canadian centres too and they

offered everything from poker to roulette. Some tables were honest and some were not.[49] All did a pretty good job of separating the men from their hard-earned cash. Card games did not of course, require the casino setting. Private games were often played in homes and bunk houses. What was reputedly "the greatest blackjack game ever played in Alberta" took place in the late nineties in High River between two men named Iken and Todd. After the game, Iken was forced to turn over land that Todd was able to sell for forty thousand dollars.[50]

Of course, the mix of liquor, prostitutes, gambling, and idle young men was potentially explosive and frequently led to violence. With respect to Montana, as in the Great Plains frontier states generally, tales of violence have been richly documented by newspaper reporters and fiction and non-fiction authors who have painted lurid pictures of quarrels that all too often ended in gunfights and death. Theodore Roosevelt, despite being enthralled by the cowboys, was prepared to concede their brutal nature under the influence of alcohol. In his book *Ranch Life and the Hunting Trail* he praised them to the skies, but at the same time he acknowledged that when drunk on the "villainous whiskey of the frontier towns, they cut mad antics, riding their horses into saloons, firing their pistols right and left, from boisterous light-heartedness rather than from any viciousness, and indulging ... in deadly shooting affrays."[51]

Given the natural desire of most writers to market their work, this kind of activity has probably been overblown. Often, for instance, the "deadly shooting affrays" were something less than deadly. Teddy Blue Abbott remembered that "nine-tenths" of the cowboys who went to town in the early days with their guns on were looking for fun not a fight. "They didn't get to drink very often. They were out [on the range] for months on end, on the trail or living in some cow camp, eating bad food, sleeping in wet clothes, going without everything that means life to a man." Consequently, "when they hit the bright lights of some little cow town that looked like gay Paree to them, they just went crazy." To many of them gunplay was part of the fun, but they seldom actually hurt anyone. "They just shot up in the air and shot out a few lights, and as often as not the boss would pay for it all in the morning." For example, one night in Douglas, Wyoming, when some men were trailing cattle north for T.C. Power's ranch in the Judith Mountains, "the boys started tearing things up to pieces in this little saloon, and they roped the bar and drug it out on the prairie." The following day the trail boss, Bill Deaton, handed over two hundred dollars to pay for it.

"A lot of this shooting ... was just crazy high spirits," Abbott insisted. "You'd be standing up to the bar with a pipe in your mouth,

Bow Gun Ranch cowboys, Montana

and bang! the pieces would fall on the floor. Somebody took a shot at it but it was all in fun."

There was a fellow that used to be around Miles City, by the name of Tom Irvine, who was the best shot I ever saw. One night when they were all in the saloon, Louis King ... was standing there with a cigar in his mouth, and Tom pulled his six-gun out and shot the end off. Louis never budged. He just stuck his face out a little further and Tom clipped another half inch off the cigar so it was down to a little stub. Still Louis never moved, but only stood there with it held out between his lips as though he was daring Tom to come on and shoot again. Tom said: "You go to hell," and shoved his gun back in the scabbard.[52]

Even considering the relatively harmless nature of some of the gunplay, however, when the participants were from the seamiest elements of cowboy society, bloodshed did occur on numerous occasions. Sometimes the sport ended in the situation often glorified by Hollywood where the good guys took the law in their own hands to defend their town and property against the bad guys. In 1884 a man known as Rattle Snake Jake appeared in Lewistown and, after fortifying himself on rather large amounts of whiskey, he and a friend began shooting up the town. The local citizens armed themselves with Winchesters and killed them.[53] There were times too when the forces of law and order did not win out. One night "two cowboys got in a mix up in the Red light district in Bozeman." A warrant for disturbing

the peace "with a few shots," was sworn out and the sheriff and his deputy followed them to a cabin at Cherry Creek, in Madison County. When the deputy opened the door he was shot and killed. The two desperados then "commenced to throw lead" at the sheriff. Luckily he managed to get away unhurt though he was "shot through the collar of his overcoat" in the process.[54]

Of course instances when bad guys took on bad guys could be equally deadly. One of the most famous Montana shoot-ups occurred in the town of Landusky in 1894 between Pike Landusky and the celebrated outlaw cowboy Kid Curry. After they had wrestled and knocked each other around the bar with their fists, the younger Curry ended up astride Landusky on the floor, pounding him savagely. When Landusky conceded defeat Curry slowly got off him. "He was blood-spattered and his gouged eye was swollen almost shut." As Pike staggered to his feet he reached into his overcoat pocket and "his hand came out holding a new automatic pistol pointed at the Kid." He squeezed the trigger, but the gun failed to go off. "Then Kid Curry reached for his six-shooter ... thumbed back the hammer and pulled the trigger twice ... The heavy slugs thudded into Pike's body" and he dropped to the floor dead.[55]

If this sort of thing has been overstated with respect to the American West, just the contrary is true further north. Modern-day chroniclers of the Canadian ranching frontier have largely blotted the subject of violence from their pages, in part, it would seem, because of their inclination to embrace the image of the orderly society. Yet any diligent historian or writer who searches through the newspapers, police reports, and court records finds a staggering number of incidents in which guns or other weapons were used. Of course, some of these were also relatively harmless. L.V. Kelly, who admired cowboys as much as Roosevelt did, wrote that in Alberta they "might go on hilarious 'busts' when in town, they might 'shoot-up' a bar-room and smash every light in the place, they might ride into stores on the backs of frantic horses."[56] But for the most part they were basically "good men" just having a little innocent fun. Inevitably, however, blood was shed on the Canadian frontier too. In 1884 a settler near Qu'Appelle named John McCarthy was murdered and robbed by John and George Stephenson. Both were tried and executed.[57] In 1887 Sergeant Gordon of the Mounted Police arrested two suspicious characters known as Gallagher and "Crackerbox" Jones outside Calgary, handcuffed them, and headed for town. On the way they stopped for dinner and the men pleaded with the officer to remove their irons so they could eat. The Sergeant complied, and Jones "promptly plucked the revolver from the policeman's holster, shot and disabled him and then escaped

Canadian cowboy

with his companion."[58] In 1899 one E.A. Harris of Calgary shot and wounded his partner,[59] and the following year James S. Huggard, a rancher at Nose Creek, was found murdered near his hay camp. He had a bullet hole in his head and another in his chest, and had also been "battered with an axe."[60] The same year John Morrison murdered five members of a family in the Regina area and then attempted to "ravish" the remaining one, a fifteen-year-old girl. He was arrested, tried, and hanged.[61] On 16 March 1902, George Scouten got in a "fistic encounter" with Arthur Simpson in the Atlantic Hotel in Calgary. Scouten apparently got the worst of it and as his adversary tried to leave he drew a revolver, fired two shots, and killed him.[62] Scouten too was tried for murder.

The point has been made that the tendency towards violence in general was tempered in Canada by the police, who were known to confiscate guns from men they did not like or trust.[63] However, the amount of shooting that went on suggests that this approach was not

G.E. Goddard, Bow River Horse Ranch, Cochrane area, Alberta

very successful. Years after the fact, an elderly Canadian pioneer who had also experienced the ranching frontier first hand remembered that "most cowboys had only one aim, that was to buy as much ammunition as they could, become as 'quick on the draw' as possible, and become deadly accurate shots."[64] Moreover, as an editor for the *Macleod Gazette* noticed in 1886, single young Mounties could be as irresponsible with the gun as anyone else, at least on the not infrequent occasions when they themselves happened upon illegal liquor. "Blazing away with a pistol," whenever a man gets a little too much to drink, "whether it be in the hands of a policeman or a citizen is getting monotonous," a reporter complained.[65] Ten years later an English youth named Simpson "rolled" into Calgary, seeking the wild life. He soon got was he was looking for. "Coming from an upper-class Victorian family in Stamford with all its Elizabethan, Jacobean, and Georgian homes ... and seeing all this wild country around me, and meeting hardened railroaders, rum-soaked remittance men, horse thieves, and Indians would be too much for most teenagers," he recalled, "but this was just the crowd I liked." When mingling with the locals on "the very first day" he was "shot at by a drunk."[66]

One form of violence that Americans unquestionably saw a lot more of than Canadians resulted from Native versus non-Native disputes. General Custer's "last stand" at the Little Big Horn in 1876 is the most famous, but such conflicts were frequent in Montana. For instance, in 1867 some soldiers and civilians putting up hay near Fort Smith were attacked by warriors from the Sioux Band. By the end of the day eight Natives, two soldiers, and one civilian were killed and over thirty men were wounded.[67] A cowpuncher who had some first-hand experience with this kind of thing tells us that in a single region near the mouth of the Musselshell River there were more than thirty separate massacres from the sixties on.[68] The same cowpuncher relates a particularly ugly episode that occurred in the Tongue River country in 1884. A man named "Packsaddle Jack" trampled a Cheyenne's garden and when the Native complained he shot him in the arm. This "led to more and still more trouble." Eventually, after several white men were found dead, the U.S. Army was called in. Realizing that the odds against them were insurmountable, two young Native warriors decided to make the ultimate sacrifice. They "went up on top of a hill ... sang their death songs ... painted themselves, and braided their horses' manes." Then they ended their lives doing battle with two companies of soldiers.[69]

Several reasons why the Canadian West experienced less racial violence than the American come quickly to mind. One is that the North West Mounted Police may have done a more effective job than American authorities of settling Native bands on the reserves and then cementing tolerable relations with them. A perhaps more important explanation may be that white people moved into frontier communities a lot more slowly above the border than below, and European society therefore crowded in on Native communities somewhat less obtrusively. A third explanation rests in the fact that the Canadian government sent out surveyors to determine the boundaries of Native reservations, whereas the American government did not. Suzanne Schrems has recently described how this omission promoted conflict between the Cheyenne Nation and white settlers in southern Montana beginning in the mid-eighties:

In 1884, two cultures converged along the Tongue River, where both tried to maintain their way of life by occupying the land. White settlers were looking for range on which to graze more cattle and resented the occupation of land by the Cheyenne. Some settlers built homesteads and grazed cattle on land rightfully belonging to the Cheyenne people. Evidently the Executive Order of 1884, which established the Cheyenne Reservation, did not provide for a land survey. Without boundary lines, white settlers were free to move into Cheyenne

Territory. While the settlers were enjoying the benefits of the Cheyenne's land, the Indian people were without the means with which to support themselves.[70]

To concede that there was less racial violence in Alberta and Assiniboia than in Montana is not to suggest, however, that it did not occur from time to time. Indeed the historian finds a surprising amount of it. It is well known that the Blood named Charcoal and the Cree Almighty Voice[71] each accounted for a number of deaths before being caught by the Mounties in the late nineties and hanged. A number of incidents of white/Native violence are less well known. Some time in the 1870s or early 1880s, a white buffalo hunter enduring the infirmities of old age was shot in what was claimed to be a mercy killing by the Siksika at Dead Man's Slough not far from Gleichen. The man was buried in a shallow grave covered with stones. In 1886 some settlers discovered the grave and dug the body up. The "skeleton was clothed in a buckskin suit," and "a ball of lead" was still embedded "in the skull."[72] In 1884 members of a marauding band shot and killed a settler named Pollock in southern Alberta and a member of a band apparently of South Peigans from Montana shot and killed a "halfbreed" named Paul. In both cases the Natives were attempting to steal livestock. The offending parties were never caught.[73] In 1887 a cowboy on High River came upon "two Blackfoot Indians killing cattle and ordered them off. They refused to go and pulled their gun on the cowboy, when the latter shot one of them dead and fatally wounded the other."[74]

At the Blackfoot reserve something close to a vigilante killing occurred in 1894. One night a member of the reserve approached the Indian Agent (named Begg) and the Issuer of Rations (named Skinner) for meat for his sick child. When they turned him down he told them that "meat was the only thing that would save his child and if the child died he would return and shoot them." That night the child passed away and the Native appeared at Skinner's shack. "When the issuer opened the door he evidently turned away quickly to escape." Unfortunately, he was "shot in the back of the head, the bullet coming out in the eye." Later the Native was tracked down at Blackfoot Crossing by "a posse" of enraged and trigger-happy citizens led by some Mounties. He was first spotted "armed to the teeth," on a hillside. "Bullets were exchanged from a distance and a lucky shot by one of the posse struck the Indian in the arm and broke it." The wounded man dropped his gun and ran into the bush. The police ordered that "the fugitive was to be taken alive." However, when he reappeared "waving a knife," and "bleeding badly from his wound" someone in the posse "leveled his rifle and shot him dead." The only

repercussion from the incident was that one of the Mounties "had to take the blame and was moved to another district."[75]

Many other incidents of racial bloodletting in Western Canada could be detailed here.[76] The historian is thus bound to acknowledge not only that they happened but that they happened all too often. Of course the reasons behind them were essentially the same as those further south – people of European descent wandered into new frontiers igniting competition for land, which, however plentiful, immediately began to dwindle in a per capita sense. In both cases the problem was also exacerbated by cultural differences. Invaders originally from eastern industrial societies and indigenous hunting and gathering tribes found it more or less impossible to achieve any consistent level of mutual understanding.

Alcohol consumption, prostitution, and gun violence – both inter- and intra-racial – were only a few of the unruly activities in which frontiersmen north and south of the border tended to indulge. There were many others, such as petty theft, rape, and assault, which this study will leave to scholars whose expertise and central interests lie in the legal field.[77] What we have tried to illustrate here is that the conditions of frontier life and the social environment it created dictated that both Montana and Alberta and Assiniboia would have a proclivity for violence of various forms. It seems essential to point out as well that in Western Canada citizen action in law enforcement, though rare, was employed more frequently than has generally been acknowledged. Besides the case mentioned above, there was the time in 1882, for instance, when a man named Bowles refused to help some Macleod cowboys to fight a prairie fire. "After the boys got it out, they went to the creek where he was camped, took him out and hung him."[78] Jim Boyle, born of a ranching family from north of Calgary, remembered years he spent on his grandfather's ranch. "Many people think the Canadian West was tame," he said, "but that wasn't so. A lot of cowboys carried guns." Once "a trail herd came through swinging a wide loop that picked up some of the local ranchers' stock. A posse was formed to retrieve the cattle and when the ranchers returned with their recovered stock they were all missing their ropes. Nobody reported seeing the trail herders again."[79] It was not hard for them to surmise what purpose the ropes had been put to.

Except in the case of Native versus non-Native conflict, no attempt has yet been made to grapple with the question of which society did the better job of dealing with violent behaviour. That issue is far more complex than it may on the surface appear. As has been seen, the population density differed on the two frontiers. Moreover, because

these frontiers were so large, open, and difficult to police, a great number of crimes must have gone unsolved and, as with a number of the episodes mentioned, were never recorded in the surviving court records. Finally, as circumstances in both societies were constantly fluctuating, no single area can be considered to typify the whole ranching community on either side of the line, over an extended period. Ultimately, however, it is the historian's responsibility, whatever the difficulties, to come up with the generalizations that help us to see the societies under study in the clearest light possible. At the conclusion of this work an effort will be made to provide very basic comparisons of the *degree* of crime that occurred on these two frontiers. To do that with any depth we must first turn to one other form of lawbreaking that virtually all livestock men had to deal with on the open range – the plague of rustling.

6
Rustling

The fact that so many men on Western cattle ranching frontiers operated outside the norms of more mature family-oriented societies had major economic implications for the ranching industry. Their value system inevitably led to a great deal of livestock theft. Substantial numbers of cowboys who worked on ranches also turned to stealing because of the seasonal nature of their profession; every year they were unemployed for long intervals. This and their own reckless attitude towards money when they had it left them vulnerable to periodic destitution.[1]

"I never saw so many idle men," James Fergus observed in 1894. "We have two ranches on the public road and have from four to six men every night and all ride. We have to feed them and their horses for nothing."[2] Fergus finally was forced to start charging fees for boarding both riders and horses. This situation of seasonal idleness prevailed in Alberta and Assiniboia, where some of the wandering cowpunchers became squatters on the big leased operations. In 1884 the wife of one of the great ranchers told relatives in Ontario that "a lot of young men" had "fenced in a few acres of land" on her husband's holdings where they lived in quickly constructed log huts with dirt floors. "It seems a hard life for very little return," she commented, "except that it suits the nomadic nature of the men."[3] More than a decade later a report in the *Regina Leader* entitled "How to Manage Tramps" announced that out of work labourers were "the bugbears of the rural districts," and called upon the government to "offer a small reward" for tramps "captured" and give them six weeks' hard work as punishment.[4]

The herds that roamed across the open range with only minimum supervision were a constant temptation for such men. Horses may also originally have enticed them into a life of crime. All the bigger ranches kept extra horses for the round-ups. During the winter and between

round-ups they were left to themselves on the open range and, because they were not being marketed and thus had no direct relationship to regular ranch income, they were watched even less closely than the cattle herds. Furthermore, because horses are very mobile they tended to wander a long way from home and were easy for riders to move quickly over long distances. "There seems to be a gang of horse thieves scattered over Montana, Idaho, Utah and Wyoming who play into each others hands," Granville Stuart wrote in 1891. "We have helped convict about a dozen of them but the supply seems perennial, and in these thinly settled regions where great numbers of horses run the year round upon the ranges," they can be "stolen and driven away," very efficiently. They are a "constant temptation to ex cowboys and others of the reckless, roaming class."[5] Incidents of horses disappearing without a trace were almost commonplace. In 1890 a hundred head belonging to ranchers Story, Dilworth, and Anderson disappeared along the Yellowstone River in Montana.[6] Two years later Nat Maclaren lost a carload of valuable Percheron horses on the range near Cayley, Alberta. Fred Ings suspected that the horses had been taken to a place known as the Robber's Roost by a "rough, tough character who went about armed and opened the door to strangers with a gun in his hand." Ings led the distraught Maclaren there and "sure enough, on the hill close to the [man's] house," were the horses. Ings gathered them up and started them for home. "The occupants of the house could not have missed seeing me," he said, "but likely thought it wiser not to start anything further."[7] Ings, himself, along with Duncan Cameron and John Sullivan, lost a hundred head in the mid-eighties that were never found.[8] There were also regular incidents of cross-border trade in stolen horses. Montana horses "are stolen from ones and twos to whole bands," a letter in the *Husbandman*, stated. They are "taken north and sold in the British country." At the same time, "horses are brought from there and sold here, or taken by boat or rail and sold in the States" further east.[9] The writer was undoubtedly correct. In 1889 one of the newspapers reported that a "gigantic horse stealing industry" was at work along the Missouri River. Stray animals, it said, were rounded up by some members of a particular gang and then turned over to other members, who drove them as far as South Dakota and "the British possessions."[10] Another crime ring was apparently working the other way. That same year a gang consisting of Charles Farrell, William Farrell, and Jeff Pruit were caught in Montana with thirty-nine head of horses marked with the brands of Alberta ranches. It was estimated that these were only a small proportion of the total numbers of Canadian horses these men brought to their ranges. They were arrested by two American lawmen and take to Fort Benton for trial.[11]

Stray horses may have been the temptation that drew men into the rustling trade but rustlers frequently went on to pillage other types of livestock in the course of their careers. As Granville Stuart commented, they "begin by taking" horses and "wind up by taking anything that has not a mar[k] on it."[12] Many horse thieves became cattle rustlers or, indeed, highwaymen, or bank robbers.

Open range ranching also produced mavericks, which were easy prey to cowboys bent on cattle rustling. The term "maverick" loosely referred to any animal that was not branded, or otherwise marked, as the property of a particular owner. There were two types of mavericks. One was the newborn calf. Unbranded calves appeared even after the spring round-up because of the fact that on the open range few ranchers followed the practice of pulling their bulls at certain times of the year in order to prevent out-of-season mating and births. As a result, many calves saw their first light of day in the middle of the summer (between the big round-ups) or in the winter. These calves were a constant enticement to the unemployed cowboy because he could easily kill and sell or eat one without ever having to admit that he knew it belonged to someone else. He could also build up and augment a herd of his own if he so chose by slapping his own brand on mavericks one or two at a time.[13] In a time when the cattle business was conducted with little paperwork, he could argue that he had bought the animals from a migrant settler. Stuart sarcastically recounted: "Near our home ranch we discovered one rancher whose cows invariably had twin calves and frequently triplets, while the range cows in that vicinity were nearly all barren and would persist in hanging around the man's corral, envying his cows and their numerous children and bawling and lamenting their own childless state."[14] There were older mavericks on the open range as well. These were either calves that happened to avoid the round-ups for two or more years in a row and therefore were never branded, or yearlings and more mature animals belonging to smaller operators who were not members of cattle associations and could not register brands with them. Some of these animals inevitably strayed and became fair game for other cattlemen.[15]

The "system" of claiming the right to place a brand "on every calf found unbranded on the range, without even trying to ascertain to whom the animal belonged"[16] was the result of a value that appears to have made its way north from Texas. It started after the civil war when cattlemen began to reclaim the livestock that had been allowed to roam unsupervised on the plains during the chaos. The custom developed that "if you could catch any animal it was yours" and, as prices started to improve after the war, some ranchers sent out, whole teams of men to gather as many of them as possible.[17] This value was

in vogue in Montana from the beginning of the ranching era, and there is no doubt that it spread into the Canadian territories. A pioneer in the area between the Cypress Hills and the international border to the south later remembered that "mavericks were considered the property of the first man to run his brand on their virgin hides."[18] The North West Mounted police, like Granville Stuart, bemoaned the rapid increase of some herds in districts under their jurisdiction and, although they were pretty sure how some of the theft was being carried out, they sometimes felt powerless to do much about it. In 1906 the commanding officer at Lethbridge told his superiors that he was not sure whether or not rustling had increased in the past year, but that he was "inclined to believe it [had], judging from the rapid increase of some of the herds in this district, and from the numerous reports received."[19] The same officer was quite explicit: Since "the cattle rustler rides the ranges with a[n] ... iron strapped to his saddle and generally in stormy weather and picks up calves which have arrived at the age to be easily weaned from their mothers, it is only a work of a few minutes for these experts to rope the calf and drive it to some place where it is held till it would not be claimed by the mother, or recognized by the owner."[20]

The practice of taking mavericks was so firmly embraced that even people who were fresh from Britain and who otherwise preserved the values of their original culture adopted it. Kathleen Lindsay wrote in her memoirs that at her place near Miles City they simply killed and ate strays when opportunities presented themselves: "You were unaware of where it came from or what it was," she said, "just meat, and no questions asked."[21] In a letter of 1883 the Sussex gentleman rancher, Moreton Frewen, stated categorically not only that it was the usual practice on the Powder River Ranch to put his 76 brand on all mavericks but that he was on the point of ordering his men to do so with cattle already marked with the brand of some men he felt had built their own herd on the basis of theft.[22] As time went on even branded animals were not safe because the so-called running iron proliferated across the plains. It was an iron with a short round or straight edge that was most amenable to altering brands. During an 1885 round-up near Macleod a number of cows of the Oxley Ranch were found with the letters QC burned over the Oxley brand. The imposed brand belonged to ranchers Quinn and Campbell of the Porcupine Hills. They both eventually fled to Montana to avoid prosecution.[23]

Although the big ranch owners were inclined to be very self-righteous about the problem of livestock theft, there is no question that they themselves practised it. On the round-ups they would take every unbranded animal they found and, usually without even trying

to identify the owner, would sell it to the highest bidder. They would then turn over the proceeds to their association to defray the costs of range management. They seem to have felt that since they were normally the victims of crime rather than the perpetrators, this was just one way of recouping some of their losses.[24] In 1895 Sergeant A.F.M. Brooke at Calgary observed: "It is the general custom of the large ranchers and ranch associations at the spring and fall round-ups to either brand or sell all stray and unbranded cattle, including calves ... for their own benefit." Brooke believed that at any one time many of the large ranchers thus had cattle "in their possession that legally they [had] no right to."[25] South of the border, there is even a case of the organizers of the round-ups in adjoining districts bickering over how the proceeds of the maverick sales should be divided up.[26]

It is common knowledge that some Canadian Mounties themselves succumbed to the temptation to take unidentified animals.[27] There is actually a case in which police rustling was institutionalized. "There were lots of big Montana steers ranging all over the [Canadian] territories," in the nineties, a pioneer remembered. Occasionally a man working for the Mounties "would drive one up into the bush and kill it." After hanging the four quarters on some trees, he would "make six or eight meat sticks, build a fire and cook some of the heart and liver on the sticks, one at a time." The next day he would lead his Sergeant to the scene of the crime. The Sergeant would take out his report book, and confirm an "Indian" killing by inspecting the meat sticks and the brand on the animal's hide lying nearby. The policemen would then load the hanging quarters on a "buckboard" and "go home – everybody satisfied – and no more salt pork" for a while at the detachment.[28] This cannot be passed off as a rare occurrence. The Montana cowboy Con Price tells us that one summer when he was helping the Mounties patrol the herds along the border they instructed him to "kill all the beef [they] could eat."[29] Law enforcement agents could be at least as fraudulent in Montana, and even federal soldiers were observed on occasion hauling "the hind quarters of a freshly killed beef behind their saddles."[30]

What emerged was not just rustling but a veritable culture of theft. The little men stole from the big and from each other, more or less constantly; the big participated too, presumably with the rationalization that they were working for their collective good; and lawmen who have been immortalized for their efforts to prevent crime also got into the act. It is not surprising, then, that numerous individuals turned professional and made rustling a full-time career.[31] The reminiscences of one Assiniboian frontiersman relate a particularly daring form of rustling that occurred in the 1890s when "dogies," motherless calves,

were regularly being shipped west from Manitoba on the Canadian Pacific Railway. "There was a long, heavy grade west of Gull Lake station" where the train had to slow down to "a walk." Two men "established a camp south of the grade" and "would ride up to the station ... turn their ponies loose [and then] lie around the pumphouse for a doggie train to stop for water." When one arrived they would climb into a car, and once "the train hit the grade they would throw the doggies off, till the train started to speed up, then they would close the door ... jump off and walk down to the gate, get their ponies and gather up the pickings."[32]

By the mid-nineties, policemen who took the fight against rustling seriously, complained about their inability to gain the upper hand. "This is an enormous territory to watch," Commissioner Herchmer complained in 1896 while lamenting the amount of livestock theft going on.[33] One year later he noted: "We have endeavoured, with our greatly reduced strength, to patrol the country as usual, and while we have been successful in arresting many cattle thieves and other delinquents, advantage has been taken, of our inability to keep up as frequent patrols as formerly, by cattle thieves and others to follow their unlawful calling."[34] The commissioner and his subordinates believed that rustling was part of a growing trend towards crime in general. "The detailed list ... has been forwarded," the commanding officer at the Moosomin sub-division reported on 26 November 1899. "It is a rather long one, including many different kinds of offences."[35] A year later his equal at Regina repeated those sentiments.[36]

As rustling grew to new heights it induced extreme frustration among the Canadian ranchers and, as we have seen, in at least one instance it induced a lynching.[37] Citizen action did not always end in violence. In 1882 a cowboy riding in the dry forks of the Kootenay River came upon some Stoneys butchering a beef. He rode into Pincher Creek where a posse was formed under John Herron, an ex-Mountie. The Stoneys were rounded up, taken to Fort Macleod and turned over to the authorities. Some of them were sentenced to two years in jail.[38] When rustling increased dramatically some fourteen years later in Western Assiniboia, ranchers there clearly considered turning to vigilante justice. A letter to the *Regina Leader* in 1896 described a case in which a man named George Brewster was convicted for stealing over fifty head of cattle from one owner. "A great deal of stock has been stolen in this district during the last few years," the rancher stated, "but up to the present time sufficient evidence had not been secured to convict, or even to connect anyone to the thefts. In consequence of these thefts and the seeming inability of the 'law' to cope with them there ... now

are, I believe, steps being taken to form a 'Stock Association,' which will ... protect its members and punish thieves."[39]

In Montana rising rates of rangeland crime almost invariably induced vigilante activity. In the gold mining communities of the early sixties such vigilantes apparently achieved their aims. According to one eyewitness it was soon afterward "that peace and security came to the people, and a lock was seldom found on a door, for robbery became almost unknown."[40] If that is true, the effects certainly wore off before long. As the big ranching era opened in the eighties, cattlemen felt that livestock theft was a major threat to their entire industry and they formed two stock associations in part to deal with it. In 1885 the two associations amalgamated specifically "to advance the interests of the Stock Growers in Montana and adjoining Territories and for the protection of the same against frauds and swindles and ... the stealing, taking and driving away of cattle, horses, mules and asses from the rightful owners."[41] Shortly thereafter the Board of Livestock Commissioners "agreed to employ a man in each county as a detective whose duty it would be to track up rustlers and horse thieves"[42] and to inspect brands on cattle shipments out of the state at the railhead in St Paul, and the stockyards at Chicago and Omaha.[43] The board imposed an "inspection and detective tax" on all the cattlemen in their various districts to pay for the service.[44] The impact of these measures was disappointing, however, and in 1884 Granville Stuart and Andrew Fletcher organized a group of ranchers, often referred to as "Stuart's Stranglers," to take more decisive action. They shot and hanged many of the known and suspected rustlers primarily along the Musselshell and Missouri Rivers.[45]

This clean-up made an impression on crime rates for several years. Many cowboys condemned the vigilante action, but Deputy Marshal Sam Fischel took part in it and ranch owners gave Stuart their blessing. "We cannot forget the services he ... and others rendered the stock interest by risking there [sic] lives against great odds to rid our country of organized bands of horse and cattle thieves," the knowledgeable and respected James Fergus commented in 1887. They "made it possible for ... all the rest of us to keep cattle in this part of Montana."[46] Unfortunately the action did not put a stop to rustling forever. By the end of the eighties the frontier form of ranching had pretty much come to an end in two-thirds to three-quarters of the state as rangelands were fenced off and cattlemen moved towards mixed farming. Then the open range system was confined mostly to north of the Missouri River and east along the Yellowstone.[47] As rustling plagued those areas, ranchers again showed a willingness to get involved. In most

cases they seem to have worked directly with regular lawmen. They rounded up suspected criminals and turned them over to officials to be jailed and tried in the courts.[48] However, in a few cases at least, they acted on their own. When a gang from northern Idaho was preying on the herds in 1891, some ranchers who had become disillusioned with legally sanctioned measures hunted down, tried, and executed suspects. Stuart gave them his blessing: "We here in the West have to occasionally take matters into our own hands," he wrote, "because of the many failures of justice, owing to the sympathies of some jurors [and] legal technicalities as to evidence, jurisdiction,"[49] and so on.

Eventually, once they had understood that they had consistently to work together, regular lawmen on both sides of the border played central roles in curtailing livestock theft.[50] Cooperation started early in part because the Canadian Mounties initially received their provisions from Fort Benton in Montana, and were thus constantly aware of the challenges they shared with American authorities. A former Chouteau County sheriff recalled in his autobiography that officials "on both sides of the border helped one another in controlling crimes such as murder, cattle and horse stealing, and locating all kinds of wrong doers." In his mind there seems to have been very little difference in the amount of disorder they faced. "Not only was there a lot of crime among the Indians and breeds, but the white men as well ... The lawmen on our side as well as the Northwest Mounted Police had their hands full. We helped locate 'wanted' men on both sides."[51]

The first significant example of cross-border cooperation came as early as 1881 when professional crime-fighters joined with a few ranchers, a hired stock detective, and the leaders of a Native band in Montana to curtail Native trafficking. There were a number of tribes located adjacent to, or in the heart of, ranching areas on both sides of the border. In the south the Crow, Cheyenne, Peigan, Cree, Blackfeet, and Flathead were the dominant tribes, as were the Siksika, Blood, Peigan, Sarcee, Stoney, Cree, and Saulteaux in the north. Knowing that the tribes had ready access to their animals on the open range, the ranchers often blamed them for stealing and killing cattle.[52] The Natives were undoubtedly wrongly accused at times, but particularly when the winters were long and buffalo scarce, they do seem to have taken livestock to survive.[53] In the late seventies and early eighties it was common knowledge in Montana that there was a problem with Canadian or "British" tribes crossing the border and making raids on American livestock and then smuggling their take back to the Territories where they were out of reach to American authorities.[54] In August 1881 a Canadian band raided the Yellowstone region, driving off some

Montana Peigans dancing

twenty-five head of "good American horses" belonging to ranchers Brown, Harrison, and Murray. Sheriff Healy and a detective named Harris went north and found two of their horses on the Siksika reservation, "right under the nose at the agency and directly under the eye of the agent." The sheriff captured a man named Bad Bull, a Blood, "and brought him back to Benton in Irons." Harris, accompanied by the Peigan Chief, White Calf, and seven "warriors," continued the journey north to Fort Macleod and in conjunction with the Mounties captured seven more Natives. They were tried in Canada and found guilty. Harris and his Peigan helpers also recovered another twenty-five horses that had been stolen at various times and took them back to their original owners.[55]

From the mid-eighties to the early nineties the Montanan and Canadian authorities worked primarily on their own problems as if the two frontiers were totally separate. However, it was widely recognized that rustlers had little respect for political boundaries. After Stuart's Stranglers began to take matters into their own hands in 1884[56] an article entitled "Horse Stealing" in the *Macleod Gazette* contended that it had become "too hot in Montana for horse thieves so many [had] headed north."[57] Stuart's campaign must have had a dampening effect on rustling in Canada too, as it became quite clear that ill-gotten gains could no longer be driven across the line with impunity. A few months later the same newspaper reported that two southern Albertans – one a renegade North West Mounted Police constable – were arrested in Montana with stolen Canadian horses. In the process of being transported to Fort

Benton for trial they were intercepted by a party of cowboys. After "very few preliminaries," they were "taken to the nearest tree" and sent on "the hemp line route to the great hereafter."[58]

Authorities only began to make a real impression on rustling, however, when the open range system itself was approaching its end, even in the region stretching from the plains of northern and eastern Montana to the remotest eastern regions of southern Alberta and on into Assiniboia.[59] Unquestionably, a good percentage of the thieves on both sides were Americans. Rising crime rates in the nineties were in part a sort of chain reaction to events in Wyoming. Many of the victims of the range wars down there fled to the ranges of Montana where outlaws amongst them resumed a life of crime. However, Canada also supplied a considerable number of the "bad" guys – some of the very worst. Henry Ieuch, or Dutch Henry as he was more often known, started his illustrious career in the vicinity of Muddy Lake and Wood Mountain on the Canadian side, though he regularly alternated his residence between there and Valley County. Around the turn of the century Henry and his followers joined forces with the Nelson-Jones gang, which was well established in the same criminal business and had a particularly large Canadian leadership. Frank "Slim" or "Left-handed" Jones himself is supposed to have got his start as an outlaw in the Wood Mountain district when he stole thirty head of horses from a farmer who refused to pay him past due wages. He is said to have "used his gun often" in the course of his violent career.[60] His partner, Charley "Red" Nelson, was described by a Glasgow Montana newspaper in the late nineties as a "tall red-headed Irishman recently from Canada." Apparently he had come west from Nova Scotia.[61] Frank Carlyle who also played a leading role in the gang, originally left Toronto to join the North West Mounted Police. He was discharged from the force for fighting and other offences.[62] A man known as Kid Trailer, who was born in England and immigrated to Canada, joined the outlaws about 1903.[63] Finally, Alec McKenzie, formerly of Prince Edward Island, arrived in the Glasgow-Culbertson area of Montana some time in the nineties and became Dutch Henry's friend. McKenzie is credited for murdering his friend in 1905 over a few dollars.[64]

The Dutch Henry–Nelson-Jones connection was not responsible for all the illicit cross-border trade that occurred in this period. Valley County and the Wood Mountain and Big Muddy regions were considered to be the most lawless and crooked anywhere, and the Big Muddy was thought to be the worst part. Its broad valley begins near Willow Bunch in present-day Saskatchewan and runs south, entering Montana near Regway. The area was a haven for rustlers. It was open range at a time when that kind of country was rapidly disappearing

and it contains badlands with "rugged sandstone buttes, sheer cliffs, and rough-hewn hogbacks." These "made a perfect hideout for road agents [and] horse thieves."[65] The Mounties in particular recorded case after case of the depredations of individual outlaws.[66] In 1893 an Assiniboian rancher gave public airing to his frustrations with this situation in the *Regina Leader*. "Probably never before in the annals of this country," he ranted, "has there been so much horse thieving ... as there has been this year. Formerly the nefarious business was carried on in a rather underhand way, but this spring it has ... boomed ... Things have reached such a climax that to possess a stray horse is about on an equality with possessing a dead one."[67]

The regular lawmen from both sides were thus forced to work together, as numerous examples illustrate. In 1889 Sheriff O'Neal in Montana was notified by Canadian officials that Charles Farrell and one or two other men had been stealing horses "over the Canadian line," and taking them to Montana. O'Neal and a stock inspector located the men on the Marias River with thirty-nine head of Canadian horses and took them to Fort Benton for trial.[68] In 1898 the Mounties at Regina were asked by a Montana sheriff to look out for a thief called Stowell, who had headed north with a band of stolen horses. On investigation Corporal Purvis discovered that seven of the horses had been sold to a local rancher. He then helped the Americans piece together enough information to trace Stowell all the way to Princeton, Iowa, where he was captured.[69] When a man named Smith was suspected of stealing cattle and conducting cross border trade in 1901, Sergeant Burton Deane of the Mounties went down to Montana and helped work up a case against him in Great Falls that got him sentenced to a year in jail.[70] While in Montana Deane also helped present a case against a rustler named De Wolf that put him behind bars for ten years.[71]

This type of cooperation was effective. However, initially it did little to stem the overall flow of stolen merchandise. "The number of cases of horse stealing, and convictions ... have been larger than in any previous year," the annual report for the Regina detachment stated in 1902: "This particular crime is no doubt on the increase to a very large extent, [and seems not to have] reached the limit."[72] By then the Dutch Henry and Nelson-Jones gangs were almost certainly the main offenders. Henry is supposed to have started his operation about 1894. In that year he owned four head of cattle and four horses, which, in part by pillaging from his employer, Pascal Bonneau, who owned the biggest operation in Big Muddy, he soon turned into a significant herd of 400. Henry's specialty was trading stolen livestock around Assiniboia, Montana, the Dakotas, Wyoming, and Minnesota.

When Henry and his followers merged with the Nelson-Jones gang, they constituted a formidable force. On 22 June 1900 the *Macleod Gazette* reported that Jones and Nelson alone had "stolen over 300 head of horses and thousands of cattle from the northern [Montana] ranges, all of which were driven into Canada and disposed of."[73] The gang was eventually put out of business by the combined efforts of the Mounties, a particularly dedicated Valley County sheriff named Cosner and a force of special deputies he put together for the purpose, one or two detectives hired by the Montana Stock Growers Association, and local ranchers on both sides of the border. Some of the outlaws were also eliminated as a result of quarrelling or duplicity within the group. The Mounties deserve due credit for the gang's eventual demise, but no more than the other agents, both *ex-officio* and otherwise, with whom they worked. Indeed, they were sometimes made to look rather foolish when animals were stolen from pastures close to their detachments.[74] On one occasion some of their own horses were taken from their ranch as a mocking gesture and then left in a pasture only a few miles away.[75] The Mounties were able to arrest only three of the outlaws and bring them to trial in Canada. Five were arrested in Montana or other states, several were eventually shot by American lawmen, two were shot by other outlaws, and three fled the area before they could be caught. The fight was protracted and difficult. It was not really won until the final years of the first decade of the twentieth century.[76] By that time settlement was progressing rapidly on both sides of the border, and fences had greatly reduced the open range that both *bona fide* ranchers and rustlers needed for their operations.[77]

Obviously, the members of the Dutch Henry–Nelson-Jones connections and a host of freelance desperados over the years survived as long as they did in part because they were able to complicate law enforcement for both Canadian and American authorities by smuggling their booty across the international border. The smuggling game was also played by supposedly more "respectable" cattlemen largely as a means of gaining free access to Canadian ranges. Evidence suggests that these cattlemen were also involved in theft.

Since the Americans overstocked and overgrazed their ranges from an early date some of their cattle were naturally inclined to wander across the border. Canadian cattlemen saw this wandering as a real threat because of the danger that their own pastures would become inundated and because of the potential this allowed the Americans of making off with cattle that did not belong to them at round-up time. The Canadian ranchers and the Mounties made great efforts to keep the southern herds out,[78] but the long unfenced border was difficult to patrol properly and they were only partially successful. Customs

officials consequently felt compelled at times to take drastic measures such as seizing American cattle and selling them in lieu of unpaid duties. These actions caused hard feelings in Montana to the point where some ranchers believed that Canadian authorities had themselves acted fraudulently. As the "customs officers of the North West Territory were paid a proportion of the sales of all seizures," someone argued at a meeting of the Montana Stock Growers Association in 1887, "they even crossed the line to the American side and drove cattle across to the British side and then seized them."[79]

Eventually, however, cooler tempers seem to have prevailed and a number of American cattlemen began cooperating with their northern neighbours to keep their herds apart.[80] However, some big operations actually smuggled livestock across the border primarily as a means of cheating the Canadian customs service. Usually the outfit involved set up operations in northern Montana and then attained a lease directly across the border. Each spring the owners would drive a proportionately small number of cattle north to stock the lease, declare them at the border, and pay the import duties on them. They would then drive much larger numbers across without notifying customs. They would turn these cattle loose on the Canadian range, where they became indistinguishable from the cattle that had been brought in legally. This posed a problem for the Mounties. Even when they could see that there were more cattle on a particular ranch than there should have been, it was difficult to lay charges because they could not be sure that the animals had not simply strayed in on their own accord.

Thus, before the turn of the century a lot of Montana stock was gaining free access to Canadian grasslands and, in areas where the open range still prevailed, they could wander widely and help to deplete the grass supply far beyond the parimeters of their owner's lease. In 1902 Sergeant Deane, then the commanding officer at Maple Creek, finally decided something had to be done and he hired a crew of cowboys to round up all the cattle they could find carrying brands of the brothers Samuel and John Spencer, who were thought to be the worst of the offenders. Deane considered the Spencers wealthy American ranchers but in fact they had originally come from Middlesex County, Ontario. Sam had arrived in Montana in 1879. Some two years later he located a big spread on the Marias River there and then, near the turn of the century, he took out a lease along the Milk River north of the border.[81] After weeks of work Deane and his crew were able to identify 587 animals that because of age or brand could not have been among those the ranch had previously declared at customs. The Spencers were initially fined $10,000. If Deane is to be believed, this fine was very generous to them. The Spencer brothers, however,

by complaining to officials in Ottawa with whom they had considerable influence, were able to recover a substantial portion of the fine. Following the Spencers' example a number of ranches apparently adopted similar frauds. Deane believed that the other principal tax evader was the Circle Ranch owned by the Conrad brothers but he seems to have been suspicious of all the outfits that at any time worked cattle back and forth across the border, such as the Bloom, Pioneer, N bar N, Cresswell, and Matador ranchers.

Rustling was clearly an immense problem for the ranchers in both Alberta and Assiniboia and Montana. The major difference between the areas appears to be that the Canadians did not at any time experience anything as brutal as the work of Stuart's Stranglers and others. One might argue that they also did not produce anything as effective in resisting rangeland crime. Montana lawmen had to face two disadvantages in comparison to those further north: the difference in population and the fact that the state was unfortunate enough to border Wyoming. Not only did the state have its own homegrown criminals but it was also inundated by numerous outlaws fleeing the defenders of the ranges to the south. All such men were capable of wreaking true havoc on the cattle business of the entire plains. Granville Stuart himself tells the story of a "Scotch half-breed" named Sam McKenzie, who stole horses in Montana in the early eighties, "drove them across the line ... sold them, then stole horses up there and brought them back." On 3 July 1884 a band of cowboys caught him near Fort Maginnis, and "that night he was hanged from a cottonwood tree."[82] If the Montana cattlemen had not adopted extreme measures to stop them, thieves might well have affected both the American and Canadian industries even more severely. It seems not unlikely that such direct action could ultimately have inspired a good deal of citizen law enforcement north of the forty-ninth parallel too.

It would seem appropriate to conclude the discussion of rustling on these two frontiers with the reservation that respect for law and order was not totally lacking. While cases can easily be found of cattlemen and cowpunchers stealing the product of their industry from each other, cattlemen also exerted strenuous efforts beyond their involvement in citizen action, to instill respect for property among their peers. Riders who patrolled the herds of their ranches in part to discourage rustling were known to be fiercely loyal.[83] Many were prepared to risk life and limb to protect their employers' livestock from predators or any other type of harm.[84] Moreover, when round-ups were organized in particular districts, representatives or "reps" from ranches in neighbouring

districts were usually invited to participate in order to pick up properly branded animals and return them to their rightful owners.[84] Ranchers also sometimes took it upon themselves to reimburse the owners of strays found grazing with their herds.[85] This chapter and the previous one have tried to illustrate not that everyone constantly broke the law but simply that a cavalier attitude towards legal constraints was a prominent feature of the frontier ethos and that this was true on both sides of the international border.

7
*Rangeland Entertainment**

No study of cowboy and rancher culture would be complete without an examination of the activities to which the cattlemen turned in order to fill their leisure hours. Since we have already looked at the "coarser" pastimes, such as drinking, gambling, looking for sex, and law-breaking, attention is now due to the "finer" ones such as singing, dancing, story-telling, and athletics.

Although many of the cowboys' entertainments of choice originated centuries earlier in England, Ireland, or Scotland, all of them reflected in some way the social and natural environments the men who worked the herds regularly confronted. Since those environments were strikingly similar on both sides of the forty-ninth parallel, attempts by Canadian historians to find something unique about their ranch hands look somewhat overstated. The following is one of the best known examples:

The newly arrived cowboys were usually American, frequently young, and often lean and tough. And when they came, they not only brought cattle and horses with them, but also customs and traditions that could sometimes be traced back to Old Mexico and Spain. Yet within a short time, these men absorbed some of the uniqueness of the Canadian prairies and its people, thus creating a new breed of men – the Canadian cowboy. They were much like their counterparts in many respects, yet they could not help but be affected by Canada's land leasing and marketing methods, the presence of British mores and values, and the West's unique system of law and order.[1]

They had the American "savvy" when it came to handling cattle but they also learned to cope with unique situations such as blizzards at calving time, and with clothing and horse gear adapted to meet Canadian conditions.

* Thanks to Anthony Thomas Worman for vital information in this chapter.

They watched polo being played at gymkhanas, saw red-coated Mounted Police enforcing the law, and tried to keep up with the West's changing but always conservative liquor laws. They were cowboys through and through, but they were Canadian cowboys.[2]

Most of these supposedly unique features can be waved away with a stroke. British mores and values were at least as strong in Montana as in southern Alberta; polo and gymkhanas were enjoyed frequently in that state, too, along with other cultural activities such as the hunt, the theatre, and the opera. And beyond any doubt cattlemen from the American North West had to "cope with *unique* situations such as blizzards at calving time, and to use clothing and horse gear adapted to meet" climatic conditions in the northwest. Law and order may have been somewhat more systematically imposed north of the border, making range wars and, for most of the time, lynching unnecessary. But, at the height of the open range system, it could not be said to have subdued to any considerable degree the universal activities of single young males, such as drinking, whoring, fighting, and most of all cattle rustling.

Moreover, if, in the following statement, we were to replace "Ontario farm boys" with "easterners" and "English" with "British" (making it more relevant for both societies), it could equally well be used to describe Montana cattlemen.

As the years passed, the ... cowboys became a mixture of American westerners, Ontario farm boys, English immigrants, and boys born on the western frontier. They included Anglos, blacks, Mexicans, Indians, halfbreeds, and men from every social class on the continent. But their teachers and their role models were the cowboys who had learned their trade in Texas, Wyoming, and other centers of America's ranching West.[3]

One would be wise to keep in mind as well that there was a not inconsiderable Canadian element in Montana and vice versa.

When turning from lifestyle in general to popular entertainment culture in particular, the difference between the young men in these two societies is obscured further. Both frontier groups designed, developed, and participated in leisure activities under the heavy influence of the following six frontier circumstances: (1) a scarcity of women; (2) seasonal unemployment; (3) youth combined with the rugged kind of occupation that encouraged a tough, macho image; (4) the weakness of moderating institutions such as the law and the family; (5) the cold northern climate; and (6) the isolation and the dreariness of everyday life.

The relevance of the first five conditions will be obvious as this discussion proceeds. The last one, however, requires some detailed

explanation. In many ways the forms of entertainment that cowboys typically embraced arose from the lonely and isolated nature of their existence. Their loneliness was a much more severe affliction than one might expect. Even when they were together driving or rounding up livestock, the cattlemen were away from towns or cities for long periods of time. As well as lacking female company, they missed pursuits that occupied their leisure when they came in off the range. Moreover, a great deal of the work was incredibly dull. Trail drives can have sporadic action, when things go wrong and the animals threaten to – or actually do – stampede. However, more common are the long stretches when the men just ride along hour after hour pushing the herd very slowly over no more than seven or eight miles a day. Each man normally stays with a particular section of the herd and the hours can drag on mercilessly.

Round-ups of course also had their exciting moments. As the ranchers worked their way across the open range over the course of a few weeks, the men who scoured the countryside each morning to gather up animals so that the calves could be branded and castrated and the fat steers separated out for marketing often had some hard riding to do. After months in the wilderness the cattle were usually only semi-domesticated and would commonly take off the instant they sighted human beings. The cowboys had to chase them at high speeds over difficult terrain.[4] And branding and castrating the calves was anything but boring. The animals had first to be cut out of the daily gathering by topnotch riders and very fast, well-trained cutting horses. Then they had to be roped one at a time and dragged by equally skilled horse-and-rider teams over to a fire where the necessary operations were performed.

The ropers, spurring and checking the fierce little horses, drag the calves up so quickly that a dozen men can hardly hold them; the men with the irons, blackened with soot, run to and fro; the calf-wrestlers, grimy with blood, dust, and sweat, work like beavers; while with the voice of a stentor the tallyman shouts out the number and sex of each calf. The dust rises in clouds, and the shouts, cheers, curses, and laughter of the men unite with the lowing of the cows and the frantic bleating of the roped calves.[5]

However, two of the jobs most of the men were assigned at some point on the round-ups were far less interesting. One was wrangling or looking after the mounts. Horses tend to wear out if worked excessively and so it was usual for each outfit to take between five and ten horses per cowboy to the big gatherings. A major ranch with say 10,000 cattle would normally send out ten men and up to a hundred horses; a round-up with several large ranches might have to take along

The Roundup

some four hundred.[6] Wranglers specialized in looking after them. They worked in shifts to hold the animals together each day, all day (and night), moving them around from time to time to keep them standing in fresh, unsullied grass and to make sure they were available whenever riders needed fresh mounts. This work was tedious, particularly during the long night hours when the horses and the other cowpunchers slept.

Equally uneventful for much of the time was the job of looking after the cattle in the "day herd." Each afternoon when the branding and other operations were done most of the cattle that had been rounded up that day were turned loose again to resume life on the range. However, certain ones were pulled out from the rest to be kept together like the horses. These were: the cattle that had strayed in from distant ranges and needed to be returned to their original owners; the fat steers that were to be marketed; and the cows and bulls that had to be culled because they were old, unproductive, or of dubious quality. On a long round-up covering some 200 square miles, the day herd could grow to 1,500 head and the cowboys had to take turns looking after it.[7] While a stampede might well break the tedium at least once during the weeks of the round-up, most days were humdrum and the long, uninterrupted hours spent largely just watching the stock could be incredibly dreary. Indeed, at night some of the least committed riders were known to slip off to a quiet place away from the herd to catch some sleep.[8] Of course rain and other forms of bad weather made the hours seem even longer.

If cowboys suffered from isolation and boredom on the trail or during round-ups, their long winters could be even more trying. While the big ranches laid-off workers after the fall round-up, they liked to

keep the best of their workers around because "good hands were scarce," and they preferred riders who "knew their range and brands," to run the herds again when the busy times returned.[9] Therefore, they often gave some skilled men a place to live when there was no gainful employment and supplied them with food. Normally the place to live was a bunkhouse or line shack where they would just hang out, so to speak, for months. The men had to live "without pay," there being "no work of any kind," and so were for the most part unable to engage in barroom activities and other forms of entertainment in any nearby towns.[10] If there was something around the bunkhouse to read, literate cowboys would end up reading it all, and sometimes over and over again, no matter how old or obscure it was.[11] Generally speaking, however, the ranch library was extremely limited – "a saddle catalog, maybe a back number *Police Gazette*, sometimes a well worn novel"[12] or perhaps "fragments of old newspapers from widely scattered localities and vintages."[13]

For the most part, therefore, the men were left to their own devices to fill the time. "There wasn't anything to do except talk and the talk soon ran out. We told each other everything we knew in a week."[14] Some would undertake odd jobs such as making pieces of equipment like hackamores or ropes, but these tasks could not possibly use up their full time all winter.[15] Some would also ride out occasionally to check on the cattle, though this was rather pointless since even if the animals were starving there was not much that could be done for them. "They didn't feed hay ... in the early days of the open range; and in fact you couldn't have fed them even if you'd had the hay, because they scattered so." The men also went hunting in order to bring variety to their diet. That helped, but only to a point. "For a while we'd go out and kill deer for meat, and that was something to pass the time. Over in those hills there were so many tracks, you'd think it was sheep. It was deer, hundreds of them. We ate them until we couldn't look at a piece of deer meat anymore ... So after that it was nothing but sowbelly and beans, three times a day."[16]

Boredom could only be tempered, not eradicated. The problem was so severe that some men were actually known to lose their minds, particularly in cases where they were left on their own with no companionship at all. There was a "fellow down in Texas who was stuck out in a horse camp by himself all winter, and when they went and hunted him up in the spring, they found he had his hat and coat draped on a stump and was shooting at it. He said: 'I'm going to get the son of a bitch before he gets me.'"[17]

The need to counteract monotony and dreariness, whether during drives, round-ups, or periods of unemployment was one of the major

Montana night-herder catching some sleep

motivators of virtually all forms of country and Western entertainment. When cowboys guarded livestock at night they sang because they felt it calmed the animals down and made them less likely to stampede. "The singing was supposed to soothe them and it did," a cowboy recalled. "I don't know why unless it was that a sound they was used to would keep them from spooking at other noises."[18] They also sang to pass the long hours when the cattle and the day riders were sleeping,[19] and, undoubtedly to practise for entertaining their friends when they were back on regular duty and all sitting around the fire at the end of a day. Some of the men also relied on singing when they were holed up on one of the ranches in winter. Teddy Blue Abbott was a singer and at the Musselshell camp during the winter of 1884–85 he used up his repertoire all too quickly. "I knew about ten songs," he said, "and I sung them until everybody was sick of them."[20]

Some songs, such as "The Cowboy's Lament" (derived from an Irish song), "When I Was on Horseback," "O Bury Me Not on the Lone Prairie," or "The Little Black Bull," were well known.[21] Refrains such as "Whoopee Ti Yi Yo, git along little doggies, it's your misfortune and none of my own / Whoopee Ti Yi Yo, git along little doggies for you know Wyoming (or Montana, or Alberta) will be your new

home," were repeated over and over again. Some of the songs were improvised and might contain "anything that came into your head."[22] Abbot sang all the old favourites but he seems to have been particularly proud of his own "Forty Years a Cowpuncher." The song eulogizes the life and adventures of a working cowboy and has a chorus designed to encourage the audience to join in.[23] Most American songs made their way up to Canada, and some came from there. The earliest version of "Blood on the Saddle" was composed at the Cochrane Ranch in 1905 and "The Red River Valley" appears to have originated in Manitoba during the first Riel Rebellion.[24]

The themes of cowboys' songs related to all aspects of their lives. Among these, boredom and man's difficult struggle in a harsh environment were mainstays:

> The cowboy's life is a dreary old life,
> All out in the sleet and snow.
> When winter time comes, he begins to think
> Where his summer wages go.[25]

A theme that dominated many songs was tragedy. "Cowboys used to love to sing about people dying," one old-timer recalled, "I don't know why. I guess it was because they was so full of life themselves."[26] Perhaps it was more because it helped them deal with some of the frightening aspects of their profession. Death was an ever-present companion to the average cowboy. Men were thrown by half-broke horses, drowned trying to cross swollen rivers, lost in winter storms, or fatally wounded in barroom battles.[27] Perhaps the greatest threat, however, was the stampede. Men who night-herded on trail drives or round-ups lived in constant dread of stampedes because they were both extraordinarily dramatic and life-threatening. In the still of the night any sudden noise, such as a sleeping cowboy falling off his horse or a tree falling in the distance or a gun inadvertently fired – or even a coyote or wolf howling – could set the cattle off.[28] A handful of them would suddenly come alive and begin to mill around. In a few minutes their fear would sweep through the entire herd as they became agitated by the sound of their own movements. Suddenly they would begin to run to and fro. They would bolt one way and then another. At such times the cowboys were overtaken with a sense of their own inadequacy. The only hope they had of stopping the cattle was to race in front of the leaders and attempt to turn them in a circle, back to their original position. In the dark this was often futile and always incredibly dangerous. If a rider's horse tripped over a stump or a fallen tree or a cut bank, he could be trampled by a sea of terror-stricken beasts.

Like a Flash They Turned

One Montanan recalled that on virtually every major round-up in his district at least one cowboy died.[29] Teddy Blue Abbott was in two stampedes during his career. In one, his mount "stumbled over a little bank about a foot high" and fell on him. As he lay there unable to move, the "swing of the herd come around," and nearly trampled him to death. He "broke a couple of ribs" and badly injured his hand.[30]

It is no coincidence that many songs that were composed and sung during the long periods of monotony between these occurrences vented the ranch hands' anxieties about stampedes.

> That very night this cowboy went on guard.
> The night, it was dark and 'twas storming very hard.
> The cattle got frightened and rushed in mad stampede.
> He tried to check them, riding at full speed;
> Riding in the darkness loud he did shout,
> Doing his utmost to turn the herd about.
> His saddle horse stumbled, on him did fall;
> He'll not see his mother when work's all done this fall.[31]

While many of the songs told of life on trail drives and round-ups, others were set in the saloons and whorehouses of the frontier towns. And because they were meant for young, male audiences lots of them were nothing if not risqué. As one old hand told the famous folk-song collector John Lomax, "in singing about camp, a cowboy would often cut loose with a song too vile to repeat; great cheers and hurrays would

usually follow and there would be calls for more."[32] One such song ends: "She's a dancing young beauty; she's a rose in full bloom, and she fucks for five dollars in the Red Light Saloon." [33] A ditty entitled "All Night Long" had a number of alternate titles including "Four Old Whores," "Five Women in Canada," "Three Whores from Canada," or "Four Old Whores from Mexico," depending on the geographic location in which it was sung. The song appears to be an adaptation of "A Talk of Ten Wives on Their Husbands' Ware," the original manuscript version of which was written in Britain in 1460. It may be the oldest surviving erotic song in the English language. The women in the lyrics drink and brag about the size of their sex organs. "The first one said hers was as big as all the moon. Two cowboys rode in in March and didn't come out till June."[34]

Less musically inclined cowboys who wanted to be artistic would wile away time on the range or in the bunkhouses memorizing or composing verses.[35] They brought to life the vast range of country poetry which has been passed down from generation to generation and constantly augmented ever since. While it too naturally tended to glorify men who were "slow of speech, but quick of hand, and keen and true of eye ... wise in the learning of nature's school – the open earth and sky," some of it also dwelt on common emotions about, for instance, "the peril of hoof and horn at the head of the night stampede."[36] Songs and poetry both rapidly became a prominent feature of cowboy culture and they travelled with the men once their lonely stints on the range or in the bunkhouses ended. One of the reasons they remained so popular was that in celebrating the cattleman's life they helped the cowboy achieve the high self-image he had been searching for when he originally headed west. "While cowpunchers were common men without education," one of them once said, "they set themselves way above other people who, the chances are, were no more common and uneducated than themselves."[37]

In keeping with their appreciation of Western entertainments the men who rode the range were also inclined to turn up at country dances whenever they were held. In the southern states, halls built before the civil war were commonly used, but in both Montana and Western Canada one of the bigger ranch houses or a barn or sometimes a newly constructed hotel seems to have been the more common staging ground.[38] The dances were typically held when a round-up passed close by one of the frontier towns. "The cowboy balls ... are always great events ... where they take place," Teddy Roosevelt informed his readers. "Everybody round about comes in for them. They are almost always conducted with great decorum ... There is usually some master of the ceremonies, chosen with due regard to

brawn as well as brain. He calls off the figures of the square dances so that even the inexperienced may get through them, and incidentally preserve order."[39] Perhaps to do this the caller had first to explain some of his terminology. "S'lute yer pardners! Let 'er go! Balance all an' do-ce-do!"[40]

Country dances were also held to mark special occasions. In 1884 "Buck" Smith built the first "stopping-house" at High River, Alberta, and the following January he celebrated with a party. No fewer than 150 ranchers and cowboys showed up. A cowboy named John (probably John Ware) "astonished the assemblage with such pronounced knowledge of parlor tricks that he was made the official 'caller-off.'"[41] Sometimes the shortage of women was so bad that these affairs were labelled "stag dances." This has augmented suspicions that homosexuality at times crept into the cowboy lifestyle. "There were no maidens to add the feminine charm," wrote an observer of one American dance in 1885, but "a number of the bovine guardians agreed to don the female attire."[42] A cattleman remembered a drunken ball at which two of his drovers danced together happily all night. "She ain't much for pretty," one of them said of the other, "but she's hell for active on the floor – so dod-burned active couldn't tell whether she was waltzin' or tryin' to throw me side-holts."[43]

Storytelling was another favourite way of whiling away the time on the open range. A lot of cowboys loved to tell yarns, many of which were based on real life adventures they or their friends had experienced. Teddy Blue Abbott was known to be a storyteller as well as a singer and many a time he amused his fellow cowpunchers with both. His friends "would all be standing around in a saloon, or they might be in a round up camp by the fire," and he "would start in" like he "was going to give them a recitation." He would first tell a short story to set the background and finally break into song.[44] Charlie Russell liked to tell stories and commit them to memory. "All his cowboy acquaintances remembered him modeling and sketching and talking and listening, storing up the impressions that would stock his art and his writing" in later years. He began publishing his stories after Nancy Cooper married him and essentially became his business manager in 1896. The first was "Early Days on the Buffalo Range," which appeared in the April 1897 issue of *Recreation*. Later, others were published in the sportsmen's journal *Outing* and in three volumes entitled *Rawhide Rawlins*, *More Rawhide*, and *Trails Plowed Under*.[45]

A lot of the tales cowboys told each other described the silly and sometimes rather cruel things they did on drinking sprees. Many, including the following, are still being retold. One night John Thompson and his friends from a round-up camp "spent too much time at the bar" in

one of the Montana towns. "As they went to the hitching rack to get their horses," planning to head back to camp, "John spotted a group of Indian teepees at the 'half-breed encampment' near town. This encampment was known to be one of the toughest places in the country."

Suddenly wanting to have a "little ornery fun," John "began roping the teepees and dragging them away." Somehow he lost his equilibrium and "wound up with his saddle under his horse" and himself "where the saddle should have been." His drunken friends found this all very funny and they sat "on their horses on the sidelines, laughing." Of course, the occupants of the teepees were not amused. They "were cursing and throwing rocks and bottles." Finally John's friends were able "to help get his saddle righted so they could all get back to the roundup camp" without anyone getting hurt.[46]

The simplicity of many of the tales is indicative of just how starved for amusement these men could be. The following story illustrates this perhaps even better. A cowboy in Montana was "celebrating around for a while and he got pretty full in the saloon." When the celebrating was over he and a friend went back to their sleeping quarters, and the "two of them laid there and talked." As they did so the cowboy "kept helping himself out of this barrel of Indian whisky." When at last he "stretched out and got ready to go to sleep," he said to his friend, "very solemn and careful: 'John, will you do me a favor? Will you close my eyes for me?' He was so drunk he couldn't close his eyes."[47]

This story was a major hit with a number of John's acquaintances, who "laughed about it" and told and retold it all the next winter. As one of them explained, "a little thing like that was a big kick to us ... a bunch of men there by ourselves ... and nothing to do but get up and feed the stove." Because the main objective of the stories was entertainment rather than truth, they, like the songs and poems, have to be taken with a grain (or perhaps a whole bag) of salt. The greatest storyteller and entertainer in Western Canada was reckoned to be Fred Stimson, of the Bar U. He became so practised at telling yarns that he could mould them to fit almost any situation. "He could entertain a drawing room audience of men and women comprising the elite of Montreal's society, with grace, charm and wit, and on the other hand he could keep a gathering of tough and seasoned cowboys and range hands out on the round-ups in roars of laughter with his stories of another type."[48] A tall tale he related when out West came out of a trip he made to London. The Queen, hearing that he was in town, he recounted, invited him to stay at Windsor castle. One evening he taught the Queen and Princess Beatrice to play euchre. The Queen retired early, leaving Stimson and the princess alone in a pavilion on the grounds. They passed several hours together there and when they

returned to the castle the door was locked. Stimson woke up the Queen by pounding on the door with the butt of his six-shooter. When she discovered that it was only "old Fred Stimson from Pekisko," she yelled to him, "Just wait for a minute until I put my Crown on and then I will come down and let you in."[49]

"Speakin of liars," Russell once said, "the Old West could put in its claim for more of 'em than any other land under the sun." Russell understood too that frontier conditions helped to dictate this. They "weren't vicious liars," he said. "It was love of romance, lack of reading matter, and the wish to be entertainin' that makes 'em stretch facts and invent yarns."[50] In one of his own yarns Russell gives the example of a man named Jack who was a famed storyteller until he swore off lying. One day when he showed up at a bar in Fort Benton his friends all gathered around him for a story. "No, boys," he said, "I'm through. For years I've been tellin' these lies – told 'em so often I got to believin' 'em myself. That story of mine about the elk with the 15-foot horns is what cured me. I told about that elk so often that I knowed the place I killed it. One night I lit a candle and crawled up in the loft to view the horns – an' I'm damned if they was there."[51]

If young men left to themselves for their entertainment were likely to use their imaginations, they were also, as the above stories suggest, bound to develop their sense of humour. They got a great deal of enjoyment out of simply joking and kidding around. They would tell jokes and play tricks on each other and anyone who happened to come along.[52] The most frequent butt of their practical jokes were the "tenderfoots" or the men who were new and inexperienced in the life and ways of the West. "Ever' tenderfoot was fresh meat for the cowhand, stringin' a greener was a fav'rite sport of the cow country."[53] Such tricks were intended mainly for fun but they also could teach lessons about the way things were done on the frontier.

The story is told of a man from Britain named Bob Newbolt, who took part in a cattle drive for the Military Colonization Company ranch near Calgary in 1884. He came dressed "like a dapper young Englishman" in a three-piece suit and bowler hat. His trail boss assigned him an impossible workload. "Along with driving the wagon all day," he was given the job of night-herding, "and all night at that." He "did not catch on for quite a while that the other riders were being relieved at midnight because, meeting them in the dark," he could not tell them apart.[54] When he did find out, he got the work roster changed but that did not end the trickery. Presumably wanting to fit in more, he went into one of the towns along the way and got himself a more appropriate "western cowboy outfit" including a wide-brimmed hat. He put his "beloved bowler" in the wagon where he "thought it would

be safe." Unfortunately, the other riders found it and soon used it for target practice.[55]

The uninitiated, particularly those who were not well liked, were also subjected to the so-called snipe hunt. This was such a common trick when cowboys were trying to amuse themselves during the fall round-up that one old-timer called that time of year "snipe huntin' season."[56] Snipe are birds found in and along marshes, sloughs, and lakes. In the presence of a newcomer cowboys would claim that the birds roamed all around them as they slept at night and they would concoct gripping stories about catching them. A "half-breed" named Joe Mellette, who joined a group of men camped one fall on Mosquito Creek in the southern Alberta foothills, annoyed his companions by talking "incessantly" and boasting "of his hunting exploits." One of the men "made the suggestion that it would be a wonderful night for snipe hunting." So they pretended to organize a hunt. They explained how one man had to walk along the creek "with a bag and a candle, holding the bag open above the water" and attracting the birds to the light. The other men were to flush the birds out of the woods and drive them towards him. "Everyone clamoured for the privilege of holding the bag." However, the honour fell to Joe because "he was such a hunter and a newcomer to the outfit." Joe stood on a "little island," in the middle of the creek with the candle and sack. The other men went "up-stream, shooting off our six-shooters, shouting and making a fearful din." Then they disappeared in the dark. "About midnight, a very irate and belligerent Joe returned to a soundly sleeping camp, demanding that we come out and fight." When no one responded he grew "angrier and angrier." Finally someone laughed, "and shouts of laughter arose from every tent. Poor Joe gave up and retired."[57]

The greenhorn was also commonly given a broken-down old horse while being told that it was in reality mean and vicious; or he might be given a "gentle-lookin' hoss" that was notorious for throwing its riders.[58] The former trick was played on both Newbolt and John Ware before their colleagues found out what competent horsemen they were.[59] The latter trick is depicted in Charles Russell's pen and ink drawing "Initiation of the Tenderfoot."[60] Usually it left the poor, unsuspecting novice red-faced in a humiliated heap on the ground. Canadians C.L. Johnstone, in her 1898 work *The Young Immigrants*, and W.H.P. Jarvis, in *Letters of a Remittance Man to His Mother* published in 1909, have given us literary renditions of such initiations.[61] Sometimes the prank was tried on a seasoned cowboy, in which case it was liable to backfire. On one occasion in 1884 W.D. Kerfoot, manager of the first Cochrane lease, lent an "outlaw horse" to the famed bronco buster Frank Ricks. Kerfoot did not bother to tell Ricks

Laughs Kills Lonesome

that the horse "was a man-killer – a savage, untamed brute" that could "buck in a thousand different and original twists." Ricks roped and saddled the horse and then jumped on. When it reared and kicked and tried to heave him into the dust, he rode it "until it could scarcely stand." He "cut it from tail-stump to ears with his spurs, he temporarily beat the spirit out of it with his heavy quirt," and he "left a wreck in the place of the thousand pounds of fighting horseflesh he had mounted."[62] It was Kerfoot who must have felt the fool.[63]

Practical jokes went on virtually non-stop on most ranches. Con Price liked to recall the time when he was working for the HD outfit in Montana. One night the boss brought a new Winchester rifle into the bunkhouse to show the boys. "There were ten or twelve ... crowding around the boss to admire his new gun." The men were warned a couple of times to be careful because it might be loaded. Con was sitting on his bed and "decided to have some fun." He pulled his 45 from under his pillow and discharged it into the floor. In the confined space of the bunkhouse it "made a noise like a canon" and it "poured out a lot of smoke." It scared the cowboys and every last one of them "tore out of the bunkhouse." Con "fell back on his bed laughing as he heard one guy shout, 'I told you the damn thing might be loaded.'"[64] Out on the open range this kind of humour would often start with the daily work routine. The initial horse roping, or the "morning catch up" as it was called, "was apt to be a hilarious affair. There would be jokes and much laughter, good-natured jeers and cries of 'Ride him cowboy!' or 'Stick him son!' for in all probability, there would be several bucking contests going on around camp, contests between man

Bronc to Breakfast

and horse."[65] When these events were not set up by unsuspecting riders being given wild horses, it was often because burrs had been stuck under saddle blankets.[66] Some mornings saddles were put on backwards just for the fun of it.[67] The humour went on at the end of the working day as well. In the course of most round-ups, for instance, a snake or lizard would be placed in somebody's bed roll at least once.[68]

The most popular man on any outfit was likely to be the one most adept at providing comic relief. Teddy Blue Abbott would often have all his colleagues in stitches with his jokes and yarns.[69] His boss said that for that reason alone he was worth the forty dollars a month he was being paid for driving cattle. Charlie Russell was also known and admired for his practical jokes.[70] Abbott commented that he liked Russell because "we felt the same way about pretty nearly everything, and he could always see the funny side of things."[71] A facility for humour is reflected in many of Russell's stories and also in paintings such as "Bronc to Breakfast," in which a bucking horse knocks a cook's hard work and the cowpunchers meal into the fire. "Laugh Kills Lonesome" pretty well sums up what underlay much Western humour. It depicts grinning cowboys exchanging tales around a campfire at night. They are surrounded by a dark, empty prairie landscape that appears, like a long trail drive or a cold winter, to go on almost for ever.[72]

Humour became so much a part of the cowboys' way of life that it quite naturally flowed into their everyday lingo. They would go out of their way to find the witty phrase to express almost anything. Canadian born Bud Cotton, for instance, related that he originally wanted to get rid of his derby hat for a Stetson because it would look better to the cows.[73] One American cowboy remarked that he traded his saxophone off for a cow. "Made about the same noise," he said, "and gave milk besides."[74] After roping a grizzly bear some men were asked why they didn't brand it and turn it loose. They replied that the branding was possible but the turning loose would require more help.[75] When the stampede was first held in Calgary in 1912 the former bronco buster Johnny Franklin was appointed judge of the bucking event and a friend naïvely asked him how he was going to decide the winner if two men tied. By 1912 Franklin was growing older and had long since given up using his renowned skills. However, instead of explaining to his friend about re-rides, he simply said "I'll just ride both them horses myself. That's the only way to find out which bucks hardest."[76]

A fellow called Charlie Brewster, who worked for the Circle C ranch, used to carry on quite a conversation with the horses he was breaking, often for the benefit of anyone sitting on the corral fence watching. After he roped and saddled up an animal, for instance, if it lowered its head, stopped stiff-legged, and whistled in an ominous and defiant way through flared nostrils, he would say something like, "That young feller thinks he's a plumb warthog. He's fixin' to give a man a hard time. The way he sunfishes, he's showed me his hole card. I aim to call his bluff while he's still in the notion." Charlie would then pull on his chaps while quoting the old adage, "Never was a bronc never got rode, Never was a rider never got throwed." Just before mounting he would look the animal in the eye and tell him: "Time me'n you got this here argument settled, young feller, once and for all."[77]

For their entertainment cowboys also used to dream up competitions with one another whenever and wherever possible. One of the most popular contests was simply to determine who could be the best looking. As trite as it may sound, style meant a lot on the range, perhaps a testimony to the power of the literature that first attracted so many young men to the West. Would-be cowpunchers from the East had read again and again the lucid depictions of Western heroes, from Kit Carson to Buck Taylor, which described their facial expressions and builds, their clothes, their horses, their gear, and their tack in meticulous detail. When they reached the frontier they had images firmly planted in their minds of how a frontiersman of gallant stature should look and they were keen to live up to it. That is why almost the first thing many of them did when they reached Great Falls or

Calgary was put together their cowboy kit.[78] At first they tended to look garish and silly but those who became *bona fide* cattlemen soon learned how to make subtle adjustments to their outfits to fit the part. Hats were creased in a way that hid their newness and matched local styles, boots were scuffed up just enough to look used but not too old, shirts that were overly colourful were replaced by ones that suited the look of the working cowboy rather than the dude rancher.

When these young men mixed on the open range or in the cattle towns, their concern about appearance sometimes seemed to wane, but the reason for that may have been shortage of money. The seasonal nature of his trade and the cowboy's tendency to spend or gamble away what he had could easily make it impossible for him to keep up his kit. Expensive guns or *chaparajos*, saddles or even horses were lost in games of poker or hawked for bread money.

> My saddle and my gun's in soak; my spurs I've long since sold;
> My rawhide and my quirt are gone, my chaps – no they're too old.
> My stuff's all gone; I can't even beg a solitary smoke,
> For no one cares what becomes of a cowboy who is broke.[79]

However, most cowboys never lost their eye for style and those who managed to afford it were, in Charlie Russell's words, "mighty particular about their rig." In every cow town and round-up camp "you'd find a fashion leader" and if he had the pizzazz to go with his technique he was greatly admired. "There ain't no prettier sight for my eyes," Russell unashamedly asserted, "than one of those good-lookin', long-backed cowpunchers, sittin' up on a high-forked, full-stamped California saddle with a live hoss between his legs." As an artist Russell naturally had an eye for detail and from memory he could describe the fashion leader and every piece of his dress and equipment. "His hat was the best; his boots was made to order, with extra long heels. He rode a center-fire, full-stamped saddle, with twenty-eight-inch tapaderos; bearskin ancaroes, or saddle pockets; his chaparerjos were of the same skin. He packed a sixty-five-foot rawhide. His spurs an' bit were silver inlaid, the last bein' a Spanish spade." And his gun was "a forty-five Colt's, silverplated an' chased with gold." It had a pearl handle "with a bull's head carved on."[80]

Roughly according to where the men who worked the herds had learned their trade, they adopted one of two styles. Those who were born or had spent most of their careers on the northern Great Plains developed a culture of their own. They wore a low-crowned Stetson hat with a narrow brim that provided just enough shade in the cooler northern climate. The hat was creased in four separate dents and

Rawhide Rawlins

lacked the fancy hatband sometimes worn today. They also wore angora wool chaps that kept their legs warm in cold weather. Their pants were usually held up by suspenders rather than a leather belt. Some of the cowboys wore leather cuffs made from saddle leather and they all sported buckskin gloves. In the winter the gloves were lined with fur and the men normally pulled on fleece-lined overshoes specially made to fit over their high-heeled boots. The *tapaderos* covering their stirrups were also lined to keep their feet from freezing. The work boot was made of cowhide, and the dress boot had an alligator leather foot and a stovepipe top of stitched calfskin. In the earliest period many cowboys also draped a cartridge belt with a holstered 45 Colt six-shooter around their waist. As time went on, however, the belts and holsters were discarded and those who still carried guns usually tucked them inside the waste-band of their pants.[81] The horse was also an important piece of the cowboy's kit and a source of pride. The men from northern regions liked to ride big-boned, long-legged horses capable of coping with deep falls of snow. In 1887 William Bell reported with obvious pleasure that one of the Walrond men had just got back from Montana with twenty-eight new saddle horses. "He

paid fifty-seven dollars and a half per head for them." This was considered a high price. However, said Bell, "they are a good lot of horses similar to those bought there years ago but better as they are ... on the average larger."[82] It was important for these animals to show some bloodlines and the ranchers often used Thoroughbreds or Irish Hunters to upgrade the mixed-breed "cayuses" that roamed the open range.[83] Normally the saddle was three-quarter rigged with a single cinch that was tied immediately behind the mount's front legs rather than a little further back as in the case of the centre-rigged California type described by Russell.[84]

In most gatherings in both Western Canada and Montana there were a number of cowhands who had come north from Texas. They were considered tough as nails and universally praised for their cow savvy.[85] They were also relatively easy to pick out. They wore a wider-brimmed hat with a high crown with no dents except sometimes a crease down the middle. Some of them tucked their pant legs into their boots and wore longer-shanked spurs than the northwesterners, or Mexican spurs with large rowels that made a ringing sound when they walked. These men sat on a double rather than single-rigged saddle. With time this type was widely adopted in the northwest because a second cinch at the flank prevents the saddle from tipping forward when a big animal is roped.[86] The *tapaderos*, like their chaps, were made of leather alone. The men carried a shorter rope, one end of which they tied to their saddle horn before catching an animal rather than wrapping, or "dallying," it after the fact. As a rule their horses were a smaller breed that initially had been introduced to Mexico by the Spanish. They were deep-chested with a broad muscular rump that enable them to produce the short bursts of speed required for quickly catching up to a bovine in full retreat.[87] Adhering to a chosen style evidently helped working cowboys to think beyond the hardships of life on the range. If some were unable to be as fashionable as they would have liked, they had standards in their minds to strive for, if and when their fortunes changed.

Competition related to the skills of the craft helped men to use some of the equipment they were so proud of and thus to live up to an image. These contests also made the job of cowpunching somewhat less onerous in the sense that they blurred the line between work and play.[88] Most important among the skills to be honed was the art of roping. Catching livestock with a rope or "rawhide" from the back of a galloping saddle horse was and is a very difficult undertaking, and cowboys needed to practise it whenever they could. If they were sitting around with nothing much else to do they would pull out their lariats and challenge each other to contests – often at the expense of wild animals. Wolves, coyotes, deer, antelope, elk, mountain sheep, buffalo,

porcupines, lynx, and bears were in frequent danger of being caught on a dare.[89] On one round-up a hundred dollars was offered for the first man to rope a jack-rabbit and someone actually managed to accomplish the feat.[90] Cowboys seem to have had little sympathy for the creatures they found on the plains. The usual outcome of these displays was the death of the animal. "In the summer the cowboys frequently found a den [of wolves] and then there would be great sport roping them and shooting the awkward sprawling whelps with their six-shooters."[91] The smaller animals normally spent their last few moments being "dragged and bounced ... across the prairies and hills."[92] Larger ones would be roped by several cowboys at the same time around the "neck and foot and body." Before being put out of their misery they were "tangled and tripped and hauled about" until they were "helpless, strangled and nearly dead." Sometimes the animals were used for food but unquestionably sport was the main object. "No feat better than this could show the courage of the plainsman and of the horse which he so perfectly controlled."[93]

The bucking contest was also a favourite on the range. Suitable horses were always easy to find. The mounts on the ranches, like their riders, lived a rough existence. Many of them roamed free during the winter and over the weeks between round-ups, and tended to be only "semi-broke" when they were brought in for work. As Fred Ings once said, almost any of them "might give a buck or two" when saddled up. Most ranches had certain men whose job it was to break the horses, and they were the ones usually involved in the contests. On one occasion Fred Stimson, manager of the Bar U ranch in the foothills of Alberta, promoted a competition between the one-time Texan slave John Ware and Frank Ricks. Ware went first and Ricks so admired his ride that he conceded.[94]

When cowboys were not bucking horses they were inclined to be racing them. The races were not the formal eastern-style races with track, club facilities, people attending in formal dress, and purebred animals vying for honours. More usually they pitted one well-known fast horse against another on a route mapped out along a dusty road or across a pasture.[95] Almost every ranch had at least one "running pony" that it believed could "outpace any other," and challenges were often issued. [96] Both Canadian and American cowboys remembered the races as some of their "greatest sources of amusement."[97] The competitions were not taken lightly, however. Ranch pride was at stake – and often considerable amounts of the cowboys' hard-earned cash.[98] Ranch hands also competed with cutting horses. They would bring a group of cattle into a central area and then a horse and rider would go into the herd, cut an animal out, chase it away from the others,

"The Cowboy Race"

and attempt to keep it away. The herd instinct is powerful in the bovine species and the animal would twist and turn and do everything in its power to get back with the others. The horse had to be very fast on its feet and both it and the rider needed "cow sense" in order to anticipate their adversary's every move.[99]

Spontaneous competitions of roping, racing, bucking and/or cutting often took place during the general round-ups when several ranches came together. The *Yellowstone Journal* commented on one such event on 15 October 1885: "Will G. Comstock in town from the nine-six-nine ranch reports a grand time on Saturday and Sunday at the Capital X Ranch on Mezpah." Over seventy-five cowboys were present and the roping and cutting "matches" both offered prize money for the winners.[100] People from far and wide were sometimes invited to attend. "There were race meetings ... and, at intervals between races, roping the wild steer, riding the bronco and other events peculiar to a great stock country were indulged in."[101] In this manner the rodeo, first

established in the American south, proliferated across the northern states and into the Canadian territories.[102] By the early nineties, professional cowboy athletes were appearing at these events along with local working ranch hands. A North West Mounted Police officer recalled that "the competitors ... had often come from a long distance and were past-masters at the games, sometimes champions of the great stock regions south of the line and in our own country from the ranches in the vicinity."[103]

Cowboy culture did not get its start in Montana or in Alberta or Assiniboia. On the North American continent it emerged first in Mexico and then spread north to Texas, California, Oregon, and any region where the conditions of the grazing industry prevailed for any significant period. However, each region contributed and helped to mould it in specific ways. The north adopted certain peculiarities of style and dress, particular versions, lyrics and titles of songs, and a host of individual recollections – both real and imagined – that have been passed along from generation to generation. Unquestionably, Montana as well as Alberta and Assiniboia played a substantial and important role in this process. However, it was everyday life more than anything else that defined and shaped cowboy culture. Young men were forced to find ways to deal with the dangers, hardships and, most of all, monotony, of the open range system. In their ample moments of relative idleness they dealt with their fears of an early grave, grappled with the harshness of mother Nature, and immortalized their activities through song, poetry, and tall tales (or lies). They also clowned around, developed a Western lingo and sense of humour, and competed with each other in style, dress, and the skills of their trade.

The frontier was an ideal setting for exercising even meagre natural talents, but except for Russell and, a few years later, Quebec's Will James, it produced relatively few *contemporary* visual artists in comparison to storytellers, poets, and singers.[104] The reason is probably that artists required certain materials in addition to an active imagination and good memory. Paints, canvases, easels, and brushes were not readily available to most cowpunchers and they must have been a real nuisance to carry around. Long before Charlie Russell turned professional he is said to have practised sculpting on bits of clay and wax and painting on scraps of paper, pieces of finely tanned buckskin, wood, tin or anything else that happened to be available when he was in the mood. He is even supposed to have fashioned crude paint brushes by chewing the ends of wooden matchsticks or green twigs. Presumably Russell was destined to express his enormous talent under

even the most primitive circumstances. Once he overcame the material hardships, however, the ranching environment offered him encouragement as well. Long stretches of isolation and inactivity, a very limited social life, and a most appreciative and largely captive audience did as much to motivate him as they did other artistic Western souls.[105]

8
"Nice" Ladies and "Sporting" Girls

Saving pretty young women from horrible dangers was one of the features that gave the protagonists of dime and romantic novels their heroic stature.[1] In *Stampede Steve*, for example, Dora Dale, a beautiful young lady, finds herself about to be skewered by an enraged steer, when out of the blue ...

> The red scarf about [her] waist appeared to doubly infuriate the beast; and, ceasing to paw the ground, it lowered its head, gathered all its immense muscular force, and shot forward with a terrible and unearthly roar of frantically furious madness!
>
> Like as if suddenly transformed to stone, ghastly as the dead, her eyes fixed and staring, glassy and filled with dread, terror and deathly despair, her tongue cleaving to the roof of her mouth, powerless to move or speak. Thus stood Dora Dale!
>
> An instant more, and the long lance-like horns would be plunged through that fair form and she be tossed in the air, and then fall, and be gored and trampled beyond the semblance of humanity!
>
> But, in that one brief instant, the sharp whip-like report of a rifle sounded on the still morning air, and the huge black brute fell dead, the blood gushing from mouth and nostrils, at the very feet of its intended victim.[2]

Who was Dora Dale's saviour? Of course, it was the hunter, cowboy, and champion of the story, Stampede Steve. This kind of scenario helped to create the impression that among the earliest cattleman a chivalrous attitude towards women flourished.[3] Unlike many of the aspects of Western life eulogized in print, however, this portrayal is more than mere myth. Indeed, as unlikely as it may sound on the surface, the respect that frontiersmen paid to the opposite sex may well in part account for the power behind women's rights movements in later years.[4]

Rancher's wife bringing elegance to the family washing

Being a good entertainer or a skilled roper or bronco buster – or just plain nice to look at – could only improve a young man's chances in the necessary frontier rivalry for the opposite sex. Of course competition for women among young males is universal – as is its counterpart among females. In early ranching society, however, gender imbalance dictated that it be played out under exceptional conditions and with its own set of rules and values. Because there were so few women and they were so unavailable, cowboys spent long hours out on the range talking and dreaming about them. A narrative about two men holed up at a ranch on the mouth of the Musselshell River through the winter of 1884–85, fantasizing about potential wives, illustrates the simplistic thinking that isolation could induce in virile young men. "It was a grub line rider, who came down and told us about the pretty girls" at Granville Stuart's ranch, one of the cowboys recalled.[5]

The Fellow told us that ... Stuart had two grown daughters living at the ranch with him, and an old partner of his named Reece Anderson had three more. This was the biggest kind of news to lone cowpunchers. Most of us hadn't spoke to a nice girl in years. I know I hadn't; only to a few married ladies.

We talked them all over for days, and each of us picked out the one he was going to marry. It was something to talk about. And I remember I picked the younger one of Granville Stuart's two daughters, and I can tell you the reason. The grub line rider told us that Granville Stuart said he would give five hundred

head of cattle to whoever married the oldest girl, though he said the little one, only fifteen years old, was the best-looking of the lot.

And I remember the horse wrangler said: "I'm going to take the oldest one and get the cattle." And I said: "I'll take the pretty little one." And we picked up our hats and went outside – said we were going right over to the DHS [ranch] to get these girls, seventy-five miles away. We were joking of course. We went about ten feet in the snow and come back – concluded we'd wait until spring.[6]

It should come as no surprise that most of the female company cowboys kept were prostitutes. These women took advantage of the predominantly single young male composition of society and scores of them coincided their arrival in the cattle towns with the times when the boys were most likely to be around. That is "they followed the trail herds." When the round-ups ended and the men drove the marketable cattle to town for shipment east, the women came out under the supervision of madams from cities like Omaha, Chicago, and St Paul and they did a kind of circuit between Ogallala, Nebraska, Cheyenne, Wyoming, Miles City, and so on. As the populations of Alberta and Assiniboia started to grow, their towns became part of the circuit too.[7] The prostitutes knew how to make the best of the situation from a financial point of view. They told the cowpunchers who had money that they were the "best-looking" cowboys they had ever seen. Then they "cleaned" them "down to [their] spurs."[8] At first the girls' interest in the towns remained high only as long as the money lasted. "When the herds was all gone and the beef was shipped, the town was dead. The girls would go back where they came from and the gamblers would go with them." However, as the urban centres grew and demand became more consistent, prostitutes set up permanent residence in them and carried on their business year round.

Evidence suggests that in comparison to their eastern counterparts the prostitutes who went West were in a relatively favourable position. But it is true that they were not completely mistresses of their own fate. Many were beholden to and somewhat controlled by the "madams" who brought them out or by male pimps who got a hold on them after they arrived. Among the latter were often "tin horn gamblers"[9] who, as James Gray has illustrated, worked closely with girls in agricultural districts to separate the men from whatever money they had.[10] In Montana they were also local marshals and other law enforcement agents whom the girls needed both for protection and for the discretionary power they wielded with respect to enforcing (or failing to enforce) the law.

Many of the girls had rather short or brutish lives.[11] They lived constantly with the fear of venereal disease and pregnancy; some overdid the partying, became alcoholics, or drug addicts, spent their money, and ended up either dead or destitute. In Miles City, a girl known as "Cowboy Annie" eventually "took to drinking and bad acting ... rode her horse up and down the street, and got arrested." Then she "went on downhill from there." She ended up in "a soldier's dive." The cowboys considered this the very bottom. "When a woman left the dogs" they claimed, "she'd go to the soldiers."[12] "In death, the extent to which liquor and drugs dominated the lives of prostitutes became clear," writes A.M. Butler; "the accounts of these ran like a litany of destroyed youth." Butler gives examples: Inez Maybert in Butte, who "after several days of heavy drinking, died from an overdose of morphine"; Florence Bentley from the same town, who also perished from the drug; and Polly Ensigham from Lewis, Montana, who committed suicide with strychnine.[13] Prostitutes were also too often the victims of violence. In 1889 the "mutilated body of a murdered squaw" named Rosalie was discovered in William "Jumbo" Fisk's living quarters above the Turf Club restaurant in Calgary.[14] A North West Mounted Police detective testified that the murderer had torn open the victim's abdomen with his bare hands. In 1893 May Buchanan was axed to death by a client at Sheep Creek, Alberta,[15] and on 10 April 1890 Ella Hamilton was shot by "one of her 'lovers'" in a Lewistown saloon.[16]

All of this aside, however, it is clear that life for many single young females on the ranching frontier could be significantly better in some important respects than in Older World urban settings. Men in round-ups, trail drives, and bunkhouses were aware that they had no women of any kind around them most of the time and did not have wives to go home to. Their tendency, therefore, was to see prostitutes or "sporting girls" as they called them, in a better light when they got to town than they otherwise might have. This is suggested by a number of observations. For instance, it was not unusual for a young cattleman to fall in love with one of the prostitutes. One cowhand believed that a colleague would gladly have tied the knot with a particular "awful pretty girl" if she had been prepared to accept him. He also estimated that "she could have had her pick of a dozen fellows, but she didn't want any of them."[17] Under everyday circumstances, cowboys were inclined to form far closer relationships with sporting girls over a longer period of time than would have been the case in eastern cities. In Lethbridge the "gaggle of whorehouses" were far more than just places for sexual encounters. After satisfying his basic urges a cowhand could relax among the women with a good book, or "be taught to

read by a former school teacher turned prostitute." He could also "lean back and enjoy a piano solo" or get one of the girls to instruct him on "the latest dance steps." He might even get "a girl who had been a faro dealer in Fort Benton" to teach him how to "spot a crooked card dealer in a poker game."[18] In Montana the cowboys often stayed day and night with a young woman for the duration of their stints in town. "We all had our favorites after we got acquainted," one of them recalled, "we'd ... marry a girl for a week, take her to breakfast and dinner and supper, be with her all the time."[19]

There can be little doubt, moreover, that the women were less stigmatized by the general population on the frontier than they were in older communities. Teddy Blue Abbott had been with prostitutes in more easterly cities and he could see the difference. In Lincoln, he said, you could not treat them the same way you could out West. He recalled the time he wanted to take two girls to a show in that city. "I had to take them in a hack, because if they had walked down the street they would have been arrested ... You couldn't walk around with those girls in the daytime like you could in Miles City."[20]

Consideration for prostitutes can be detected among the men in the Calgary police force. When two girls named Nina Dow and Nellie Swift were given six months' hard labour for being inmates of "a house of ill fame," for example, the judge – a North West Mounted Police officer – stayed the commitment for twenty-four hours to give them the chance to "leave by first train." Both did so.[21] Years later, Carmen Hall, "a lady of leisure," lost forty-five dollars when she fell, walking across a vacant lot after spending some time at the "Chicken Ranch" on Ninth Avenue. A man named "Slim" whom she later met in a bar went back to the lot and found the money. When he refused to turn it over to her, he was arrested, charged with theft, and imprisoned for thirty days.[22]

Cowboys are known to have shown a protective attitude towards the ladies of the night. In a recent article G.K. Renner has pointed out that Charlie Russell had a habit of defending the virtue of the prostitutes he hung out with in his earlier days.[23] Abbott was convinced that most men "treated them sporting women better than some men treat their wives."[24] A Niobrara ranch hand rode off after staying a week with a girl, owing her seventy dollars. He was fired for the indiscretion and the other men from the ranch took up a collection and paid her back. "Any man that would abuse one of them was a son of a gun," a fellow worker mused. "I remember one time when a P.I. [pimp] beat up on his girl for not coming through with enough money or something like that, and a fellow I knew jumped on him and half-killed him. The man hadn't done nothing to him. It was none of his business. It was just the idea of mistreating a woman."[25]

Inevitably some of the women learned to exploit their relatively privileged circumstances. Perhaps Russell was referring to this fact when he mused that "a woman can go farther on a lipstick than a man can with a Winchester and a side of bacon."[26] There was a young lady who was considered the N Bar outfit's girl – "they were all struck on her." She was not at all backward about taking advantage of the male competition for her favours. One day, "kind of coaxing," she said to a cowhand, "Oh Johnny, I've got a sealskin coat and cap coming from Chicago, and there's still $150 against it at the express office. Won't you get it out for me?" At first Johnny pleaded that he couldn't afford it. She pouted for a while and then told him that one of the guys from the ST outfit would get it for her. That was all Johnny could take. "I've got just as much money as any ST son of a gun," he told her. Then he went down to the express office, paid what was owed, and got the coat and cap.[27]

It is clear, however, that many of the women appreciated the comparatively high quality of life they were able to achieve. "There's a kind of a fascination about it," one explained. "Most of the girls that are in it wouldn't leave it if they could."[28] Some of them talked to their clients "about how they got started, and how in Chicago and those eastern cities they wasn't allowed on the streets, how their clothes would be taken away from them, only what they needed in the house, so it was like being in prison." They realized that out West, where they "could do as they pleased" and where they were generally respected, life was a whole lot better for them. As a result they developed a genuine affection for their male clients and were even prepared on occasion to help them out with their finances. In at least one of the Canadian towns, after the cowboys had blown all their money in the gambling joints, they were likely to "seek shelter from the weather" in one of the well-known houses of ill repute. They were almost never turned away.[29] Individually, the girls "always had money and they would lend it to fellows who were down on their luck. The wagon boss would come around looking for men in the spring, and when a fellow was hired he would go to his girl and say: 'I've got a job, but my bed's in soak.' Or his saddle or six-shooter or his horse. And she would lend him the money to get it back."[30]

The comparatively favourable opinion men had of sporting girls was also reflected in their attitudes towards Native and Métis women. Many of the Native women they met were, like the white women, involved in prostitution. "The first Lethbridge brothels were the teepees the Indians pitched on the Belly River flats," some 300 feet from the spot on which the city itself was eventually located.[31] Tribes in Montana did "a regular business of that kind and some of them,

especially the Crows and Sioux ... got so low they would offer you their wives." Usually they too "had special teepees for the purpose," where "certain squaws that was just like sporting women among the whites" were made available.[32] Some Native women, though, were considered more respectable by the cattlemen and, given the shortage of white women, were highly sought after for long-term relationships. Teddy Blue Abbott married the daughter of Granville Stuart and a member of the Shoshone tribe.[33] In the following excerpt he speaks of his own and his colleagues' willingness to cohabit with Native girls. First he acknowledges that before he met his wife-to-be he himself once "tried hard to get a Cheyenne girl."[34]

I wanted this girl so much that I asked her if she'd marry me, but she wouldn't do that either. I asked her through old High Walking, and as I told him: "She's good enough for me."

Well, she was, or that was the way I felt about it at the time. And I wasn't the only one by a long way, because there was plenty of cowpunchers in the early days who were not ashamed to marry an Indian girl ...

Those Indian women made wonderful wives. The greatest attraction in a woman, to an Indian, was obedience. They were taught that and they inherited it. Their husband's will was their law. Every white man I ever knew that was married to an Indian – like Granville Stuart – thought the world of them.[35]

The proclivity for mixed-race relationships in the Assiniboia area is evidenced in one reporter's estimation that about 90 percent of the people near Wood Mountain in 1902 were "halfbreed" and "all ranchers."[36] It strongly suggests that white men would have been initially less inclined to choose Native women, had they been able to be more selective. The well-known fact that many men left their Native partners as soon as more white ones became available, however, underscores the role of the scarcity of women in fostering interracial association on both sides of the border.[37]

At times men met what they considered "nice," non-Native women, though such encounters tended to be rare. "I can't remember that I ever spoke to but three good women in all the time after I left my family," a cowboy reminisced, "and they were all older women, or at least they were married ... I'd been traveling and moving around all the time, living with men, and I can't say I ever went out of my way to seek the company of respectable ladies."[38] Cowboys were in awe of "respectable" women, but felt small and uncomfortable in their presence. "We didn't consider we were fit to associate with them ... the cowpunchers was afraid of a decent woman. We were so damned scared for fear that we would do or say something wrong – mention

Métis ranchers, Maple Creek, Assiniboia

a leg or something like that would send them up in the air."[39] Obviously the men found it difficult to relax around "proper" women – particularly those that put on airs. "You never knew when they were going to take some little thing you said, meaning no harm, and twist it into a cause for offense."[40]

Con Price relates an incident involving a school teacher who "was a great favorite with everybody." One evening when Price was at a dance the floor manager announced a "Ladies' Choice." "I heard that call and figured I was out for that dance – and took a big chew of tobacco – when to my surprise this little lady stepped up to me and asked me for that dance. Now I had no chance to get rid of that chew and rather than let the little queen know I chewed tobacco or lose that dance, I swallowed the whole works, tobacco juice and all." In later years Price felt obliged to comment on "the high regard and respect we had for those good women of that day, as we saw so few of them." He felt they reciprocated too. "I know good women appreciate those things, I believe they liked us and valued our friendship." Clearly, however, it was the men who were affected the most in mixed company. "Some old hard-faced cowpuncher that had a grouch about something," he said, would appear, "and when one of those women would give him some little attention his face would soften up until you couldn't tell it from the face of the Virgin Mary."[41]

Ranching family, Pincher Creek, Alberta

A principal argument that only a few years later would be put forward by many women's rights crusaders was that their sex was *morally* superior to men. It would be overstating the case to suggest that conditions on the frontier were responsible for this belief; however, they almost certainly helped to fuel it.[42] Evidence of the high stature of "respectable" women during the ranching era is also seen in the sense of urgency with which men, once they got over their initial fears, attempted to court them. "In frontier countries, girls are scarce, and so it was here," Fred Ings said of the Highwood River district in the foothills of Alberta. "Hardly had a visiting sister, niece, or friend arrived, than she was besieged by suitors. Practically every girl or young woman who came in married at once. In fact it was looked upon as a foregone conclusion."[43] Moreover, men instinctively accorded such women the right, which many of them were fully prepared to assume, to define what was and was not socially acceptable. The cowboys might claim to find them oppressive and even small-minded when they put on too much "agony" but they seldom ever fought them. When the new bride of a ranch owner near Pincher Creek, Alberta, came west, for example, she insisted that the young cowboys "live up to a new regime." They were required to wear "a black alpaca

coat" over their flannel shirts when eating at her table so that she could approximate the Old World ideal of formal dining.[44] She was thrilled that they donned the coat "so enthusiastically and with such good will." "They are a nice lot of men," she said, "and I love their attempts to help me feel civilized."

It seems, then, that all types of women in some sense enjoyed an improved stature under the conditions of the frontier. Prostitutes were more socially acceptable and wielded more power than they did elsewhere, respectable Native women were considered more valuable in the marriage market, and white ones were placed on a pedestal and were able to assume considerable influence over moral and social values. Correspondingly, women in general had a somewhat better chance to both improve their economic circumstances and take on challenges normally reserved for men. Some astute ladies of the night managed eventually to make good as entrepreneurs by saving up money they acquired from their clients. They moved up the social scale and took up new careers such as operating their own boarding houses.[45] One or two became business tycoons. Lizzie House operated a series of extravagant bordellos in Calgary with furnishings that are supposed to have equalled those of the best houses in the East.[46] Carrie McLean, better known as "Cowboy Jack," started her career as a prostitute in Montana and then moved on to operate her own establishments north of the line. In Lethbridge she had "an imposing two-storey house with a horse trough in front where drunken cowboys frequently dumped their frolicking pals."[47] Josephine Hensley, better know as "Chicago Joe," began her career in the prostitution business in Helena in the 1860s. By the 1880s she had risen to the top of the city's business class. She owned most of Helena's prostitution district and she acquired unimproved lots, a farm, a warehouse, small saloons or "hurdy gurdies," and the Coliseum, a theatre where prostitutes serviced Johns in the curtained boxes.[48]

Among the more "respectable" women, Helen Piotopowaka Clarke, the daughter of a rancher and a woman from the Blackfeet tribe, became a teacher in Montana and, as the Lewis and Clark County superintendent of schools, the first female elected to office in the territory. A host of others raised their profile on their own ranches by taking on traditional male responsibilities. "A Montana matron of fifty summers rode on horseback into Livingstone last week, did her trading and returned to her ranch riding fully one hundred miles with but little rest on the trip," a reporter acknowledged with obvious admiration in 1885. "The gun that hung on her saddle showed that she was prepared for defense." She was "a pioneer of the Yellowstone" and "wealthy in horses, cattle and sheep," which she frequently "attended to personally."[49] In the fall of

Cowgirl from the Strathmore, Alberta, area

1891 another, rather famous, Montana lady whose husband had fallen sick, took charge of their cowhands, gathered up their pasturing cattle, trailed them to Great Falls and then, to avoid would-be buyers who seem to have been trying to take advantage of her, shipped them to Chicago herself.[50] In the Wood Mountain area of Assiniboia, a woman named Chamberlain and her daughter, who was "scarcely out of her teens," took over their debt-ridden ranch after Mr Chamberlain died and for a while at least they made a success of it. They donned men's clothing and proceeded to milk cows, market butter, cut, mow and rake hay, brand calves, and haul manure. They even built an addition to their house and were said to have learned to "rope a steer and ride a horse with any rancher in the country."[51] Mary Inderwick[52] and Monica Hopkins[53] in the foothills of Alberta also mastered the art of horsemanship and helped their husbands tend livestock on the open range.

In 1913 Violet LaGrandeur's husband, Emery, competed in the Winnipeg Stampede where he won the $1,000 purse and the championship medal. At the end of the rodeo he put on what Guy Weadick called "the most complete, daring and reckless ride made anywhere."

Lady Buckeroo

After it was finished he got away from his cheering companions as soon as he could and "made his way through the crowd to where his wife was sitting ... He handed her the cheque for the thousand dollars and told her, "'Violet, here's the money – it's yours; get what you want with it.'"[54] Emery was showing her the consideration he realized she had earned. Born in Montana, she had come to southern Alberta at the age of fifteen to live on the Spencer Ranch, where she found herself riding the open range and working the cattle with the cowboys. During their married life she did all of that as well as riding bucking horses, keeping tabs of the family money, and, on at least one occasion, single-handedly marketing their cattle.[55]

It is a testimony to the propensity of women to break out of traditional roles on the frontier that, as the photograph below demonstrates, the first big stampedes, like those at Calgary and Winnipeg, had women's competitions in such rough-and-tumble events as bucking horse riding and steer roping. In accounting for the blurring of gender roles on the frontier, historians have largely concentrated on hardship. They have pointed out that as families filed into the West, isolation, a dearth of kinship networks, and an insufficient labour pool forced women to

Lucille Mulhall, champion bucking horse rider at the Calgary Stampede

work closely with their male counterparts to build homes and operate their farms. This explanation is beyond dispute. However, it would seem logical to argue as well that women's relative scarcity in the earliest frontier period gave them a heightened sense of their own stature and potential, and thus much-needed confidence when they were called on – or wished – to overstep longstanding barriers.[56]

9
Where Have All the Range Cattle Gone?

On the northern plains the system of open range grazing had a very brief history. It started with great optimism in the late 1870s and early 1880s and then, within a number of years in central Montana, and some two decades in Alberta, Assiniboia, and northern and eastern Montana, it had basically disappeared, as one after another the ranchers either modified their approach or quit. Before the end of the first decade of the twentieth century the system continued in name only. The vast majority of the big or "great" ranch operations had faded into the records of history, replaced by a host of much smaller and in many cases family-owned units. Many smaller operators still called themselves ranchers, but primarily out of habit and because they recognized the high esteem accorded cowboys and cattlemen during a now bygone era.[1] What they were actually doing on their spreads, however, was a form of mixed farming or ranch farming that entailed a much more intensive approach. They still grazed cattle but mostly just in the summer months and they practised a whole array of traditional farming methods including haying, soil cultivation, seeding, grain growing, harvesting, and irrigation. And they had diversified into other branches of animal husbandry such as sheep, dairying, poultry, hogs, and grain-finished beef.

The standard explanation for this transition is the same on both sides of the international border. The original ranchers were crowded off the range by hordes of homesteaders who fenced up the open pastures and watering places and turned the free grass into small, privately owned fields of wheat and other crops.[2] This chapter proposes a different thesis: the open range grazing system on the northern plains was doomed from the start because it was based on the false assumptions of dreamers rather than on sound economic principles and a thorough knowledge of the frontier environment.

Undeniably, overcrowding of the ranges became in time a problem both north and south of the international border. The first frontier ranchers established their operations ahead of the initial waves of homesteaders and they found that their own claims to the land were tenuous in comparison to the rights granted by the *Homestead Act* and other acts to the men and women who followed in their wake.[3] In Montana the first cattlemen operated mostly on publicly owned land, of which they had merely taken possession; and in Alberta and Assiniboia they held leases based on dominion legislation that enabled them to rent large tracts at the low price of one cent an acre per year. In either case very few of them had the legal right to prevent settlers from invading their domains.[4]

American ranchers tried to protect as much land as possible through purchase. It is well known that some induced their workers to claim land as homesteaders and then to "sell" it to them. Some, like Pierre Wibaux and John M. Holt, also bought from the railways; and others, including the McNamara Ranch, purchased land from settlers[5] and were allowed to lease public tracts, though the amount available was much smaller than in the Canadian West.[6] Others still, including Granville Stuart[7] and Conrad Kohrs, acquired land through soldier's scrip.[8] For the most part, however, Montana cattlemen had to use the same expedients as were available to regular homesteaders. They used the *Preemption Act*, which allowed them to stake a claim on a quarter section in an unsurveyed area and then to buy it at the minimum price; they claimed 160 acres of surveyed land under the *Homestead Act* for $1.25 an acre or for filing fees and improvements; and they acquired land under the *Timber and Stone* acts and the *Desert Land Act* in return respectively for clearing, cleaning up, and irrigating it.

However, as it took up to twenty-five acres per head to keep cattle fed, these means did not give them anywhere near enough land for herds numbering in the thousands. For as long as they were active the majority of the bigger ranchers continued to depend on free access to the public domain for most of their grazing needs, and the prospect of being crowded off the range seemed very real. The major flaw in the crowded-off-the-range theory with respect to Montana, however, is that most of the great ranches closed down operations in the late eighties and early nineties before settlement reached a threatening point. To demonstrate this, one needs only to cite the census reports. Most of the initial big ranches terminated operations soon after the terrible winter of 1886–87 destroyed their roaming herds.[9] The population of Montana in 1880 was about 39,000.[10] Ten years later it was still just over 133,000.[11] Between 1880 and 1890, therefore, it increased by some 94,000 people. If one assumes that every year in

the decade of the eighties pushed the population up by a tenth of the overall increase between 1880 and 1890 or by 9,400 people, it would have stood at about 95,400 in 1886 (6 × 9,400 + 39,000). That today would make up a very small city. In 1880 the population density of the territory was 0.3 persons per square mile and in 1890 1.0 persons.[12] In 1886, therefore, it could not have been more than about 0.7. That density now would be lower than even Alaska, the least crowded state in the union. Moreover, most of the people were still concentrated in the Rocky Mountain valleys and foothills on the western side of the state where farming had begun as a service industry to the mining sector in the sixties and seventies.[13] The vast plains regions where most of the big ranchers had located were thus even more sparsely settled than the overall density figures suggest. It hardly seems possible that they were yet being crowded off the range.

Few ranchers who survived the 1886-87 winter started claiming that settlement was a major problem before the mid-nineties.[14] It was in 1895, when Montana's population had increased to almost twice what it had been in 1886, that James Fergus complained about the sheep having taken "all our home range," and the watering places being "nearly all fenced up." We are, he said, "obliged to take our cattle to the badlands and herd them."[15] Interestingly, even then, he blamed the financial difficulties he was having on other things too, including "wolves, hard winters, Indians, half breed[s], thieves and mud holes."[16] By the nineties the open range system had largely been abandoned in some two thirds or more of the territory.[17] At that time, however, most regions like Fergus County, which had been invaded by homesteaders, were still sparsely enough settled that they had large, unfenced, publicly owned "commons" on which cattle operations of all sizes were allowed to graze their animals.[18] In 1895 the *Rocky Mountain Husbandman* was still looking forward to "the time ... when the tide of immigration of farmers will set in, our valleys become populous and our rural wealth multiply fifty fold."[19]

In Canada the commonly assumed argument is at least as difficult to make even though most of the original ranchers lasted well into the settlement period. The original lease legislation and further regulations in 1892 and in 1896 allowed them to purchase substantial proportions of their lands at favourable rates. After the Calgary Edmonton Railway came into existence in the 1890s, in order to finance construction, it sold ranchers sizeable pieces that the crown had granted it in the foothills. Also, between 1906 and 1911 the ranchers were given the right to bid on the precious water reserves that had been protected for them over the years by successive federal governments. The directors of a number of companies took advantage of these opportunities and

their pasture lands, though considerably reduced, remained very large by industry standards. The Bar U, for instance, held close to 19,000 acres of deeded land, the Cochrane 63,000 acres, and the Walrond some 37,500.[20] As occupation of these lands was now based on private ownership, they were impervious to settlement, however dense. And yet nearly all of the Canadian cattle outfits had ceased open range operations by the end of the first decade of the twentieth century.

In neither case, then, does the argument that the great ranches were crowded out seem to hold water – or at least to offer a complete explanation. Much more important in bringing the ranching era to a speedy conclusion was misplaced confidence in a number of basic premises that originated with the early promotional literature. This can be illustrated with respect to four principles that the publicity expounded, and which all the early ranchers seem to have believed in: 1, that the northwestern plains were so immense that an unlimited number of animals could graze on them virtually forever; 2, that the dry natural grasses in these regions were so nutritious that cattle could be grass-fattened efficiently year after year; 3, that cattle could fend for themselves on the open range summer and winter with very limited human intervention; and 4, that fattened animals could be shipped efficiently and cheaply over the long distances to the East and overseas.

It is more clear-cut to demonstrate the misguided nature of some of these ideals than others. Probably the easiest misconception to refute is the belief that cattle could be left alone to graze throughout the year. "In the 'old west' and eastern states the stock grower is always obliged to work hard for six months of the year to raise food to keep his cattle through the severe wet winters," the promotional literature had said, while on the northern Great Plains, "cattle are especially self-reliant, and if left to take care of themselves, winter and summer, will grow while their owner sleeps, and come off the range, even in the spring, in good condition for market."[21]

Few ranchers did any significant preparation for the cold season. They did not provide barns or even high-board fences for the animals to take refuge behind when cold winds blew across the region, and few put up anywhere near sufficient amounts of hay to feed them when the snow was deep.[22] Consequently, they were in for a rude awakening. In Montana Conrad Kohrs soon learned that the "hard winters" that killed so many grazing animals would in fact hardly ever be further apart than "five years."[23] In Alberta and Assiniboia nine out of the first twenty-six winters following 1881 brought widespread distress to the herds and financial hardship to their owners.[24]

Stories of devastation on both sides of the border are legendary. Indeed, even as the era of the great ranches was opening, the ranchers

Dead cattle, Shaddock Boys Ranch, Langdon, Alberta

starting up in Montana must already have wondered if the promoters had lied to them. On 13 January 1881 James Fergus wrote to his son: "5 inches of snow fell night before last and 8 inches last night and [it is] still snowing fast. It is not cold and the snow settles very fast but it is deep all over the country and stock [are] dying. George Breck in one day looking for horses in the valley counted 110 head of dead ones and there is said to be about 50 in the neighbourhood of Silverman's ... I expect everything will die here."[25] His expectations were only a little overstated. In the spring the "coulees were dotted with dead critters and skinners were peeling them for their hides."[26]

But for Montana the pivotal winter was 1886–87. It illustrated the fallacy not only of the appropriateness of winter grazing but also of the capacity of the open range to handle innumerable cattle. Much-needed rains did not fall over the previous spring and summer, and drought set in. At the same time the ranchers tried to graze unprecedented numbers of cattle.[27] "Ranges adjacent to Miles City are dangerously overstocked," the *Rocky Mountain Husbandman* warned on 20 January 1887, "and the grass last fall and summer eaten down more closely than ever before ... Unless cattle are kept well back in the hills where the grass was allowed to grow unmolested ... it cannot be expected that they will come out of the winter in a condition to fatten for the market very early next summer."[28] In fact many of the cattle went into winter "poor in the flesh" and they starved and froze to death very quickly. The snow did not come until after Christmas but when it did fall it refused to stop. "There was two feet on the level," and, to find the public road, the stage line had to have men "stick willows in the snow." Those willows "in part of the road were [still] standing in May."[29] One night Jesse Phelps, the owner of the

Waiting for a Chinook

OH Ranch, got a letter from Louis Kaufman, one of the biggest cattlemen in the country who was living in Helena at the time, wanting to know how the cattle were doing. When the letter was shown to Charlie Russell, he was inspired to sketch his famous picture of a starving and incredibly skinny cow, standing head down in the storm with hungry coyotes circling, ready to feast on its bony carcass.[30] It said all that needed to be said. "It was a wicked winter, hard cold and steady." Some ranchers "spent most of it in the saddle, turning back their cattle from ranging too far and digging them out of snow drifts – all for nothing. There was not enough feed to give them and they died by the thousands."[31] A few of the big outfits called whatever they could find of the remnants of their workforces back to service during the winter and the men worked feverishly to push as many cattle as possible back against the wind and up into the protection of hills and trees. They apparently saved thousands, but losses were still enormous. And the strain on the workers was incalculable.

Think of riding all day in a blinding snowstorm, the temperature fifty and sixty below zero, and no dinner. You'd get one bunch of cattle up the hill, and another one would be coming down behind you, and it was all so slow, plunging after them through the deep snow that way; you'd have to fight every step of the road. The horses' feet were cut and bleeding from the heavy crust, and the cattle had the hair and hide wore off their legs to the knees and hocks. It was surely hell to see big four-year-old steers just able to stagger along."[32]

"The disastrous results," the *Rocky Mountain Husbandman* later declared, "were such as to strike terror to the hearts of all live stock

owners and no sooner did it become a settled fact ... than stockmen throughout the territory at once sprung to their feet and set about whatever preparations were in their power to render their herds" more secure for winters of the future.[33] In other words the system of leaving cattle to fend for themselves summer and winter was largely invalidated. Estimated losses ran from 50 to nearly 70 per cent.[34] When Gibb brothers had gathered all their animals they discovered that a mere 320 of about 2,500 were still alive.[35] On actual count Teddy Blue Abbott figured out that Granville Stuart's herds were reduced from 40,000 to 7,000.[36] In the fall of 1886, the Montana-Nebraska–based Niobrara Land and Cattle Company had claimed to creditors and investors that it had 39,000 head of cattle valued at over a million dollars; it had liabilities amounting to three hundred and fifty thousand dollars. After the spring round-up its riders managed to find only 9,000 cattle, "valued nominally at only $250,000 and actually worth much less." In Custer County two hundred operations had been assessed for over twenty head of cattle by the Montana Stock Growers Association in 1886. Two years later "only 120 were still so assessed," and "the average size of their holdings was considerably smaller than at the previous date."[37] Numerous ranches and ranch companies were either forced into bankruptcy or took stock of their depleted position and abandoned the profession.

Of course, not all the ranchers of the period followed the trend; there were a number of notable exceptions. In 1891, for instance, Frank Bloom purchased land at the junction of Assiniboine Creek and Milk River, six miles north of the village of Malta, where he established a ranch headquarters for the Circle Diamond Ranch. In 1892 he trailed in some 25,000 steers. Within a few years, under the management team of Bloom and John Survant, the Circle Diamond was pasturing between thirty and forty thousand head of cattle on range rights running east to west from Hinsdale to Chinook in the valley of the Milk River and south to north from the Milk River to the Canadian border, an area encompassing some $2\frac{1}{4}$ million acres.[38] In 1904 Bloom and Survant expanded once again by taking a large lease across the border in southern Assiniboia. Another case of bucking the trend was the N-N ranch, owned by the Neidringhaus brothers. They lost 20,000 head in 1886–87, but stubbornly continued to bring herd after herd of yearlings and two-year-olds from Texas to winter on the northern ranges. In 1891 they apparently paid taxes on 100,000 head ranging in Custer, Valley, and Dawson counties. In 1893 they shipped 23,000 to market.[39]

Conrad Kohrs essentially went broke in the winter of 1886–87. He got a chance to start over, however, when his former partner, the Butte

banker A.J. Davis, lent him 100,000 dollars without security. In the spring of 1888 he bought 9,000 head in Idaho and turned them loose on eastern Montana ranges where he started up again as the CK outfit.[40] In later years he also grazed several thousand head on the Milk River range as the Pioneer Ranch and he took up a lease under the Pioneer name on the Canadian side.[41] Pierre Wibaux had come to Montana in 1882 and started up a herd on the eastern ranges. He was in France lining up investors when the storm struck, and he returned loaded with nearly half a million dollars of new capital. During the next few years he was able to expand with purchases of the cheap cattle that became available as others were selling out. In 1890 he bought out the Powder River herd, and was said to have been branding 10,000 calves a year by then. The celebrated Matador Ranch controlled a large parcel in northern Montana. It continued to hold onto this and, as of 1904, a sizeable lease in Assiniboia, until well into the twentieth century.[42]

Despite some successes, however, large-scale open range ranching such as these outfits were engaged in was now almost totally confined to the regions north of the Missouri River and in the eastern and southeastern regions of the state more or less in the wake of the Yellowstone River.[43] Hired hands from other parts of the state who wanted to cling to the life of the cowboy moved north or east to join them. Charlie Russell was one who passionately loved the old ranching ways. In 1892 he told a friend, "I left the Judith country like all cow punchers ... the big herds have moved out across the Missouri River. I am now on Milk River. This is a good cow country and as the greater part is badlands ... it will last."[44] Actually such areas had experienced the greatest devastation in 1886–87 as the drought had been the most severe there and the relatively flat and treeless environment lacked much in the way of natural shelter for the cattle.[45] The reason the open grazing system continued a while longer, however, is that the soils were considered too thin and the climate too dry for the ranchers to move on to a more intensive approach (or sell out to farmers who wanted to try one). The cattlemen stuck almost exclusively to fattening two- and three-year-old steers for the slaughter market, since that younger, hardier type had proved much more durable through cold spells than the gestating cows and the overworked breeding bulls.[46]

Canadian herds were also devastated in the 1886–87 winter. Again it is hard to get reliable estimates but a well-known journalist believed that "the average" loss was "about twenty-five per cent in the Calgary district, fifty to sixty per cent from High River to the Old Man's River, twenty to twenty-five per cent in the Pincher Creek country, and fifty per cent in Medicine Hat." Statements by or about individual cattlemen

painted a very bleak picture. A rancher from Nanton offered the opinion that "few ... lost less than 40 per cent, some losing 100, many losing 75 per cent." The Quorn lost "nearly every hoof." Tom Lynch, who had imported nearly three hundred stockers the previous summer, was left with eighty. The N Bar N outfit of Montana had just started operations in the Wood Mountain area the year before with six thousand cattle. Its cowboys pulled out of Canada in the spring trailing a scant two thousand. However, the death rate appears to have been somewhat lower in Canada and large-scale ranching was not destroyed to the same degree. There were two ostensible reasons for this. First, the Canadians had not yet got to the stage where their ranges were overstocked. In 1886 the Great Plains north of the border contained only about 130,000 cattle – perhaps a seventh of those in Montana.[47] Therefore the animals had not needed to compete as much for the available grass and almost certainly entered the winter in a hardier state than the American stock. Second, most of the bigger Canadian outfits were situated in the foothills up against the Rockies where the lofty mountains and dense forests helped to protect the herds from the icy winds that blew in from the northwest. "The Home Cattle Company whose range is at Wood Mountain, 400 miles east of Caglary, lost 4,000 head out of 6,000," the *Yellowstone Journal* announced in the summer of 1887. "Alberta stockmen whose losses were small in comparison may consider themselves lucky."[48]

For the Canadians the pivotal moment came twenty years later. The winter of 1906–07 was the last straw for many cattlemen and, after it was over most of the great ranches and a good number of the smaller ones followed their Montana counterparts into the annals of history. The disaster actually began in the autumn of 1906 when fires, along with an extremely dry late summer and almost unending hot winds from the west, damaged much of the pasture across the entire country south of Calgary. A bad outbreak of the parasitic disease known as the mange also left many cattle with a lot of the hair scraped off their hides and thus poorly protected from the cold. This situation was made substantially worse by the fact that Canadian ranchers were now also overstocking their ranges.[49] Cattle entered the winter in poor shape and found it more difficult than usual to rustle up enough feed to survive.

Years later a rancher from the Rosebud area near Gleichen recorded his reminiscences of the destruction to the industry and of the enormous effort some ranchers went to in a futile endeavour to save their herds.

Serviceberry Creek and the Severn Creek were the places where the most cattle perished. I started to make a rough estimate of the dead cattle in the Severn Creek starting from where Rosebud is today. In the first mile I counted

200 head but it proved too big a job. In the high water of spring the dead cattle went off downstream, and those that had died on the prairies just dried up in their hides ... Along in February a Chinook blew for a few hours and just enough snow melted to form an ice crust on the deep snow. Then a blizzard came up lasting for a day or so. The ice crust cut the cattle's feet and legs until they bled, and even our saddle horses' legs got sore. I rode the range nearly all winter in a vain attempt to keep our cattle from drifting away. I brought a few to the feed lot ... these cattle [were so weak and sick that they] had to be lifted up by the tail each day, and when the warm weather came they would not eat a bite and nearly all of them died. A favourite place for the cattle to pile up was in the pot holes of small creeks. The sheltered holes gave relief to the suffering animals until they finally got away from it all in death. I found a hole one day that was full of the dying animals so I mercifully destroyed them.

We went about a week skinning at [a neighbour's ranch] in bitterly cold weather [so the hides could be salvaged and sold]. A hundred or more [cattle] lay in his feed lot and by the time we got finished another [hundred] would be piled up. We finally left as it was hopeless to keep up with the dying cattle.[50]

Overall losses in Alberta and Assiniboia were about the same as they had been in Montana twenty years earlier.[51]

If misconceptions about winter grazing and unlimited space proved disastrous for the ranchers on the northwestern plains, the idea of keeping labour costs down to the bare minimum made them worse. In February 1887 as the storm raged, a newspaper man in Miles City calculated that a significantly larger work force might well have saved a lot of animals by guiding them to areas where they were better protected from the elements. "Along the river bottoms dead cattle were seen in some profusion," he said, "and also on an island in close proximity to the town [of Hathawa], but up in the hills not a dead animal was visible, nor any ready to die." His conclusion was that the losses "could have been materially decreased by proper range riding and attention, such as can only be obtained from the employment of triple the number" of men to drive "the cattle out into the hills where shelter and feed can be obtained." The writer was criticizing the ranchers' convention of laying off high numbers of their men in the wintertime. However, he was also at least inadvertently suggesting that the workforce needed to be larger throughout the year. In future, he stated, the ranchers are going to have to set more men to work "in the summertime [too] putting up hay for stormy weather [and] building sheds to protect livestock from climatic extremes."[52]

As bad as the two pivotal winters were for the ranching industry on the plains, one must be careful not to overstate their importance in

bringing the open range system to an end. In the first place, while it is evident that they vastly speeded up the abandonment of year-round grazing, they did not initiate it. This was the case even in central Montana where large-scale grazing came to an end almost as quickly as it had begun. In the fall of 1886, just before the first of the most tragic winters unleashed its power, the *Rocky Mountain Husbandman* had already observed: "There is a tendency noticeable now for the country to return to small herds again, and though large herds may stay with us for many years yet, the bulk of the business five years hence will be confined to small owners."[53]

A second mitigating factor is that the ranchers seem to have themselves been understating their previous losses that were attributable to frontier factors to keep their investors happy or, in some cases perhaps, to avoid coming to grips personally with their own economic plight. In compensating, they now overstated the immediate damage to clean up their accounting. As Colonel Sam Gordon, editor of the *Yellowstone Journal*, stated, "it was a hard winter" but "it came as a God-sent deliverance to the managers who had for four or five years past been reporting 'one percent losses,' and they seized the opportunity bravely, and comprehensively charged off in one lump the accumulated mortality of four or five years. Sixty percent loss was the popular estimate. Some had to run it up higher to get even, and it is told of one truthful manager ... that he reported a loss of 125% ... The actual loss was probably thirty to fifty percent, according to localities and conditions."[54]

On top of their previous unwillingness to face the declining values of their bovine inventory was the fact that almost all the big ranches had originally bought their stock on what was known as "book value"; that is, because it was difficult counting the animals on the open range, they had accepted vendors' written accounts of the numbers they should have had based on original herd size and the estimated death and birthing rates over the years. J.R. Craig of the Oxley outfit defended the Canadian ranchers' acceptance of this system by pointing out that herd size was often confirmed by checking the number of calves the vendor had branded during the previous season and figuring on a 25 to 30 per cent yield. With that formula, a "branding of 500 calves" would have represented "a herd varying from 1,800 to 2,000."[55]

This had to be a very dubious assessment. For one thing, in any given year the calf yield could vary greatly from the norm or, of course, the branding count itself could be inflated by the owner. The truth of the matter is that few large-scale cattlemen had an accurate estimate of their herd size when they started and almost none did a regular tally.[56] They simply relied on the figures their vendors gave them and then used various formulae themselves to try to approximate where they

stood thereafter.[57] In short they were guessing and, given the incredible optimism with which this industry started, the natural tendency was to guess high. In the nineties the Walrond ranch in the foothills of Alberta estimated its death losses at 5 per cent per year. As it turned out, this was far too low.[58] In 1895 one of its directors announced: The English shareholders "have determined to quit the business ... the affairs of the company will ... be wound up as quickly as possible ... the returns for the years past not having been what was expected."[59]

Managers on some big ranches had frequently found themselves faced with major discrepancies, and the well-publicized terrible winters gave them the perfect opportunity to come clean without seeming incompetent or corrupt. In reality, livestock roaming the ranges on their own regularly succumbed to a host of environmental forces that together must have been almost as destructive as the bad winters. These included predators. Along with the two-legged type dealt with in an earlier chapter, the four-legged kind also preyed on the herds of both cattle and horses.[60] "Wolves raiding cattle has become serious," the *Yellowstone Journal* stated in 1886.[61] Eight years later the manager of the Walrond Ranch noted in his journal that one settler who owned a "small bunch" of cattle "ranging within a few miles of his shack," had lost "no less than nineteen head" to wolves.[62] The same month he informed his boss that within a few nights on their own spread the animals had killed ten head of yearling colts as well as a number of yearling cattle and calves. "They seem to have migrated up into this district since spring," he said. "We found several of the carcasses freshly killed, in fact warm, and poisoned some of these but the wolves did not touch the bait."[63] The beasts often ran in packs and were known to bring down even full-grown cows.

Ranchers and their men tried several means to defend their stock. They shot the wolves with rifles and six-guns, hunted them down with hounds, and roped them from their horses either snapping their necks or dragging them across the prairies until they were dead.[64] However, strychnine tablets placed in the carcasses of sick cattle or the horses the men shot or found dead on the range seem to have been the best defense, as sometimes numerous predators could be destroyed when they devoured a single carcass.[65] The ranchers learned to cut the dead animals open and drag their carcasses across the range so that the wild creatures would be attracted by the smell of the blood.[66] On both sides of the border the governments and stock associations offered bounties for shooting the animals, and professional "wolfers" both Native and white appeared.[67] However, the livestock herds continued to be plagued by wolves, as they wandered so far from human supervision so much of the time. They also became prey to mountain lions,[68]

wildcats, and bobcats.[69] It was only in the era that followed that of the open range, when the pressure of human population pushed four-legged predators off the plains and reduced their overall numbers, that this threat was to be alleviated.

The other major source of destruction for unsupervised herds was disease. This was a particularly difficult problem in the free grass period because of two frontier factors. First, the thousands of animals brought in all the way from Texas, Oregon, the East, and overseas brought with them all the disease pools of their home lands. Second, since the animals on the open range mingled freely over great areas they could share all the infections they had contracted either in distant lands or on the frontier itself. As a result unidentified illnesses broke out among both cattle and horses in epidemic proportions from time to time. In 1887 a huge percentage of the Montana horses were wiped out from unidentified infections.[70] From the southern Montana ranges to those north of the border, cases of a well-known illness called glanders kept appearing. It "has been found throughout the northwest and needs to be stopped," the *Yellowstone Journal* quite rightly announced in 1887.[71] There was no cure, however, and when the disease was discovered the only realistic course of action was to destroy the infected animals.

Among cattle the most frightening plagues were blackleg, pleuro-pneumonia, for which both Canadian and American cattle were eventually embargoed in Britain,[72] and foot and mouth disease.[73] Such diseases could suddenly and without warning destroy a herd. "One morning I rode south to where our cattle ranged and everywhere were dead yearlings," a rancher remembered. "In a few days most riders were also finding dead young cattle, so the veterinarian" was called in. "When he was told that only yearlings were dying and that a front shoulder would puff up and crackle when touched with the hand, and was black when scored with a knife, he knew without coming to see the dead animals that the disease was blackleg."[74] A vaccination for blackleg became available in 1895.[75] However, outbreaks kept appearing probably because some cattlemen did not know about it or just never got around to using it. Regular appearances of somewhat less destructive but nonetheless costly ailments such as pink eye, lump jaw, and tuberculosis as well as periodic localized epidemics of unidentified maladies also gave the cattlemen lots to be concerned about.[76]

Ranchers on both frontiers well understood that a great many diseases were regularly passed from animal to animal. Governments on both sides passed quarantine regulations in the eighties in an attempt to stop the spread of infections from incoming herds[77] and in 1887 the Montana Territorial Legislature enacted legislation making

it illegal for anyone with diseased animals to allow them to "run on any range," or even in any enclosure where they might "come in contact with any other animal not so diseased."[78] The effects of such measures were disappointing and outbreaks of all sorts of infections continued. Ultimately more costly than any was probably mange. It spread through the Montana herds and on up to Canada in the late 1890s.[79] The disease is a parasite that attacks the hides of both cattle and horses, causing them tremendous discomfort. It usually manifests in gigantic sores because the animals tend to scratch against trees, posts, buildings, or anything else they come across until their hair drops out and their hides are torn. The only way to treat mange was to conduct a special round-up and dip the animals in tanks filled with a solution of kerosene and/or sulphur mixed with lime and water.[80]

Even dipping was far from foolproof until the range was divided by fences and each ranch's animals could be kept in their own enclosed pastures. In 1902 the *Rocky Mountain Husbandman* aptly illustrated this. Rancher A, it said, "goes to the expense of putting in a dipping vat and buying dip," then he "dips his cattle in a thorough manner twice, takes them home and says he is A all right so far as itch is concerned. The next evening he rounds up his cattle and finds three or more of [his neighbour's] diseased cattle in his herd and two weeks later finds his cattle" more severely infected than before he dipped. The paper went on to suggest that government officials should make sure that all infected animals on the range are "close-herded" by their owners to keep them separated from healthy herds and then "compel all cattle to be dipped twice" every year.[81] Two years later the Federal Government passed just such a law, but enforcing compliance seems to have been difficult and it was far from successful.[82]

Among the cattle on the Canadian ranges, mange became so widespread that the government erected tanks in strategic locations near the border in which to dip animals imported from the United States.[83] In 1904 it declared a huge tract running east of the Rockies well into Assiniboia "an infected place" and ordered that all animals subject to the contagion in that area be isolated and treated.[84] This measure did not have the desired effect either, and livestock associations soon began to develop a communal approach to dipping the cattle. This was costly not just in terms of the construction of the vats, tanks, and corrals needed to process the animals but also because of the special round-ups that had to be undertaken. The cattle had to be trailed in over long distances from all directions and be held in crowded conditions for days at a time waiting to be dipped at least twice; and they also had to endure the frightening process of being forced by their alien tormentors through the vats of hot, stinking solution. The following

description by "Dude" Lavington of a mange round-up in southern Alberta colourfully conveys the wear and tear on the stock.

There were two epidemics of mange in the area entailing extra roundups. Of the first I can only remember Dad riding away with two saddle horses, one with a light pack on, as on spring and fall roundups. But the second mange epidemic produced one of my most vivid memories. I was seven years old at the time.

Every hoof of stock on the range had to be rounded up and dipped. The dipping vat was about forty miles away at Sam Savage's ranch. Being summer time I was out of school and allowed to go on this roundup. A lot of the ranchers in the area pooled their stock and drove together. Dad had close to four hundred head then and Ralph, my cousin, had about one hundred and fifty. Roy Seeley and Ralph and Dad and I went with our drive. We were soon joined by seven or eight of our neighbours, and their stock, and quite a few more riders ...

The nearer we got to the dipping vat the more cattle we came in contact with, till, toward the last, the whole countryside seemed to be a moving mass of cattle. Somehow we had to hold ours separate from other herds till it came our turn to go through the vat. We moved our cattle closer as other herds ahead of us went through, and the last day or so we had our herd in a fenced holding pasture and didn't have to night herd.

The vat was on the shore of a lake. Sulphur and lime were mixed with water and boiled awhile. A steady stream of the stinking mixture was being pumped into the vat from one side, and lake water was being pumped in from the other side. There were great big holding corrals which funneled into a chute, and this in turn funneled into the vat which, I believe, was forty or fifty feet long.

Cattle dived off a platform and went right under for a few seconds, came up snorting and blowing, looking like drowned rats, and then swam to the far end and walked out. This steady stream of cattle went through day after day for weeks and months. I felt very sorry for the poor miserable-looking devils. After they had gone through once, we had to hold them again till our turn came around to run them through again.

I vaguely remember our camp. It was hot and clear in the day time and around the corrals a fog of dust all day. We had no tent and just spread out blankets on the ground at night. I can remember getting mighty chilly before morning, so I reckon our bed roll was pretty skimpy. I even seem to remember having frost one morning.

After the last dipping we started for home, and when the herd realized they were not just being held, they really started to line out. There was a lake well over a mile wide right across our general homeward direction. These cattle had been forced to drink horribly dirty, riled up water all the time they had been held. Now they got the smell of this fresh water and a stampede started for the lake ...

Dipping tank, Russell Ranch, Drumheller, Alberta

That huge mass of moving, running cattle, with their horns flashing in the sun and their hooves rattling, was really something to thrill anyone. The leaders were pushed a mile or more out into the lake by the very momentum of the herd, and must have caused a small tidal wave on the far shores of the lake. Soon they were all swimming; a sea of swimming cattle, and there was no turning them back.[85]

There is little question, in addition, that all the livestock lost weight during the ordeal and that some must have contracted other illnesses like bad colds, pneumonia, or worse.[86]

The open range system not only promoted the transmission of diseases but, as time and experience taught the ranchers, it also allowed for a plethora of other destructive phenomena. In 1905 a Montana rancher surmised that "nature and man had combined for the undoing of the cattlemen ... The average price of all the beef steers sold this year, he said, "has not been $3.40 per hundred, and the average net loss ... cannot have been less than $10 per head when all sources of expense and of loss are taken into account. By that I mean maintaining ranches, winter feeding, interest on investment, taxes, losses by storms, air holes in the reservoir ... wolves and the irrepressible rustler."[87] Another way to state this is that cattle need help and protection on a regular basis. Turn them loose without proper human supervision and they are liable either to die of starvation or to be taken by one of the environmental or human adversaries of the range. The journal of Billie Cochrane, who came West to run the Cochrane Ranch for his father

Montana cattle

in 1884, illustrates the assortment of difficulties unattended cattle can get themselves into. In January 1885 he recorded that two calves and two bulls were found dead from unknown causes; one bull also fell into the well in a neighbour's milk house and broke his neck, and two more were found dead in another neighbour's stable. Presumably they had ventured into it and then starved to death because they could not get out. Cochrane also noted that some of his cows were giving birth in the depth of the winter, at which time the survival rate for the calves was vastly reduced, and that some calves had no mothers, presumably because the cows had died giving birth on their own. In March, April, and May he recorded that a number of animals had been found dead and that Natives were skinning them as well as killing and butchering live ones for food. Two animals also were lost after getting "mired in the mud" and another after falling down a bank and into a creek.[88] Cochrane, who had thousands of cattle at this stage, was not reporting, nor did he know, all the deaths among them. He was just listing those he happened to find out about for a short period of about three months. Unquestionably there were lots of other losses from sickness and a number of other causes that went unnoticed.

In listing the difficulties they were becoming familiar with on the open range, the ranchers might also have mentioned the poor quality of their herds. Partly in their quest to keep labour costs down, the first ranchers generally did not try to exercise much control over breeding.

Alberta cattle

Some of them invested in good stock but inevitably poor or "scrub" bulls were turned out with the cows of less discriminating operators, and very ordinary male calves were missed at castration time and became breeders as soon as they were old enough.[89] To try to rectify this situation the Montana Stock Growers Association in 1885 stipulated that all its members should turn out bulls that were "$^1/_2$ pure now and $^3/_4$ pure in 5 years."[90] However, few members seem to have responded and, with their extremely limited workforces, there was no way for the ranchers to ensure that the right bulls mixed with the right cows. Therefore, characteristics of some of the worst animals tended to make their way down through the herds. The animals on both ranges were generally described with adjectives such as "low and inferior,"[91] "nondescript,"[92] and "wretched"[93] – and even "inbred" – for the duration of the frontier period.[94]

A skeleton labour force also meant that conception and birth rates were lower than desired. Not only were the ranchers unable to control which bulls mixed with which cows but they also could not determine when breeding took place. The gestation period for cows is nine months. Ideally, bulls should be put out with them in June and gathered up again in late August so that the calves are all born in March, April, and May. This timing ensures that they do not see their first light of day when the weather is least cooperative and also that they have enough time to grow and fatten on their mother's milk to deal with

the winter months when they come. Because the ranchers let so many of their men go between round-ups they did not have the manpower to control their bulls the way they should have. Thousands of calves were born between the fall branding and the spring round-up and many of them were lost. Moreover, the ranchers soon learned that to keep gestating and nursing mothers strong enough to produce healthy calves under harsh environmental conditions when the grass was less than abundant, they had to go to the expense of providing extra feed for them. "There are quite a number of calves arriving at present," J.F. Scott of the Walrond ranch reported on 7 February 1891, "they are all gathered and the cows fed."[95]

The ranchers also had difficulty ensuring that a high enough percentage of their cows conceived. The members of the Montana Stock Growers Association were particularly concerned about this. They figured, quite optimistically, that only about 70 per cent of their cows were getting pregnant, while dairymen in their state were achieving something like 90 per cent conception rates. To a certain degree this low rate was due to the fact that some cattlemen felt they need not go to the expense of buying a lot of bulls because, since all the herds on the open range effectively ran together, bulls from other ranches would do the job. This practice led to an overall deficiency, and ranchers were repeatedly admonished to stop relying on neighbours to keep their "she-stock" serviced.[96] The problem was not just one of numbers, however. Without constant attention, bulls on large pastures did not have the common sense to hunt for cows in heat. The tendency was for several to stay together, fighting and jostling with each other in an attempt to access a single receptive cow. Or several might spend their weeks with a small herd of cows competing for each one as it came into heat. Bulls are a little more agile than pregnant cows or those with calves at foot, and so they also sometimes drifted further in bad weather. "The report of the losses in bulls was unfounded," Duncan McEachran wrote after the terrible winter of 1886–87, "they had merely separated from the herds as the Buffalo used to do and got off in 'bunches' in the hills and coulees."[97] Whatever the case, a considerable amount of breeding power was wasted, and a good proportion of the she-stock never managed to get serviced at all. Cattlemen with big herds solve this problem today by keeping cowboys riding through them constantly to spread the males out, but for the major frontier ranchers this was impossible. Their herds were too big in comparison to the labour force and they dispersed too widely across the unfenced land.

Some of the ranchers might well have anticipated some of these problems when trying to calculate beforehand what their profits would

be. But few, if any, seem to have grasped the full implications of all of them combined. Even if none of these difficulties had emerged when the ranchers commenced operations, however, they would have found that one of their most basic and fundamental assumptions – that cattle could be properly and efficiently fattened on the hard grass of the arid plains – was far from sound. The brief ranching history of the Powder River Land and Cattle Company appropriately illustrates this point. This operation was started by Sussex-born Moreton Frewen, who appeared in Wyoming Territory in 1878, became enchanted with the plains, and with his brother Richard started an enormous operation that eventually covered some 4,000 square miles in northeastern Wyoming and southeastern Montana. In 1885 he also took a large lease in the Canadian Territories that he was forced to turn over, before he ever got a chance to use it, to Sir John Lister Kaye. It eventually became the immense Stair or 76 ranch.[98]

The Frewens started with some 13,000 cattle and then after the dissolution of their partnership, Moreton expanded dramatically in 1882 by forming a syndicate with the Duke of Manchester and a number of other members of the elite British aristocratic and land-owning classes. At one point he reported that he had 40,800 head, for which he had paid $1,041,000.00.[99] Frewen believed all the misconceptions of the enthusiasts and repeated them at length when encouraging his investors to get involved.[100] During the short interval between 1882 and 1886 when his partners fired him as their manager, he saw all his illusions shattered. This is abundantly clear in the letters he wrote to his board of directors in England and his wife in New York, in which he talked of rustlers and winter storms taking the unattended cattle and the problems of disease, low calving rates and overstocking of the ranges.[101] The last great illusion to go, and the one with which he struggled the most, was the belief that the cattle could be properly fattened on the marvellous hard grasses of the Great Plains and then, because they were so well-finished by those grasses, shipped with only acceptable shrinkage over the great distances to eastern and overseas markets. "The shrinkage I have always observed is on the first two days on the trains, the result of the fright caused by the novelty of the position, and by the strangeness of the diet – hay," he told a friend. "You will bear in mind the immense difference between steers fattened on the soft green grasses of the Eastern States or England, & the solid flesh put on by these sun-dried mountain grasses; I am prepared to find that the shrinkage is less on this class of stock than even in the case with corn-fed steers."[102]

From that point on his lesson on finishing cattle had to be learned from the best tutor of all, practical experience. Frewen wanted at this

early stage to pay high regular dividends to his stockholders in order to attract more investment. Dividends had to come out of the proceeds of selling the finished product – fat cattle – so he was anxious to market as many as possible at the earliest practical date. For that reason he advised his board in June 1883 that he intended to reinvest some 25,000 pounds sterling from the fall sales to buy yearling and two-year-old steers. He believed this plan would improve his cash flows because these animals could start being shipped to slaughter in two years and thus fill the gap, so to speak, while he was waiting the necessary four or five years for the calves born on the ranch to mature.[103] After the fall round-up he gathered the older steers that had been in his herds at purchase, but was disappointed to discover that considerably fewer were ready than he had expected. "Markets hold up pretty well," he told his wife, "but still shareholders must be content with a moderate dividend as a great deal of the beef was not fat enough to market."[104] When he went to Chicago with what was left after cutting out the poorest of these cattle, he was even more disappointed. "The financial aspect is so bad that there is really a comic side to it," he wrote. "We had a thousand head on the worst market of the year ... but it was useless to think of selling more ... the fact is the cattle are not half fat, they must wait till next year ... Our sales will barely reach 4,000 head instead of some 7,000 as I had intended."[105]

The next year he was disappointed again. He told his wife: "The cattle ... which I had expected to be so good, are not half fat, and I can get no offer at all reasonable for them and they are not fit to ship to England."[106] Frewen was a fighter, however, as well as an eternal optimist, and he devised a plan to solve the problem. It illustrates his realization that grass-fattening on the much-touted native growth of the plains was not a viable approach. The plan involved turning to the expensive process that all the early ranchers hoped to avoid – intensive feeding. He set up a feedlot of sorts near Lake Superior in order to finish his most mature steers on hay and corn after the train ride east before offering them for sale. His spirits were lifted tremendously by the prospects. He first tried this with a small number of cattle to prove the advantages to his board in England. The "cattle [are] looking blooming," he wrote to his wife. "We shall have no difficulty in paying a ten per cent dividend on the six months ending last July and another ten per cent up to December during next April out of sales of cattle we are feeding and again a ten per cent up to June next ... Dividends twice a year will make us popular and I want very much to get support and a fresh issue of capital."[107]

The results of this experiment were again disappointing, however, possibly in part because he only tried a small percentage of the

available stock in the experiment and because they were of the poorest quality – "the tails to some 2,000 head," as he himself later put it.[108] Nonetheless Frewen was convinced at this point that only intensive feeding would solve the problem of under-finished carcasses. "I have been at the greatest trouble for twelve months to persuade the Board that they must establish a permanent feeding station," he said in August 1885.[109] Rather than admit that his earlier enthusiasm for the properties of the hard grasses had been misguided, he blamed over-stocking on the ranges, which he believed had now become so severe that it was preventing the cattle from getting enough to eat even during the summer months.

Evidence suggests, however, that he did realize that his earlier enthusiasm for grass-feeding had been misguided. He had by this time leased a large area in the Canadian Territories because he felt that there he would have the security of tenure he required to prevent overstocking. His intention was to move Powder Ranch cattle north and keep them on the range for two years to take advantage of a Canadian law that allowed American lessees to avoid a 20.5 per cent *ad valorem* import duty on cattle they brought to Canada on the condition that they kept them in Canada for at least that long. He did not, however, see this as a way to avoid feeding. Indeed, he felt that the only way to proceed was on the basis of his experiment – but this time in a big way.

By then Frewen realized that the Powder River operation was close to insolvency. "It is impossible that it can pay. Our calf brand is falling off, the steer calves of 83 are some 4,600, allowing for loss not more than 4,000 can be expected to come up as beeves next year. The steer calves of 84 will come up in 87 even shorter. Off the grass they cannot be relied on to get more than 30%."[110] Under severe financial stress, Frewen was concerned about getting the most per head possible out of his existing marketable animals so that he could pay off the ranch's preferred debt. Grain finishing seemed the only hope. In Chicago the ranchers sold to bidders by the pound and he felt he had to put enough weight on his steers to bring forty-five dollars a head or else "the enterprise is doomed and the property had better be wound up." Small under-finished carcasses would bring no more than thirty-two dollars, he estimated dejectedly once he realized that his board was not prepared to undertake the heavy outlay of capital.

Frustration at the inability to fatten cattle properly on grass alone was an experience that Frewen shared with a lot of cattlemen. From the beginning brokers in Chicago warned all the Western producers that if they wanted to get full value out of their slaughter animals they were going to have to keep them longer. In a circular newsletter printed in 1887 the livestock commission agents Rosenbaum Brothers and

Company reported that well-finished animals were bringing $5.00 to $5.10 per hundredweight. The range animals on the other hand were "coming too freely to improve in value." They were being discounted by almost two dollars. The company admonished the ranchers to hold back more of their steers and to do a better job of finishing. "Cattlemen had better ... take the chances of shipping late than to send them here now in poor condition."[111] The *Rocky Mountain Husbandman* frequently reiterated this view. "One of the surprising features of the western stock yards is the very large proportion of the cattle offered for sale in an unfinished condition," the editor observed in July 1895. This, he argued, meant that the ranchers were going to have to turn to raising more products from the land than grass. "Thousands of tons of wild hay are ungathered every year in this happy country ... that could be turned into first class beef ... thousands of acres of clover are unsown," and "car load after load of the grain now grown goes out of the northwest."[112]

As well as realizing the difficulty of properly finishing their stock on grass, ranchers also became aware of the cost of shrinkage on long journeys to market. Of course, this loss was particularly marked with shipments to Britain. Frewen wanted to supply that market and before he was fired he came to the conclusion that after he had saved the Powder River operations by getting his present animals big and fat enough to bring in the 45 dollars per head, he and the other cattlemen should limit themselves to producing what he called "store" cattle or big feeders for the British farmers to finish with their surplus grain.[113] In advancing this argument he reveals that he also had come to realize the flaws in the hypothesis of the contemporary literature that somehow the Western plains could produce enormous supplies of cheap beef ready for the palates of Europe's masses. "Fattening cattle in this cold climate," he argued, "is an expensive process." Moreover, "even when fattened," the stock "cannot be sent five thousand miles by land and sea without such a shrinkage that the profit on the transaction is destroyed."[114]

The following eye-witness report from a man who was employed on one of the ships taking cattle across the Atlantic in 1889 dramatically substantiates the hardships of ocean travel. On the boat this man, like the others hired, was in charge of twenty-five head of cattle in six pens. His duties included feeding and watering them and poking them with sticks to keep enough of them standing that no more than two in each pen could lie down at one time. Presumably this was to cut down on sea sickness. As the journey started everything went swimmingly. "The first three days out were passed in routine duty beneath a cloudless sky and over the most beautiful, the smoothest sea that I have ever sailed." Then calamity struck:

Soon after the 7 o'clock breakfast [on the fourth morning] I had barely finished my round of dealing out hay and water when suddenly a mighty gust of wind struck the boat.

My cattle were on the upper deck and I realized the full force of the hurricane, as its battering rams punched our ribs. Quicker than I can write it, another broadsider struck us. Black clouds instantly blotted out the sun. The sky grew as dark as night. All hands were called on deck. Coming up from the southwest, we could see a hideous mountain of storm rolling towards us, bounding at us, and the dense, frowning clouds split by blinding forks of lightening. In a moment the storm stood like a towering wall of death before us. The treacherous seas reared and bucked and pranced like a mad monster. The winds raved and tore and shook the boat as if it had been a toy, heaving her high on the crest of a frantic wave. Back we sank, with a swift and sickening lunge, into the valley of the waters, and the sea that had reared now pounced down upon our deck and broke with the thunder of a million guns.

I have seen animals panic-stricken in a billow of flame: but never before had I witnessed a scene such as this. Never do I want to see another one like it. My heart wept for the poor brutes as they caught the spirit of the coming disaster and bellowed and moaned in frightful distress ... Another wave, almost scaling the sky, it appeared, washed up and fell to pieces on our deck, crashing through all barriers. To save my own life I climbed in the hold and waited for the storm to die away.[115]

By the time the hurricane abated three men and seventy-nine cattle had been killed.

This was obviously a very bad and difficult crossing. However, many voyages must have involved quite rough seas and a good deal of shipping sickness among the livestock. The weight loss must have been substantial. Cattlemen today attest to the cost of shrinkage even among cattle hauled long distances under the best of circumstances over dry land. Before the opening of the twentieth century Americans took appropriate steps to curtail shrinkage en route to Chicago primarily by getting the railways to provide special stock cars with feeding and watering facilities.[116] Though these made the beef trade possible, steers still sustained a live weight reduction of about 7 per cent.[117]

Ranchers north of the border also continued to struggle with the difficulties of grass-fattening. "The cattle buyers were here a few days ago and looked through the cattle but did not think they would suit them as they said a great many of the older steers were too coarse for their purpose and the younger ones too light," William Bell told Duncan McEachran at a time when the Walrond outfit clearly could have used a fresh injection of cash.[118] A report written in 1909 by the Canadian veterinary-general gives further evidence that poor finishing

and weight losses on the way to market were both major problems. "Cattle wild, excitable and soft off grass," he wrote, "are driven to the railway, held sometimes for days on poor pasture waiting for cars, and finally, after more or less unavoidably rough handling, are forced" first on railway cars and then onto ocean liners. "Is it matter for wonder that after a journey of five thousand miles, made under such conditions our grass-fed range steers arrive in British lairages gaunt and shrunken, looking more like stockers than beeves, that our Scottish friends think we have no feed, or that I should declare a business so conducted as sinfully wasteful."[119]

The writer also observed that while the Americans had come to grips with their transportation problems they had also largely given up the entire idea of grass-fattening.

Our friends in the United States long ago realized the folly of shipping to Europe, alive, steers direct from the range. Their range cattle are brought to the Middle West, dehorned, if this has not earlier been done, fed for at least sixty days on a ration comprising a liberal allowance of grain, then sent to market, generally in Chicago, and carefully inspected and culled. Those deemed fit for export are then taken to the seaboard by fast trains and in cars specially fitted for feeding and watering en route ... As a result of these superior methods, United States cattle even when originally from the Western ranges, arrive in Britain in much better condition than Canadian cattle and, of course, command correspondingly higher prices.

At this stage, cattlemen in the Canadian West were also looking to their railways for better cars and beginning to embrace more refined feeding practices. Ranchers on both sides were also engaging in a much more intensive form of production in almost every respect than the system they had tried to rely on in the era of the open range. Generally speaking those who did not make the change suffered financially and dropped out. In Montana, as Robert S. Fletcher has put it, "while some of the large companies," bought land and changed their methods, "a much larger number gave up the ghost and gave place to small cattle ranchers who kept a few cattle or sheep, or both."[120] In Alberta and Assiniboia virtually every big ranch we know about experienced severe financial difficulties at one time or another. The Northfork Ranch near Pincher Creek ceased operations after only a few years because of heavy losses;[121] the Walrond Ranch was reorganized by Duncan McEachran in the 1898 because English directors were disappointed by their miniscule or non-existent profits. McEachran himself is supposed to have avowed a short time later that he regretted purchasing and reviving the operation.[122] He finally closed it down

after the devastating winter of 1906–07. The Stair ranch, which took over the Powder River lease in Assiniboia, closed down in 1909 because of depleted resources;[123] the Cochranes lost some 400,000 dollars in their first two years of operation and then sold out when higher land prices enabled them to recoup some of their losses in the new century;[124] the Ross Ranch in southern Alberta and northern Montana essentially went bankrupt after the 1906–07 winter and then again after the 1919–20 winter; the Turkey Track and Bloom outfits pulled out of Assiniboia after taking severe losses in 1906–07; A.E. Cross had to solicit a major injection of cash from his wealthy family in the East in order to carry on; and, finally, George Lane on the Bar U or North West Cattle Company struggled with enormous dept and insolvency before his death in 1926.[125] All such ranches on both sides of the border were eventually replaced by what was to become the family owned and operated farm or ranch-farm, which has endured to the present. The next objective here will be to document and to examine the most important reasons for the comparative success of that agricultural form.

10

The Triumph of Ranch Farming

While the great majority of the biggest ranches on both sides of the forty-ninth parallel were closed down either in the late eighties or in the early years of the twentieth century, many smaller ones managed to carry on by changing their methods. Most of these limited their operations to thousands, rather than hundreds of thousands, of acres and ran from several hundred up to two thousand cattle. They joined multitudes of new settlers in adopting age-old mixed-farming techniques and in so doing embraced an agricultural approach suited to the northwestern plains.

The model for an enduring form of beef production in this region was developed by the farmers who came to the foothills of Montana during the 1860s and 1870s. Most of the men who entered the business in the earliest days were migrants who brought a few head of cows to the area around the mining towns of Virginia City, Bannack, and Helena in order to market dairy products.[1] The first cattlemen initially squatted on public land and grazed their livestock in the valley bottoms between the mountains and the foothills, where good natural pastures sprang from the residue of the spring melt and the summer rains.

To ensure that their cows continued to lactate, these farmers had to keep them bred and calving every year. The first herds were composed mostly of dual purpose cattle, a mix of Shorthorns and dairy breeds such as Devonshires. Naturally, about half of the calves were males and of no use in the production of milk. In most cases they, along with any females that proved the least suitable for dairying, were pastured until they had substantial carcasses and then they were killed for fresh meat. In the beginning the animal husbandry practised with respect to the beef herd was, like ranching, extensive rather than intensive. The main reason was that the homesteaders were incredibly busy. While they were getting set up on the land they not only had to undertake

all the regular agricultural activities but they also had to create infrastructure for the future. They had to build some sort of dwelling for themselves and their families, corrals for their work horses, and a lean-to or barn in which to milk and shelter their dairy cows. As they turned to market gardening and began to put up hay and grains, moreover, they needed to erect fences to keep their livestock out of the crops.[2] None of this was easy. To acquire logs for buildings or posts and rails for fences they first had to fell Tamarack and Lodge Pole Pine trees with axes and then either float them out of the bush on a river or drag them by horse.[3] Then, of course, the farmers had to cut the logs by hand into the desired lengths for the specific facility under construction.

As a result, in the early years farmers gave little care and attention to much of their most resilient stock. Cattle, they felt, were big and strong enough to fend for themselves under reasonable conditions; they could roam the countryside finding their own grass and water and put up some resistance when attacked by natural enemies. They also understood that the cattle would grow heavy coats of fur in the wintertime to protect them from cold spells that were not too long or too severe. In the stage when they were constructing basic infrastructure, therefore, most livestock men took a chance with the cattle they were not milking every day. They usually rounded them up once or twice a year in order to separate out the animals they wanted to offer for sale. Otherwise, they pretty much left them alone in the wilderness both summer and winter.[4] This system gave the farmers a chance to get started and allowed their herds to grow considerably. By the late seventies many who had started with a handful of cows had augmented their beef herds by purchasing breeding stock and were running between a hundred and two hundred head. Some had as many as five hundred.[5]

This approach did not last long. It soon proved uneconomic largely because, as the ranchers were soon to discover, natural pastures were easily overgrazed and the elements on the northern Great Plains were too harsh for domesticated animals to withstand on their own.[6] When large-scale ranching started up and spread eastward across the plains in the late seventies and early eighties, most of the farmers in the settled valleys either got out of beef or sold their farms and joined the movement east. "About five years ago the ... boom set in and the range being pretty well eaten off in the settlements, those who wished to follow the tamer pursuit of farming sold their [beef] stock while others moved to the frontier," the *Rocky Mountain Husbandman* reported in 1886. The farmers who stayed in the older valleys concentrated on improving their dairy herds and building up their flocks of sheep,[7] while those who headed to the new ranges "bought additional cattle," or "c[l]ubbed together and formed stock companies" of their own. From

that point the production of beef was principally in the hands of big ranchers, or what the *Husbandman* rightly called "extensive owners."[8]

The settlers in the foothills did not stay out of beef production for very long. Seeing the market boom in the early eighties and realizing that the natural pastures were becoming replenished, many of them slowly reverted to grazing. This time, however, they took a more refined approach.[9] They kept their beef herds much smaller than they had in the past in order to control them better and give them more attention.[10] This was the era of barbed wire and by the early nineties Montana farmers had enclosed much of their pastureland so they could keep all their cattle close to home during the winters.[11] They also put up a lot more hay than they had in the past. If their lands bordered rivers and streams they dug ditches and canals to irrigate their fields, and they all plowed up fields of wild grasses to convert them to domestic varieties such as timothy, brome grass, clover, and alfalfa.[12] Thus they were able to keep a better watch on their herds and offer some protection from wild animals, as well as getting feed to them when necessary over the entire winter. Most continued to pasture beef cattle in the summer on a communal, largely open range system, but now they gathered them up at the end of the season. Rounding up the herds and fencing them in allowed the cattle to be sorted according to age, size, and gender. The bulls could also be held back until early June so that the beginning of the nine-month gestation period could be set to produce a calf crop during the spring or early summer. As these setlters improved their corral systems and added chutes and squeezes, they began to ensure that their animals were properly branded as security against frontier thieves.

By the late eighties the typical valley settler had become what might be termed a small, diversified mixed farmer, and he owned most of his land. He had begun as a squatter but once he had the basic infrastructure in place, he secured his holdings through the *Homestead Act*, the *Preemption Act*, the *Desert Land Act*, or the *Timber Culture Act*[13] or by purchasing land from the railways.[14] He had expanded his dairy herd to between twenty-five and thirty-five head, which he fed and milked inside a barn in the summer, and he now also kept a herd of about forty beef cows and a few horses.[15] He probably owned around 320 acres of land. His beef cows roamed communal pastures in a free range situation in the summer but were enclosed in smaller areas in the winter and fed hay in periods when grazing became impossible. In many cases this farmer also kept small flocks of sheep and both chickens and pigs, which were broadening his diet and providing more products for him to offer the local market. By now he had also added buildings to his farmyard to shelter his smaller animals from severe

Branding chute and squeeze

weather and was feeding them homegrown chopped or ground grains as well as roots and frozen vegetables from his garden.[16]

Though they obviously operated on a larger scale, the ranchers who invested millions in the Great Plains cattle business starting in the late seventies went through almost exactly the same evolutionary pattern as the farmers in the foothills of Montana. This is testimony to the power of the environment. It dictated that to survive they too had to scale down their operations, put up ample quantities of feed for their animals during the winter months, and fence off special pastures where they could keep their stock confined in harsh weather.

The necessity of having adequate supplies of feed seems to have been the first of the lessons learned. Prior to 1886–87 many of the ranches, including the Fergus Land and Livestock Company,[17] the Cochrane,[18] the DHS,[19] the Walrond,[20] and the Stair,[21] had been putting up some roughage. However, in most cases it was just enough to see the younger calves, older gestating cows, and breeding bulls through brief periods when accumulations of snow were heavy and the temperature low.[22] In those days, "the policy was to put up as much ... as they could," remembered a woman who had been on the Spencer ranch, "but with so many cattle they could not begin to feed all."[23] The more moderately sized operations led the movement to change this pattern after the spring of 1887. They were among the settlers who flooded into Montana, and trickled and then poured into Alberta and Assiniboia.

Most of the new arrivals were homesteaders who started up on the basis of the 160-acre holding. While they were getting established they too grazed animals on the open range. But once they had built homes for themselves and shelters for their smaller livestock, broken up and sown down some of the virgin soils, and fenced in their pastures, they did what they had intended to do from the first. They proceeded into intensive mixed farming.[24] The ranchers followed suit. Abandoning year-round grazing, they became horticulturalists to a greater degree than ever before.

Indications for the value of feeding cattle through the winter had started to appear well before it became general practice. One of the first examples was the experiment of J.D. Adams on his ranch at Little Goose Creek, Montana. In the fall of 1884 he started forking hay to his herd of cows. The next spring he got 76 calves, while a neighbour with a herd the same size who did not feed got 82. Undeterred, Adams fed his cows again over the 1885–86 winter and in the spring he got 75 calves, while his neighbour got only 35. Buoyed by this progress, he again fed over the 1886–87 winter and got 100 calves, while his neighbour got a paltry 16.[25] After that, as ranchers from all over the plains saw such irrefutable evidence, they slowly became converts and started providing hay for their cows during the coldest months of the year. To obtain supplies they mowed the taller wild grasses wherever possible in the summertime on the flood plains of the rivers and in the valley bottoms of the highlands, and when it had dried in the sun, they forked it onto wagons and stacked it in strategic places for their wintering cattle.

Initially, the cattlemen reckoned they needed to have as little as sixty days of feed on hand for all their stock.[26] As time went on, however, they put up larger and larger amounts so that eventually most of their animals could be fed right through even the longest cold seasons. To build up that kind of supply, they too planted fields of domesticated grasses.[27] This obliged them to break up and cultivate the virgin soils and then to work them again every four or five years to replant. Some of them also boosted their roughage production by setting up irrigation systems where streams and rivers were in close proximity to their hay meadows.[28] In 1880 there were 56,880 acres of Montana in hay; by 1900 there were 712,000.[29] Similar statistics are not available for the region north of the border but it is clear that from the spring of 1886–87 cattlemen there also put up increasingly large quantities of roughage. At the end of 1888 a North West Mounted Police commissioner reported that all the ranchers, "no matter what class of stock is their specialty, now cut large quantities of hay, and nearly all have shelter of some description for weak stock. Some of the more advanced cow-men are

now yarding up their calves in the fall and feeding all winter."[30] After the pivotal winter of 1906–07 another officer reported that the "small owners" who did not depend on the open range during the cold season and had plenty of feed for all their animals "suffered very insignificant losses."[31] Increasingly, ranchers turned as well to green feed made from the stalks of green oats or a mixture of green oats and barley.[32] This required tilling, planting, stooking, and stacking every year.

As ranchers improved their feed supplies they quickly realized that they were going to have to do more and more fencing. There was no point in having roughage on hand to feed their herds in the wintertime if the animals were spread out across the free range and could not be found or accessed.[33] Therefore, they also began to enclose winter pastures. In some areas this process started early. In 1884 residents of Miles City were already voicing concern that the fencing of the open range could hinder cattle drives and threaten "the supremacy of our cattle center."[34] In 1888 the Montana Stock Growers Association discussed the problem of barbed wire fences cutting across the "travelled roads," in Custer County "where stock is driven for shipment to the railroads."[35] By this time both ranchers and settlers were working at it simultaneously and by the turn of the century an estimated three quarters of the livestock owners in Montana had fenced their lands and were able to feed all their cattle through a good portion of the winter months.[36] North of the line, the area west of Calgary and close to the Bow River and the Canadian Pacific Railway, succumbed to enclosure rapidly from 1883 on. Further south an entire twenty-five mile stretch on the Belly River was completely fenced in as early as 1885.[37] By 1901 fences had made district round-ups virtually impossible everywhere except south of Medicine Hat, here and there in the hills, along the Bow and Red Deer Rivers southeast of Calgary, and in some districts of southern Assiniboia.[38] At that time those who had not yet sufficiently divided up their lands were buying up wire – some by the "car load" – in an effort to get the job done.[39]

Fencing off the open range and feeding all their cattle through winter both dictated new size restrictions for all the ranchers. To comprehend the scale of this endeavour, it is necessary to keep in mind how limited the ranchers' human resources initially were. The ranchers were determined to run their operations as economically as possible; furthermore, they had devoured all the literature on ranching in the West before investing in the northern Great Plains. They believed that they shouldn't have to increase their labour force – that keeping workers to a bare minimum was one of the secrets of success.[40]

During periods of employment, therefore, cowboys were already pushed to the limit fulfilling their regular duties. Their busy season

began with the late spring round-up when all the newborn calves were branded and the males divested of their testicles. In the days working up to this big event all the men were busy refurbishing and provisioning their chuck wagons, mending harness and tack, and, most of all, preparing an adequate contingent of horses. As each outfit needed so many mounts, this was a major undertaking. Over the winter all the horses except those the ranch hands kept for personal use were allowed to roam the open range. The first task in preparing for the round-up was to find them and bring them to a central holding area. This was not easy, as the horses were usually spread out in small bunches all over the countryside, and the men had to go out repeatedly and drive them in a few at a time.

When the horses were penned up they had to be reacquainted with the finer points of the "cowpony." Most of these animals were sturdy, stockier "cayuses," presumably of complex lineage, and had become quite wild and unruly after months of freedom.[41] In the days before the round-up the men had to ride them one at a time. This took concerted effort. An expert roper would go into the corral, single out a horse, and throw a lariat over its head. He would quickly tie the horse to a snubbing post and then two or three of his fellow workers would rush in, grab the rope, and help hold the animal in one spot. Then it would be saddled and bridled and boarded by a bronco buster. At this point some of the horses remembered former training and responded the way they should to the rider and his instructions. Often, however, all hell broke loose. The animal would suddenly leap in the air, head between its front legs, back arched, and hind legs flailing wildly in all directions. The seasoned bronco buster knew what he was doing. He used specialized techniques such as steadying his stirrups by "hobbling" or tying them together under the horse's belly, and moderating the power and direction of the buck by setting the reins so that when the horse moved the head was forced up and to one side.[42] Know-how and skill usually enabled the rider to win out, but horses frequently needed several re-rides and even then entered the round-up in only a "green broke" state.[43]

Life on the range once the round-up got underway continued to tax the cowboy's energy and stamina. The day usually began at the crack of dawn and continued to 8:00 or 9:00 at night.[44] During that long period the cowboy's constant attention was required for one or more of the tasks of gathering, driving, herding, guarding, roping, branding, cutting, or castrating livestock under his care. When the work ended he usually fell into his bedroll exhausted. This relentless pace went on for several weeks and through all weather.[45]

In the fall, there was another major round-up to brand and castrate the calves born after, or missed in, the earlier gathering, to separate out the steers that were fat, and to move the cattle to winter pastures.[46] Then the fat cattle had to be driven to the railhead for shipment east. From the late 1890s on, most ranches also took part in equally taxing mange round-ups in between the other two. Even when not preparing for or carrying out one of these projects, moreover, cowboys normally had as much on their plate as they could handle. The usual practice on the ranches was to put them in line camps so they could ride out each day to keep an eye on the grazing herds. They would try to protect the cattle from predators, help them out of mud holes, and act as midwives when cows had trouble birthing. They also coaxed the cattle back more or less to within the parimeters of their home range when they wandered too far. This was a formidable task. For each cowboy it was equivalent to being in charge of at least a thousand animals (and often more since a lot of men were usually laid off between the round-ups), spread out over thousands of acres.[47]

This situation was made worse by the fact that when the range was still open it was often impossible to keep cattle on their home ranges. Under certain conditions unfenced cattle are so disposed to drift that they cannot be stopped even when cowboys are close by. James Dilworth found this out when trailing more than two thousand head to Montana from Oregon in 1881. Trying to cross the desertlike plains between the Snake and Boris rivers, he and his men were longer than they should have been, and the cattle, "frantic for water," decided to head back to the last place where they had been able to quench their thirst. In trying to stop them, the men worked their horses to the point where they were totally exhausted; many of the mounts simply lay down in the wilderness and had to be left behind. The ordeal took its toll on the riders too. One man, Dilworth said, "looked like death – his face as black as the sand and dust could make it and all grimy with sweat, sitting on a horse that looked ready to fall down." In the end the cattle made their way back to water and the riders had to regroup and start the crossing all over again.[48]

Severe rain or snow storms were the most recurrent cause of drifting herds on the ranches. The cattle would turn their backs to the wind and move in the direction it was blowing, pushing their human guardians with them. By the end of a storm they might be miles from where they had started out. This is illustrated by an experience Harry Longabaugh, better known as the Sundance Kid, and Fred Ings had while rounding up cattle for the OH Ranch in the foothills of Alberta in the eighties. While they were guarding a large bunch of cattle one night, a blizzard

Haying

suddenly struck and the animals started to move with the wind. The two men could not hold them so, in an attempt to keep them together, Longabaugh rode in front of the herd and Ings followed along behind. They "found it desperately cold and in the thickly falling snow lost all sense of locality." Ings was riding "a sure-footed, thick-set, little gray horse," but it was so blinded by the storm that it kept stumbling on the uneven terrain. Finally the men decided to give up and allowed their horses their head to see if they could make their way back to camp. They "eventually arrived," and the round-up boss decided not to send anyone else out until the storm ended. When it did end, it took "several days' hard work" to gather the cattle up again.[49]

Of course, the vastness of the open range encouraged cattle to drift great distances without anyone knowing, and between round-ups the cowboys had to scour the wilderness in a somewhat vain attempt to keep track of them. Their jobs were so labour-intensive that they could not possibly have been expected to carry the extra load that the feeding and fencing era brought with it. Harvesting hay required mowing and raking the grasses with horse-drawn implements and many hours of work with pitchforks and wagons. Building networks of barbed wire fences was also a hard, time-consuming task. First the logs had to be brought in and cut up into posts. Holes at least two-and-a-half feet deep had to be dug in the ground every twenty to forty feet along the route where the new fence was to be installed. After the posts were placed in the ground and dirt filled in around them and tamped with a "crow bar" until it was firm enough to hold them upright, three or four lines of barbed wire had to be strung along them and stretched and nailed into place.[50] Most of the fencing, like the haying, had to

be done in the warm months when the ground was not frozen or covered with deep snow. Therefore, it came just at the time when the men were already preoccupied with other responsibilities.

The ranch owners had two alternatives. They could either hire a lot more men or limit the size of their operations in terms of both area and cattle numbers. Hiring more men seemed out of the question because the owners were not prepared to undertake heavier investment in labour or, indeed, in fencing materials and haying machinery, particularly on land that did not belong to them.[51] It is difficult to grasp to what extent the large operations would have had to increase their investment of they had undertaken just to put up enough roughage to keep all the cattle they tried to run in their early days properly fed all year round. In the 1890s the Walrond Ranch put up an average of 550 tons of hay a year to keep on hand primarily for older cows that were doing poorly over the winter, and as a supplement for calves that were old enough to wean from their mother's milk in the fall. The hay was mowed, raked, and stacked mostly by contract at $3.75 a ton. The total cost was just over $2,000.00 (550 × 3.75).[52] To ensure that none of the ranch's cattle would go hungry for any significant spells in the winter time, this amount would have had to be multiplied many times over. Gestating or nursing cows, the bulls that serviced them, and growing or fattening steers required about a ton and a half of hay a piece to be more or less assured of surviving a long winter on the northern plains in prime condition.[53] The Walrond owned about 8,500 head in its beef herd, excluding newborn calves.[54] About 5,200 they classified as cows,[55] 300 were bulls, and 3,000 were steers. They would have needed 12,750 tons of hay (1.5 × 8,500). About 1,400 of the ranch's 2,000 or so calves also had to be fed when pastures were covered with snow. To keep them growing and healthy would have taken about a ton of hay per head or another 1,400 tons. In total the ranch would have required at least 14,000 tons of hay. The cost to procure it would have been 52,500.00 – an increase of over 2,500 percent.[56] This was unthinkable. It went against the extensive approach the owners had adopted from the start.

It scarcely needs to be added that costs were not the only inhibiting factor. The Walrond normally employed about eleven men on monthly wages in the summertime plus perhaps five or six who worked for the contractors.[57] To gather 14,000 tons of hay with horse-drawn equipment it would have needed an army of over 200 men and then another one of perhaps half that size to haul the hay and feed it to the cattle.[58] There were surpluses of labour between round-ups on the frontier but they would never have been sufficient to supply manpower of that sort. The Walrond was not a typical ranch in that

it was much bigger than the average. However, proportionately, all of them faced similar challenges with respect to investment and labour. The smaller rancher with a crew of, say, four and a single line of haying equipment was no better prepared than the Walrond managers to see his inputs multiplied. It made more sense to most owners to take advantage of whatever devices were available in their respective countries to acquire deeded land, and then to considerably curtail the scale of their operations.[59] The successful ones achieved this changeover in a few years. They first made sure they had title to their home places and then they acquired whatever additional parcels they could. They fenced their deeded land, divided it into hay meadows and winter pastures, reduced the number of cattle they were running to match the amount of winter feed their land enabled them to procure, and began using the open range for summer pastures only. At the end of each grazing season they were able to round up all the cattle in their down-sized herds and bring them home where they could keep them enclosed and sheltered and feed and tend them every day if necessary.

Numerous examples illustrate that from the late eighties the majority of the ranchers on both sides of the border cut their herds down to what the "owned land could support."[60] In Montana, the Rustin and Ike outfit of Rosebud had 3,000 cattle in 1884, 2,000 in 1886, and only 1,600 in 1890; Hubbard and Thompson of Muddy Pond had 4,000 in 1884, 3,000 in 1887 and 2,750 in 1890; Johnson and Graham of Powderville had 4,000 in 1883, 1,000 in 1888 and 1,610 in 1890; N.D. Conners of Custer County had 6,000 in 1883, 3,000 in 1886 and 1,220 in 1888; Ferris and Bristol of Terry had 2,300 in 1886 and 720 in 1890; Ferdon and Biddle of Powderville had 7,000 in 1883 and 1,224 in 1890; and Harmon and Hale of Miles City had 2,472 in 1887 and 455 in 1890.[61] Most of these outfits thus cut their herds at least by half in the eighties and a number reduced them by considerably more than that. There were 6,000 brands recorded by the Montana Stock Growers Association in 1889. Eleven years later there were 16,000.[62] By then the association's total enrolled members had reached the new all-time high of 362. Seventy-five percent of these people "were classified as 'small owners.'"[63] In Alberta and Assiniboia the reduction can be seen in the size of the leases cattlemen negotiated from 1886.[64] Around the turn of the twentieth century small-scale operators such as the McHugh Brothers, John Quirk, Charlie Lyndon and his son Billie, H.B. Alexander, Walter Huckvale, Bob Newbolt, and A.E. Cross greatly outnumbered the so-called cattle barons.[65] In general the ranchers who operated at the more moderate level also greatly outlasted them.[66]

Many such ranchers found it both convenient and advantageous to push the process of intensification several steps further as time went

on. Since they were now keeping their cattle enclosed for a considerable part of the year, they could exercise better control over them in virtually every respect.[67] They could, for instance, protect them much better from both two- and four-legged predators. Probably even more important was their ability to raise the overall quality of their stock by regulating bloodlines and breeding patterns. Bulls were now pulled out of the herds at the end of the summer season and held out until June. Many of the scrub bulls that had formerly weakened the bloodlines on the range were pulled off and sent to slaughter along with the poorer "she-stock." A better job was also done of ensuring that all the male calves got castrated and the poorer young females were spayed and marketed for beef.[68] At the same time, efforts to import heavier-set British breeds were renewed. Herd improvement was a painstaking task and was not achieved overnight. As a man who worked on an Alberta ranch remembered, it took many years both "to weed out" the inferior animals and to replace them with "a better type."[69] The following observations in the *Rocky Mountain Husbandman* in 1899 show not only that higher standards were current in Montana by the close of the century but also that there was still considerable room for improvement:

For ten years we have urged cattle owners to cut their herds in half in respect to numbers but increase their value by breeding. But it is only within the past few years that we feel assured that the era of improved stock is certainly at hand. It is only with the passing of the old extensive range system and the dawn of the positive winter feeding era that the owners of livestock have been made to finally realize the importance of improved animals ... Since every bovine must now be gathered to an enclosure in the early winter months ... the owner naturally takes more account of the class of stock he is producing. The pure-blooded early maturing symmetrical animal will consume no more feed in a winter or a lifetime than the large-boned, rough animal that is the produce of haphazard breeding, but the smooth steer will sell more readily and bring a better price than the long-legged scrub ... There is a good demand for a good grade of bulls and we look to see pure-bred animals bringing top prices in a year or two ... The country will continue to move until the pure blood and high grade will be the rule rather than the exception.[70]

The paper praised a number of breeders with moderately sized operations for their progressive practices, including Alex Metzel, Charles Anceny, Charles Bader, Reuben Lattimer, William Gaddis, J.T. Moore, and Len Lewis.[71]

By the end of the period under study here, one other process of refinement was beginning to be implemented that was to some extent

dependent on better-quality livestock. That process – the feedlot finishing business – has in the modern era become a pillar of Western beef production. It first developed with hay as the principal feed but before World War I it began to take its modern form, whereby the cattlemen marble and tenderize their beef by feeding substantial amounts of grain.

Before 1900 most cattlemen were feeding just enough to ensure that their entire herds would survive the winter. Even then, however, few could claim that they were actually trying to fatten any of their stock. Mostly they were merely supplementing the pastures when necessary to keep the animals from going hungry.[72] More intensive feeding programs started in Montana primarily as the result of disappointment with attempts at grass-fattening on overcrowded ranges. Ironically the ranchers found that even on the rare occasions when their cattle seemed to be as well-fed as those from the middle states, they sold for less simply because of a bias that developed among eastern buyers against range animals. "A few prime double extra westerns sold today for 6.90," a sales agent from the Union Stock Yards told John Survant in 1902, "they were full as cheap as anything that sold on today's market, taking quality, flesh and fat into consideration; they were equally as good as any 7.50 corn cattle sold on this market today, but it is difficult ... to get the price for range cattle even if they are fully as good as corn cattle."[73]

The stockmen who wanted to continue supplying the slaughter market thus began to recognize that it was necessary to place their animals on intensive feeding programs for some time in order not only to improve their product but also to change its image. This approach brought another advantage. As they worked on upgrading their herds, the cattlemen discovered that with intensive winter-feeding programs, the new shorter, heavier-set British breeds could be readied for market much more quickly than had been the case with the leaner, lankier types the range had produced in the past. In earlier days the mixing of breeds on the open range had resulted in virtually all the cattle being tall and relatively thin, and inclined to put on fat only when they were fully mature. Before the stockmen could even think of getting them ready for market, they had to grow them out until they were four and five years old and weighed 1,500 to 1,800 pounds. The Hereford, Angus, Shorthorn, and other British breeds, on the other hand, were finer-boned, shorter, and fleshier, and with sufficient feed their carcasses could be properly finished at an earlier stage of life. The cattlemen discovered that in fact by putting them on feedlots after they came off the grass in the fall and giving them all the hay they could eat they could get them ready for the slaughter market at less than three years

of age when they weighed only 1,100 to 1,300 pounds.[74] This was an attractive proposition. A much shorter turnover time vastly improved cash flows. It also brought a premium on the market because consumers – and therefore the eastern buyers – prized the younger, tender, and less stringy meat.[75]

Considering such advantages, the ranchers embraced the concept of winter finishing surprisingly slowly and spasmodically. "The experiment of making beef with Montana hay has been tried so long ago that we have almost forgotten the date," a writer acknowledged in 1897, "but it was not until the fall of 1893 that any considerable number of the people of the state engaged to any extent in feeding for the eastern market."[76] Before the latter year the vast majority of the cattlemen had been shipping their bigger yearlings directly to Chicago after the fall round-up. Because they were under-finished many of these animals had been shunned by the packers and ended up selling as "store cattle" to farmers in the middle states who then put the final pounds of fat on them by feeding them their surplus corn. However, in the fall of 1893 the beef market collapsed and a number of the Western cattlemen who had lots of hay on hand held onto their bigger yearlings over the winter and plied them with feed in hopes that prices would be better in the spring.[77] They were not disappointed.[78] The market recovered for a few months in early 1894 and the feeders were well compensated for their hay. Their success established heavy winter finishing as a viable alternative in the state. In the spring of 1897 Smith Valley alone produced seven hundred head of finished stock.[79]

Over most of that decade, however, the winter-feeding approach did not really flourish. Markets remained unstable at best, and most ranchers, fearing that hay finishing would not bring appropriate recompense, reverted to using their feed simply as a means of preventing starvation.[80] It was not until the turn of the century when beef prices seemed to show signs of long-term improvement that renewed interest was stirred.[81] At that stage the cattlemen began to use feed grains in their finishing programs as well as roughage. Relatively speaking, course grains such as oats, barley, and feed wheat are high in caloric energy and low in protein in comparison to grasses, alfalfa, and clover. While they are not thus as well suited to bovine growth, they are better for the development of flesh and fat. That is why cattlemen today feed copious amounts of grain when they get their feedlot animals to the stage where they are putting on the final two or three hundred pounds. As they developed an interest in finishing their animals properly, Montana feeders of the early twentieth century began to add chopped or ground grain to their daily rations, usually pail-feeding it into specially constructed troughs. In the beginning most of the feeders seem

to have started by using oats, barley, and/or feed wheat for only sixty days as a means of "topping" their cattle, or hardening their flesh with a final coat of fat for the trip east.[82] In time, however, they fed grain for longer periods as they attempted to get the cattle ready for market at younger and younger ages. Before the war many of them were able to send their slaughter stock off to market, much as they do today, at around two years of age.[83]

Canadian cattlemen had the same problems with underfinishing as the Americans. They watched their neighbours adopt this system and in time they embraced it too.[84] In the years 1906 through 1908 the number of cattle western Canadians sent to slaughter markets rose from 131,641 to 170,088 and those finished on dry feed rose from 16.37 per cent to 48.67 per cent.[85] By the war, hay- and grain-finishing had thus become a regular part of the beef industry. "More tame hay, more fodder and more grain was grown, and particular pains were taken to fit ... steers for market."[86] This brought positive results and it vindicated men like Moreton Frewen who had learned through bitter experience the inefficiencies of grass fattening. The cattlemen saw for themselves that "an animal not only held its grass flesh when hay-fed in winter, but actually gained eighty to one hundred and twenty-five pounds." On "a grain ration in addition it showed in some cases a gain of four hundred pounds."[87] The most intensive fattening programs were started by feeding one or two pounds of ground grain per animal per day along with the roughage, and then gradually increasing it to six or eight times that much.[88] Interest in grain-finishing became widespread enough in Alberta that in 1914 the government farm at Claresholm experimented to develop the best possible combinations of feed and conditions to sustain it. Their published findings demonstrate the close and careful barnyard management required. The experimenters used mostly "range steers two years old past, with a few threes and fours. Cattle were fed loose and in the open on the lee side of buildings and with eight-foot high board fence shelter ... The feeds included hay, green-feed and straw for fodder, and oats, frozen wheat and barley for grain. The racks were kept filled with long feed, consisting of hay and green sheaves, chop[ped] oats and/or barley] were fed on table tops twice a day. Salt and [warm drinking] water were always available ... Feeding began on November 1st and the cattle were sold on May 1st.[89]

Proper finishing programs forced ranchers to take further steps in the farming direction. Now they had to plant and put up not only domestic hay and green feed but also oats, barley, and wheat and they also had to invest in machines to cut and harvest it. By this time a degree of specialization in beef production also appeared. Those cattlemen who preferred not to get into intensive feeding procedures made the decision

to concentrate their efforts on keeping, improving, and developing their herds. They tried to produce the best possible calves every spring. These they would normally sell in the fall rather than wintering them, pasturing them the next year, and then feeding them through to slaughter. In many cases men who wanted to get out of the breeding end of the business purchased calves in the fall, wintered them on hay, put them out to pasture as yearlings, and then, often depending on perceived market conditions, either sold them to grain finishers or fed them to slaughter themselves the second winter. As this suggests, some cattlemen also specialized in the finishing trade. They stayed away from both cows and calves and bought the larger yearlings. These they put on heavy grain rations and then sold on the slaughter market after only a few months.[90]

By the time of World War I most of the ranchers had enclosed their deeded land and gone into roughage, grain, and finished beef production and they were undertaking closely managed selective breeding programs. This change does not mean that all the skills of the cowboy became redundant on their spreads. Summer pasturing continued to be important on a majority of the operations. Therefore, while the district round-ups on the open range disappeared, it remained necessary for individual outfits to have expert riders who knew how to gather livestock on horseback. Clearly, however, the trade of the cowboy changed dramatically. After the turn of the century the minority of the ranchers who were not able or prepared to embrace mixed-farming techniques sold out and moved on. When lands came up for sale the word "ranch" was often conspicuously absent. "We have 100,000 acres of the finest farm and wheat lands, all within thirty miles of the city, at the right prices and on easy terms," a Calgary real estate company advised in 1904. "We also have some fine improved farms, all ready to carry on the business either of wheat raising or dairying."[91]

As the latter words suggest, a significant proportion of the cattlemen on both sides of the border who continued to operate in time took the process of diversification as far as the farmers in the western foothills of Montana, by embracing sub-industries of mixed farming including dairying, hogs, and poultry. They also experimented with a wider variety of field crops.[92] Now the type of operation that was being held out as the model for all the rest was one like Paris Gibson's Sam Coulee Ranch located some three-and-a-half miles from the city of Great Falls. Gibson owned 2,100 acres, had "a splendid herd of fine bred cattle," and "75 head of purebred Holstein cows which he housed and milked in an immense stable." He also had his own creamery to separate the cream from the skim milk. The former he sold in Great Falls and the latter he fed to his calves and pigs. In 1895 he was expecting to go into the manufacture of cheese as well. That year he planted 350 acres to peas, potatoes, oats, alfalfa, and root crops and he cut between 700

and 1,000 tons of hay. He was also considering going into irrigation.[93] In Alberta a typical moderate rancher turned intensive mixed farmer was Bob Newbolt. He homesteaded 160 acres and then took a preemption quarter on the Bow River east of Calgary in 1884. He also leased several sections of range land. He obtained a few hundred head of well-bred cattle and went into horse breeding. The cattle he grazed in enclosed pastures and fed through even the longest winters.[94] He experimented with irrigation and eventually got to the point where he was "farming in a big way" by cultivating a large portion of his land, harvesting "some excellent crops" of grain, and nurturing hogs.[95]

The general movement by so-called ranchers into farming techniques led to considerable confusion and sometimes heated debates about how precisely they should be labelled. Most of the great ranches that continued to operate after 1886–87 in Alberta and Assiniboia and in northern and eastern Montana put up more roughage than they had in the past and fenced in large tracts of their land but, given their limited labour resources in comparison to the massive numbers and acreages they were trying to control, they never managed to finish the job. As much as anything else, that deficiency proved their downfall.[96] While they survived, they were sometimes simply called mixed or "stock" farms "conducted on a huge scale."[97] Just after the turn of the century the *Rocky Mountain Husbandman* presented a piece on Len Lewis, who would have been one of the foremost owners who operated just below the great ranch level. He owned two thousand acres on the North Fork of Smith River, a farm on White Tail Deer Creek, one on Beaver Creek, and another on the main Smith River. The writer estimated that Lewis cropped more land than all the rest of the men in his area combined and noted that he owned sheep, horses, cattle, and hogs. Yet, he said, people claimed he was a rancher not a farmer, presumably because he had started as a livestock man. The piece ended on a sarcastic note. "In our simplicity nursing 'moss back' ideas, we supposed that a man engaged in mixed husbandry [and soil cultivation] was a farmer in the purest sense of the term, but then we don't know much. The 'science' we confess is on the other side of the controversy."[98] Many of the men involved in agriculture continued to call themselves ranchers but as much out of tradition and acknowledgement of the high stature the cowboy had attained during the era of the open range, than as a precise reflection of what they were actually doing on their spreads. To solve the dilemma of how to categorize them, modern historians have devised the terms "rancher-farmer," "granger-ranger," and "granger-rancher."[99]

11
Conclusion

Some would argue that even the heritage of the ranching frontier on the northern Great Plains is now rapidly being lost, in part as a result of the fact that the beef economy has oscillated so severely in recent years. They find evidence of this loss in the migration of young people from ranch/farms to cities and in extraneous indications such as their apparently growing disinclination to enter the sport of professional rodeo.[1] Recently, however, when I attended the funeral for Malcolm (Mac) James MacKenzie, a well-known Western artist, rancher, outfitter, and cowboy, I saw signs that these predictions may be somewhat premature. The funeral was held outside on the site of the first Cochrane ranch, under a knoll upon which Mac's life-size bronze sculpture of a cowboy on his horse sits facing west toward the rolling foothills and the Rocky Mountains. Knowing how much of his life Mac had devoted to his culture, I dusted off my old Stetson hat, Wrangler jeans, Western shirt, belt, buckle, and boots and donned them for the funeral as a mark of respect. I knew the company Mac had kept all his life and I expected that many others would be similarly attired.

I was not disappointed. There were around a thousand people in attendance, and the vast majority of them looked as if they came straight out of the frontier. The service was not what most of us would consider usual in the modern sense. The casket with Mac's brand on it was carried to the hillside by horse and wagon accompanied by the age-old gospel music of a small band known as the Christian Cowboys and by an honour guard of "wranglers" on horseback. The master of ceremonies and a number of individuals from Mac's wide circle of family and friends spoke of their life experiences with him and their respect for him. One of the speakers was his brother-in-law, the cowboy poet and stock contractor Doug Richards, who regaled the audience with stories of earlier days they had spent together on their

ranches and on camping trips by horseback into the mountain wilderness. Richards had the audience in stitches with lingo that Charlie Russell might well have used. For instance, he said that one summer when they first "come across the twin fillies" who were eventually to be their wives, Mac had boldly sought the affections of the one named Judy but he, Doug, being younger and more bashful, had wasted a great deal of valuable time "just kinda sniffin' the air around the herd."

The funeral demonstrated that, along with cowboy witticisms, Western forms of entertainment have been woven into the very fibre of country culture. As everyone knows, there are all sorts of professional entertainers these days. But what impressed me this particular afternoon was that folksy rhymes and tunes are still recited and sung in public by ordinary cattle people who have no aspirations whatever to see their performances published or recorded. The last speaker was an old-time rancher named Bobby Turner. He offered an impassioned eulogy to Mac and then recited a poem he had written in his honour. Finally he broke into the following song:

> Campfire coffee from a tin cup in my hand
> Sure warms the fingers when it's cold,
> Playing an ol' guitar, a friend I understand
> It sure smoothes the wrinkles in my soul,
> Sleeping in the moonlight with a blanket for a bed
> It leaves a peaceful feelin' in my mind,
> Wakin' up in the morning with an eagle over head
> Makes me long to fly away before my time.
>
> And I think God must be a cowboy at heart
> 'Cause He made wide open spaces from the start,
> He made grass and trees and mountains
> And a horse to be a friend,
> And trails to lead ol' cowboys home again.
>
> The night life of big cities is allright for a while,
> It sure makes you feel good when you're there,
> But the country's so pretty, it goes on and on for miles
> And it takes away my troubles and my cares.[2]
>
> And I think God must be a cowboy at heart ...

Given the relatively short history of extensive ranching on the northern Great Plains, it would seem that the longevity of country and western culture, rather than its demise, requires explanation. It no doubt has

Calgary Stampede

something to do with the fact that in the earliest years the range man had all the skills and specialized equipment to deal with the challenges of the open range system. In that sense the culture is a product of frontier environmental selection. However, it is more than that. It also unquestionably reflects the great variety of eulogies to the cowboy and the rancher that were fabricated and eagerly devoured in the east and overseas beginning in the late nineteenth century. These helped to create a tradition of respect that became so strong and so widespread that, to the present, writers, composers, painters, and filmmakers have found it appropriate to keep adding to them.

This work has stressed the similarities between two adjacent North American ranching frontiers resulting from their relatively analogous physical and social environments. In summarizing, we should not neglect to discuss their dissimilarities. Was there anything that could realistically be called unique or exclusive to the development of either region? National mythologies north and south of the forty-ninth parallel have for many years claimed almost diametrically opposite characteristics. Canadians have been identified with tradition, Old World social hierarchy, and love of law and order, and Americans with individualism, self-reliance, and a flare for wild and woolly behaviour. There were differences, however, as this final analysis underscore, the attributes distinguishing these two frontiers were subtle compared to those they held in common. Consequently, the political boundary between them still appears to have played a less significant role in the

history of ranching on the northern Great Plains than many of us have been inclined to believe.

The initial period of rapid expansion in both regions began in the early eighties for the same basic reason. The Old World and the New came together to produce an irresistible force. Human imagination, as expressed through various media forms, enabled the Western environment to make a profound impact on eastern industrial societies, convincing young men and hardened entrepreneurs alike to invest their energy or capital there. The first to catch frontier fever were explorers and adventurers, novelists, dime novelists, photographers, artists, and promoters. Their abundant enthusiasm overflowed into heavily populated eastern communities where much of the air was filled with soot. The word "fever" seems appropriate because, like a contagion, passion for the West spread very rapidly and in the end it did considerable harm. It encouraged a form of agricultural production that could not possibly succeed on the northern plains. Within a short time financial necessity forced the great majority of the ranchers either to give up altogether or to completely alter their approaches.

In both ranching societies the process of selection was governed by the frontier environment, but the form of agriculture that process eventually brought to the fore to replace it was strictly Old World in derivation. Herds succumbed to climatic, ecological, and genetic stresses. Ambitions were also thwarted because, in their fledgling state, both societies lacked facilities to control cattle movements, efficient agencies of law and order, and family stability to temper the tendency of young men toward a raucous and often illegal existence. Geographic isolation also forced the first cattlemen to undertake the unrealistic risk of shipping their quasi-finished stock countless miles over land and sea. However, the mixed farming procedures that the moderately sized ranchers and the settlers later introduced to the high country and the valleys of the major rivers had, like the cultivation and harvesting techniques of the grain farmers who took over the flatter dryer plains, long been practised in the eastern homelands from which many of the cattlemen came.

If the patterns of development were very similar on the two frontiers, the pace was not. From the beginning change occurred substantially faster to the south of the line. Initially there were many more big Montana ranches than Western Canadian ones and they imported enough stock to overwhelm their ranges much earlier. As a result many yielded sooner to the frontier and the elements and were replaced by smaller ranchers and homesteaders some two decades ahead of their Canadian counterparts. This fact brought about some methodological differences. For one thing Montana livestock men turned to irrigation

Sheep beside Powder River, Montana

a lot faster than Canadian ranchers. In 1895 there were only 120 irrigation systems in operation in southern Alberta and western Assiniboia and some 50 under construction. They almost all serviced fodder fields in the livestock districts.[3] In Montana by contrast, over 8,000 farms, or about a third of the total, were able to water their fields by 1899.[4] Annual precipitation figures do not seem to fully account for the difference. Montana receives about 15 inches of moisture from rain and melted snow in an average year while southern Alberta and the western districts of Saskatchewan get just over 16 inches, amounts that are borderline for agriculture.[5] More important was the fact that irrigation in the early days was mostly undertaken by intensive, small-scale producers. In Montana that kind of operator, having started up in the western valleys in the sixties, had a significantly longer time period to instigate and refine the process.

The Americans also produced considerably more sheep than the Canadians.[6] In 1890, when its human population was only 132,159, Montana had over 2,228,000 sheep. This was more than twice its number of beef cattle; in 1910 it had 5,385,000 sheep and only 919,000 beef cattle.[7] Some ranchers, including big owners like James Fergus, branched into that species, but it was the small farmer who accounted for most of the output. Many of the farmers in the foothills marketed wool and mutton in the seventies along with dairy products and beef, and as the homesteaders came in later, many of them did the same. In this pre-synthetics era there was still a dynamic European

and domestic demand for wool as well as mouton, which gave the rancher/farmer a way to regularize his income.[8] He could get into the business in a significant way with a much lower initial investment than was the case with cattle and he could feed a substantial flock from his modest pasture and hay fields.[9] Sheep are relatively delicate when compared to cattle or horses, but he could look after them properly. With the help of one or two good dogs he could drove them quite easily and it was a relatively simple matter to enclose them in small pastures or construct simple lean-tos and buildings to shelter them from severe weather.

The sheep business was tried in Alberta and Assiniboia as well but it did not expand as an industry to nearly the same extent.[10] Sheep were initially banned from southern Alberta by the federal government because it was felt they ruined the grass by grazing it too low to the ground and, presumably, because of the conflict that was known to have developed between sheep ranchers and cattlemen in some parts of the United States.[11] As the sheep business developed in Canada it continued to be hindered, however, by slower settlement and by politics. Ottawa resisted geography and disrupted the free flow of goods by imposing a 25 percent *ad valorem* duty on American sheep. It became an expensive proposition for Western Canadian stockmen to acquire start-up herds.[12]

On both frontiers Old and New World influences came together not only to govern agricultural practices but also to shape social life. In each case eastern elites left an indelible stamp. Polo matches, "fox hunts" with wolves and coyotes, operatic music, theatre, and grand balls regularly entertained participants in virtually every locality. Bowler hats, fancy dress shoes, and three-piece suits were commonly seen on the streets of towns like Calgary and Miles City, and, catering to eastern and European tastes, round-ups were at times enhanced with feather beds, heated tents, and improvements on baked beans. Even cowboy culture was affected by media coverage in Chicago, New York, Montreal, and London. Frontiersmen's attire had been prescribed in meticulous detail, and their supposed ideals of manliness, independence, and individuality had been glamorized by Old World writers and artists well before they headed west. From the time they arrived in Montana or Assiniboia young men found themselves attempting to live up to the images that novelists and pamphleteers imposed on them. Moreover, the entertainments many cowboys devised to offset the harshness of their new environment had eastern derivations. As indicated above, one of the songs sung on several Western cattle frontiers had its origin in Britain some four and a half centuries earlier.[13] One might point out that the well-known ditty "Cowboy's Lament" combined

its Irish origin with a cowboy setting, and that a number of others were heavily influenced by tunes passed down through the generations long before settlement on the Great Plains began.[14] In addition, frontier circumstances dictated that single young males vastly dominated the population numbers and that riding, roping, branding, and Western equipment and stock were necessary to operate the open range cattle industry. These indigenous factors helped to ensure that cowpunchers became role models, that country music was played in ranch houses, dance halls and saloons, that a sort of folksy cowboy ethos resonated loudly almost everywhere, and that whiskey and prostitution were rife. They also accounted for the reality that neither society was particularly orderly or law-abiding.

There can be little doubt that, even irrespective of Native white conflicts, overall violence in Montana exceeded that in Alberta and Assiniboia. Vigilante activity alone substantiates this. "Stuart's Stranglers" were ruthless, with little regard for due process, and their methods were adopted in later years when rustling proliferated. Nothing on the same scale ever occurred in southern Alberta or Assiniboia. Too much should not be made of vigilante activity, however. Regular law enforcement agents at times worked directly with the vigilantes, and ranchers and ordinary citizens frequently praised and supported it.[15] To them, this practice, far from being criminal, was a means by which to enforce property rights and other legal principles upon which they believed their society depended. It has persuasively been argued that vigilante activity saved the Montana ranching industry; it certainly helped contain the rustling problem in Western Canada. Moreover, even though they had the Mounties to protect them, some cattlemen from Alberta and Assiniboia were not reluctant to suggest – and on a few occasions even to employ – such tactics when they felt them necessary.

It is difficult to know for sure in which frontier society the problem of rustling was the greater. Quantitative comparisons are impossible to make with any accuracy because so much rustling and other illegal activity on the open range went undetected and unrecorded. How many times was a single calf killed by one or two hungry cowboys in a remote part of the wilderness and eaten without anyone knowing? How many stray animals were taken and rebranded by round-up crews? How often was the running iron used to create new brands or remake old ones? How many horses and cattle did thieves make off with in the dark of night and sell before anyone missed them? There is no way to know, particularly as the large outfits tended to rely on book values rather than actual counts to determine their cattle numbers from purchase to sale. In dealing with criminal activity on the frontier

the historian is left relying on impressions. In reading contemporary manuscripts and newspapers one tends to find somewhat greater evidence of rustling in Montana than on the Western Canadian ranching frontier, but this does not mean that the state was more lawless in the per capita sense. It needs to be kept in mind that it had greater numbers of both people and cattle.

The same could be said when examining other forms of crime. Canadian historians have taken pride in highlighting contemporary statements that claim greater general respect for law and order on the Canadian ranges. John R. Craig, who managed the Oxley Ranch for a few years in the eighties, stated his belief that "there was very little of what was termed the 'wild and woolly' West in evidence; the people were law-abiding, and there was absolute freedom from such objectionable incidents as were encountered south of the boundary line, where the sale of firewater was a legalized traffic." He credited the North West Mounted Police for their vigilance in strictly enforcing the law against drinking.[16] Craig was writing in 1882 after very limited experience.[17] Had he known the kind of life the police themselves lived and sometimes encouraged in local communities, and their disinclination to enforce the liquor laws, he might well have written differently. Some observers occasionally commented on the civilized nature of specific Canadian communities. On passing through Lethbridge in 1898 David B. Christie mused that while "there is entirely too much drinking here" the "community is law-abiding" and "nothing short of good order will be tolerated." He was probably exaggerating only a little. As a North West Mounted Police headquarters, Lethbridge may well have been less plagued by the crimes that police in other places chose to prosecute. Christie estimated that there were only "say 1,000 inhabitants" in the town at that time along with "some 50 Northwestern policemen in scarlet-jackets."[18]

One should note that descriptions such as this were also forthcoming with respect to places in Montana. After praising the efforts of the Mounties, John Craig also complimented Billings. "It was a lively town," he remembered, "and as tough as any other town ... but while I saw ... the drinking, and the gambling, the faro, the poker rooms day and night – there was very little disorder or violence."[19] Charlie Russell, looking back on the open range era in general, said: "Those were honest days ... thievery was unknown. The latch string was always out. No cabin was ever locked. If the owner was away ... help yourself, wash the dishes and leave. The owner didn't care ... It was God's country." He felt that there were far higher standards of honesty in the days of the open range than in the era that followed it: "And

then came civilization and law and last and worst the farmer ... We had to lock our doors. Nothing was safe."[20]

Testimonies such as Russell's, whether they referred to Canadian or American society, were often reactions to the frontier more than reflections of its reality. They were the product of people's psychological need to minimize some of the crude and ugly elements that plagued their communities. The truth is that it was when the open range had disappeared in Montana and settlers replaced the cowboys that many excesses diminished. A case in point is unorganized gun-fighting. "So much has been written" about it, one old-timer stated, "and it is nearly all exaggeration as far as this part of the country is concerned. I worked up here from 1883 on and I saw a lot of hard work on the range but very little shooting. In fact, from '85 on, until it quit being a range, there was never but one shooting scrape here in the Maginnis district, and then nobody got killed; and over on the Judith and the Moccasin which were the next ranges, they never had one."[21] He was talking about three districts in the central part of the state at a time when the open range system was rapidly being phased out. In this period he, like a host of other settlers, took up a homestead, married, and settled down to a relatively sedentary life.[22]

By the end of the eighties the grazing industry in Montana was limited mainly to remote areas north of the Missouri and south and east of the Yellowstone. On the Canadian plains the last areas to give up the system were those furthest east. By early in the new century homesteaders were pouring into the western foothills and the Milk River country and the open range was soon largely restricted to the Wood Mountain and Big Muddy districts of Assiniboia.[23] It was in these regions on both sides of the border that a numerical preponderance of young, unattached, seasonally unemployed, and armed males maintained their raucous and relatively disorderly way of life the longest.[24]

As other regions moved on, the gun became significantly less prominent. Canadian historians sometimes emphasize that their cowboys were not as likely to wear firearms as the Americans. They are at least partly correct. James Alcock, who along with his brother Joe ran 650 cattle on the Milk River Ranch in 1899, stated that he saw gunplay in those days but "most of the boys didn't carry them – just trouble makers."[25] When Tom Whitney moved up from southeastern Montana to western Assiniboia in the early nineteen hundreds, for example, he was in the habit of wearing his six-shooter most of the time, but he quickly found that this practice was frowned on in his new homeland. One day he strapped his six-shooter on to go into Maple Creek. He was met at the livery barn by a Mountie named Jack Redmond. "I'm

awfully sorry, Mac," Redmond said, "but I'll have to take that hogleg off you. You won't need it around Maple Creek and it might even get you into trouble. We don't permit guns around town. You call in to the detachment when you leave town and you can get your gun back."[26] Two important facts should be kept in mind, however. First, by the early 1900s the country around Maple Creek was no longer predominantly open range. If Whitney or Alcock had moved into the area further east, they would almost certainly have noticed more "liberal" attitudes towards the gun. Indeed, if they had lived almost anywhere on the Canadian plains some fifteen years earlier, they would have found not only well-known former Americans like George Lane, Jim Patterson, Frank Ricks, and John Ware sporting six-shooters but also easterners including Fred Ings, Billie Cochrane, and Sir John Lister Kaye.[27] A settler on Sheep Creek near Okotoks, Alberta, observed in 1884: "Everyone goes armed here ... cowboys, farmers, everyone, with a revolver about a foot long in a holster at their side and a hunting knife at the other side."[28] Second, it is evident that in many parts of Montana the practice of wearing firearms was also largely given up as soon as social factors permitted. Miles City outlawed the carrying of guns as early as 1885, inspiring inhabitants to develop their own legends about the town as a haven of order. The stranger here will find that "should he happen to be wearing a pair of shoes with remarkably broad soles or a plug hat he need be in no fear of having either article of dress investigated by an unerring bullet," the *Yellowstone Journal* proudly announced in 1885. "The day is past for that kind of fun ... No, the hurried march of civilization has reached Montana and is quickly doing its work."[29] In the next few years men were disarming in large parts of the countryside too. An old-time rancher tells us that in the nineties "a lot of people" in his area "began to quiet down and start leaving off their guns. The country was getting so thickly settled then and the houses was so close together they figured they didn't need them any more."[30]

Does this mean that the Canadian and American frontiers experienced the same level of gun violence? No, it probably does not. First, it would seem logical to conclude that, in the earliest open range stage, firearms were a little more ubiquitous in Montana. Citizen action was relied on so heavily to protect the cattle that virtually every man who rode herd was in a sense an officer of the law; that is, he was required to protect as well as nurture livestock for his owner. Thus he felt the gun was as regular a tool of his trade as his rope or saddle. After the Wyoming range wars it became more so than ever before. Up to that point Montana cattlemen had "considered themselves well armed with one six-shooter." However, after that many of them felt "they had to

adopt the fashion of the Wyoming 'two-gun' men and carry a gun in each holster strapped to their sides."[31]

It was in part because of the relative prevalence of firearms during the wildest days that the cattle towns in Montana experienced particularly high levels of gunplay. According to Charlie Russell, "the leadin' industries" in Landusky between the Missouri and Milk rivers, "was saloons an' gamblin' houses with a fair sprinklin' of dance halls. For noise and [gun] smoke there wasn't nothin' ever seen like it before the big fight in Europe ... Little lead [was] wasted, as the shootin [was] remarkably accurate an' almost anybody" was liable to become a target. Russell claimed that there were so many funerals in the town that they had to be "held at night under a white flag, so that business" could go uninterrupted during the day time.[32]

Russell was certainly exaggerating. Though he lost a number of acquaintances "in a hail of lead," he became openly disdainful of the way gun violence was so vastly overdone in Hollywood film.[33] One can be pretty sure, too, that he overstated the aggressiveness and accuracy of the shooting. In assessing gunplay on the Western cattle frontiers as whole, current authorities have told us:

Few wranglers went looking for trouble, and in fact few were even proficient with their six-shooters. Most gunshot wounds, it turns out, were accidental. Particularly dangerous were the new "double-action" revolvers introduced by the Colt Repeating Firearms Company in the late 1870s, guns that could be fired either by pulling the trigger or by cocking and releasing the hammer. "It is well known that most of the accidents with revolvers arise from the unintentional manipulation of the hammer," reported the *Dallas Weekly Herald*, "Either it receives a blow, or it is allowed to slip off the thumb in cocking, or it is caught against the clothing, and particularly when it is in full cock." Men shot themselves while working, while removing their guns from wagons or packs, even while undressing.[34]

The reputations of towns like Landusky, Glasgow, and Culbertson suggest, however, that Russell did not err in emphasizing a generally high level of violence.[35] The Canadian towns appear to have been a lot less quiescent than historians have been inclined to admit but none of them seem quite to live up to the image of one or two of their Montana counterparts. Along with the slightly lower general propensity to carry the gun, the explanation lies with the Mounties. The force was stationed in most towns and, notwithstanding the regular indiscretions of its own members, it did go to some effort to prevent gunplay from getting out of hand. Also, since it was appointed by the federal government, it could enforce its authority with a certain amount

of objectivity. In Montana, on the other hand, officials were elected by the citizenry. The men entrusted with the task of keeping the peace were sometimes therefore more concerned about cramping the style of the saloons or whorehouses than with enforcing the law. Thus, for instance, when the cowboys came to town it was not uncommon for them to saddle up their horses and head off on some distant mission just to give such establishments a freer rein.[36]

When making such observations, however, it is necessary to add two qualifications. One is that the Canadian ranching era witnessed plenty of violence of its own. Ironically, much of this occurred after the earliest frontier stage, when the Mounties' numbers had been so badly depleted. It is no accident that most of the incidents mentioned above occurred in the nineties and later, when a smaller proportion of men were actually still carrying arms. The other qualification is that in Montana the most violent stages ended relatively quickly. Within a short time settlers arrived in greater numbers, officials were elected on law-and-order tickets, and reliance on the gun was much reduced. Therefore, the difference in the two societies was neither universal over time or geographic area nor by any means unqualified. Moreover, if the Montana experience was not exactly like that of Alberta and Assiniboia, it also was not the same as that of other plains states further south.

Like Alberta and Assiniboia, Montana did not really have range wars. There were some conflicts between cattlemen, and between cattlemen and sheep men, over the rights to land in various districts, some of which ended in bloodshed; however, these were both small scale and few in number.[37] The comparative calm seems to have been the result of a more paternal attitude that developed among some of the most respected big ranchers towards the smaller-scale farmers and settlers who moved in amongst them. Far from chasing them from the plains, Granville Stuart and others are known to have built local schools for their children, allowed them to milk their range cows when times were tough, and helped them financially by employing them, purchasing produce such as milk, butter, hay, and green feed from them, and lending them horses and farm machinery. They also apparently helped them recover stolen horses and cattle.[38] In Wyoming and other states, by contrast, the big men declared open war on anyone who invaded what they considered their space. Many of the members of their so-called citizen action committees were simply hired guns, and they killed and ran off outlaws and *bona fide* settlers alike.[39]

One of the things that this comparison suggests is the danger of attempting to apply general descriptions to distinguish between Canadian and American plains ranching frontiers. Clearly, when one does this, one risks overlooking important nuances. While short periods of

regular gun violence and vigilante justice in Montana may allow us to speak of there being less respect for law and order there than in Western Canada, the state seems to have been relatively civilized in comparison to some of its other neighbours. Our tendency might well be to miss that fact altogether. One might also neglect the reality that regions within particular states or territories developed at different rates. What was true of northern or eastern Montana at a particular time may not have been true of central or Western regions. A condition that pertained to the foothills of Alberta may not have described the North-West Territories as a whole. Finally, to suggest that the Montana ranching frontier was in some respects more unruly than that of Western Canada does not permit us to go as far as treating them as opposites. The truth is that the difference between them was relatively small. The Canadians were not all law-abiding and tame and the Americans not all vicious and blood-thirsty. Montana may at times have seen somewhat more gunplay than Western Canada, but those times were short and the levels of drinking and prostitution on both sides of the border seem to have been about the same. Livestock rustling was a common problem that the two societies shared and in the end addressed together.

Again, this commonality speaks to the necessity in the frontier environment of delegating to small police forces on both sides of the line the daunting task of imposing a legal culture that had been transported from the East. These forces soon found themselves taxed to the limit by the immensity of the regions they had to serve, the variety of roles they were required to assume in fledgling communities, and the disproportionate number of young males in their populations. To put this another way, the New World constantly competed with the Old in setting standards and it often won out. And that statement could apply to a lot more than just the question of law and order.

Much has been said here about the refined social behaviour of the British and eastern ranching elites. Elegant evening dinner parties with Victorian furniture, expensive china dishes, and formally attired diners were, as in the Ferdons' home near Miles City or the Inderwick household in Alberta, usually staged against a backdrop of hurriedly constructed log walls, crude furniture, and unfinished wooden floors.[40] Moreover, a social outing that on the surface appears to have been both refined and stately may well have been something else. Balls also took place in rough-hewn buildings and were attended by doughty frontiersmen as well as the privileged few.[41] Often, too, such affairs deteriorated into drunkenness and debauchery. An 1880 Christmas ball attended by the North West Mounted Police aptly illustrates this. "All the Officers were present [and] also the ladies. [They] passed a very

nice evening till about one when some of the boys [in the force] got drunk and commenced to fight." Despite the fact that these were prohibition days the officers did nothing to eradicate the source of the trouble. They too helped themselves to copious amounts of "Jamaica Ginger," and before the ball ended "most of the men were completely inebriated."[42] At Millarville, Alberta, the annual Race Days celebration presided over by influential Britons was touted as "the social event of the year."[43] In relating the activities there of two English lads in 1909, Mark Zuehlke illustrates that the event could indeed be most chaotic. One of the lads was a member of the Race Club and another a founding member of the local polo club. Both were "notorious drinkers, and many of the Canadian ranchers in the area were amazed at the quantity of liquor [they] could put away and still remain steady on their feet." At one of the bars set up at the celebration, "events turned from rowdy to riotous" and "the police moved in to shut things down and confiscate the liquor supply." Unfortunately, the two young men discovered the liquor first. They "bundled up" most of it and escaped to one of their homesteads. The next morning a local resident who had witnessed the escape went out to check on them. Seeing their horses "saddled up and tied to the hitching post outside the shack" he went in and found the two, "dressed for serious cowboying." They had changed out of their race meet clothes into boots, chaps, and spurs and were trying to make a wager over whether or not they could swim across Sheep Creek in this get-up. The resident talked them out of the bet and went outside to put their horses away. When he came back, "he found both men passed out on bunks amid the scattered bottles of what must have been one of their best drunks ever."[44]

It can certainly not be argued that race days and other such celebrations in New York or London did not also sometimes deteriorate to rowdiness and depravity. However, the scarcity of women and families on the frontier, the predominance of men, and the weakness of law enforcement agencies together produced the kind of society that such a combination would likely have produced anywhere. It was these conditions, along with the dearth of infrastructure such as fences to control the livestock, and isolation from distant markets that combined with natural forces such as winter weather, drought, wolves, and the mange to destroy the open range ranching approach in both the American and the Canadian West.

In sum, a frontier interpretation of the early West can still be useful. While writing this volume I have come to agree with Richard Slatta, who has "questioned the strain of over-revision" in recent historiography, "that relegates the concept of the frontier to … oblivion."[45] When Frederick Jackson Turner laid out the first, and best-known,

frontier thesis over a hundred years ago, his approach enabled scholars to bury his ideas when it suited them. He was well aware of, but not interested in, detailing the impact of Old World influences – from cultural baggage to laws and institutions, however weakened – that people brought West with them. He also failed to sketch out in intricate detail the mechanics of how forces on the frontier affected law enforcement, agricultural methods, women, popular culture, and so on. And he was not interested in pinpointing the ways in which novel conditions in fledgling societies forced people to take a hand in making up new rules and designing new practices. To him it was sufficient to insist that pioneers heading onto Western frontiers were able to break loose from the institutional restraints and social mores of the Old World and develop a level of freedom, individuality, democracy, and patriotism previously unknown. Moreover, he was far too America-centric. He wanted above all to illustrate that frontiers defined (or redefined) the United States and made it the world's leading voice of freedom.

A hypothesis should not, however, be discarded because it is flawed. If reduced to its most fundamental assertion – that the frontier moulded society – and softened with the declaration that it did not ever work alone, Turner's approach undoubtedly has relevance. There clearly is merit in his insistence that institutional and social restraints were less powerful on these two ranching frontiers than in the Old Worlds from which their peoples came, and that this diminished influence helped to change them. It was, for instance, the reduction of the influence of the family and the controlling hand of the law that allowed such an extraordinary percentage of the citizenry to take up rustling and other forms of violence. The need for stronger law enforcement also provoked the ranchers to take action on their own by forming livestock associations, registering and publishing brands, hiring their own detectives, and adopting – or at least contemplating adopting – vigilante justice. Assuming responsibility for self-regulation in turn enforced the principle of citizen action, a principle which no doubt had a democratizing effect on society as a whole.

Turner's detractors would be justified in arguing that the ranching frontier was anything but democratic because of the great disparity in wealth and social standing between the cattle barons and the cowboys, the small farmers and the ranchers.[46] The former controlled and managed the cattle associations and lobbied eastern governments when necessary for their own well-being. It cannot be denied, however, that the convention of individuals getting together to deal with their common problems on the frontier stimulated the development of a tradition of citizen jurisdiction and control. When the large ranch owners disappeared they were replaced by men – and gradually more

women – who secured almost equal amounts of cheap land through the auspices of *Homestead* and *Preemption* acts. It was their common interests that eventually governed the cattle associations. The precedents they then set for communal action in those organizations could only have helped them to pool their resources in endeavours to develop and utilize facilities such as churches, schools, libraries, and recreational services that were so needed in early pioneer communities. Modern studies indicate that as they did that they were forced, as Turner suggested,[47] to de-emphasize many of the ideas of racial, religious, and gender exclusiveness they had brought with them from distant homelands.[48] The process was almost certainly not as complete as Turner would have liked to believe, but there seems reason to argue that this participation in community building did encourage a more egalitarian culture than might otherwise have developed.

The rise in the stature of women contributed to this emerging sense of egalitarianism. "Sporting girls" lived in communities where they could operate largely free of oppressive moral judgments and where gender imbalance enhanced demand for their services and enabled them to exercise enormous sway over men. Married and "nice" women were able to preside unchallenged over certain values and etiquette and were often virtually worshipped by the males around them. To say as much is not to insist upon an idyllic portrayal of life on the frontier for women in general. The experiences of the women who came to settle and raise families were as varied as those of the prostitutes. Some unquestionably were exploited and abused by domineering husbands and others faced poverty, hardship, and even malnutrition in their struggle to keep their children clothed and fed. However, some gained a sense of self-confidence that helped them break Old World values – which were also diminished by distance and necessity. They became business persons, took on crucial duties in operating farms and ranches, and ran for public office.

It is no accident that the list of women from these two societies who achieved regional and national eminence just after the open range ranching industry came to an end is a long and imposing one. North of the border, for instance, Emily Murphy, a self-taught legal expert, became the first female magistrate in the province of Alberta – and the British Empire – in 1916, and then waged a decade-long battle to gain women the right to legal recognition and thus to appointed positions, including the Senate. Louise McKinney, a teacher, organized the Women's Christian Temperance Union in 1903, took a seat in the Alberta legislature in 1917, and then spent the rest of her life helping Murphy with her case and championing social welfare measures for immigrants and widows. Violet McNaughton became joint secretary of the

Saskatchewan Grain Growers Association in 1912 and then spearheaded the establishment of a "Women's Congress" within that association, of which she was the first elected president. She also initiated the formation of the Saskatchewan Equal Franchise League and became the president of the Interprovincial Council of Farm Women and the editor of the "Mainly for Women" section of *Western Producer* magazine. Nellie McClung,[49] Irene Parlby, and Henrietta Edwards wrote books and articles, joined the crusade for the vote and better dowry rights, and voiced their opinions in organizations such as the Red Cross, the Women's Christian Temperance Union, and the Women's Institute.

In Montana Jeannette Rankin got her start in politics campaigning for the vote in 1914. Then she became the first woman ever elected to the United States Congress. In that role she not only fought for the rights of women to hold office but also spoke out against economic injustice and war, and crusaded for civil liberties.[50] Maggie Smith Hathaway, a longtime educator in Stevensville and Helena, served several terms as the Lewis and Clark County superintendent of schools between 1894 and 1911. She contributed to the cause of social reform through the Women's Christian Temperance movement and she also joined the suffragettes' campaign. In 1917 she and Emma J. Ingalls were the first women elected to the Montana Legislature.[51] Ella L. Knowles became the first female lawyer in the state in 1918. While practising law in Butte she fought for the rights of women in professions, industry, politics, and suffrage. She also gained appointment as the state's Assistant Attorney General.[52] In relation to population size, politically and publicly active women seem to have emerged in much greater numbers in Montana, Alberta and Assinibioa, and other Western regions in this period than in older, more mature, and more easterly societies. What becomes clear is that to understand and explain this empowerment fully it is necessary to go all the way back to the earliest frontier period when female numbers, relatively speaking, were at their lowest.

The egalitarian strands that emerged from the frontier social environment were to make their impressions on provincial and state party politics in later years. South of the border a "populist tide" swept Montana in 1892, "scrambled party lines," and then "left an enduring legacy of party irregularity and anti-corporate, anti-Eastern radicalism on the left."[53] Mining interests played an important (at times dominant) part in state politics but the voice of the agricultural sector also made itself heard. While the Populist Party itself died out after 1896, its ideology and rhetoric lived on for many years in farmer-labour denunciations of exploitation by banks and railroads and in the liberal ideology of politicians such as Burton K. Wheeler and Lee Metcalf. In

Alberta, Henry Wise Wood founded the United Farmers of Alberta (UFA) on principles of direct democracy such as plebiscites and referenda, non-partisanship, and the advancement of the power of the legislature over the executive. In 1921 the UFA was strong enough to convince the electorate to reject the traditional Liberal and Conservative parties and hand it the reins of power – which it was able to maintain for some fourteen years.[54] After the province of Saskatchewan was formed out of the territories of Saskatchewan and Assiniboia in 1905, a Liberal government rose to office and managed to remain in power for an extended period. However, the principle of direct citizen involvement was kept strong in the cooperative approach of organizations such as the Saskatchewan Grain Growers Association and the Progressive and Farmer-Labour connections. In the thirties these elements were melded together to form the leftist and somewhat socialist Cooperative Commonwealth Federation.[55] It took office under T.C. Douglas in 1944 and eventually became the New Democratic Party, which is still a dominant power in Western provincial politics today.

In the final analysis the two regions of concern in this study shared a great deal of history as the ranching frontiers came and went. They both forged societies composed of a people attracted from eastern homelands by the magic of the visual and promotional media. They both enjoyed short periods of immense hope that were shattered by the effects of the natural, social, and legal frontier environments. They both were dominated by wealthy cattlemen mainly from the east and a popular cowboy culture suited to the conditions of the frontier but designed in part by books, dime novels, and Wild West shows popularized in New York, Chicago, Montreal, Toronto, London, and Edinburgh. They also went through a similar pattern of agricultural development in which open range ranching eventually yielded to the mixed or ranch farm as the approach most suited to stock raising under northwestern conditions. And they helped to prepare the ground for the emergence of populist political approaches in which local women as well as men could demand and attain a prominent place. These commonalities would seem to suggest the importance of historical analyses that cut across international political boundaries.

Notes

ACRONYMS

AHC American Heritage Center Archives, Laramie
CHS Colorado Historical Society Archives, Denver
GA Glenbow Alberta Institute, Calgary
MHS Montana Historical Society Archives, Helena
MSU Montana State University Archives, Bozeman
PAA Provincial Archives of Alberta, Edmonton
PAC Public Archives of Canada, Ottawa
PAS (S) Provincial Archives of Saskatchewan, Regina
PAS (N) Provincial Archives of Saskatchewan, Saskatoon
UM University of Montana Archives, Missoula

INTRODUCTION

1 The provinces of Alberta and Saskatchewan were formed out of the territories of Alberta, Saskatchewan, and Assiniboia in 1905.
2 MHS, Rankin papers, MC 162.
3 See B.W. Dippie, "Charles M. Russell, Cowboy Culture, and the Canadian Connection," *Cowboys, Ranchers and the Cattle Business: Cross-Border Perspectives on Ranching History*, ed. S. Evans, S. Carter, and W.B. Yeo, Calgary and Boulder: University of Calgary Press and University Press of Colorado, 1999, 25; MHS, Rankin papers, MC 162-2-26: Brig. Gen. H.F. McDonald to J. Rankin, 4 December 1936.
4 Canada, *Sessional Papers*, 28:9 (1895), n. 15 (North West Mounted Police Annual Reports), 18: Report for Macleod District, 30 November 1894.
5 For a discussion of the literature see W.M. Elofson, *Cowboys, Gentlemen, and Cattle Thieves: Ranching on the Western Frontier*, Montreal and Kingston: McGill-Queen's University Press, 2000, xiii–xx.

6 D.H. Breen, *The Canadian Prairie West and the Ranching Frontier, 1874–1924*, Toronto: University of Toronto Press, 1983.
7 L.G. Thomas, *The Ranchers' Legacy: Alberta Essays by Lewis G. Thomas*, ed. P.A. Dunae, Edmonton: University of Alberta Press, 1986.
8 Hugh A. Dempsey, *The Golden Age of the Canadian Cowboy: An Illustrated History*, Saskatoon and Calgary: Fifth House, 1995.
9 R.H. Fletcher, *Free Grass to Fences: the Montana Cattle Range Story*, New York: University Publishers, 1960.
10 M.G. Burlingame, *The Montana Frontier*, Helena, Montana: State Publishing Company, 1942.
11 J.M. Hamilton, *History of Montana: From Wilderness to Statehood*, Portland: Binfords & Mort, 1957.
12 T.G. Jordan, *North American Cattle Ranching Frontiers: Origins, Diffusion, and Differentiation*, Albuquerque: University of New Mexico Press, 1993.
13 R.W. Slatta, *Comparing Cowboys and Frontiers: New Perspectives on the History of the Americas*, Norman and London: University of Oklahoma Press, 1997.
14 B. LaDow, *The Medicine Line: Life and Death on a North American Borderland*, New York: Routledge, 2001.

CHAPTER ONE

1 R.H. Fletcher, *Free Grass to Fences: The Montana Cattle Range Story*, New York: University Publishers, 1960, 19–27.
2 This was in the 1850s; see Granville Stuart, *Forty Years on the Frontier, as seen in the journals and reminiscences of Granville Stuart*, ed. P.C. Philips, Cleveland: A.H. Clark, 1925, vol. 2, 97.
3 Fletcher, *Free Grass to Fences*, 28–42; Stuart, *Forty Years on the Frontier*, vol. 2, 97–9. Westerns were the progeny of Shorthorns and milk-producing breeds like Devonshires. They were quite well adapted to the northern climate, knew how to rustle for their feed and protect their young, and were considered to be good for both meat and milk.
4 See below, 158–60.
5 Fletcher, *Free Grass to Fences* 20–3, 33, 45; Stuart, *Forty Years on the Frontier*, 97–101.
6 R.V. Hine and J.M. Faragher, *The American West: A New Interpretive History*, New Haven & London: Yale University Press, 2000, 305–7.
7 R. White, "Animals and Enterprise," *The Oxford History of the American West*, eds. C.A. Milner II, C.A. O'Connor, and M.A. Sandweiss, New York and Oxford: Oxford University Press, 1994, 260.
8 W.M. Elofson, *Cowboys, Gentlemen, and Cattle Thieves: Ranching on the Western Frontier*, Montreal and Kingston: McGill-Queen's University Press, 2000, 3. Strictly speaking, the Reverend John McDougall was an

ordained minister and David a trader. However, their contemporaries considered them both missionaries for the work they did among the Indians. See F. Ings, *Before the Fences: Tales from the Midway Ranch*, ed. J. Davis, McARA Printing, 1980, 6.

9 A. Sibbald, "West with the McDougalls," *Alberta Historical Review*, 18:1 (winter 1971), 1.
10 Elofson, *Cowboys, Gentlemen, and Cattle Thieves*, 4–5.
11 Ibid., 3–22.
12 MSU, Abbott-Stuart-Matejcek papers, MC 532.
13 See *Charlie Russell Roundup: Essays on America's Favorite Cowboy Artist*, ed. B.W. Dippie, Helena: Montana Historical Society Press, 1999, 1–32; G.K. Renner, "Charlie and the Ladies in his Life," ibid., 133–53.
14 MSU, Abbott-Stuart-Matejcek papers, MC 532; T.M. Cheney with R.C. Cheney, *So Long, Cowboys of the Open Range*, Helena: Falcon Publishing Inc., 1998, 80–8.
15 Ibid., 194.
16 See S. Evans, "Tenderfoot to Rider: Learning 'Cowboying' on the Canadian Ranching Frontier during the 1800s," *Cowboys, Ranchers and the Cattle Business: Cross-Border Perspectives on Ranching History*, eds. S. Evans, S. Carter, and W.B. Yeo, Calgary and Boulder: University of Calgary Press and University Press of Colorado, 1999, 61–80.
17 GA, New Walrond Ranche papers, M8688-1-3: W. Bell to D. McEachran, 2 June 1888.
18 Ibid., W. Bell to J.G. Ross, 9 July 1888.
19 "Came out to be a Cowboy," *Calgary Herald*, 12 April 1904.
20 H.R. Whates, *Canada: The New Nation. A Book for the Settler, the Emigrant and the Politician*, London: J.M. Dent, 1906, 213, quoted in M. Zuehlke, *Scoundrels, Dreamers and Second Sons; British Remittance Men in the Canadian West*, 2nd edition, Toronto, Oxford & New York: Dundurn Press, 2001, 58.
21 Ibid.
22 E.C. Abbott and H. Huntington Smith, *We Pointed Them North: Recollections of a Cowpuncher*, Norman: University of Oklahoma Press, 2nd edition, 1955, 191.
23 Ibid., 191–2.
24 G.A. Wilson, *Outlaw Tales of Montana*, Havre, Montana: High-Line Books, 1995, 147.
25 Ibid., 49; W. Coburn, *Pioneer Cattleman in Montana, the Story of the Circle C Ranch*, Norman: University of Oklahoma Press, 1968, 53–110.
26 Wilson, *Outlaw Tales*, 68.
27 Approximately 1898 (ibid., 72).
28 Ibid., 78.
29 White, "Animals and Enterprise," 261.

30 CHS, Incorporation Records, Western Range Cattle Industry Study.
31 Elofson, *Cowboys, Gentlemen, and Cattle Thieves*, 16.
32 All types of cattle in all of Montana (A. Merrill and J. Jacobson, *Montana Almanac*, Helena: Falcon, 1997, 309).
33 All types of cattle in all of Alberta and Assiniboia (S.M. Evans, "Stocking the Canadian Range," *Alberta History*, 26:3 (summer 1978) 1; Canada, *Fourth Census*, 1901, vol. 2, 52–3. For other reports on the development of the cattle business see L.V. Kelly, *The Range Men*, 75th anniversary edition, High River: Willow Creek Publishing, 1988, 82–3, 97–8, 126–7, 172–3; J.G. Rutherford, *The Cattle Trade of Western Canada*, quoted in Kelly, *Range Men*, 197–212).
34 Abbott and Huntington Smith, *We Pointed Them North*, 64–5.
35 *Forty Years on the Frontier*, vol. 2, 188. Relying on his memory, Stuart felt that the influx had begun in 1880. However, the numbers of cattle already in Montana by that year suggest that it had begun one or two years earlier.

CHAPTER TWO

1 W.M. Elofson, *Cowboys, Gentlemen, and Cattle Thieves: Ranching on the Western Frontier*, Montreal and Kingston: McGill-Queen's University Press, 2000, 6–7.
2 R.H. Fletcher, *Free Grass to Fences: the Montana Cattle Range Story*, New York: University Publishers, 1960, 43–61.
3 See J. Clay, *My Life on the Range*, new edn., rprt of 1916, Norman: University of Oklahoma Press, 1962, 305. For an in-depth study see, W.M. Pearce, *The Matador Land and Cattle Company*, Norman: University of Oklahoma Press, 1964.
4 For which see UM, Fergus papers, MC 10. James Fergus, was born 1813 in Lanarkshire Scotland and emigrated to America at 22. He arrived in Montana in 1861 and was elected recorder for Alder Gulch mining district near Virginia City. In 1865 he went into ranching, first around Helena and then, in 1880, in the Judith Basin. He raised cattle, horses and, sheep and farmed one of the biggest operations in the Territory. He died in 1902.
5 MHS, SC 1692, Memoirs of Lady Kathleen Lindsay.
6 MHS, Progressive Men of the State of Montana, Chicago: A.W. Bowen and Co., 1900, 1714. Peter McDonald was born in Scotland.
7 Fletcher, *Free Grass to Fences*, 53.
8 MSU, Hart Papers, MC 751.
9 MHS, Rankin papers, 162-2-2, W. Flower to J. Rankin, 13 February, 1937.
10 The Powder River Ranch operated in northwestern Wyoming and southern Montana. It was started up by two young Sussex-born lads,

Moreton Frewen and his brother Richard. Also on the board were the Earl of Manchester's nephew, Frederick Augustus Ker Bennet, educated at Trinity College, Cambridge, and a member of the Inner Temple Bar; Sir Frederick George Milner, a baronet; Lord Henry Gilbert Ralph Nevill, son of the Marquess of Abergavenny; and Earnest William Beckett, a very prominent parliamentarian who later became Lord Grimthorpe. Among Beckett's assets was his wife, who was said to be the "most celebrated hostess in London." Lord Wharncliffe, who also carried the intimidating name of Edward Montagu Stuart Granville Montague-Stuart-Wortly-Mackenzie, succeeded Manchester as chairman of the board in the eighties (L. Woods, *British Gentlemen in the Wild West: The Era of the Intensely English Cowboy*, New York and London: The Free Press, 1989, 82–3).

11 William G. and Charles E. Conrad were principal shareholders in the first of these ranches and in the Alberta version of the second. In Montana the Circle Ranch was also known as the Price-Conrad outfit. W.G. Conrad was a partner and treasurer in it. The brothers were also partners in the Conrad Banking Company and owned much of the freighting and mercantile conglomerate known as I.G. Baker and Company. For an in-depth study see H.C. Klassen, "The Conrads in the Alberta Cattle Business, 1875–1911," *Agricultural History*, 64 (summer 1990), 31–59; and Klassen, *Eye on the Future: Business People in Calgary and the Bow Valley, 1870–1900*, Calgary: University of Calgary Press, 2002, 155–9.

12 With his brother-in-law, Alpheus Decker. In 1900 the ranch had 1,680 deeded acres (MHS, *Progressive Men of the State of Montana*, Chicago: A.W. Bowen and Co., 1900, 405).

13 He ranched with B.B. Bishop (M.A. Leeson, *History of Montana, 1739–1885*, Chicago: 1885, 1036).

14 Ibid., 1258.

15 R.G. Raymer, *Montana, the Land and the People*, 3 vols., Chicago and New York: The Lewis Publishing Co., 1930, vol. 3, 696–97.

16 MHS, *Progressive Men of the State of Montana*, 222.

17 Roosevelt's name appears a number of times in the Montana Stock Growers Association, minute book, MHS, MC 45, vol. 8. See also, Clay, *My Life on the Range*, 337–43.

18 "I have just come back from the West," he told Lord Carnarvon in England on 16 May 1887, "where the ranchers have all suffered much from the hard winter (British Library, Add MSS, Carnarvon papers, 60866A, 62).

19 London: T. Fisher Unwin, 1888.

20 G.A. Wilson, *Outlaw Tales of Montana*, Havre, Montana: High-Line Books, 1995, 49; Fletcher, *Free Grass to Fences*, 111.

21 MHS, *Progressive Men of the State of Montana*, 104.
22 Ibid., 1912–14.
23 In 1866 Coburn started his first ranch on Flatwillow Creek (R.H. Fletcher, *Free Grass to Fences*, 49). For an in-depth study see W. Coburn, *Pioneer Cattleman in Montana; The Story of the Circle C Ranch*, Norman: University of Oklahoma Press, 1968.
24 Leeson, *History of Montana, 1739–1885*, Chicago: 1885, 1027. For the strategic location of the Spencer lease, see below, 93–4.
25 R.S. Fletcher, "The End of the Open Range in Eastern Montana," *Mississippi Valley Historical Review*, 16 (1929–30 188–211; R.H. Fletcher, "Wolfer's shack," *Free Grass to Fences*, 68–9.
26 Elofson, *Cowboys, Gentlemen, and Cattle Thieves* 3–22.
27 Ibid., 16.
28 Day and Cresswell sold out to the Harris Franklin Cattle Company in Montana and then ranched in Assiniboia alone (Fletcher, "The End of the Open Range," 210–11).
29 Coburn, *Pioneer Cattlemen in Montana*, 136.
30 Elofson, *Cowboys, Gentlemen, and Cattle Thieves*, 2.
31 Fletcher, *Free Grass to Fences*, 90.
32 See below, 161–3.
33 See below, 139.
34 Elofson, *Cowboys, Gentlemen, and Cattle Thieves*, 19, 21, 136, 147.
35 E.C. Abbott and H. Huntington Smith, *We Pointed Them North: Recollections of a Cowpuncher*, Norman: University of Oklahoma Press, 2nd edition, 1955, 208–10.
36 Elofson, *Cowboys, Gentlemen, and Cattle Thieves*, 71–98.
37 For instance, the Harris Franklin Cattle Company started in 1881 as a small operation, purchased the Continental Land and Livestock company in 1887, and then, in 1900, bought out all 20,000 cattle of the Day and Cresswell outfit in the state. In 1903 it sold out all its marketable beef and put the rest of its stock on pastures in western Nebraska (Fletcher, "The End of the Open Range," 210–11).
38 The first line was the Utah and Northern, a branch of the Union Pacific Railway, which came north from Ogden, Utah, to Dillon in 1880 and then was pushed through to the mining center of Butte in 1881. The transcontinental Northern Pacific made its way to Gold Creek in 1883. In 1887 the St. Paul, Minneapolis and Manitoba Railway joined Minot, North Dakota to Great Falls.
39 *Fourth Census of Canada,*, (1901) vol i, 9. All of Alberta and Assiniboia had just over 133,000 people. Around 33,000 would have lived in central and northern regions of Alberta. For Montana numbers see A. Merrill and J. Jacobson, *Montana Almanac*, Helena: Falcon, 1997, 46.

40 The figures for 1884, 1888, 1890, 1892, 1894, 1895, and 1896 are found in Canada, *Sessional Papers*, (Department of Interior Annual Reports). After 1888 the decline is more or less continuous.
41 Ibid., 26:9 (1893), n. 15 (North West Mounted Police Annual Reports), 90: Report for K Division, 1892.
42 Ibid., 27:11 (1894), n. 15, Report for K Division, 1893.
43 GA, Calgary, Cross papers, M 1543, f. 445: W. Skrine to A.E. Cross, 14 June 1901.
44 Canada. *Census of Prairie Provinces* (1916), Ottawa, 1918, 44–127.
45 Canada, *Sixth Census* (1921), vol. 5, xxiii. In 1921 the average farm in Alberta had 352.5 acres and in Saskatchewan, 368.5 acres. The average in Montana would have been very close to that. In 1910 there were just over 26,000 farms in the state. On average each had just under 140 acres of improved, or cultivated, land and, since it also had about 40 head of cattle, would have needed around 200 acres of grazing land (Montana Department of Publicity of the Bureau of Agriculture, Labor and Industry, *Montana*, compiled by W. Boyle, Helena: Independent Publishing, 1912, 111–12). Figures for the other types of livestock are also given.
46 Figures for the various types and numbers of farms are available for 1916 for Macleod, Calgary, Medicine Hat, Lethbridge, and Maple Creek (Canada, *Census of Prairie Provinces*, (1916), 305, 310–11. For further discussion see W.M. Elofson, "Adapting to the Frontier Environment: Mixed and Dryland Farming near Pincher Creek, 1895–1914," *Prairie Forum*, 11:12 (fall 1986), 35–45.
47 Canada, *Fourth Census* (1901), vol. 1, 132–3.
48 Canada, *Census of Prairie Provinces* (1916), 44–127. United States. *Tenth Census of the United States*, 1880, vol. 1, 602; *Eleventh Census* 1890, lxii; *Twelfth Census*, vol. 1, xcii; *Fifteenth Census*, vol. 1, 2, 7.

CHAPTER THREE

1 W.M. Elofson, *Cowboys, Gentlemen, and Cattle Thieves: Ranching on the Western Frontier*, Montreal and Kingston: McGill-Queen's University Press, 2000, 134–49; R.H. Fletcher, *Free Grass to Fences: the Montana Cattle Range Story*, New York: University Publishers, 1960, 110–12.
2 Elofson, *Cowboys, Gentlemen, and Cattle Thieves*, 8–16.
3 In 1874 they bought I.G. Baker and Company (H.C. Klassen, "The Conrads in the Alberta Cattle Business, 1875–1911," *Agricultural History*, 64 (summer 1990), 31–59).
4 Fletcher, *Free Grass to Fences*, 53.
5 R. White, "Animals and Enterprise," *The Oxford History of the American West*, eds. C.A. Milner II, C.A. O'Connor, M.A. Sandweiss, New

York and Oxford: Oxford University Press, 1994, 256. "The Dead Meat Trade," *Bristol Evening News*, 22 August 1877.
6 G.O. Shields, *Rustlings in the Rockies: Hunting and Fishing by Mountain and Stream*, Chicago: Belford, Clarke and Co., 1883, 126.
7 W.F. Butler, *The Great Lone Land: A Narrative of Travel and Adventure in the North-West of America*, London: Sampson Low, Marston, Low and Searle, 1874, v.
8 *Peace River: A Canoe Voyage from Hudson's Bay to the Pacific by the Late Sir George Simpson in 1828...*, ed. M. Macleod, Ottawa: J. Durie and Son, Montreal: Dawson Brothers, Toronto: Adam Stevenson and Company, 1872, 77. See also W.F. Munro, *The Backwoods of Ontario, and the Prairies of the North-West*, London & Glasgow: Marshall and Co., 1881; *Across the Canadian Prairies: A Two Months' Holiday in the Dominion*, London: European Mail, 1896; D.T. Hanbury, *Sport and Travel in the Northland of Canada*, New York: The MacArthur Co., London: Edward Arnold, 1904.
9 See M. Zuehlke, *Scoundrels, Dreamers, and Second Sons: British Remittance Men in the Canadian West*, 2nd edition, Toronto, Oxford and New York: Dundurn Press, 2001, 21–2.
10 G.M. Grant, *Ocean to Ocean: Sanford Fleming's Expedition through Canada in 1872*, 2nd edition, Toronto: Prospero Books, 2000, 149.
11 *The North-West Passage by Land, being a Narrative of an Expedition from the Atlantic to the Pacific*, 6th edition, Toronto: Prospero Books, 2001, 178.
12 D. Eaton and S. Urbanek, *Paul Kane's Great Nor-West*, Vancouver: University of British Columbia Press, 1996; B.W. Dippie, "The Visual West," *Oxford History of the American West*, 675–705.
13 See F.M. Szasz, *Scots in the North American West, 1790–1917*, Norman: University of Oklahoma Press, 2000, 132–41.
14 This is evidenced by the sheer volume of works produced. See, for instance, B.H. Revoil, *Shooting and Fishing in the Rivers, Prairies, and Backwoods of North America*, London: Tinsley Brothers, 1865; J.L. Peyton, *Over the Alleghenies and Across the Prairies, Personal Recollections of the Far West One and Twenty Years Ago*, London, 1869; A.D. Richardson, *Beyond the Mississippi: from the Great River to the Great Ocean. Life and Adventure on the Prairies, Mountains and Pacific Coast*, Hartford: American Publishing Co., 1869.
15 See below, 57–8.
16 Fletcher, *Free Grass to Fences*, 54.
17 See H. Nash Smith, *Virgin Land: the American West as Symbol and Myth*, Cambridge, Mass.: Harvard University Press, 1950, 90–111.
18 J.F.C. Adams, *The Fighting Trapper; or Kit Carson to the Rescue*. Beadle and Adams, New York, 1879, 28.

19 *American Exhibition, 1887, the Life and Adventures of Buffalo Bill; Habits and Customs of the Indians; and Country Life in the Wild West,* London: F. Wells, n.d.. For a history of the shows see, P. Reddin, *Wild West Shows,* Urbana and Chicago: University of Illinois Press, 1999; D. Russell, *The Wild West or, A History of the Wild West Shows...,* Fort Worth: Amon Carter Museum of Western Art, 1970. The standard biography of Cody is D. Russell, *The Lives and Legends of Buffalo Bill,* Norman: University of Oklahoma Press, 1960.
20 P. Ingraham, *Buffalo Bill, from Boyhood to Manhood. Deeds of Daring, Scenes of Thrilling Peril, and Romantic Incidents in the Early Life of W.F. Cody, the Monarch of the Borderland,* 2, quoted in Smith, *Virgin Land,* 107.
21 S.S. Hall, *Stampede Steve; or, the Doom of the Double Face,* New York: Beadle and Adams, 1884, 2–3.
22 J.S.C. Abbott, *Christopher Carson familiarly known as Kit Carson,* New York: Dodd, Mead and Co., 1874, 62.
23 See C. King, *Dunraven Ranche,* London: F. Warne & Co., 1889; and following note.
24 Collins, c.1899.
25 R. Connor, *Sky Pilot; a tale of the foothills,* Chicago, New York, Toronto: R.H. Revell, 1899, 27, 31–2.
26 G. St Rathborne, London: Shumen Sibthorp, [1902].
27 Ibid., 13.
28 Ibid., 15–16.
29 Ibid.
30 H.S. Canfield, New York: Century Co., 1902, 16–17.
31 Ibid., 25–6.
32 Ibid., 234–5.
33 *The Virginian: A Horseman of the Plains,* New York: Macmillan Co., 1902.
34 M. Howe, afterwards Elliott, Boston & Cambridge: Roberts Brothers, 1884.
35 H.L. Williams, London: General Publishing Co., [1890].
36 W.L. Chittenden, New York and London: Putnam's Sons, 1893.
37 H.L. Williams, *The Chief of the Cowboys: or the Beauty of the Neutral Ground,* New York: R. Midewitt, [1870].
38 W.T. Larned, "The Passing of the Cow-Puncher," *Lippincott's Magazine of Popular Literature and Science,* old series, vol. xvii, new series, vol. I, Philadelphia: J. B. Lippincott, 1881, 268.
39 "Came out to be a Cowboy," *Calgary Herald,* 12 April 1904.
40 Theodore Roosevelt, *Ranch Life and the Hunting Trail,* London: T. Fisher Unwin, [1888], 7.
41 London: T. Fisher Unwin, [1888] 9–10.

42 R. Aldridge, *Ranch Notes in Kansas, Colorado, the Indian Territory and Northern Texas*, London: Longmans, Green and Company. 1884.
43 *Texan Ranch Life; with Three Months through Mexico in a Prairie Schooner*, London: H. Cox, 1894.
44 C.C. Post, Chicago: Rhodes & McClure, 1888.
45 E. Hough, New York: D. Appleton, 1897.
46 Quoted in "Ranching at a Profit," *The Regina Leader*, 11 June 1896.
47 "Cowboys in England," *The Missoulian*, 12 August 1887,
48 White, "Animals and Enterprise," 257.
49 *The Beef Bonanza or How to get Rich on the Plains; being a description of cattle-growing, sheep-farming, horse-raising, and dairying in the West*, Philadelphia: J.B. Lippincott & Co. 1881,
50 *Cattle Raising on the Plains of North America*, New York: D. Appleton & Co., 1885.
51 *Trans-Missouri Stock Raising; the Pasture Lands of North America; Winter Grazing*, Omaha: Daily Herald Steam Printing House, 1871.
52 *Historic Sketches of the Cattle Trade of the West and Southwest*, Kansas City: Ramsey, Millett & Hudson, 1874.
53 General James S. Brisbin, *The Beef Bonanza, or, How to Get Rich on the Plains*, Philadelphia: J.B. Lippincott, 1881, 79.
54 Brisbin promised "at least 25 per cent per annum." 77–8.
55 See note 77 below.
56 D.H. Breen. *The Canadian Prairie West and the Ranching Frontier, 1874–1924*, Toronto: University of Toronto Press, 1983, 3–22.
57 See for instance "Grain for the English Market," *Bristol Evening News*, 5 June 1877; "The Weather and the Crops," ibid., 18 April 1881; "Sir S. Northcote on Canada," ibid., 18 January 1882; "The Foreign Cattle Trade and the Dock Board," *Liverpool Daily Courier*, 19 July 1880; "Canadian Emigration," ibid., 20 July 1880.
58 "Importation of Cattle at Bristol," 19 July 1877.
59 "Treatment of Cattle," 15 July 1880.
60 *Food from the Far West*, New York: Orange Judd Co., vii, xiv, 47.
61 "Agricultural Interests Commission, Reports of the Assistant Commissioners presented to both Houses of Parliament by Command of Her Majesty," *British Parliamentary Papers, Area Studies: United States of America*, 1 (Agriculture, 1878–99), 67.
62 Ibid., 68.
63 "English and American Agriculture," *Manchester Guardian*, 21 July 1880; "The Agricultural Commission," *Bristol Daily Courier*, 23 July 1880.
64 L. Woods, *British Gentlemen in the Wild West: The Era of the Intensely English Cowboy*, New York and London: The Free Press, 1989, 84.
65 *Range and Ranch Cattle Traffic of the United States*, New York: Office of Poor, White and Greenough, [1885].

66 Ibid., 15.
67 Ibid., 1.
68 Ibid.
69 See below 149–50.
70 *Range and Ranch Cattle Traffic*, 12.
71 The reporters figured the cost of feed at "about $1.25" per head per year, and that of transportation "2500 miles by rail, and 3000 miles by ocean steamer" at "$25."
72 MHS, Fergus papers, MC 28-1-6: Circular letter from Clay, Robinson and Co., 27 July 1889.
73 *Range and Ranch Cattle Traffic*, 15.
74 *Farming and Ranching in Western Canada*, [Montreal, 1890], 3.
75 Ibid., 34.
76 Elofson, *Cowboys, Gentlemen, and Cattle Thieves*, 29–31, 138–40.
77 A.W. Rasporich, "Utopian Ideals and Community Settlements in Western Canada, 1880–1914," *The Canadian West*, ed. H.C. Klassen, Calgary: University of Calgary Press, 1977, 37–62; R.D. Francis, *Images of the West: Changing Perceptions of the Prairies, 1690–1960*, Saskatoon: Western Producer Prairie Books, 1989, 37–153; L. Foster, *Women, Family, and Utopia; Communal Experiments of the Shakers, the Oneida Community and the Mormons*, Syracuse: Syracuse University Press, 1991.
78 C. Russell, *Trails Plowed Under: Stories of the Old West*, introduced by W. Rogers and B.W. Dippie, Lincoln: University of Nebraska Press, 1996, 191.

CHAPTER FOUR

1 To a much smaller extent we have also stressed that these same people used a significant portion of their investment capital to import Old World agricultural expertise and to upgrade the motley American cattle herds with purebred Hereford, Angus, and Shorthorn cattle from Ontario, Quebec, and Britain, (W.M. Elofson, *Cowboys, Gentlemen, and Cattle Thieves; Ranching on the Western Frontier*, Montreal and Kingston: McGill-Queen's University Press, 2000, 23–31).
2 In 1901, of 66,593 people in the North-West Territories who were born outside Canada, 17,347 had been born in Britain (*Fourth Census of Canada*, vol. 1, 416–17). Many others of course came from Ontario and other eastern regions.
3 L.G. Thomas, *Ranchers' Legacy: Alberta Essays by Lewis G. Thomas*, ed. P. Dunae, Edmonton: University of Alberta Press, 16–24.
4 S. Steele, *Forty Years in Canada*, 2nd edition, Toronto: Prospero Books, 2000, 272.

5 See, for instance, M.E. Inderwick, "A Lady and Her Ranch," *Alberta History*, 15:4 (autumn 1967), 1–9.
6 M. Hopkins, *Letters from a Lady Rancher*, introduced by S. Jamison, Calgary: Glenbow Alberta Institute, 1982 59: letter of June 1910.
7 F. Ings, *Before the Fences: Tales from the Midway Ranch*, ed. J. Davis, McARA Printing, 1980, 61.
8 H.A. Dempsey, *Golden Age of the Canadian Cowboy*, Saskatoon and Calgary: Fifth House, 1995, 20; McKimmie Library, University of Calgary, "Gymkhana Meeting Victoria Driving Park, Saturday, 26th of October, 1889;" "Gymkhana in Aid of the General Hospital under the Auspices of the Winnipeg Riding Club, 26 June and 28 June 1902."
9 Elofson, *Cowboys, Gentlemen, and Cattle Thieves*, 9–10.
10 L.V. Kelly, *The Range Men*, 75th anniversary edition, High River: Willow Creek Publishing, 1988, 78; PAC, Department of Interior papers, RG15-1-13, from M.H. Cochrane, 20 March, 1883.
11 PAC, Sir John A. Macdonald papers, MG26-2-64: petition of the Directors of the Cochrane Ranch Co. Ltd., 22 December 1885; ibid. f. 49: Alexander Staveley Hill to Macdonald, 22 November 1882; PAC, Department of Interior papers, RG15-1-16: from D. McEachran, 8 December 1890; ibid., f. 3, from John Lister Kaye, 22 May 1888; ibid., f. 10: from J.M. Browning, 26 May 1886; ibid., from M.H. Cochrane, 11 June 1888; ibid. f. 16: from D. McEachran, 8 December 1890; ibid. f. 20: from James Hargrave, 14 January 1901; ibid. f. 25: from William Cochrane, 21 October 1886; ibid.: from D. McEachran, 5 August 1887; ibid.: from F.L. Stimson, 1 September 1887; ibid. f. 26: D. McEachran to William Pearce, 23 July 1895; ibid. bx. 2, f. 27: petition from Alberta ranchers to William Pearce, 28 January 1896; ibid. f. 27: from D.W. Marsh, secretary of Western Stock Growers Association, 11 November 1897.
12 D.H. Breen, *The Canadian Prairie West and the Ranching Frontier, 1874–1924*, Toronto: University of Toronto Press, 1983, 109–20, 136–62.
13 Elofson, *Cowboys, Gentlemen, and Cattle Thieves*, 17–19.
14 See below, 134–5.
15 Elofson, *Cowboys, Gentlemen, and Cattle Thieves*, 65–7, 93–4, 123–5, 132.
16 GA, Western Stock Growers Association Minute Books, M2452-1-3.
17 MHS, Western Stock Growers Association Minute Books, MC 45 vol. 8, 112–13.
18 Ibid., 213.
19 MHS, Stuart papers, MC 61-1-4: G. Stuart to J.E. O'Connor, 8 March 1890. Members of both the North West Mounted Police and the United States army were at times involved in rustling themselves. However,

the Mounties unquestionably put a lot more effort into reducing the depredations of civilian thieves (below, 81–95).
20 Below, 87–8, 94.
21 For less detailed accounts of the hunt in Montana see, MHS, Memoirs of Lady Kathleen Lindsay, SC 1692; "Local Notes," *Yellowstone Journal*, 3 August 1887; ibid., 26 August 1887; ibid., 1 October 1887.
22 "Grenfell Notes," *Regina Leader*, 5 May 1898.
23 "Expert Cattle Feeders," *Calgary Herald*, 9 February 1903.
24 H.W. Riley, "Herbert William (Herb) Millar," *Canadian Cattlemen*, 4:4 (March 1942), 168.
25 S. Evans, "Stocking the Canadian Range," *Alberta History*, 26:3 (summer 1978), 4; *Prince Charming Goes West: The Story of the E.P. Ranch*, Calgary: University of Calgary Press, 1993, 58.
26 Evans, "Stocking the Canadian Range," 2; E. Brado, *The Cattle Kingdom: Early Ranching in Alberta*, Vancouver: Douglas and McIntyre, 1984, 64; GA, Stair Ranch Letter Book, M2388: W.F. Cochrane to D.H. Andrews, 6 October 1891.
27 GA, New Walrond Ranche papers, M8688-1-3: journal entry by J.W. Mathison, 13 April 1889.
28 "Unique Bunch of Cattle," *Calgary Herald*, 10 February 1903.
29 Evans, "Stocking the Canadian Range," 4.
30 GA, Cross papers, M1543, f. 480: A. McCallum to A.E. Cross, 22 May 1908; ibid., f. 472: Cross to J.G. Rutherford, 19 September 1907.
31 F.W. Godsol, "Old Times," *Alberta Historical Review*, 12:4 (autumn 1964), 23; "F.W. Godsol's Ranche," *Calgary Herald*, 21 October 1902.
32 Elofson, *Cowboys, Gentlemen, and Cattle Thieves*, 27–8.
33 "Alberta Stock Raising," 20 September 1888.
34 Now Quordon.
35 Ings, *Before the Fences*, 78; Kelly, *Range Men*, 94, 109.
36 Evans, "Spatial Aspects of the Cattle Kingdom," *Frontier Calgary, 1875–1914*, eds. A.W. Rasporich and H. Klassen, Calgary: University of Calgary Press, 1975, 50; Kelly, *Range Men*, 50–4.
37 Evans, "Spatial Aspects," 50; Kelly, *Range Men*, 97
38 Ibid., 107.
39 H.C. Klassen, "The Conrads in the Alberta Cattle Business, 1875–1911," *Agricultural History*, 64 (summer 1990), 31–59.
40 The Matador Ranch leased 130,000 acres on the South Saskatchewan River near Rush Lake in 1904 (D. McGowan, *Grassland Settlers: The Swift Current Region during the Era of the Ranching Frontier*, 4th edn. Cactus Publications: Victoria, 1989, 87).
41 For more information on these men see below, 105, 108, 115, 157, 184.
42 "Alberta Cow Country," *Macleod Gazette*, 30 November 1886.

43 M. Zuehlke, *Scoundrels, Dreamers, and Second Sons; British Remittance Men in the Canadian West*, 2nd edition, Toronto, Oxford and New York: Dundurn Press, 2001, 57–8.
44 GA, Cochrane papers, NA-967-37. Billie Cochrane from the eastern townships in Quebec, Fred Ings from Prince Edward Island, and other easterners also took to wearing revolvers; see below, 154.
45 Elofson, *Cowboys, Gentlemen, and Cattle Thieves*, 38–46.
46 Ings, *Before the Fences*, 25.
47 W.R. (Bob) Newbolt, "Memories of the Bowchase Ranch," *Alberta History*, 32:4 (autumn 1984), 7.
48 Hopkins, *Letters from a Lady Rancher*, 21: letter of October 1909.
49 "The Montana Cow Boy," 3 July 1884.
50 B.W. Dippie, *Remington and Russell: The Sid Richardson Collection*, Austin: University of Texas Press, 1994.
51 MSU, Worthen Fergus papers, MC 913-2-12: J. Fergus to J. Simpson, 1894.
52 United States, *Tenth Census of the United States*, (1880), vol. 1, 378. Nearly all the Canadians must have been easterners too since the Canadian West had a very small population at this time.
53 United States, *Twelfth Census of the United States*, (1900) vol.1, clxxxii.
54 United States, *Eleventh Census of the United States*, (1890), part 1, census 2, lxxxvii–clxvi.
55 The figures are given in the 1900 census (United States, *Twelfth Census of the United States*, (1900) vol. 1, cxxvi–clxxxii). Of 176,262 native-born in 1900, 21,633 came from northern Atlantic States – predominantly from New York and Pennsylvania – and 3,397 were from southern Atlantic states, especially Virginia.
56 Canada, *Fourth Census of Canada* (1901), vol.1, 392. In Alberta, for instance, more than 44,000 out of over 65,000 people in 1901 were from Britain, Germany, or France. To compare figures see United States, *Twelfth Census of the United States*, (1900) vol. 1, xcix.
57 "Toward a Reorientation of Western History: Continuity and Environment," *Mississippi Valley Historical Review*, 41 (1955), 591.
58 Canada, *Fourth Census of Canada* (1901), vol.1, 121, 126, 127. Maple Creek had 382 inhabitants, Macleod 796, Medicine Hat 1570, Lethbridge 2,072, and Calgary 4,392.
59 *Great Falls Tribune*, 3 May 1889, and many others.
60 "Some News Just Received," *Great Falls Tribune*, 27 November 1888.
61 "Grand Ball at Forsyth," *Yellowstone Journal*, 31 December 1885; "Mother Hubbard Masquerade," ibid., 7 February 1885; "A Season of English Opera," ibid., 9 January 1886. See also "The Miles City Opera House," ibid., 11 October 1885; "Barlow and Wilson's Minstrels," ibid., 10 June 1885; "Amateur Dramatic Association," ibid., 25 November

1886; "The Charity Ball," ibid., 11 December 1886; St John Baptiste Day to wind up with a Grand Ball," *Missoulian*, 17 June 1887; "A Theatrical Treat," ibid., 18 April 1888.
62 "New Opera House," *Great Falls Tribune*, 20 June 1890.
63 National Library of Scotland, Calder papers, Ac 9000, Donald Calder to John Calder, 14 September 1890.
64 Ibid., Donald Calder to John Calder, 4 August 1892.
65 "Something New," *Yellowstone Journal*, 26 September, 1885.
66 "St. Patrick's Day in Great Falls," *Great Falls Gazette*, 17 March 1890.
67 G.A. Wilson, *Outlaw Tales of Montana*, Havre, Montana: High-Line Books, 1995, 115; for Culbertson, Glasgow, and Malta, see 61, 64.
68 MSU, Worthen Fergus papers, MC 913-2-12: J. Fergus to J. Simpson, 1894.
69 MHS, Memoirs of Lady Kathleen Lindsay, SC 1692.
70 Ibid.
71 Great Falls City Library Archives, Macdonald papers, MC 100: Margaret Macdonald to Flo, 11 December 1903.
72 Ibid.: Macdonald to Pips, 6 May 1904.
73 Ibid.: Macdonald to Mims, 8 August 1904.
74 "Horse Racing," *Yellowstone Journal*, 31 October 1885; "Local Notes," ibid., 17 January 1886; "Our Race Track," ibid., 17 January 1886. "A Great Race," ibid., 13 November 1886; "Montana Racers," ibid., 22 March 1885.
75 "Fine Horses," *Missoulian*, 2 September 1887.
76 "Local Notes," *Yellowstone Journal*, 10 April 1885; "Spray of the Falls," *Great Falls Tribune*, 26 May 1888; Ings, *Before the Fences*, 61.
77 "Grand Annual Hunt," *The Missoulian*, 23 September 1887.
78 Hunting expeditions also occurred in the Canadian West. See, for instance, Ings, *Before the Fences*, 15.
79 "Local Notes," *Yellowstone Journal*, 4 October 1887. See also "Successful Hunting," ibid., 23 December 1886; "Hunting Rocky Mountain Goats," ibid., 16 October 1887; "Local Notes," *Rocky Mountain Husbandman*, 4 November 1880; and following note. In some cases upper-class women took part in these expeditions. Later in the same month the newspaper reported: "Two English gentlemen, [Edmund Giles and Captain C.D. Radcliff] who left the Flathead agency in August to hunt Rocky Mountain goats, have just returned and are the guests of Mr and Mrs Ronan. Mrs Radcliff, [who] accompanied her husband, thoroughly enjoyed the expedition." She is "no novice in camp, having spent seven months under canvas in the Himalayas." The party was guided by a man named Hank Carnes, "whose skill as an explorer, trail finder and hunter" was "well known to sportsmen" in both the United States and Europe. Also employed were a cook, three labourers and nine

pack animals. Carnes led them all to the "highest mountains and most rugged peaks" in the "little known country beyond the Jocko lakes and Clearwater Valley" ("Hunting Rocky Mountain Goats," *Yellowstone Journal*, 16 October 1887).
80 "Camping on the Trail," 4 November 1887.
81 MHS, Memoirs of Lady Kathleen Lindsay, SC 1692.
82 See MSU, Hart papers, MC 751, boxes 1–2.
83 "Imported Stallions," *Yellowstone Journal*, 12 December 1885.
84 "Imported Horse Stock," ibid., 5 February 1886.
85 "Local Notes," ibid., 16 April 1885.
86 M.A. Leeson, *History of Montana, 1739–1885*, Chicago: 1885, 1275–6.
87 MSU, Hart papers, MC 751-1-24 provides a brief description of this ranch.
88 MHS, Fergus papers, MC 28.
89 "The Favored Valley," *Rocky Mountain Husbandman*, 23 January 1896.
90 With, for instance, Monica and Bill Hopkins near Millarville, and Claude Gardiner near Macleod (Elofson, *Cowboys, Gentlemen, and Cattle Thieves*, 144).
91 MSU, Christie papers, MC 1365-1-5: D.B. Christie to Sister and Brother, 13 September 1885; ibid., 1–6, Christie to his son, 15 May 1898.
92 Canada, *Sessional Papers*, 22:13 (1889), n. 17 (North West Mounted Police Annual Reports), 20: Report of the Commissioner, 31 December 1888.
93 Elofson, *Cowboys, Gentlemen, and Cattle Thieves*, 134, 156. The cowboys who originated from the East were also more likely than those from the south to broaden their working responsibilities beyond what could be undertaken from the saddle. As Sam Steele related: "Several of the cowboys on the [Glengarry] ranch were brought from Mr. Macdonald's county of Glengarry, a very Highland Scotch corner of Ontario, and under his careful instruction developed into that useful person the Canadian cowboy. Not confining themselves to the mere handling of the cattle, these men could do any useful work, evidence of which was to be seen on all sides, in that neatness so attractive on a well-managed ranch or farm (S. Steele, *Forty Years in Canada*, 2nd edtn. Toronto: Prospero Books, 272).
94 MHS, Rankin papers, MC 162-1-2, J.R. Barrows to J. Rankin, 3 April 1938.
95 E.C. Abbott and H. Huntington Smith, *We Pointed Them North: Recollections of a Cowpuncher*, Norman: University of Oklahoma Press, 2nd edition, 1955, 137–8.
96 MHS, Fergus papers, MC 28; UM, Fergus papers MC 10.
97 Holt was born in Missouri to parents from North Carolina (MHS, *Progressive Men of the State of Montana*, Chicago: A.W. Bowen and Co., 1900, 1688).

98 Ibid, 904–5.
99 Ibid., 222.
100 MHS, Stuart papers, MC 61-1-4: G. Stuart to J. Ettien, 20 June 1890.
101 R.H. Fletcher, *Free Grass to Fences: The Montana Cattle Range Story*, New York: University Publishers, 1960, 62–73
102 MHS, Montana Stock Growers Association Minute Book, MC 45, vol. 8, 1–9.
103 J. Clay, *My Life on the Range, with an introduction by Donald R. Ornduff*, new edn., Norman: University of Oklahoma Press, 1962, 340.

CHAPTER FIVE

1 G.A. Wilson, *Outlaw Tales of Montana*, Havre, Montana: High-Line Books, 1995.
2 See W.M. Elofson, *Cowboys, Gentlemen, and Cattle Thieves: Ranching on the Western Frontier*, Montreal and Kingston: McGill-Queen's University Press, 2000, xiii–xx.
3 Canada, *Sessional Papers*, 36:12 (1902), n. 28 (North West Mounted Police Annual Reports), pt. 1, 1–2: Report of the Commissioner, 17 January 1902; Ibid., pt. 2, 3–4.
4 Ibid., pt. 1, 2.
5 D.H. Breen, *The Canadian Prairie West and the Ranching Frontier, 1874–1924*, Toronto: University of Toronto Press, 1983, 83–8.
6 "Town and Country," *Regina Leader*, 22 April 1897.
7 W. Beahen and H. Horrall, *Red Coats on the Prairies: the North-West Mounted Police, 1886–1900*, Regina: Centax Books, 1998, 14.
8 R.C. Macleod, *The NWMP and Law Enforcement, 1873–1905*, Toronto: University of Toronto Press, 1976, 22ff; C. Price, *Memories of Old Montana*, Hollywood: Highland Press [1945], 45; R. Burton Deane, *Mounted Police Life in Canada: a Record of Thirty-one Years' Service*, 2nd edition, Toronto: Prospero Books, 2001, 98, 154–80.
9 "Mounted Police in the North," *Regina Leader*, 31 March 1898.
10 Canada, *Sessional Papers*, 36:1 (1902), n. 28 (North West Mounted Police Annual Reports): Report of the Commissioner, 17 January 1902.
11 F.R. Prassel, *The Western Peace Officer: A Legacy of Law and Order*, Norman: University of Oklahoma Press, 1972, 220–43.
12 The hiring of police for individual communities tended to pit taxpayers against advocates of law enforcement. Sometimes the latter lost out; see "Atchison's Plight," *Missoulian*, 1 July 1887. A city marshal and one police officer were patrolling the town. This was considered inadequate; however, funds were short. The marshal warned that the city was already overrun with pickpockets, thieves, and confidence men. See also "Police," *Missoulian*, 14 March 1888. It discusses the need for more

police protection balanced against the reluctance of taxpayers to foot the bill.
13 Prassel, *The Western Peace Officer*, 94–125.
14 Canada, *Fourth Census* (1901) vol. 1, 5; United States, *Twelfth Census of the United States*, (1900) vol. 1, cxxvi–clxxxii.
15 "After the Rustlers' War in Wyoming, the cattlemen there chased most of the 'wanted dead or alive' men out of the state, and other cowboys just left because of the trouble. Many of these fugitives, good and bad, drifted to Montana. Cowboys were scarce and were usually hired with no questions asked ... Wyoming cowboys continued to drift into Montana. Some came because of the trouble there, and they objected to the ruthless killing of homesteaders who were falsely accused of being rustlers. Others, like the Curry brothers, who were part of Butch Cassidy's gang, came because they were wanted for crimes in Wyoming. Many of the law-abiding men found work on the northern Montana ranches or with the roundups and eventually settled on the land there," (T.M. Cheney with R.C. Cheney, *So Long, Cowboys of the Open Range*, Helena: Falcon Publishing Inc., 1998, 46–7).
16 United States, *Twelfth Census of the United States*, (1900) vol. 1, cxxvi–clxxxii.
17 Wilson, *Outlaw Tales of Montana*, 62.
18 Theodore Roosevelt, *Theodore Roosevelt: An Autobiography*, New York: Charles Scribner's Sons, 1928, 97, 112–20.
19 See below, 79.
20 Prassel, *The Western Peace Officer*, 94–125.
21 T.J. Dimsdale, *The Vigilantes of Montana*, Virginia City: D.W. Tilton, 1882, 20–2; G.F. Brimlow, *Good Old Days in Montana Territory: Reminiscences of the Harrington and Butcher Families*, Butte: McKee Printing, 1957, 8.
22 Ibid.; G.W. Davis, *Sketches of Butte from Vigilante Days to Prohibition*, Boston: The Cornhill Co., 1921, 11. Some twenty years later this approach was used again; see *Yellowstone Journal*, 30 July 1884, first page, no headline.
23 "Good Way to Stop Horse Stealing," *Yellowstone Journal*, 27 June 1884; "The Vigilantes of Today," ibid., 28 January 1885; "The Inception of the Vigilantes of Montana," *Great Falls Tribune*, 9 April 1887.
24 "False Notions of Western Character," *Rocky Mountain News* (Denver), 26 June 1869.
25 Canada, *Fourth Census of Canada* (1901), vol. 1, 132–3.
26 United States, *Tenth Census of the United States*, (1880), 1, census 1, 602.
27 United States, *Eleventh Census of the United States*, (1890), part 1, census 2, lxii.

28 Elofson, *Cowboys, Gentlemen, and Cattle Thieves*, 20–1; United States, *Fifteenth Census of the United States* (1930), III, part 2, 7.
29 Ibid., 150–1.
30 GA, M229: entry for 5 December 1880. For drinking and prostitution in general, see Elofson, *Cowboys, Gentlemen, and Cattle Thieves*, 116–20.
31 S.W. Horall, "The (Royal) North West Mounted Police and Prostitution on the Canadian Prairies," *Prairie Forum*, 10 (spring 1985), 108, 111.
32 "Cow Men and Cow Boys," *Yellowstone Journal*, 28 March 1885; PPA, 72,27/SE, V.P. LaGrandeur, "Memoirs of a Cowboy's Wife," unpublished manuscript, n.d., 13.
33 MHS, Memoirs of Lady Kathleen Lindsay, SC 1692; See also Granville Stuart, *Forty Years on the Frontier, as seen in the journals and reminiscences of Granville Stuart*, ed. P.C. Philips, Cleveland: A.H. Clark, 1925, vol. 2, 181–4.
34 This comes from a description of the Murray Ranch Hotel at Emmetsville (now Emmet), Idaho, in 1883 (Idaho State Archives, Boise, Murray papers, Ms. 2/0692).
35 [J. Geltz], *Uncle Sam's Life in Montana*, [Butte, 1905], 23. See also E. Baumler, "Devils Perch," *Montana Magazine*, 48:3 (autumn 1998), 4–21.
36 MHS, Rankin papers, MC 162-1-14: F. Edmunds to J. Rankin, 17 February 1938. Miles City had a similar establishment (E.C. Abbott and H. Huntington Smith, *We Pointed Them North: Recollections of a Cowpuncher*, Norman: University of Oklahoma Press, 2nd edition, 1955, 80).
37 Ibid.
38 F. Ings, *Before the Fences: Tales from the Midway Ranch*, ed. J. Davis, McARA Printing, 1980, 48.
39 Steele, *Forty Years in Canada*, 177. For other notable incidents see Deane, *Mounted Police Life*, 40–1.
40 Canada, *Sessional Papers*, 22:13 (1889), n. 17 (North West Mounted Police Annual Reports), 10–11: Report of the Commissioner, 31 December 1888.
41 Ibid., 25:10 (1892), n. 15, 17: Report for E Division, December 1891.
42 Ibid., 32:12 (1898), n15, 39: Report for D Division, 30 November 1897.
43 Canada, *Census of the Prairie Provinces* (1916), 87, 89.
44 J. Bedford, "Prostitution in Calgary, 1905–14," *Alberta History*, 29: 2 (spring 1981), 2.
45 "Is Gambling Prevalent Throughout the City?" *Calgary Herald*, 17 October 1906, quoted in Bedford, "Prostitution in Calgary," 4.
46 "A Glimpse of the Red Lights," *The Morning Albertan*, 19 October 1906, quoted Bedford, "Prostitution in Calgary," 4.

47 "Hugh McDonald," *Taming the Prairie Wool*, Glendale: Glendale Women's Institute, 1965, 148 quoted in H.A. Dempsey, *Golden Age of the Canadian Cowboy*, Saskatoon and Calgary: Fifth House, 1995, 55.
48 C. Russell, *Trails Plowed Under: Stories of the Old West*, introduced by W. Rogers and B.W. Dippie, Lincoln: University of Nebraska Press, 1996, 159.
49 Dempsey, *Golden Age of the Canadian Cowboy*, 55; Steele, *Forty Years in Canada*, 167-8.
50 L.V. Kelly, *The Range Men*, 75th anniversary edition, High River: Willow Creek Publishing, 1988, 165.
51 Theodore Roosevelt, *Ranch Life and the Hunting Trail*, London: T. Fisher Unwin, [1888], 9-10.
52 Abbott and Huntington Smith, *We Pointed Them North*, 219.
53 "Desperados," *Yellowstone Journal*, 15 July 1884; D.M. Johnson, "Independence Day, 1884," *Montana Magazine*, 8:2 (spring 1958), 2-7.
54 PAS (S), MC 87-401: "Shooting Sheriffs."
55 W. Coburn, *Pioneer Cattleman in Montana, the Story of the Circle C Ranch*, Norman: University of Oklahoma Press, 1968, 66-7. In Cheney, *So Long, Cowboys of the Open Range*, 47, the following incident is recorded about a famous killing involving two well-known desperados from Wyoming named Long Henry and Tommie Dunne (alias Starr). "The men knew that Dunne was a man who had reasons for leaving Wyoming, but only Long Henry knew his real identity. Everyone had heard of the outlaw Starr. There was no obvious quarrel in the camp that night, but when Starr bent over to picket his horse, Long Henry shot him."
56 Kelly, *Range Men*, 3.
57 Canada, *Sessional Papers*, 16:11 (1884), n125, North West Mounted Police Annual Reports, 9-10: Report of the Commissioner, 1 January 1884.
58 Kelly, *Range Men*, 98.
59 Canada, *Sessional Papers*, 34:12, (1900), n. 15 (North West Mounted Police Annual Reports), 85: Report for E Division, 30 November 1899.
60 Ibid., 35:11 (1901), n. 28, 51: Report for E. Division, 1 December 1900.
61 Ibid., 44: Report for Regina Division, 10 December 1900.
62 Ibid., 37:12 (1903), n. 28, 38: Report for E Division, 30 November 1902.
63 G. Shepherd, "Tom Whitney of Maple Creek," *Canadian Cattlemen*, 4:4 (March 1942), 156.
64 "Veteran Mountie Tells of Adventures in West," *Albertan*, 23 April 1942.
65 "A Big Drunk," *Macleod Gazette*, 16 February 1886. For other reports of this nature see "Rioting and Drunkenness," ibid., 19 September 1884;

"Macleod," *Calgary Tribune*, 11 November 1885; "Police News," *Calgary Herald*, 21 October 1902; "The Six-Shooter Again is Called in to Settle a Dispute," ibid., 21 July 1885.
66 Jimmy Simpson, taped interview on file at Glenbow Archives, tape # RCT-58-1, quoted in M. Zuehlke, M. Zuehlke, *Scoundrels, Dreamers, and Second Sons; British Remittance Men in the Canadian West*, 2nd edition, Toronto, Oxford and New York: Dundurn Press, 2001, 149.
67 J.A. Crutchfield, *It Happened in Montana*, Helena: Falcon Publishing, 1992, 45–7.
68 Abbott and Huntington Smith, *We Pointed Them North*, 116.
69 Ibid., 168. For a more detailed account see M. Liberty, "I Will Play with the Soldiers," *Montana Magazine*, 14:4 (autumn 1964), 16–26.
70 S.H. Schrems, *Uncommon Women, Unmarked Trails: the Courageous Journey of Catholic Missionary Sisters in Frontier Montana*, Norman: Horse Creek Publications, 2003, 68.
71 For those and other episodes not mentioned here see Elofson, *Cowboys, Gentlemen, and Cattle Thieves*, 113–15.
72 PAA, 70.431/77: J. Martin, "Prairie Reminiscences," n.d., 6.
73 Kelly, *Range Men,*, 86; Canada, *Sessional Papers*, 18:3 (1885), n. 153, North West Mounted Police Annual Reports, 8–13: Report of the Commissioner.
74 "Indians Shot," *Macleod Gazette*, 30 August 1887.
75 Martin, "Prairie Reminiscences," 4.
76 For more instances of racial violence in Western Canada see Elofson, *Cowboys, Gentlemen, and Cattle Thieves*, 113 – 16.
77 Canada, *Sessional Papers*, 34:12 (1900), n. 15, North West Mounted Police Annual Reports, 59: Report for the Moosomin sub-district, 26 November 1899; ibid., 35:11 (1901), n. 28, 44: Report for Regina Division, 10 December 1900.
78 "In Town and Out," *Macleod Gazette*, 14 October 1882.
79 D. Drew, "Cowboy who broke first horse at age 7 has fond memories of life in the saddle," *Western People*, 6 November 1986, 5–6.

CHAPTER SIX

1 "Range Tramps," *Rocky Mountain Husbandman*, 9 September 1886.
2 MSU, Worthen Fergus papers, MC 913-2-12: J. Fergus to Janet Simpson, 1894.
3 GA, Mrs. Charles Inderwick, Diary and Personal Letters from the North Fork Ranch, 1883–91, M376: Letter of 13 May 1884. For a printed copy of the letter see M.E. Inderwick, "A Lady and Her Ranch," *Alberta History* 15:4 (autumn 1967), 1–9.
4 25 April 1895.

5 MHS, Stuart papers, MC 61-1-4: G. Stuart to H.E. Fletcher, 4 June 1891.
6 "Stock Notes and News," *Rocky Mountain Husbandman*, 10 April 1890.
7 *Before the Fences: Tales from the Midway Ranch*, ed. J. Davis, McARA Printing, 1980, 50–1.
8 Ibid., 49.
9 28 August 1884. Quoted in MSU, Abbott-Stuart-Matejcek papers, MC 532-1-4.
10 "Stock Notes and News," *Rocky Mountain Husbandman*, 15 August 1889.
11 Ibid., 2 May 1889.
12 MHS, Stuart papers, MC 61-1-4: to H.E. Fletcher, 4 June 1891.
13 "Stock Notes and News," *Rocky Mountain Husbandman*, 4 January 1894.
14 Granville Stuart, *Forty Years on the Frontier, as seen in the journals and reminiscences of Granville Stuart*, ed. P.C. Philips, Cleveland: A.H. Clark, 1925, vol. 2, 195. See also MU, Fergus papers, MC 10-11-63: J. Fergus to L.P. Slater, 24 January 1884.
15 See W.M. Elofson, *Cowboys, Gentlemen and Cattle Thieves, Ranching of the Western Frontier*, Montreal and Kingston: McGill-Queen's University Press, 2000, 123–6; E.C. Abbott and H. Huntington Smith, *We Pointed Them North: Recollections of a Cowpuncher*, Norman: University of Oklahoma Press, 2nd edition, 1955, 86.
16 Stuart, *Forty Years on the Frontier*, vol. 2, 167.
17 Huntington Library, San Marino, Frank King papers, Box 1, King to H. Crain, 10 April 1915.
18 "Medicine Hat Pioneer, William Mitchell, 1878–1946," *Canadian Cattleman*, 9:3, (December 1946), 150.
19 Canada, *Sessional Papers* 41:11 (1906/07), n. 28 (North West Mounted Police Annual Reports), 63: Report for K Division, 1 October 1906.
20 Ibid.
21 MHS, Memoirs of Lady Kathleen Lindsay, SC 1692.
22 AHC, Frewen papers, MC 9529-2-11: Frewen to "My Dear Judge," 9 August 1883.
23 "Northern Cattle Thieves," *Great Falls Tribune*, 15 August 1885. See also Abbott and Huntington Smith, *We Pointed Them North*, 86.
24 "Local News," *Rocky Mountain Husbandman*, 5 August 1880.
25 Canada, *Sessional Papers*, 31:11 (1897), n. 15 (North West Mounted Police Annual Reports), 160: Report for E Division, 1 December 1896. See also "Medicine Hat Pioneer, William Mitchell, 1878–1946," *Canadian Cattleman*, 9:3 (December 1946), 150.
26 See, for instance, MU, Fergus papers, MC 10-11-60: J. Fergus to G. Stuart, 1884.

27 "Lynched in Montana," *Macleod Gazette*, 11 April 1885.
28 PAS (N), Harry H. Maguire papers, A99, "How the Northwest Mounted Police got Fresh Meat on Detachment."
29 C. Price, *Memories of Old Montana*, Hollywood: Highland Press [1945], 45.
30 CHS, Stuart papers, MC 1601-2: Stuart to S.L. Hauser, 6 December 1881.
31 Stuart, *Forty Years on the Frontier*, vol. 2, 198–202; "Caught at Last," *Yellowstone Journal*, 21 April 1885; "Dastards and Desperadoes Foiled," ibid., 18 December 1884.
32 PAS (N), Harry H. Maguire papers, A99, "Stories of the West," 1896–1920, "Cattle Rustling Deluxe," 1899.
33 Canada, *Sessional Papers*, 31:11 (1897), n. 15 (North West Mounted Police Annual Reports), 9: Report of the Commissioner, 10 December 1896.
34 Ibid., 32:12 (1898), n. 15, 2: Report of the Commissioner, 17 December 1897.
35 Ibid., 34:12 (1900), n. 15, 59.
36 Ibid., 35:11 (1901), n. 28, 44: 10 December 1900.
37 Above, 79.
38 L.V. Kelly, *Range Men*, 75th anniversary edition, High River: Willow Creek Publishing, 1988, 78.
39 "A Cattle Stealing Case," *Regina Leader*, 12 March 1896.
40 G.W. Davis, *Sketches of Butte from Vigilante Days to Prohibition*, Boston: The Cornhill Co., 1921, 11.
41 MHS, Montana Stock Growers Association, minute book, MC 45, vol. 8, 13–14. See also, "The New Stock Association," *Yellowstone Journal*, 17 January 1885.
42 Stuart, *Forty Years on the Frontier*, vol. 2, 177.
43 MHS, Stuart papers, MC 61-1-4: G. Stuart to J. Ettien, 20 June 1890.
44 Ibid. After the 1886–87 winter the numbers of detectives waned badly because of the state of the industry.
45 "Swift Judgment," *Yellowstone Journal*, 7 February 1884; "Good Way to Stop Horse Stealing," ibid., 27 June 1884; "Lynched Rustlers," ibid., 23 November 1884; "The Vigilantes of Today," ibid., 28 January 1885; "Two Horse Thieves Hung," *Helena Independent*, 4 April 1885; H. McCracken estimates that at least twenty-one were hanged in 1884 (*The Charles M. Russell Book: the Life and Work of the Cowboy Artist*, New York: Doubleday, 1957, 90).
46 MHS, Fergus papers, MC 28-2-13: Fergus to C. Kohrs, 5 May 1887; Letter by "Bad Lands Cowboy" to *Yellowstone Journal*, 8 April 1885.
47 "Live Stock," *Rocky Mountain Husbandman*, 21 September 1899.
48 MHS, Stuart papers, MC 61-1-4; Stuart to J. Ettien, 20 June 1890; ibid., to H.E. Fletcher, 4 June 1891.

49 Ibid., to J. Ettien, 20 June 1890.
50 See, for instance, "Caught at Last," *Yellowstone Journal*, 21 April 1885.
51 Bob Kennon, *From the Peace to the Pecos: A Cowboy's Autobiography*, Norman: University of Oklahoma Press, [1965], 209–10.
52 GA, Cochrane Ranch Letter Book, M234: entries for 6 and 21 February, 26, 28, and 31 March 1885; Kelly, *Range Men*, 60–2; "Maple Creek Murder," *Yellowstone Journal*, 6 July 1884; "Life for a Life," ibid., 19 June 1884; "Indian Innocents," ibid., 4 June 1884; see also, "Natives, Newspapers, and Crime Rates in the North-West Territories, 1878–1885," *From Rupert's Land to Canada*, ed. T. Binnema, G.J. Ens, R.C. Macleod, Edmonton: University of Alberta Press, 2000, 249–69.
53 Canada, *Sessional Papers*, 25:10 (1892), n. 15 (North West Mounted Police Annual Reports), 70–1:Report for K Division, 1 December 1891.
54 Stuart, *Forty Years on the Frontier*, vol. 2, 157–60; "Local Notes," *Yellowstone Journal*, 8 July 1885; CHS, Stuart papers, MC 1601 box 2, Stuart to S.T. Hauser, 5 February 1881.
55 Stuart, *Forty Years on the Frontier*, 161–3.
56 "His Last Fight," *Yellowstone Journal*, 12 August 1884; "Foiled – Cowboy that Shot Black Wolf Arrested, Held Several Days and Turned Loose," *Yellowstone Journal*, 26 September 1884.
57 30 October 1884.
58 "Lynched in Montana," *Macleod Gazette*, 11 April 1885.
59 Stuart, *Forty Years on the Frontier*, vol. 2, 198–201; The annual reports for the North West Mounted Police consistently played down the level of crime throughout the eighties, essentially arguing that almost none existed.
60 G.A. Wilson, *Outlaw Tales of Montana*, Havre, Montana: High-Line Books, 1995, 68.
61 Ibid.
62 Approximately 1898 (Ibid., 72).
63 Ibid., 78.
64 Ibid., 99–101.
65 A Saskatchewan provincial tourist brochure quoted in Wilson, *Outlaw Tales*, 57.
66 For instance, Canada, *Sessional Papers*, 35:11 (1901), n28 (North West Mounted Police Annual Reports), 16–17: Report for D Division, 30 November 1900.
67 "Correspondence," *Regina Leader*, 22 June 1893.
68 "Stock Notes and News," *Rocky Mountain Husbandman*, 2 May 1889.
69 "Town and Country," *Regina Leader*, 25 August 1898.
70 Canada, *Sessional Papers*, 36:12 (1902), n. 28 (North West Mounted Police Annual Reports), 43: Report for D. Division, 30 November 1901.
71 Ibid.

72 Ibid., 37:12 (1903), n. 28, 71:3 December 1902.
73 "Stock Notes."
74 "Town and Country," *Regina Leader*, 8 December 1898.
75 PAS (S), MC 18 (4): *Tales and Legends of Wood Mountain and District*.
76 S. Hanson, "Policing the International Boundary Area in Saskatchewan," *Saskatchewan History*, 19: 2 (spring 1996), 61–73.
77 R.H. Fletcher, *Free Grass to Fences; the Montana Cattle Range Story*, New York: University Publishers, 1960, 145–9. "The Range," *The Ranching News*, Maple Creek, 20 August 1903.
78 See "American 'Stray' Cattle," *Macleod Gazette*, 31 October 1902.
79 MHS, Montana Stock Growers Association, minute book, MC 45, vol. 8, 168.
80 R. Burton Deane, *Mounted Police Life in Canada: A Record of Thirty-one Years' Service*, 2nd edition, Toronto: Prospero Books, 2001, 159.
81 M.A. Leeson, *History of Montana, 1739–1885*, Chicago: 1885, 1027; Deane's suspicions and the entire Spencer episode are found in Deane, *Mounted Police Life*, 154–80.
82 Stuart, *Forty Years on the Frontier*, vol. 2, 198–201.
83 See, for instance, Kelly, *Range Men*, 3.
84 G. MacEwan, *John Ware's Cow Country*, new edtn., Vancouver: Greystone Books, 1995, 37–41; Kelly, *Range Men*, 3.
85 MacEwan, *John Ware's Cow Country*, 75
86 Stair Ranch Letter Book, M2388, 86: 29 September 1890. In September 1890 D. H. Andrews acknowledged receipt of a cheque for $440.00 for the sale of seventeen steers from a rancher in Montana named Thomas Clary. He offered thanks and help for Clary on the Canadian side of the border.

CHAPTER SEVEN

1 H.A. Dempsey, *The Golden Age of the Canadian Cowboy*, Saskatoon and Calgary: Fifth House, 1995, 11.
2 Ibid., 20.
3 Ibid.
4 For a description of a round-up see T. Roosevelt, "The Round-Up," *The Complete Cowboy Reader: Remembering the Range*, ed. T. Stone, Red Deer: Red Deer College Press, 1897, 188–212.
5 Roosevelt, "The Round-Up," 206.
6 MHS, Rankin papers, MC 162-4-3: A.B. Stuart to J. Rankin, 4 April 1937.
7 Ibid., MC 162-1-1: A.P. Andrews to Rankin, [1938].
8 W.R. "Bob" Newbolt, "Memories of Bowchase Ranch," *Alberta History*, 32: 4 (autumn 1984), 3.

9 E.C. Abbott and H. Huntington Smith, *We Pointed Them North: Recollections of a Cowpuncher*, Norman: University of Oklahoma Press, 2nd edition, 1955, 124–5.
10 Ibid.
11 E.J. "Bud" Cotton, *Buffalo Bud: Adventures of a Cowboy*, North Vancouver: Hancock House Publishers, 1981, 45.
12 C. Russell, *Trails Plowed Under: Stories of the Old West*, introduced by W. Rogers and B.W. Dippie, Lincoln: University of Nebraska Press, 1996, 159.
13 P.A. Rollins, *The Cowboy: an Unconventional History of Civilization and the Old-time Cattle Range*, Albuquerque: University of New Mexico Press, 1979, 170.
14 Abbott and Huntington Smith, *We Pointed Them North*, 125.
15 Russell, *Trails Plowed Under*, 159
16 Abbott and Huntington Smith, *We Pointed Them North*, 125.
17 This story could be a yarn of course. Even so, the fact that it circulated among the cowboys illustrates a general anxiety about winter isolation.
18 Abbott and Huntington Smith, *We Pointed Them North*, 223.
19 Ibid., 87.
20 Ibid., 125.
21 Ibid., 222–33; Cotton, *Buffalo Bud*, 45.
22 Abbott and Huntington Smith, *We Pointed Them North*, 223.
23 Ibid., 87, 231–2.
24 E. Fowke, "American Cowboy and Western Pioneer Songs in Canada," *Western Folklore*, 21 (1962), 247–56.
25 "The Cowboy's Life," *Songs of the American West*, ed. R.E. Lingenfelter, R.A. Dwyer, D. Cohen, Berkeley and Los Angeles: University of California Press, 1968, 347. See also "Git Along Little Dogies," ibid., 365–6.
26 Abbott and Huntington Smith, *We Pointed Them North*, 223.
27 W.M. Elofson, *Cowboys, Gentlemen, and Cattle Thieves: Ranching on the Western Frontier*, Montreal and Kingston: McGill-Queen's University Press, 2000, 54, 97–100.
28 A storm could set the cattle off too (J.R. Barrows, *Ubet*, Caldwell, Idaho: The Caxton Printers, 129–31).
29 Roosevelt, "The Round-Up," 206.
30 Abbott and Huntington Smith, *We Pointed Them North*, 200.
31 "When the Work Is Done This Fall," *Songs of the American West*, 433; for other songs about dying, see also 421–40.
32 *"The Whorehouse Bells Were Ringing" and Other Songs Cowboys Sing*, ed. G. Logsdon, Urbana and Chicago: University of Illinois Press, 1989, 76; See also 298, 300. This source is cited in Hine and Faragher, *The American West: A New Interpretive History*, New Haven and London: Yale University Press, 2000, 313.

33 Logsdon, "*The Whorehouse Bells Were Ringing*," 76.
34 Ibid., 167–8.
35 Ibid., 289–91.
36 R. Linthicum, "The Rough Rider," (1895) quoted in *Trailing the Cowboy: His Life and Lore as told by Frontier Journalists*, ed. C.P. Westermeier, Caldwell, Idaho: The Caxton Printers, 1955, 269–70.
37 Abbott and Huntington Smith, *We Pointed Them North*, 211.
38 PPA, 72,27/SE, V.P. LaGrandeur, "Memoirs of a Cowboy's Wife," unpublished manuscript, n.d., 14.
39 T. Roosevelt, *Ranch Life in the Far West*, illustrated by Frederic Remington, Flagstone: Northland Press, 1985, 89.
40 "A Dance at the Ranch," J. Lomax, *Songs of the Cattle Trail and Cow Camp*, New York: Macmillan and Co., 1928, 118.
41 Kelly, *Range Men*, 89.
42 E.B Bronson, *Reminiscences of a Ranchman*, Chicago, 1910, 270–1.
43 Ibid.
44 Abbott and Huntington Smith, *We Pointed Them North*, 220–1.
45 For an excellent summary of Russell's publishing career see B.W. Dippie's introduction to *Trails Plowed Under*, v–xix.
46 T.M. Cheney with R.C. Cheney, *So Long, Cowboys of the Open Range*, Helena: Falcon Publishing Inc., 1998, 43–4.
47 Abbott and Huntington Smith, *We Pointed Them North*, 124–5.
48 H.W. Riley, "Herbert William (Herb) Millar: Pioneer Ranchman," *Canadian Cattleman*, 4:4 (March 1942), 142, quoted in A.B. McCullough, "Not an Old Cowhand – Fred Stimson and the Bar U Ranch," *Cowboys, Ranchers, and the Cattle Business; Cross-Border Perspectives on Ranching History*, ed. S. Evans, S. Carter, and W.B. Yeo, Calgary and Boulder: University of Calgary Press and University Press of Colorado, 1999, 38.
49 E. Brado, *The Cattle Kingdom: Early Ranching in Alberta*, Vancouver: Douglas and McIntyre, 1984, 119, also quoted in McCullough, "Not an Old Cowhand."
50 Russell, *Trails Plowed Under*, 191.
51 Ibid.
52 See, for instance, Russell's oil-on-canvas painting entitled "Laugh Kills Lonesome," below, 109.
53 R.F. Adams, *The Old-time Cowhand*, New York: Macmillan, 1961, 318.
54 "Memories of Bowchase Ranch," 3.
55 Ibid.
56 Adams, *The Old-Time Cowhand*, 320.
57 F. Ings, *Before the Fences: Tales from the Midway Ranch*, ed. J. Davis, McARA Printing, 1980, 40–1. See also P.A. Rollins, *The Cowboy*, 184.

58 Ibid.
59 "Memories of Bowchase Ranch," 3; Kelly, *Range Men*, 75.
60 *The Charles M. Russell Book: The Life and Work of the Cowboy Artist*, New York: Doubleday, 1957, 144.
61 *The Young Emigrants: A Story for Boys*, London: Nelson and Sons, 1898, 150–3; *Letters of a Remittance Man*, Toronto: The Musson Book Co., 1909, 24–9.
62 Kelly, *Range Men*, 84.
63 The trick was sometimes reversed another way as well. An expert rider would pose as a dude, inducing the boss to try to humiliate him with a wild horse. Then, after a friend had placed bets with the boys about the outcome, he would ride it to a standstill; see PAA, 72,27/SE, V. LaGrandeur, "Memoirs of a Cowboy's Wife," 11.
64 Cheney and Cheney, *So Long, Cowboys of the Open Range*, 76–7.
65 Ings, *Before the Fences*, 24.
66 Adams, *The Old-Time Cowhand*, 320.
67 Ings, *Before the Fences*, 40.
68 G. MacEwan, *John Ware's Cow Country*, new edtn., Vancouver: Greystone Books, 1995, 48.
69 Abbott and Huntington Smith, *We Pointed Them North*, 220.
70 J. Taliaferro, *Charles M. Russell*, Boston: Little, Brown and Company, 1996, 201.
71 Abbott and Huntington Smith, *We Pointed Them North*, 145.
72 P.H. Hassrick, *Charles M. Russell*, New York: Harry N. Abrams, 1989, 94; Dippie, "Charles M. Russell and the Canadian Connection," in *Cowboys, Ranchers and the Cattle Business*, 18–19.
73 Cotton, *Buffalo Bud*, 9.
74 E.E. Dale, *Cow Country*, Norman: University of Oklahoma Press, 1965, 142.
75 Westermeier, *Trailing the Cowboy*, 293–4.
76 Kelly, *Range Men*, 116.
77 W. Coburn, *Pioneer Cattleman in Montana, the Story of the Circle C Ranch*, Norman: University of Oklahoma Press, 1968, 140–1.
78 M. Zuehlke, *Scoundrels, Dreamers, and Second Sons; British Remittance Men in the Canadian West*, 2nd edition, Toronto, Oxford and New York: Dundurn Press, 2001, 57–8.
79 "A Busted Cowboy's Christmas," *Songs of the American West*, 353.
80 Russell, *Trails Plowed Under*, 4–5.
81 Coburn, *Pioneer Cattlemen in Montana*, 130–1. See also "Memoirs of an Itinerant Cowhand," *Canadian Cattleman*, 5:3 (December 1942), 100, 101, 125.
82 GA, New Walrond Ranche papers, M8688-1-3: W. Bell to D. McEachran, 28 April 1887.

83 Elofson, *Cowboys, Gentlemen, and Cattle Thieves*, 27.
84 Coburn, *Pioneer Cattleman*, 136.
85 Ibid. 136–7.
86 The Canadians may have been faster to adopt this type than Montanans; see Ings, *Before the Fences*, 96.
87 Besides the Russell reference above, see GA, Young papers, M8665, Robert Young to William Young, 8 July 1884; Coburn, *Pioneer Cattlemen in Montana*, 130–7.
88 See, R.W. Slatta, *Cowboys of the Americas*, New Haven: Yale University Press, 1990, 127.
89 E. Hough, "The Cowboy," *The Complete Cowboy Reader; Remembering the Range*, ed. T. Stone, Red Deer: Red Deer College Press, 26; H.A. Dempsey, *The Golden Age of the Canadian Cowboy*, 51–2; MacEwan, *John Ware's Cow Country*, 1995, 134–5.
90 Abbott and Huntington Smith, *We Pointed Them North*, 51.
91 Granville Stuart, *Forty Years on the Frontier, as seen in the journals and reminiscences of Granville Stuart*, ed. P.C. Philips, Cleveland: A.H. Clark, 1925, vol. 2, vol. 2, 172.
92 Kelly, *Range Men*, 115. See also Russell, *Trails Plowed Under*, 22–4; "Cowboy Sport – Roping a Wolf" in P.H. Hassrick, *Charles M. Russell*, New York: Harry N. Abrams, 1989, 40–1.
93 E. Hough, "The Cowboy," *The Complete Cowboy Reader*, 26–7. See also, *Trailing the Cowboy*, 293–4.
94 MacEwan, *John Ware's Cow Country*, 107–8.
95 "Local Items," *Yellowstone Journal*, 27 May 1885.
96 T. Roosevelt, "The Round-Up." Sometimes races included Native-owned horses (Ings, *Before the Fences*, 37; P.A. Rollins, *The Cowboy*, 180).
97 Ings, *Before the Fences*, 37.
98 J.R. Barrows, *Ubet*, 128–9.
99 E. Hough, "The Cowboy," *The Complete Cowboy Reader*, 25.
100 "Range Notes." On 14 June 1895, the *Macleod Gazette* reported: "The Pincher Creek round-up camped at the Black Springs on Sunday, and a number of townspeople seized the opportunity to pay [it] a visit ... The usual routine of roping, branding and cutting was gone through ... during the afternoon. See also "A Novel Idea," *Yellowstone Journal*, 3 July 1885; "A Trial of Skill," ibid., 5 November 1885.
101 S. Steele, *Forty Years in Canada*, 2nd edtn. Toronto: Prospero Books, 271.
102 For more on the origins of the rodeo see, R.W. Slatta, *The Cowboy Encyclopedia*, Santa Barbara, Denver and Oxford: ABC-CLIO, 1994, 313–22.
103 Steele, *Forty Years in Canada*, 270–1.
104 For James see *The West of Will James: A Portfolio of his Drawings*, introduced by A. Amaral, Reno: University of Nevada Press, 1978.

105 H. McCracken, *The Charles M. Russell Book*, 42, 69, 83, 101, 104, 106, 121. The impact of night wrangling and long cold winters in inducing Russell to paint pictures for the entertainment of his cowboy friends is illustrated especially on pages 69 and 101.

CHAPTER EIGHT

1 See for instance, J.F.C. Adams., *The Fighting Trapper; or, Kit Carson to the Rescue*. New York: Beadle and Adams, 1879.
2 S.S. Hall, *Stampede Steve; or, the Doom of the Double Face*, New York: Beadle and Adams, 1884, 2.
3 W.T. Larned, "The Passing of the Cow-Puncher," *Lippincott's Magazine of Popular Literature and Science*, old series, vol. xvii, (new series, vol. i), Philadelphia: J.B. Lippincott, 1881, 270. Granville Stuart felt that cowboys had a deep respect for women; see *Forty Years on the Frontier, as seen in the journals and reminiscences of Granville Stuart*, ed. P.C. Philips, Cleveland: A.H. Clark, 1925, vol. 2, 182.
4 See below 190–1.
5 A "grub line rider" was a hand who travelled from ranch to ranch visiting other cowboys. The hosts were glad to have him stay a few days and share their grub or food just for the pleasure of hearing news from the outside.
6 E.C. Abbott and H. Huntington Smith, *We Pointed Them North: Recollections of a Cowpuncher*, Norman: University of Oklahoma Press, 2nd edition, 1955, 127.
7 For prostitution in southern Alberta and Assiniboia during the ranching frontier see J. Gray, *Red Lights on the Prairies*, Scarborough: the New American Library of Canada, 1973.
8 Abbott and Huntington Smith, *We Pointed Them North*, 89.
9 Ibid., 103.
10 *Red Lights on the Prairies*, 28.
11 For prostitution in Helena see P. Petrik, *No Step Backward: Women and Family on the Rocky Mountain Frontier, Helena, Montana, 1865–1900*, Helena: Montana Historical Society Press, 1987, 25–58.
12 Abbott and Huntington Smith, *We Pointed Them North*, 105.
13 A.M. Butler, *Daughters of Joy, Sisters of Misery: Prostitutes in the American West, 1865–90*, Urbana and Chicago: University of Chicago Press, 1985, 67–8.
14 Rosalie was said to be a prostitute, see L.A. Erickson, "The Unsettling West: Gender, Crime, and Culture on the Canadian Prairies, 1886–1940," unpublished MA thesis, University of Calgary, 2003, 46–51.
15 F.W. Anderson, *Sheriffs and Outlaws of Western Canada*, Calgary: Frontier Publishing, 41–2.
16 "A Colored Cyprian Shot," *Great Falls Tribune*, 14 April 1890.

17 Abbott and Huntington Smith, *We Pointed Them North*, 105–6. This was not in any sense unique. Teddy Blue Abbott also said that in general "there was a lot of fellows in the eighties who were glad enough to marry" that kind of woman, although he would not have himself (ibid., 106).
18 Gray, *Red Lights on the Praires*, 183. For the Mounted Police and prostitution see S.W. Horrall, "The (Royal) North West Mounted Police and Prostitution on the Canadian Prairies," *Prairie Forum*, 10 (spring 1985), 105–27. For prostitution in Calgary see, D. Bright, "The Cop, The Thief, the Hooker, and Her Life," *Alberta History*, 45:4 (autumn 1997), 16–26.
19 Abbott and Huntington Smith, *We Pointed Them North*, 107.
20 Ibid.
21 Canada, *Sessional Papers*, 18:13 (1885), n. 153 (North West Mounted Police Annual Reports): Appendix A, 54.
22 "Where Did Slim Get The Money," *Calgary Herald*, 1 April 1907.
23 G.K. Renner, "Charlie and the Ladies in his Life," in *Charlie Russell Roundup: Essays on America's Favorite Cowboy Artist*, ed. B.W. Dippie, Helena: Montana Historical Society Press, 1999, 142.
24 Abbott and Huntington Smith, *We Pointed Them North*, 108.
25 Ibid., 108–9.
26 C.M. Russell, *More Rawhides*, Great Falls, 1925, 13.
27 Abbott and Huntington Smith, *We Pointed Them North*, 105–6.
28 Ibid., 106.
29 Gray, *Red Lights on the Prairies*, 183.
30 Abbott and Huntington Smith, *We Pointed Them North*, 108.
31 Gray, *Red Lights on the Prairies*, 188.
32 Abbott and Huntington Smith, *We Pointed Them North*, 145–6.
33 Ibid., 136.
34 Ibid., 146.
35 Ibid., 148–9. Of his own wife he said that when he first met her he was in awe: "[I] was frightened enough of Mary – just scared to death of her – but not in the same way as these other women I have been talking about. She was the sweetest, dearest little girl I had ever known or thought about, with such a sweet disposition that I knew she could never find fault or act in any way mean. And she never has in all these years. But I thought I wasn't good enough for her and of course that made me fall [in love with her] all the harder (190).
36 "Women Ranchers," *Calgary Herald*, 21 October 1902.
37 Abbott and Huntington Smith, *We Pointed Them North*, 136; S, Van Kirk, *"Many Tender Ties": Women in Fur-Trade Society, 1670–1870*, Winnipeg: Watson and Dwyer Publishing, 1980, 173–230.
38 Abbott and Huntington Smith, *We Pointed Them North*, 188–9.
39 Ibid.
40 Ibid., 189.

41 C. Price, *Memories of Old Montana*, Pasadena: Trail's End Publishing Co., 1945, 37.
42 A. Hunt, *Governing Morals: A Social History of Moral Regulation*, Cambridge: Cambridge University Press, 1999, 80, 83, 98.
43 F. Ings, *Before the Fences: Tales from the Midway Ranch*, ed. J. Davis, McARA Printing, 1980, 76.
44 GA, Mrs Charles Inderwick, Diary and Personal Letters from the North Fork Ranch, 1883-91, M376: letter of 13 May 1884.
45 Abbott and Huntington Smith, *We Pointed Them North*, 106.
46 Anderson, *Sheriffs and Outlaws of Western Canada*, 48.
47 H.A. Dempsey, *Golden Age of the Canadian Cowboy*, Saskatoon and Calgary: Fifth House, 1995, 56.
48 Petrik, *No Step Backward*, 29-54. Chicago Joe prospered because she understood the needs of her society. Unfortunately, as the frontier passed and more and more families took up residence in Helena, that society changed. Moral reformers tried to clean up the city's image and they applied political and legal pressures that, along with a depression, helped to ruin her before her death in 1899. For the theatre see also Renner, "Charlie and the Ladies in his Life," 142-3.
49 "A Female Stock Grower," *Yellowstone Journal*, 31 March 1885.
50 Mrs Nat Collins, *The Cattle Queen of Montana*, compiled by C. Wallace, St James, Minnesota: C.W. Toole Publishers, 1894, 242-9.
51 "Women Ranchers," *Calgary Herald*, 21 October 1902.
52 GA, Mrs Charles Inderwick, Diary and Personal Letters from the North Fork Ranch, 1883-91, M376: letter of 13 May 1884.
53 M. Hopkins, *Letters from a Lady Rancher*, introduced by S.S. Jameson, Calgary: Glenbow Alberta Institute, 1982.
54 PAA, 72,27/SE, G. Weadick, "Emery LaGrandeur, World's Champion Rider," sheet 6 in V. LaGrandeur, "Memoirs of a Cowboy's Wife."
55 LaGrandeur, "Memoirs of a Cowboy's Wife," 23.
56 See M. Kinnear, "Do You Want Your Daughter to Marry a Farmer? Women's Work on the Farm, 1922?" *Canadian Papers in Rural History*, 137-53.

CHAPTER NINE

1 W.M. Elofson, *Cowboys, Gentlemen, and Cattle Thieves: Ranching on the Western Frontier*, McGill-Queen's University Press, 2000, 134-58; R. White, "Animals and Enterprise," *The Oxford History of the American West*, ed. C.A. Milner II, C.A. Connor, M.A. Sandweis, New York and Oxford: Oxford University Press, 1994, 267.
2 R.H. Fletcher, *Free Grass to Fences: the Montana Cattle Range Story*, New York: University Publishers, 1960, 145-54; D.H. Breen, *The Canadian Prairie West and the Ranching Frontier, 1874-1924*, Toronto:

University of Toronto Press, 1983, 111–35; S. Evans, *Prince Charming Goes West: The Story of the E.P. Ranch*, Calgary: University of Calgary Press, 1993, 47–8.
3 "The Greedy Cowboy," *Great Falls Tribune*, 28 May 1885; "The cowmen own comparatively small acreages usually along the water courses, and many of them do not own a foot of land."
4 R.S. Fletcher, "The End of the Open Range in Eastern Montana," *Mississippi Valley Historical Review*, 16 (1929–30), 198–211. Even in the Canadian Northwest, where after 1884 the leases were no longer closed to settlement, there was little defense against the homesteaders who began in the nineties to assault the prairies with a vengeance, fully backed by *Homestead acts* and other pieces of federal legislation; see Elofson, *Cowboys, Gentlemen, and Cattle Thieves*, 2–22, 134–49.
5 19,000 acres.
6 Fletcher, "The End of the Open Range in Eastern Montana," 208–9.
7 *Forty Years on the Frontier, as seen in the journals and reminiscences of Granville Stuart*, ed. P.C. Philips, Cleveland: A.H. Clark, 1925, vol. 2, 145.
8 Fletcher, "The End of the Open Range," 209. Kohrs got 14,000 acres.
9 See below, 136–8.
10 United States, *Tenth Census of the United States*, (1880), vol. 1, 400.
11 United States, *Eleventh Census of the United States*, (1890), part 1, clv.
12 United States, *Eleventh Census of the United States*, (1890), part 1, xxxiii.
13 "Live Stock," *Rocky Mountain Husbandman*, 8 December 1904.
14 Fletcher, "The End of the Open Range," 199–204.
15 UM, Fergus papers, MC 10-11-64: J. Fergus to McNamara, 26 December 1895.
16 Ibid., J. Fergus to F.E. Bright, 5 December 1895.
17 Fletcher, *Free Grass to Fences*, 114–19; "Live Stock," *Rocky Mountain Husbandman*, 21 September 1899; ibid., 21 September 1899; ibid., 11 December 1902; In the remote regions the open range ranchers had gone largely to steers because they were less delicate and had survived the best in the winter of 1886–87. The Matador was doing this in Canada and the Home Ranch in Northern Montana and southern Assiniboia (below, 138–9).
18 "Live Stock," *Rocky Mountain Husbandman*, 19 September 1901.
19 "Agriculture," 3 January 1895.
20 D.H. Breen, *Canadian Prairie West*, 149; Elofson, *Cowboys, Gentlemen, and Cattle Thieves*, 19. For Walter Skrine on the Rocking S and George Emerson on the Rocking P, see H.C. Klassen, "A Century of Ranching at the Rocking P and Bar S," *Cowboys, Ranchers, and the Cattle Business: Cross-Border Perspectives on Ranching History*, ed. S. Evans, S. Carter, and W.B. Yeo, Calgary and Boulder: University of Calgary Press and University Press of Colorado, 1999, 38, 101–22.

21 R.E. Strahorn, *The Resources of Montana Territory and Attractions of Yellowstone National Park*, Helena: Montana Legislature, 1879, 25.
22 Elofson, *Cowboys, Gentlemen, and Cattle Thieves*, 76–8, 134–6; Fletcher, "The End of the Open Range in Eastern Montana," 204.
23 UM, Kohrs papers, LC 73, reel 1: C. Kohrs, to "Friend" Anderson, 16 December 1892.
24 Elofson, *Cowboys, Gentlemen, and Cattle Thieves*, 90–1.
25 UM, Fergus papers, MC 10-11-60: to A. Fergus, 15 January 1881.
26 Fletcher, *Free Grass to Fences*, 48.
27 A. Merrill and J. Jacobson, *Montana Almanac*, Helena: Falcon Publishing Co., 1997, 309, 126. Open range grazing reached its peak in 1886 with 700,000 cattle and nearly 1,000,000 sheep. In future years the numbers of both would climb sharply, but not based on the slim pickings of the open range alone. Thus, while overstocking continued to be a danger, the ranchers were able to avoid some of its worst manifestations by feeding hay and other foodstuffs; ("Live Stock," *Rocky Mountain Husbandman*, 24 October 1901; ibid., 19 December 1901; ibid., 30 October 1902).
28 "Stock News and Notes," *Rocky Mountain Husbandman*, 20 January 1887.
29 MHS, Rankin papers, MC 162-1-4: J.W. Bollinger notes on C.M. Russell, n.d., "CMR's own account of the 'Waiting for a Chinook,' taken stenographically from his dictation at the Lewis Glacier Hotel, Lake McDonald, Montana, August 6, 1926" in J.W. Bollinger's notes on C.M. Russell.
30 See, "Charles M. Russell, Cowboy Culture and the Canadian Connection," *Cowboys, Ranchers and the Cattle Business*, 13.
31 F. Ings, *Before the Fences: Tales from the Midway Ranch*, ed. J. Davis, McARA Printing, 1980, 67.
32 E.C. Abbott and H. Huntington Smith, *We Pointed Them North: Recollections of a Cowpuncher*, Norman: University of Oklahoma Press, 2nd edition, 1955, 176.
33 "Live Stock," 5 September 1889.
34 Fletcher, *Free Grass to Fences*, 90. Teddy Blue Abbott estimated that "fully 60 per cent of all the cattle in Montana were dead by March 15, 1887" (Abbott and Huntington Smith, *We Pointed Them North*, 184–5).
35 R.S. Fletcher, "That Hard Winter in Montana, 1886–1887," *Agricultural History*, 4:4 (October 1930), 128.
36 Abbott and Huntington Smith, *We Pointed Them North*, 184.
37 Fletcher, "That Hard Winter," 128.
38 Patterson and Poole, *Great Plains Cattle Empire*, 133–4.
39 Fletcher, *Free Grass to Fences*, 111.
40 Ibid.

41 "Crowding the Range," *Rocky Mountain Husbandman*, 7 May 1896; L.V. Kelly, *The Range Men*, 75th anniversary edition, High River: Willow Creek Publishing, 1988, 107.
42 W.M. Pearce, *The Matador Land and Cattle Company*, Norman: University of Oklahoma Press, 1964.
43 Like Pierre Wibaux and Conrad Kohrs (Fletcher, *Free Grass to Fences*, 111).
44 Russell to A.M. Joys, 10 May [1892], quoted in MHS, Rankin papers, MC 162-2-13: A.M. Joys to J. Rankin, 14 January 1937.
45 Conrad Kohrs estimated losses in those areas at 90 per cent to 95 per cent ("The Cattle Losses," *Missoulian*, 12 August 1887).
46 "The Half Not Being Told," *Missoulian*, 15 July 1887; "The Cattle Losses," ibid., 12 August 1887. *Montana Livestock Journal*: letter to the editor from "Uriel," 19 March 1889, quoted in Fletcher, *Free Grass to Fences*, 114–16.
47 Elofson, *Cowboys, Gentlemen, and Cattle Thieves*, 16.
48 "Local Notes," 18 August 1887.
49 Kelly, *Range Men*, 191.
50 PAA, 70.431/77; J.W. Martin, "Prairie Reminiscences," 10.
51 Elofson, *Cowboys, Gentlemen, and Cattle Thieves*, 90.
52 "Keep Cattle to the Hills," *Yellowstone Journal*, 12 February 1887.
53 "Live Stock," *Rocky Mountain Husbandman*, 14 October 1886.
54 Quoted in Fletcher, *Free Grass to Fences*, 90–1.
55 J.R. Craig, *Ranching with Lords and Commons, or Twenty Years on the Range*, Toronto: William Briggs, 1903, 64.
56 See also Elofson, *Cowboys, Gentlemen, and Cattle Thieves*, 13.
57 The count books for the Walrond Ranch are in GA, New Walrond Ranch papers, M8688-4-37. The main method used in the eighties to estimate numbers on this operation was to count the calves branded. In the nineties when the directors seem to have been trying to get a better idea of their company's financial position attempts were made to do overall counts. However, these were infrequent.
58 E. Brado, *The Cattle Kingdom: Early Ranching in Alberta*, Vancouver: Douglas and McIntyre, 1984, 143–4.
59 "Local Notes," *Macleod Gazette*, 7 June 1895.
60 Kelly, *Range Men*, 101, 130.
61 "Raided by Wolves," 15 August 1886.
62 GA, New Walrond Ranche papers, M8688-1-3: 2 July 1894.
63 Ibid., D. Warnock to D. McEachran, 31 July 1894.
64 "Grenfell Fox Hounds," *Regina Leader*, 21 April 1898; "Grenfell Notes," ibid., 5 May 1898; Kelly, *Range Men*, 115; E. Hough, "The Cowboy," *The Complete Cowboy Reader: Remembering the Range*, ed. T. Stone, Red Deer: Red Deer College Press, 1997, 26; MHS, Memoirs of Lady Kathleen Lindsay, SC 1692. The Bronco Buster was the "Missouri

Kid," master with a rope. One time, according to Lindsay, he roped 5 wolves in a row, snapping their necks with a jerk of the rope.
65 "The Best Way to Poison Wolves," *Yellowstone Journal*, 11 November 1887; "Range Notes," *Macleod Gazette*, 7 September 1894.
66 "The Best Way to Poison Wolves."
67 "Stock Notes and News," *Rocky Mountain Husbandman*, 16 February 1893; GA, New Walrond Ranch papers, M8688-1-3: D. Warnock to Manager River Press Publishing, 2 October 1894.
68 See, for instance, "Local Notes," *Yellowstone Journal*, 6 December 1885.
69 "Stock Notes and News," *Rocky Mountain Husbandman*, 16 February 1893.
70 "The Disease Spreading," *Yellowstone Journal*, 5 October 1887; see also "Peculiar Disease in Horses," ibid., 22 August 1885, for a no less frightening but apparently less severe outbreak; Canada, *Sessional Papers*, 25:10 (1892), n. 15 (North West Mounted Police Annual Reports), 94: Report for A Division, 1 December 1891; ibid. 26:9 (1893), n. 15, 5: Report of the Commissioner, 19 December 1892; ibid. 27:11 (1894), n. 15, 3: Report of the Commissioner, 28 December 1893.
71 "Glandered Horses," *Yellowstone Journal*, 13 May 1887; on the Canadian side the disease became a substantial threat in the nineties and after the turn of the century (see Elofson, *Cowboys, Gentlemen, and Cattle Thieves*, 55).
72 "The Scobey Cattle Sound," *Yellowstone Journal*, 15 October 1886; "Stock Notes and News," *Rocky Mountain Husbandman*, 3 May 1888; Elofson, *Cowboys, Gentlemen, and Cattle Thieves*, 31.
73 "Disease," *Yellowstone Journal*, 14 September 1887.
74 PAA, 70.431/77: J. Martin, "Prairie Reminiscences," n.d., 7.
75 "Vaccination of Calves," *Rocky Mountain Husbandman*, 12 September 1901. See also "Disease," *Yellowstone Journal*, 4 April 1886; "Local Notes," *Yellowstone Journal*, 6 August 1885; Kelly, *Range Men*, 160; "The Grange," *Rocky Mountain Husbandman*, 12 February 1880; "Black Leg," ibid., 15 April 1880.
76 Elofson, *Cowboys, Gentlemen, and Cattle Thieves*, 55; GA, New Walrond Ranch papers, M8688-1-3: W. Bell to J.G. Ross, 5 September 1888; "Local Notes," *Yellowstone Journal*, 20 December 1885; ibid., 19 June 1885; ibid. 15 October 1886; "Live Stock," *Rocky Mountain Husbandman*, 14 October 1897; "Pink Eye," ibid., 17 July 1902; "Foot and Mouth Disease," ibid., 8 January 1903; "Tuberculosis," ibid.. "Peculiar Cattle Disease," ibid., 3 January 1895. Sometimes unidentified poisonous weeds were thought to be responsible for significant losses; see, "Live Stock," ibid., 3 January 1903; "Local News," ibid., 3 June 1880; ibid., 17 June 1880.
77 "Quarantine," *Yellowstone Journal*, 1 May 1885; "Local Notes," ibid. 14 April 1885.

78 "A Law of the Range," ibid., 13 April 1887.
79 Kelly, *Range Men*, 160.
80 Sometimes an ointment made of sulphur, tar, and linseed oil was applied ("Mange at Gleichen," *Calgary Herald*, 16 February 1904).
81 "Mange," *Rocky Mountain Husbandman*, 24 April 1902. See also "Dipping Cattle," ibid., 8 May 1902; "Mange and Lice on Stock," ibid., 19 June 1902; "Scab and Dips," ibid., 27 August 1903.
82 Oddly at that stage the paper complained that this was an expense the stockmen "could illy afford," ("Live Stock," ibid., 7 July 1904). See also "Mange and Scab on the Range," ibid., 1 September 1904.
83 "Dipping of Cattle Recommended for Mange," *Calgary Herald*, 12 April 1904.
84 "Dominion of Canada, Order of the Minister of Agriculture," ibid., 19 August 1904.
85 H. "Dude" Lavington, *Nine Lives of a Cowboy*, Victoria: Sono Nis Press, 1982, 18–19.
86 Elofson, *Cowboys, Gentlemen, and Cattle Thieves*, 55–6.
87 "The Enterprise," 10 November 1905, quoted in Patterson and Poole, *Great Plains Cattle Empire*, 176.
88 GA, Cochrane Ranche Letter Book, M234. A diary with the letter book covers the period from 1 January 1885 to 17 December 1885.
89 The *Rocky Mountain Husbandman* regularly admonished the cattlemen to use better bulls; see for example "Grade Bulls," ibid., 2 February 1899. It also argued for a "general application of the castrating knife," on bull calves, ("Range Bull Trade," 29 January 1903).
90 MHS, Montana Stock Growers Association, minute book, MC 45-8 (1885), 32.
91 W.M. Elofson, "Adapting to the Frontier Environment: Mixed and Dryland Farming near Pincher Creek, 1895–1914," *Prairie Forum* 11:2 (fall 1986), 36.
92 H.W. Riley, "Herbert William (Herb) Millar," *Canadian Cattlemen* 4:4 (March 1942), 168.
93 Canada, *Sessional Papers*, 33:12 (1899), n. 15 (North West Mounted Police Annual Reports), 19: Report of the Commissioner, 20 December 1898.
94 For cattle entering Canada from the United States, see Canada, *Sessional Papers*, 37:5 (1894), n. 8, 93: Report of the Commissioner on Canadian Quarantines; ibid., 27:11 (1894), n. 15, 65: Report of Staff Sergeant Mitchell, 27 November 1893.
95 GA, New Walrond Ranche papers, M8688-1-3: journal entry, 7 February 1891.
96 Montana Stock Growers Association, minute book, MC 45, vol. 8, 31–7; Canada, *Sessional Papers*, 33:12 (1899), n. 15 (North West Mounted

230 Notes to pages 150–5

Police Annual Reports), 19: Report of the Commissioner, 20 December 1898.
97 GA, New Walrond Ranche papers, M8688-1-3: D. McEachran to Boyle, Campbell, Burton & Co., 28 June 1887.
98 AHC, MC 9529.
99 L.M. Woods, *Moreton Frewen's Western Adventures*, Boulder: Roberts Rinehart, 1993, 32–71.
100 AHC, Frewen papers, MC 9529-2-11: to W.H. Hulbert, 10 May 1883; ibid., to A. Pell, 23 June 1883; ibid., to C.F. Kemp, 8 August 1883. See also, L. Woods, *British Gentlemen in the Wild West; the Era of the Intensely English Cowboy*, New York and London: The Free Press, 1989, 84.
101 AHC, Frewen papers, MC9529-2-11: M. Frewen to T.C Sturgis, 9 June 1883; ibid., M. Frewen to J.M. Carey, 9 August 1883; ibid., to Sturgis, August 1883; ibid., to Clare Frewen, 16 July 1883; ibid., to Vernon, 20 August [1885]; ibid., to Lord Rosslyn [October 1885]; ibid., 3, to Clare Frewen, 28 August 1884.
102 Ibid., to C.F. Kemp, 8 August 1883.
103 Ibid., 2–19: Frewen to Board of Directors, [9] June 1883.
104 Ibid., to Clare Frewen, 1 October 1883.
105 Ibid., to Kali, 24 October 1883.
106 Ibid., 3–5: to Clare Frewen, 28 August 1884.
107 Ibid., 3–6: to Clare Frewen, 12 September 1884.
108 Ibid., 2–11: to Willy, 6 August 1885.
109 Ibid.
110 Ibid.
111 MHS, Fergus papers, MC 28-2-5: 22 August 1887.
112 "Selling Unfinished Cattle," *Rocky Mountain Husbandman*, 25 July 1895. See also, for instance, "Live Stock," ibid. 4 July 1895; ibid., 25 March 1897; ibid., 19 December 1901.
113 AHC, Frewen papers, MC 9529-3-9: Frewen to Sir John A. Macdonald, 9 November 1884. This he argued would be beneficial to the agricultural interests on both sides of the Atlantic. In this letter to the Canadian Prime Minister he tried to make the case for doing away in Canada with the ninety days' quarantine on cattle brought in from the places like Montana and Wyoming with the argument that this would allow farmers in Ontario to acquire feeder animals cheaply. They could then use some of their surplus wheat and other grains on them and sell them in Britain not as finished animals but again as large feeders or "store" cattle.
114 Ibid., 3–7: to Sir, 16 September 1884.
115 "A Trip on a Cattle Boat," *Great Falls Tribune*, 4 February 1890.
116 MHS, Montana Stock Growers Association, minute book, MC 45, vol. 8, 181–2.

117 This figure was about right for the cattle I myself shipped from Alberta to Toronto on a number of occasions in the early 1980s.
118 GA, New Walrond Ranche papers, M8688-1-3: W. Bell to D. McEachran, 20 August 1888. At this time McEachran seems constantly to have been concerned about the financial position of the ranch; see, ibid., W. Bell to D. McEachran, 5 September 1888.
119 A.C. Rutherford, *The Cattle Trade in Western Canada*, quoted in Kelly, *Range Men*, 209.
120 Fletcher "The End of the Open Range," 210.
121 M.E. Inderwick, "A Lady and Her Ranch," *Alberta History*, 15: 4 (autumn 1967), 1-9.
122 "Local Notes," *Macleod Gazette*, 7 June 1895; "The Mange," ibid., 14 July 1899.
123 D. McGowan, *Grassland Settlers: The Swift Current Region during the Era of the Ranching Frontier*, 4th edn. Cactus Publications: Victoria, 1989, 76-7.
124 J.J. Young, "A Visit to the Cochrane Ranch," *Alberta Historical Review*, 22:3 (summer 1974), 28.
125 For A.E. Cross, see H.C. Klassen, "Entrepreneurship in the Canadian West: The Enterprises of A.E. Cross, 1886-1920," *Western Quarterly*, 22:3 (August 1991), 313-33. For the others see W.M. Elofson, *Cowboys, Gentlemen, and Cattle Thieves*, 90, 147-8.

CHAPTER TEN

1 "Live Stock," *Rocky Mountain Husbandman*, 17 September 1903
2 W.M. Elofson, "Not Just a Cowboy: The Practice of Ranching in Southern Alberta, 1881-1914," *Canadian Papers in Rural History*, 10 (1996), 209.
3 "Live Stock," *Rocky Mountain Husbandman*, 29 January 1880.
4 Ibid., 10 November 1887.
5 Ibid.
6 Overgrazing in the valleys of the foothills was also a problem, ("Live Stock," *Rocky Mountain Husbandman*, 25 May 1882).
7 "Way to Raise Sheep," *Yellowstone Journal*, 7 April 1887.
8 Ibid., 14 October 1886.
9 "The Coming Fence," ibid., 9 February 1882.
10 The *Rocky Mountain Husbandman* estimated that the average in the earliest days before extensive feeding and fencing had been 100 to 200 head ("Live Stock," 14 October 1886). Thus the average at this stage must have been around forty or fifty head.
11 R.H. Fletcher, *Free Grass to Fences: the Montana Cattle Range Story*, New York: University Publishers, 1960, 33, 145-54. "The increase of

these fences is enormous, as may be judged from the fact that in 1876 at a single manufacturing establishment at Worcester, Mass., there were 2,840 miles of barbed wire made, which yearly increased up to the present year, when the quantity has already reached 160,000 miles ... the firm is now turning out ninety miles of barbed wire daily, besides there being in the United States about fifty other manufacturing establishments of this kind, with as many orders as they can fill." "Barbed Wire Fences Again," *Rocky Mountain Husbandman*, 4 January 1883.

12 "Live Stock," *Rocky Mountain Husbandman*, 11 December 1902; The *Desert Land Act* of 1877 required settlers to establish irrigation works on their land. ("Live Stock," *Rocky Mountain Husbandman*, 11 December 1902; ibid., 17 September 1903).

13 Repealed in 1891 and replaced in 1892 by the *Timber and Stone Act*.

14 These were largely the same methods utilized later by the Great Ranchers (R.S. Fletcher, "The End of the Open Range," 199–211). See also "Live Stock," *Rocky Mountain Husbandman*, 11 December 1902.

15 Ibid., 14 October 1886.

16 Ibid., 5 September 1895; ibid., 25 January 1900; ibid., 8 December 1904.

17 UM, Fergus papers, MC 10-11-60: J. Fergus to "Friend" Mills, 7 May 1883.

18 GA, Cochrane Ranch Letter Book, M234: diary, 21–7.

19 Fletcher, *Free Grass to Fences*, 47.

20 Elofson, *Cowboys, Gentlemen, and Cattle Thieves: Ranching on the Western Frontier*, Montreal and Kingston: McGill-Queen's University Press, 2000, 136, 137.

21 GA, Stair Ranch Letter Book, M2388, 399: D.H. Andrews to Chas. Askers, 7 August 1893.

22 On 4 August 1885 the *Macleod Gazette* warned that "every cowman in the country should put up enough hay on his range to feed weak stock through any bad storm;" if cattlemen would do this, the paper said, they would "sleep better during the cold and stormy nights of winter ("All Over the Range") Obviously many of them still were not doing even that.

23 PAA, 72,27/SE: V. LaGrandeur, "Memoirs of a Cowboy's Wife," 6.

24 W.M. Elofson, "Adapting to the Frontier Environment: Mixed and Dryland Farming near Pincher Creek, 1895–1914," *Prairie Forum* 11:2 (fall 1986), 31–50.

25 R.S. Fletcher, "The End of the Open Range in Eastern Montana," 206–7.

26 "Live Stock," *Rocky Mountain Husbandman*, 25 June 1896.

27 Ibid., 22 November 1900. Even on the Milk River Ridge and along the Missouri River, ranchers were beginning to move into domestic hays by the turn of the century and most had built fences to enclose their calves and she-stock during the winter (ibid., 24 October 1901).

28 In 1895 there were 120 irrigation systems in operation in southern Alberta and western Assiniboia. They were almost all used on fodder fields in the livestock districts. There were another fifty or so under construction or in the planning stage (Canada, *Sessional Papers*, 29:10 (1896), n. 13 (Department of the Interior Annual Report), 144-9).
29 Fletcher, *Free Grass to Fences*, 111.
30 Canada, *Sessional Papers*, 22:13 (1889), n. 17 (North West Mounted Police Annual Reports), 20: Report of the Commissioner, 31 December 1888.
31 Ibid., 42:14 (1907-8), n. 28, 56: Report for D Division, 1 November 1907.
32 "The Cochrane Ranch," *Macleod Gazette*, 3 October 1884; GA, Cross papers, M1543, f. 471: C. Douglass to Cross, 11 March 1907; "Live Stock," *Rocky Mountain Husbandman*, 21 September 1899.
33 See E.C. Abbott and H. Huntington Smith, *We Pointed Them North: Recollections of a Cowpuncher*, Norman: University of Oklahoma Press, 2nd edition, 1955, 125.
34 "Cattle Drives," *Yellowstone Journal*, 13 January 1884.
35 MC 45, vol. 8, 201.
36 "Live Stock," *Rocky Mountain Husbandman*, 21 September 1899.
37 *The Range Men*, 87.
38 Elofson, *Cowboys, Gentlemen, and Cattle Thieves*, 79.
39 GA, Cross papers, M2388, f. 470: Cross to F.H. Berry, 1 September 1901.
40 See above, 36-9.
41 F. Ings, *Before the Fences: Tales from the Midway Ranch*, ed. J. Davis, McARA Printing, 1980, 9-10, 21-5, 33.
42 W.R. "Bob" Newbolt, "Memories of Bowchase Ranch," *Alberta History*, 32: 4 (autumn 1984), 4.
43 Ings, *Before the Fences*, 22.
44 MHS, Rankin papers, MC 162-3-3: B.V. Olden to J. Rankin, 4 November, 1937.
45 See T. Roosevelt, "The Round-Up," *The Complete Cowboy Reader: Remembering the Range*, ed. T. Stone, Red Deer: Red Deer College Press, 1897, 188-212.
46 In the fall there was another major round-up to brand and castrate calves born after, or missed in, the earlier gathering, to separate out the steers that were fat, and to move the cattle to winter pastures. On some ranches, including the Walrond, there were two fall round-ups. The second was simply for gathering fat animals for slaughter.
47 If one animal required twenty to twenty-five acres for grazing, 1,000 would require at least 20,000 acres.
48 UM, Dilworth papers, LC 8-1-9: Dilworth to Addi, 2 July 1881.

49 Ings, *Before the Fences*, 41. See also G. MacEwan, *John Ware's Cow Country*, new edtn., Vancouver: Greystone Books, 1995, 37–41.
50 D.H. Andrews described the construction of barbed wire fences in some detail in a letter to one of the Stair Ranch directors in 1892 (Stair Ranch Letter Book, M2388, 350: Andrews to A.M. Nanton, 29 October 1892). See also, MHS, Stuart papers, MC 61-1-4: G. Stuart to C. Kohrs, 6 March 1890.
51 See above, 36–9.
52 GA, New Walrond Ranche papers, M8688-1-3: D. Warnock to D. McEachran, 13 November 1893.
53 This is assuming that the cow would have to be fed during the worst hundred days of weather and the steer the worst 150 days to keep it at least maintaining, but hopefully, gaining weight. The cow would need about thirty pounds of dry hay a day and the steers, depending on age and size, would average about 20 pounds.
54 The count books for the Walrond Ranch are in GA, New Walrond Ranche papers, M8688-4-37. In 1891 the ranch owned 2,952 steers, 364 bulls, and 5,266 cows.
55 This included the yearling heifers from previous calf crops that were bred to replace older or poorer cows that were marketed for beef.
56 It can be assumed that had the Walrond put up all its own hay without contract the costs would have been very close to the same. The management would have had to hire many more men itself, purchase a great array of haying, hauling, and stacking equipment, and provide housing and a food supply for the men.
57 Ibid., W. Bell to J.G. Ross, 18 September 1887. In 1888 the ranch employed a total of twenty-nine men. Eleven of them worked from seven to twelve months.
58 With horse-drawn equipment one man could put up about sixty tons of hay.
59 See Elofson, *Cowboys, Gentlemen, and Cattle Thieves*, 18–19; R.S. Fletcher, "The End of the Open Range in Eastern Montana," 205–9.
60 *"Prairie Grass to Mountain Pass": History of the Pioneers of Pincher Creek and District*, Calgary: Pincher Creek Historical Society, 1974, 7: the recollections of Frank Austin and Myra (Austin) Harshman.
61 See the Tax Assessments in the Montana Writers' Project, Montana Historical Society, Helena.
62 Fletcher, *Free Grass to Fences*, 111.
63 Ibid., 131.
64 See above, 23.
65 Kelly, *Range Men*, 126–7. Cross seems in his earlier years to have had ambitions of reaching great ranch status. However, after the 1906–07 winter he gave up leases on the open range, fenced in his pastures

around Nanton, Alberta, and cut his numbers (Elofson, *Cowboys, Gentlemen, and Cattle Thieves*, 17, 137).

66 For some of the best-known ranchers in southern Alberta see Ings, *Before the Fences*, 151–84. For A.E. Cross see, H.C. Klassen, "Entrepreneurship in the Canadian West: The Enterprises of A.E. Cross, 1886–1920," *Western Quarterly*, 22:3 (August 1991), 313–33. For Bob Newbolt see, W.R. "Bob" Newbolt, "Memories of the Bowchase Ranch."

67 "Live Stock," *Rocky Mountain Husbandman*, 20 December 1895.

68 "Range Bull Trade," ibid., 29 January 1903.

69 H.W. Riley, "Herbert William, (Herb) Millar," *Canadian Cattlemen* 4:4 (March 1942), 168.

70 "Live Stock," *Rocky Mountain Husbandman*, 15 June 1899.

71 Ibid., 14 December 1899.

72 "Live Stock," *Rocky Mountain Husbandman*, 15 June, 1899; ibid., 21 September 1899; ibid., 24 October 1899, and many other issues.

73 MHS, Survant papers, SC 343-1/2: F.H. Roberts to J. Survant, 3 July 1902.

74 "Live Stock," *Rocky Mountain Husbandman*, 28 February 1895; ibid., 7 November 1895.

75 Ibid., 26 October 1897; ibid., 15 June 1899; ibid., 17 August 1899; ibid., 14 December 1899.

76 "Live Stock," *Rocky Mountain Husbandman*, 26 October 1897.

77 Ibid., 25 November 1897.

78 Most of the feeders were small operators but the *Rocky Mountain Husbandman* reported that one man did this with 3,000 head, ("Live Stock," 20 December 1895).

79 Ibid., 25 November 1897. The paper also noted the development of winter finishing in Big Hole Valley, Ruby Valley, and the valley surrounding White Sulphur Springs.

80 Ibid., 19 September 1901.

81 Ibid, 29 May 1902.

82 This is what the *Rocky Mountain Husbandman* felt would be the most sensible approach ("Live Stock," 20 August 1901). See also "Live Stock Feeding Tests at the Experimental Station," ibid., 31 January 1901; "Making Beef," ibid., 10 March 1904. Barley put on 2.34 pounds a day; the mixed grains put on 2.25 pounds per day. Presumably the mixture more than made up for the difference because it was cheaper than straight barley

83 "Live Stock," ibid., 28 May 1896; ibid., 1 November 1899.

84 W.M Elofson, "Adapting to the Frontier Environment: the Ranching Industry in Western Canada, 1881–1914," *Canadian Papers in Rural History*, 8 (1992), 323–5.

85 J.G. Rutherford, *Cattle Trade in Western Canada*, quoted in Kelly, *Range Men*, 201–2.

86 Ibid.
87 Ibid., 193-4.
88 "Barley and Alfalfa for Steers," *Rocky Mountain Husbandman*, 14 January 1904.
89 Alberta, Department of Agriculture, *Annual Report*, 1908, 151.
90 "The Feeding of Cattle," *Rocky Mountain Husbandman*, 16 January 1902.
91 Ad of Calgary Colonization Co. Ltd., *Calgary Herald*, 3 April 1905.
92 Elofson, "Mixed and Dryland Farming," 34.
93 "A Model Farm," *Rocky Mountain Husbandman*, 2 May 1895.
94 Elofson, *Cowboys, Gentlemen, and Cattle Thieves*, 17, 30, 87-90.
95 Newbolt, "Memories of Bowchase Ranch," 1-10.
96 Elofson, *Cowboys, Gentlemen, and Cattle Thieves*, 135-7.
97 Kelly, *Range Men*. 193. The Miles City correspondent of the *Montana Livestock Journal* used the term "gigantic stock farms" (19 March 1889). Quoted in Fletcher, *Free Grass to Fences*, 115.
98 "Agriculture," 26 September 1901.
99 S. Evans, "Spatial Aspects of the Cattle Kingdom," *Frontier Calgary, 1875-1914*, ed. A.W. Rasporich and H. Klassen, Calgary: University of Calgary Press, 1975, 50-2; Fletcher, *Free Grass to Fences*, 118.

CHAPTER ELEVEN

1 "Cowboy shortage hits rodeo circuit," *Calgary Herald*, 1 July 2002.
2 "God Must Have Been a Cowboy," popularized in recent years by Dan Seals.
3 Canada, *Sessional Papers*, 29:10 (1896), n. 13 (Department of the Interior Annual Report), 144-9.
4 Department of Publicity of the Bureau of Agriculture, Labor and Industry, *Montana*, compiled by W. Boyle, Helena: Independent Publishing, 1912, 59.
5 A. Merrill and J. Jacobson, *Montana Almanac*, Helena: Falcon Publishing Co., 1997, 38-9; Environment Canada.
6 R.S. Fletcher, "The End of the Open Range in Eastern Montana," *Mississippi Valley Historical Review*, 16 (1929-30), 201-2.
7 See Merrill and Jacobson, *Montana Almanac*, 309, 312.
8 See, for instance, "Live Stock," and "Wool," *Rocky Mountain Husbandman*, 31 October 1895.
9 In 1890 sheep were worth about $2.40 a head and cattle $17.40 (Merrill and Jacobson, *Montana Almanac*, 309, 312).
10 In 1910 when Alberta and Saskatchewan had nearly 1.4 million cattle and approximately 900,000 horses they had fewer than 250,000 sheep. Canada, *Fifth Census of Canada* (1911), vol. 4, 395.

11 L.V. Kelly, *The Range Men*, 75th anniversary edition, High River: Willow Creek Publishing, 1988, 82.
12 Ibid., 10.
13 See above, 101, 104.
14 "The Dying Cowboy," for instance, is "an adaptation of "The Ocean Burial," which is "still current in the East," (J. Lomax, *Songs of the Cattle Trail and Cow Camp*, New York: Macmillan and Co., 1928, 420).
15 "Swung High," *Yellowstone Journal*, 20 July 1884; "The Vigilantes of Today," ibid., 16 January 1885.
16 J.R. Craig, *Ranching with Lords and Commons, or Twenty Years on the Range*, Toronto: William Briggs, 1903, 87.
17 In 1881 Alberta, Assiniboia, and Saskatchewan had a grand total of 25,515 people. Canada, *Fourth Census of Canada* (1901), vol. 1, 5.
18 MSU, Christie papers, MC 1365-1-8: D.B. Christie to his brother, 12 April 1898.
19 *Ranching with Lords and Commons*, 75.
20 MHS, Rankin papers, MC162-1-4, Notes on C.M. Russell from Judge J.W. Bollinger, n.d. "CMR's own account of the 'Waiting for a Chinook,' taken stenographically from his dictation at the Lewis Glacier Hotel, Lake McDonald, Montana, August 6, 1926," in J.W. Bollinger's notes on C.M. Russell.
21 See E.C. Abbott and H. Huntington Smith, *We Pointed Them North; Recollections of a Cowpuncher*, Norman: University of Oklahoma Press, 2nd edition, 1955, 214.
22 The Cheneys tell us that "very few of the open range cowboys were really outlaws, but they all liked to whoop it up on their trips to town and sometimes got in trouble. Most of them had come from good homes in the Midwest or the East and they were often a happy-go-lucky bunch who had been lured to the West by a desire for adventure. They found a lot of hard work along with the excitement of being part of the big, open range cattle pools (T.M Cheney with R.C. Cheney, *So Long, Cowboys of the Open Range*, Helena: Falcon Publishing Inc., 1998, 48).
23 PAA, 72,27/SE: V. LaGrandeur, "Memoirs of a Cowboy's Wife," 13; W.M. Elofson, *Cowboys, Gentlemen and Cattle Thieves: Ranching on the Western Frontier*, Montreal and Kingston: McGill-Queen's University Press, 2000, 20; above, 48, 90-2.
24 From the North West Mounted Police annual reports it is evident that complaints about crime in general grew more vociferous and more frequent in the later nineties and early 1900s. See above 86.
25 "James C. Alcock of Okotoks Alberta," *Canadian Cattleman*, 16:1 (January 1953), 12-13, 36-7.
26 "Tom Whitney of the Cypress Hills," *Frontier Times*, March, 1977, 64.

27 Elofson, *Cowboys, Gentlemen, and Cattle Thieves*, McGill-Queen's University Press, 2000, 80, 100, 106 and above, 50.
28 GA, Young papers, M8665, Robert Young to William Young, 8 July 1884.
29 "Improvement," 8 November 1885. For a similar statement about Montana Territory as a whole, see "The West and its Future," *Great Falls Tribune*, 25 June 1885.
30 Abbott and Huntington Smith, *We Pointed Them North*, 210. Abbot himself was nearly always armed but he confessed to only a single gunfight in the course of his entire ranching career. And it was not really a fight. One night in Nebraska, when he was sixteen years old and drunk, he discharged his six-gun at a town marshal who was trying to arrest him and some friends for shooting out the streetlights. Luckily no one was seriously injured. The bullet went through the lawman's shoulder and "he was only sick a few days and then back on the job."
31 Cheney and Cheney, *So Long Cowboys of the Open Range*, 47
32 *Trails Plowed Under: Stories of the Old West*, introduced by W. Rogers and B.W. Dippie, Lincoln: University of Nebraska Press, 1996, 80.
33 *Charles M. Russell, Word Painter, Letters 1887–1926*, ed. B.W. Dippie, Fort Worth: Amon Carter Museum, 1993, 44, 289, 295, 325, 387, 388. Russell also readily admitted that cowboys like himself were known to do a lot of lying (*Trails Plowed Under*, 191).
34 R.V. Hine and J.M. Faragher, *The American West: A New Interpretive History*, New Haven and London: Yale University Press, 2000, 309–10.
35 G.A. Wilson, *Outlaw Tales of Montana*, Havre, Montana: High-Line Books, 1995, 45–6, 62; W. Coburn, *Pioneer Cattleman in Montana: The Story of the Circle C Ranch*, Norman: University of Oklahoma Press, 1968, 66–7; G. Shepherd, "Tom Whitney of the Cypress Hills," *Frontier Times*, March 1977, 64.
36 Abbott and Huntington Smith, *We Pointed Them North*, 103.
37 R.S. Fletcher, "The End of the Open Range in Eastern Montana," 202–4.
38 CHS, Stuart papers, MC 1601 bx 2, Stuart to editors of *Intermountain*, 20 October 1885; G. Stuart, *Forty Years on the Frontier, as seen in the journals and reminiscences of Granville Stuart*, ed. P.C. Philips, Cleveland: A.H. Clark, 1925, vol. 2, 186–7. See also Abbott and Huntington Smith, *We Pointed Them North*, 135–6; Coburn, *Pioneer Cattlemen in Montana*, 34–5.
39 R.M. Brown, "Violence," *The Oxford History of the American West*, ed. C.A. Milner II, C.A. O'Connor, M.A. Sandweiss, New York and Oxford: Oxford University Press, 1994, 393–408.
40 See above, 56, 120, 127.
41 GA, Mrs. Charles Inderwick, Diary and Personal Letters from the North Fork Ranch, 1883–91, M376: Letter of 13 May 1884.
42 GA, S.J. Clarke papers, M229: entry for 25 December 1880.

43 M. Hopkins, *Letters from a Lady Rancher*, introduced by S.S. Jameson, Calgary: Glenbow Alberta Institute, 1982, 59: letter of June 1910.
44 M. Zuehlke, *Scoundrels, Dreamers, and Second Sons: British Remittance Men in the Canadian West*, 2nd edition, Toronto, Oxford & New York: Dundurn Press, 2001, 157-9.
45 R.W. Slatta, *Comparing Cowboys and Frontiers: New Perspectives on the History of the Americas*, Norman and London: University of Oklahoma Press, 1997, 193.
46 See, for instance, D.H. Breen, "The Turner Thesis and the Canadian West: A Closer Look at the Ranching Frontier," *Essays in Western History*, ed. L.H. Thomas, Edmonton: University of Alberta Press, 1976, 154. For the Turner thesis and some of the chief criticisms see *The Turner Thesis Concerning the Role of the Frontier in American History*, ed. G.R. Taylor, Lexington, Toronto and London: D.C. Heath and Company, 3rd edtn. 1972.
47 See in particular Turner's "The Problem of the West," *The Early Writings of Frederick Jackson Turner: with a list of all his work*, compiled by E.E. Edwards and introduced by F. Mood, Ann Arbor: University Microfilms International, 1981.
48 P. Voisey, *Vulcan: The Making of a Prairie Community*, Toronto: University of Toronto Press, 1988, 201-46.
49 See, C.S. Savage, *Our Nell: A Scrapbook Biography of Nellie L. McClung*, Saskatoon: Western Producer Prairie Books, 19.
50 Merrill and Jacobson, *Montana Almanac*, 38-9, 181.
51 Ibid., 215, 216.
52 Ibid., 215. For more in-depth reading on Montana women see G.C. Shirley, *More than Petticoats: Remarkable Montana Women*, Helena: Two Dot Books/Falcon Publishing Inc., 1995.
53 M.P. Malone and D.G. Dougherty, "Montana's Political Culture: A Century of Evolution," *The Montana Heritage: An Anthology of Historical Essays*, ed. R.R. Swartout, Jr and H.W. Fritz, Helena: Montana Historical Society Press, 1992, 175.
54 An excellent study of the United Farmers of Alberta is B.J. Rennie, *The Rise of Agrarian Democracy: The United Farmers and Farm Women of Alberta, 1909-1921*, Toronto: University of Toronto Press, 2000.
55 See J.H. Archer, *Saskatchewan, a History*, Saskatoon: Western Producer Prairie Books, 1980, 133-260.

Index

Abbott, E.C. ("Teddy Blue"), 10, 12, 13–14, 21–2, 72–3, 138; marriage of, 125; and prostitutes, 123; rangeland entertainer, 101–2, 105–10; stampedes, 103
Adams, J.D., 162
Abilene, Texas, 9
Alberta, agricultural practices in, 22–4, 132–74; first cattle in, 9–10, 14; settlement of, 10, 17–19, 22–3
Alberta Ranch, 19
Alcock, James, 183
Alcock, Joseph, 183
Alexander, R.A., 57
Alexander, H.B., 168
Allen, H., 18
Almighty Voice, 78
Anceny, C., 169
Anderson, R., 82, 120
Assiniboia, agricultural practices in, 22–4, 132–74; first cattle in, 9–10, 14; settlement of, 10, 17–19, 22–3
Assiniboine Creek, Montana, 138

Bad Bull, 89
Bader, C., 169
Bannack, Montana, 8, 158
Bar U Ranch, (Northwest Cattle Company), 18, 19, 23, 31, 35, 48, 135, 157; breeding program, 47
barbed wire, 160, 162, 163, 166–7
Beaver Head County, Montana, 16
Beadle, E., 27
Bear Paw Mountains, Montana, 6
Beatrice, Princess, 106
Beaver Creek, Montana, 174
Begg, Mr, 78
Bell, W., 113–14, 155–6
Belly River, Alberta, 124, 163
Belmont Park Horse Ranch, 57
Bentley, F., 122
Benton and St Louis Cattle Company, 16; see also Conrad, C.E.; Conrad, W.G.
Biggs, Mr, 10
Big Muddy River and area, Assiniboia and Montana, 8, 48, 90, 91, 183
Billings, Montana, 53, 59, 182

Blackfoot Crossing, Alberta, 79
Blackfoot Nation, 78, 88, 128
Blood Nation, 9, 78, 88
Bloom, F., 138
Bonneau, P., 91
Boris River, Idaho, 165
Boston, Massachusetts, 13, 26
Bow Gun Ranch, 60, 73
Bow River, Alberta, 13, 48, 163, 174
Bow River Ranching Company, 47
Bowles, Mr, 79
Boyle, J., 79
Bozeman, Montana, 53, 73
Bradshaw, J., 57
Breen, D.H., 5
Brewster, C., 60, 111
Brewster, G., 86
Bridger Canyon, Montana, 59
Brisbin, J.S., 36–7, 38
Brooke, A.F.M., 85
Brooklyn, New York, 12
Brown, Mr, 89
Bryan, T.J., 16, 61
Buchanan, M., 122
Burlingame, M., 5
Butler, A.M., 122
Butte, Montana, 53, 69
Byron, Lord, 27

242 Index

Campbell, Mr, 84
Canadians, in Montana, 17
Calgary, 11, 23, 43, 49, 51, 68, 74, 75, 79, 85, 111, 112, 139, 140, 163, 172, 174, 180; and liquor control, 70-1; and prostitution, 71, 128; Stampede, 130-1
California, 5, 114, 116
Cameron, D., 82
Capital X Ranch, 116
Carkeek, L., 68
Carlyle, F., 13
Carson, K., 28, 41, 111
Cascade County, Montana, 9
Catlin, J., 27
cattle; diseases, 140, 144-7, 188; feeding, 8, 170-3; losses of in winter, 16, 20-1, 22, 135-41, 188; losses of from wolves, 45, 143, 188; quality and type, 9, 47, 159, 169, 170-1; rustling 81-95, 97; smuggling, 93-4; see also rustling under: cowboys; law enforcement; North West Mounted Police; stock associations
Cayley, Alberta, 71, 82
Chamberlain family, 129
Charcoal, 78
Cheadle, W.B., 26
Cherry Creek, Montana, 74
Cheyenne, Wyoming, 9, 34, 121
Cheyenne Nation, 9, 77-8, 88, 125
Chicago, 8, 25, 87, 121, 124, 128, 152, 153-4, 156, 171, 180
Chinook, Montana, 6, 138
Chisholm, J., 9
Chouteau County, Montana, 88

Christie, D.B., 59, 182
Circle C Ranch, 17, 111; see also Coburn, R.
Circle Cattle Company, 16, 19, 23, 48, 94; see also Conrad, C.E.; Conrad, W.G.; cattle, smuggling
Circle Diamond Ranch, 19, 21, 22, 94, 138, 157; see also Bloom, F.; Survant, J.
CK Ranch, 139; see also Kohrs, C.
Claresholm, Alberta, 172
Clarke, H.P., 128
Clarke, S.J., 68
Coburn, R., 17
Cochrane, Lady A., 58
Cochrane, M., 18, 25, 37, 39, 44
Cochrane, T., 58
Cochrane, W., 45, 146-7, 184
Cochrane Ranch, 18, 19, 22, 102, 108, 135, 146-7, 157, 161; breeding program, 47
Cody, W. ("Buffalo Bill"), 28, 35
Colorado, 5, 13
Comstock, W.G., 116
Connor, R., 30
Connors, N.D., 168
Conrad, C.E., 16, 19, 25
Conrad, W.G., 16, 19, 25, 61
Cooper, N., 105
Cosner, Sheriff, 92
Cotton, B., 111
Coutts, Alberta, 19
"Cowboy Annie," 122
cowboys, 6, 10-11, 61; culture, 97-118, 176-7, 181; evolution of profession, 173-4; and gambling, 71-2; and gunplay, 72-80, 183, 184-5; in media, 28-35; life style, 63-80; and liquor, 69-71, 97,

106; and prostitution, 69-71; and rustling, 69, 81-95, 113-14, 174, 181
Cox cattle ranch, 55
Craig, J.R., 142, 182
Crazy Mountains, Montana, 6, 17
Cree Nation, 78, 88
Cross, A.E., 23, 45, 157, 168; breeding program, 47
Cross S Horse Ranch, 15, 55, 58
Crow Nation, 88, 125
Culbertson, Montana, 90, 185
Curry, Kid, 74
Custer, General, 77
Custer County, Montana, 20, 138, 163, 168
Custer Trail Ranch, 27
Cypress Hills, Assiniboia, 6, 7, 19, 48, 61, 84

Dakota, 82, 91
Dallas, 52
Davis, A.J., 139
Dawson County, Montana, 16, 138
Day, J.S., 16, 61
Day and Cresswell ranch, see Turkey Track
"Deadwood Dick," 27
Deane, R.B., 91, 93-4
Deaton, W., 72
Deer Lodge, Montana, 53
Dempsey, H., 5
Denver, Colorado, 9, 34
De Wolf, Mr, 91
DHS Ranch, 121, 161
Dilworth, J., 82, 165
Dippie, B., 3
Douglas, T.C., 192
Douglas, Wyoming, 72
Dow, N., 123
Drumheller, Alberta, 147
Dudley, Lady G., 55
"Duke Darrell," 27
"Dutch Henry," see Ieuch, H.

Index 243

Eaton, A., 27
Eaton, H., 27
Edinburgh, Scotland, 13
Edmunds, F., 69
Edwards, H., 191
Elmhurst, E.P., 55, 59
Emerson, G., 10
English, T., 71
Ensigham, P., 122
Eureka Ranch, 15, 58, 59

Fallon County, Montana, 20
Farrell, C., 82, 91
Farrell, M., 58
Farrell, W., 82
Flathead Nation, 88
Fletcher, A., 87
Fletcher, R.H., 5
Floweree, D., 9, 55
Ferdon, Mr and Mrs, 55
Ferdon and Biddle ranch, 168; see also Ferdon, Mr and Mrs
Fergus, J., 15, 54, 61, 81, 87, 134, 135
Fergus County, Montana, 15, 134
Fergus Land and Livestock Company, 15, 59, 161
Ferris and Bristol ranch, 168
Fischel, S., 87
Fisk, W., 122
Ford, R.S., 9
Fort Benton, Montana, 61, 88, 89–90, 91, 122
Fort Maginnis, Montana, 94
Fort Macleod, Alberta, 3, 23, 43, 48, 68, 79, 84, 86; and liquor control; 71, population of, 53, 67
Franklin, J., 111
Frewen, M., 39, 84, 151–3, 154, 172
Frewen, R., 151
frontiers, 3, 7, 10–11; culture of, 42–62; conditions on, 3–6, 63–9, 81–4, 96–118, 187–92; influence of on women, 119–31, 190–91

Gaddis, W., 169
Gallagher, Mr, 74
Gibb brothers, 138
Gibson, P., 173
Gill, A., 12
Glasgow, Montana, 65, 90, 185
Gleichen, Alberta, 78, 140
Glengarry Ranch (44), 19, 43
Gordon, S., 142
Gordon, Sergeant, 74
Goddard, G.E., 76
Godsol, F.W., 47
Goodnight, C., 9
Grand Forks, Montana, 54
Granite, Montana, 54
Grant, G.M., 26
Gray, J., 121
Graz, B., 57
Great Falls, 52, 53, 54, 56, 91, 111, 129
Great Plains, xiii, 3; human imagination and, 25–41; natural environment of, 7–8, 15, 19
Green Mountain Land and Cattle Co, 58
Grenfell, Assiniboia, 45
Griffith, W., 66
Gull Lake, Assiniboia, 86

Half Circle V Ranch, 47
Hall, C., 123
Hamilton, E., 122
Hamilton, J.M., 5
Hanging Woman Creek, Montana, 55
Hatfield, H.M., 45
Harmon and Hale ranch, 168
Harris, Detective, 89
Harris, E.A., 75
Harrison, Mr, 89
Harrison, R.B., 61

Hathawa, Montana, 141
Hathaway, M.S., 191
haying, see mixed farming; cattle, feeding
Healy, Sheriff, 89
Helena, Montana, 8, 34, 52, 69, 137, 158, 191; population of, 53; prostitution in, 128
Hensley, J., 128
Herchmer, L., 86
Herron, J., 86
Hesper Ranch, 59
HD Ranch, 109
High River, Alberta, 35, 43, 72, 78, 105, 139
High Walking, 125
Highwood Mountains, Montana, 8
Highwood River, Alberta, 127
Hill, A.S., 18, 39, 44
Hinsdale, Montana, 138
Hobson, S.S., 16, 61
Hollywood, 185
Holt, J.M., 133
Holt, R.M. 61
Home Land and Cattle Company (N–N), 17, 94, 138, 139
Hopkins, M., 51, 129
Hopkins, W., 51
House, L., 128
Hubbard and Thompson ranch, 168
Huckvale, W., 168
Huggard, J.S., 75
Huidekoper, A.C., 27
hunting, 45–6, 56–8

Idaho, 82, 88
Ieuch, H., 13, 90, 91–2
Iken, Mr, 72
Inderwick, F.C., 50, 129
Indian Territory, the, 9
Ingalls, E.J., 191
Ingraham, P., 28
Ings, F., 51, 70, 82, 115, 127, 165–6, 184
Iowa, 5
irrigation, 59, 178–9

Jackson, W.H., 27
James, W., 117
Jarvis, Inspector, 64
Jarvis, W.L., 108
Johnson and Graham ranch, 168
Johnson, E.C., 33
Johnstone, C.L., 108
Jones, Mr, 74
Jones, F., 13, 90, 91-2
Jones, W., 66
Jordan, T.G., 5, 6
Judith Basin, Montana, 59, 183
Judith Mountains, Montana, 8, 15, 16, 17, 72

Kane, P., 27
Kaufman, L., 137
Kaye, J.L., 44, 51, 151, 184
Keats, J., 27
Keith, W., 27
Kelly, L.V., 74
Kerfoot, W.D., 108-9
Kirwan, M., 55
Knowles, E.L., 191
Kohrs, C., 8, 133, 135, 138-9
Kootenay River, Alberta, 86

LaGrandeur, E., 129-30
LaGrandeur, V., 129-30
Lamb ranch, 45
Landusky, Montana, 74, 185
Landusky, P., 74
Lane, G., 48, 157, 184
Langdon, Alberta, 136
Laramie, Wyoming, 52
Larb Hills, Montana, 20
Latham, H., 36
Lathom, Lord, 18, 25, 39
Lattimer, R., 169
Lavington, H., 146
law enforcement, 122, 186-7, 189; and frontier conditions, 63-7;

and rustling, 81-95; see also North West Mounted Police
Lethbridge, Alberta, 19, 43, 182; population, 53; prostitution, 122-3, 124, 128
Lewis, L., 169, 174
Lewis, Montana, 122
Lewis and Clark County, Montana, 9, 61, 128, 191
Lewistown, Montana, 54, 73, 122
Libby Creek, Montana, 58
Lincoln, Nebraska, 123
Lindsay, K., 55, 69, 84
Little Goose Creek, Montana, 162
Little Missouri River, Montana 20, 27
Little Rocky Mountains, Montana, 6, 12, 17
LaDow, B., 6
Liverpool, England, 26, 38
livestock other than beef cattle; dairy cattle, 8, 158-9; hogs, 8, 24, 160, 174; horses, 45, 47-8, 56-7, 115, 164 (see also rustling); poultry, 8, 24, 160; sheep, 8, 159, 160, 179-80
Livingstone, Montana, 128
Logan, H., 12
Lomax, J., 103
London, England, 6, 8, 13, 26, 28, 35, 180, 188
Longabaugh, H., 165-6
Long S Ranch, 20
Long X Ranch, 20
Loving, O., 9
Lynch, T., 10, 139
Lyndon, C., 168
Lyndon, W., 168
lynching, see vigilantism

McCarthy, J., 74
McClung, N., 191
McCoy, J., 36
Macdonald, A.B., 43
Macdonald, J., 38
Macdonald, J.A., 37
McDonald Ranch, 154
Mcdougall, D., 9
Mcdougall, J., 9
McEachran, D., 44, 45, 150, 155, 156-7
McHugh brothers' ranch, 168
McIntyre Ranch, 19
McKenzie, A., 90
McKenzie, M.J., 175
McKenzie, S., 94
Mckinney, L., 190
Maclaren, N., 82
McLean, C., 128
MacNamara Ranch, 133
McNaughton, V., 190-1
Madison County, Montana, 61
Maginnis district, Montana, 183
Malta, Montana, 138
Manitoba, 102
Maple Creek, Assiniboia, 6, 19, 23, 48, 49, 93, 126, 183; and liquor control, 71; population of, 53
Marias River, Montana, 17, 91, 93
"Marmaduke," 12
Matador Ranch, 15, 21, 94, 139
Maunsell, E., 10, 45
Mavericks, 83-5
Maybert, I., 122
Maybridge, E., 27
Medicine Hat, Assiniboia, 19, 48, 49, 139, 163; population, 53
Metcalfe, L., 191
Métis ranchers, 126
Mellette, J., 108
Metzel, A., 59, 61, 169
Mexico, 6, 96, 117

Index 245

Miles City, Montana, 9, 15, 52, 54, 56, 69, 73, 84, 121, 136, 141, 163, 168, 180; law and order in, 184; population of, 53; prostitution in 123
Military Colonization Ranch, 51, 107
Milk River, Alberta and Montana, 7, 17, 93, 138, 139, 183, 185
Milk River Ranch, 183
Milk River Ridge, Alberta and Montana, 7, 19, 48, 139
Millarville, Alberta, 43, 51, 67, 188
Miller, A.J., 27
Miller, J., 9
Milton, Viscount, 26
Minnesota, 91
Mississippi River, 17
Missoula, Montana, 53
Missouri, 5, 9, 16
Missouri River, 7, 8, 20, 21, 82, 87, 139, 183, 185
mixed farming, 8, 21, 58–9, 132, 158–74, 178; haying 162, 166–8
Mizpah Creek, Montana, 15, 116
Moccasin district, Montana, 183
Moccasin Mountains, Montana, 7
Moncrieffe, M., 55
Moncrieffe, N., 55
Montague, W.D., 15
Montana, 35; agricultural practices in, 20–4; first cattle in, 8–9, 14; settlement of, 16–17, 19–20, 22–3
Montana Cattle Company, 16, 17
Montreal, Quebec, 6, 13, 180
Moore, J.T., 169

Moose Mountain area, Assiniboia, 6
Morley, Alberta, 9
Morrison, J., 75
Mosquito Creek, Alberta, 108
Mossomin, Assiniboia, 86
Muddy Lake, Assiniboia, 90
Muddy Pond, Montana, 168
Mulhall, L., 131
Murphy, E., 190
Murphy, J.T., 17
Murray, Mr, 89
Mussellshell River, Montana, 77, 87

Nanton, Alberta, 47
Native Bands, 27–8, 35, 64; and interracial marriage, 124–5; and racial conflict, 77–9; and rustling, 61, 88–9, 148; see also individual bands
N Bar Ranch, 124
N Bar N Ranch, see Home Land and Cattle Company
Neidringhaus Brothers, 17, 138; see also Home Land and Cattle Company
Neimmela Ranch, 15, 25
Nelson, C., 13, 90, 91–2
Newbolt, R., 10, 51, 107, 168; farming practices, 173
New Mexico, 13
New York, 6, 13, 27, 151, 180, 188
Nine Six Nine Ranch, 116
Niobrara Land and Cattle Company, 123, 138
Norbury, Lord, 58
North Fork Ranch, 50, 156
Northrop, H., 11

Northwest Cattle Company, see Bar U Ranch
North West Mounted Police, 3–4, 23, 45, 67, 181, 182, 183, 185, 188; and liquor trade, 70–1; and gunplay, 76; Native relations, 77, 79; and prostitution, 123, 124–5, 190–1; and ranching, 9; rustling by, 85, 89–90; see also law enforcement; rustling
Nose Creek, 47

O'Donnell, I.D., 59
Ogallala, Nebraska, 121
OH Ranch, 136, 165
Okotoks, Alberta, 184
Old Man River, Alberta, 48, 139
Old World influences, 4–5, 11–12, 42–62, 96–7, 180–1, 187–8; through media, 27–41, 177–8, 180
Olsen, Mr, 10
O'Neal, Sheriff, 91
Omaha, Nebraska, 87, 121
Oregon, 5, 6, 8, 9, 116, 144; Trail, 8
O'Reilly, J.H., 54
Orr, W., 8
O'Sullivan, T., 27
Oxley Ranch, 18, 25, 84, 142, 182

"Packsaddle Jack," 77
Paget, D., 55
Paget, S., 55
Parlby, I., 191
Paterson, Corporal, 67
Patterson, J., 184
Paul, Mr, 78
Peigan Nation, 9, 78, 88, 89
Phelps, J., 136–7
Phillipps-Wolley, E.C.O.L., 26

246 Index

Pincher Creek, Alberta, 11, 47, 50, 67, 86, 127, 139, 156
Pioneer Ranch, 21, 48, 94, 139; see also Kohrs, C.
Pipestone River, Montana, 45, 46
Platte River, Nebraska, 14
Poindexter, T., 8
Pollock, Mr., 78
Pomeroy, E., 53
Pope, J., 44
Power, J., 17
Power, T.C., 17, 72
Powder River, Wyoming and Montana, 15
Powder River Land and Cattle Company, 15, 39, 48, 84, 139, 151–3, 154, 157; see also Frewen, M.
Powderville, Montana, 168
Pretender, J., 25
Price, C., 85, 109, 126
Price, J.H., 55
prostitution, 69, 71, 97, 103–4, 121–4; see also North West Mounted Police; cowboys; individual towns
Pruit, J., 82
Purvis, Corporal, 91

Qu'Appelle, Assiniboia, 74
Quin, Mr, 84
Quirk, J., 168
Quorn Ranch, 19, 23, 140; breeding program, 47

railways, 8, 22, 25, 86, 134, 156, 163
ranching practices, 20, 21, 132–74
range wars, 187
Rankin, J., 191
"Rattle Snake Jake," 73
"Rawhide Rawlins," 113

Rawlinson ranch, 46
Raymond, W.H., 57
Red Deer River, Alberta, 26, 163
Redmond, J., 183
Red Rock, Montana, 16
Red Water, Montana, 16
Regina, Assiniboia, 75, 91
Regway, Montana, 90
Remington, F., 12, 52
remittance men, 11–12
Renner, C.K., 123
Richthofen, Walter, Baron von, 36
Ricks, F., 48, 108–9, 115, 184
Rio Grande, Texas, 31
Richards, D., 175–6
Rocky Mountains, 8, 15, 19, 139
rodeo, origins 114–17
Roosevelt, T., 16, 27, 52, 65, 104; writings, 17, 34, 72
"Rosalie," 122
Rosebud, Alberta, 140
Rosebud, Montana, 168
Ross ranch, 157
round-ups, 61, 98–9, 163–5; see also cowboys, culture
Russell, A.J., 27
Russell, C.M. 3, 10, 52, 69–70, 71, 108, 114, 117, 136, 139, 176; on cowboy style, 112; on law and order, 182–3, 185; and prostitutes, 123, 124; storytelling, 105, 106, 110
Russell ranch, 147
Rustin and Ike ranch, 168

St Louis, Missouri, 10
St Maur, A., 58
St Maur, S., 58
St Paul, Minnesota, 54, 87, 121
St Rathborne, G., 30
Sam Coulee Ranch, 173
Sampson Ranch, 23

Sarcee Nation, 9, 88
Saulteaux Nation, 88
Savage, S., 146
Schrems, S, 77
Scott, J.F., 150
Scott, J.W., 16
Scouten, G., 75
Seeley, R., 146
Serviceberry Creek, Alberta, 140
Seven Seven Seven Ranch, 20
Severn Creek, Alberta, 140–1
Shaddock Boys Ranch, 136
Shaw, J., 9
Sheep Creek, Alberta, 122, 184, 188
Shelley, P.B., 27
Siksika Nation, 9, 78, 88, 89
Sioux Nation, 9, 77, 125
Simpson, Mr, 76
Simpson, A., 75
Simpson, G., 26
Siskiyou, Montana, 8
Skinner, Mr, 78
Skrine, W., 23
Slatta, R.W., 5, 6, 188
Smith, Mr, 91
Smith, "Buck," 105
Smith River, Montana, 174
Smith Valley, Montana, 171
Snake River, Idaho, 165
Snowy Mountains, Montana, 7
Southesk, Earl of, 26
South Saskatchewan River, Assiniboia, 7
Spencer, J., 17, 19, 93–4
Spencer, S., 17, 19, 93–4
Spencer Ranch, 19, 22, 130; see also Spencer J.; Spencer, S.
Stair Ranch, 19, 22, 51, 157, 161
"Stampede Steve," 28–9, 41, 119
Steele, S., 43, and liquor control, 70

Stevenson, G., 74
Stevenson, J., 74
Stevensville, Montana, 191
Stewart Ranch, 47
Stimson, F., 35, 44, 45, 115; storytelling, 106–07
stock growers associations; 61, 138, 144, 163; and control of breeding 149, 150; membership, 168; and rustling, 87, 92; rustling by, 84–5
Stoney Nation, 9, 51
Story, N.S., 9, 82
Stowell, Mr, 91
Strahorn, R.E., 38
Strathmore, Alberta, 129
Stuart, G., 14, 82, 83, 84, 125, 133, 138, 186; and vigilante activity, 87, 88, 89, 94, 120–1, 181
Sun River, Montana, 16
Survant, J., 138, 170
Sweet Grass Hills, Montana, 7
Swift, N., 123

Taylor, "Buck," 28, 111
Taylor, J., 45
Terry, Montana, 168
Teton County, Montana, 9
Texas, 5, 6, 9, 13, 60, 83, 116, 138, 144 ranchers from, 19–20, 114

Thomas, L.G., 5
Thompson, J., 105–6
Thompson Falls, Montana, 58
Tilley, Alberta, 71
Todd, Mr, 72
Tongue River, Montana, 15, 77
Toronto, Ontario, 25
Trailer, "Kid," 13, 90
Turkey Track Ranch, 19, 20, 21, 22, 94, 157
Turner, F.J., 188–9
Turner, J.M.W., 27
Turner, R., 176

Utah, 8, 82

Valley County, Montana, 65–6, 92, 138
Victoria, Queen, 28, 106
vigilantism, 4, 45, 67, 79, 86, 87–8, 89–90, 97, 181, 186; see also Stuart, G.
Virginia City, Montana, 8, 17, 67, 158

Walker, R.C., 16
Walker, R.P., 61
Wallop, O., 55, 57, 59
Walrond, Sir J., 18, 19, 39
Walrond Ranch, 11, 18, 22, 113, 135, 155–6, 156–7; death losses at, 143; feeding practices at, 161, 167; breeding program at, 47, 150

"Waltermeyer," 27
Ware, J., 48, 105, 108, 115, 184
Weadick, G., 129
Wheeler, B.K., 191
White Calf, 89
White Tail Deer Creek, Montana, 174
Whitney, T., 183
Wibaux, P., 133, 139
Widdow ranch, 45
Willow Bunch, Montana
Winder, W., 37
Winnipeg, Manitoba, 54, 129, 130
Wister, O., 33
women, see frontiers; prostitutes
Wood, H.W., 192
Wood Mountain area, Assiniboia, 6, 48, 90, 129, 140, 183
Wordsworth, W., 27
Wyoming, 5, 13, 35, 82, 90, 91, 94, 184, 185

XIT Ranch, 20

Yellowstone River, Montana, 7, 8, 20, 21, 82, 87, 88, 128, 139, 183
York Ranch, 59
YT Ranch, 15

Zuelke, M., 188

MARICOPA COUNTY COMMUNITY COLLEGES
CHANDLER/GILBERT COMMUNITY
COLLEGE
LEARNING RESOURCE CENTER
2626 EAST PECOS ROAD
CHANDLER, AZ 85225

Chandler-Gilbert
Community College

NOV 15 2005

Library
Technical Services